DRAWING
A Complete Guide

Giovanni Civardi

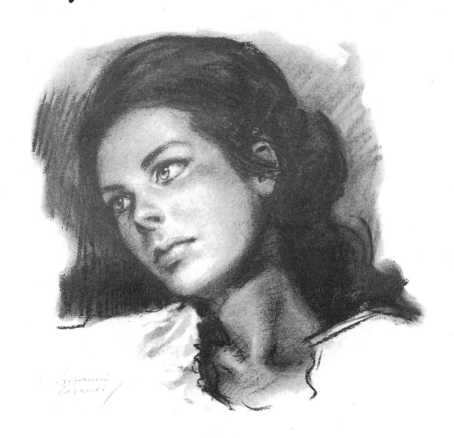

SEARCH PRESS

CONTENTS

DRAWING TECHNIQUES

Drawing was one of the first means of expression and representation invented by man, when he drew on the walls of prehistoric caves, and it is still extremely valid, both as an artistic representation of reality and as a means of expressing pure imagination.

To be able to draw means, above all, to be able to 'see', to understand rationally, to feel emotions, and to master the techniques which allow us to fully express our thoughts and moods.

This chapter focuses on the main drawing media, because technique at least can be learnt through experimentation, practice and constant application. There are plenty of manuals which deal extensively with drawing materials and how to use them, but my teaching experience has taught me that, initially, those who are new to drawing need, above all, information, comprehensive and simplified, on the most common media and on the results which can be achieved with each. Personal choices and mastering the subject can come later, when necessary, as there is no point in anticipating ideas or making suggestions which would not be acted upon or, worse, could dishearten if given too soon.

The drawings collected here represent different periods in my career and should not be taken as examples of a drawing style to imitate, but simply as an indication of the purely technical results which can be achieved with the various graphic media. Moreover, they are all of a highly figurative nature – many decidedly academic – as it is easier, and more useful, to begin learning to draw from life. But don't stop here: as soon as you feel comfortable with the various media and how to use them, try to go beyond reality; that is, use them as a source of inspiration and stimulation which will put you in touch with your deepest feelings, and then communicate them by drawing. Bear in mind that, for the true artist, technique is indeed essential but only as a tool which, once mastered, must adapt to and serve your expressive needs.

MATERIALS AND EQUIPMENT

The materials and equipment used for drawing today are, essentially, those which have been used traditionally for centuries: pencils, pens, brushes, inks, papers, etc. The diagram below features those which are indispensable when first starting to draw.

Drawing paper comes in many types, colours and qualities, each with distinctive characteristics which make it more or less suited to the different media techniques (e.g. charcoal needs a rough surface, while pen flows more easily on smooth paper). To see the effect of different media on different surfaces, experiment with some of the examples opposite.

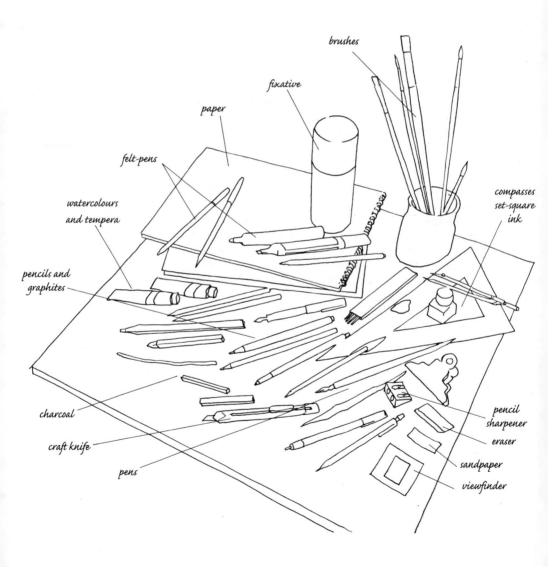

STROKES DRAWN ON SMOOTH PAPER WITH DIFFERENT MEDIA

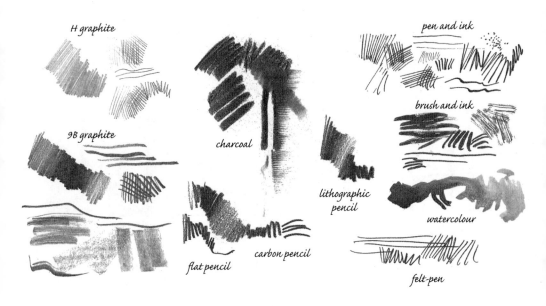

H graphite

pen and ink

brush and ink

9B graphite

charcoal

lithographic pencil

watercolour

carbon pencil

flat pencil

felt-pen

STROKES DRAWN ON ROUGH PAPER WITH DIFFERENT MEDIA

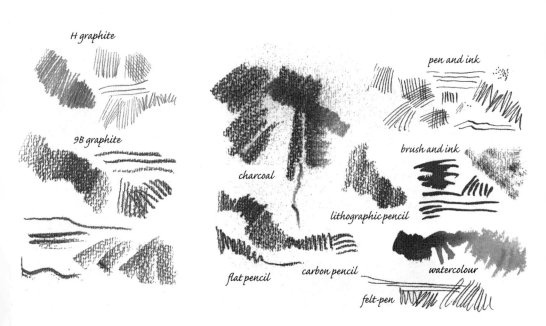

H graphite

pen and ink

brush and ink

9B graphite

charcoal

lithographic pencil

watercolour

flat pencil

carbon pencil

felt-pen

BASIC TECHNIQUES

THREE-STAGE MODEL

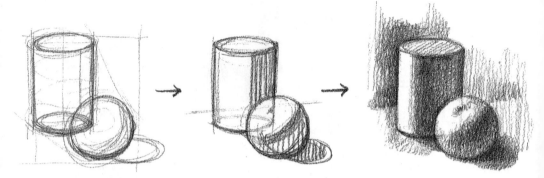

Stage 1 *Suggest the relative proportions of the objects.*

Stage 2 *Determine the shapes, tracing the contours of the shaded areas.*

Stage 3 *Complete the form, emphasising tonal values.*

TONES

Tonal gradations (light-dark) can be achieved in different ways: by varying the pressure (examples A and B); by cross-hatching (example C) and by dilution (example D).

A *2B pencil*

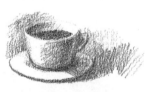

B *Compressed charcoal*

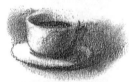

C *Pen and ink*

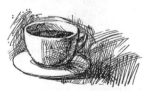

D *Water-soluble ink*

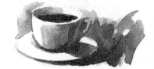

LIGHT AND SHADOW

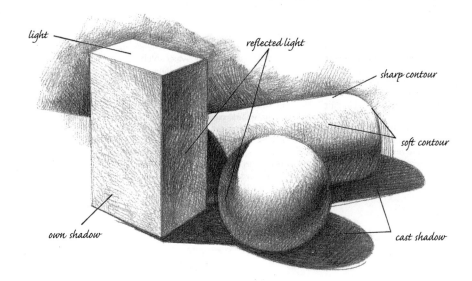

light

reflected light

sharp contour

soft contour

own shadow

cast shadow

LINE AND TONE

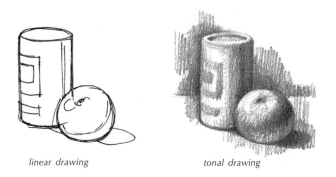

linear drawing

tonal drawing

CREATING TONES WITH HATCHING, CROSS-HATCHING AND OTHER TECHNIQUES

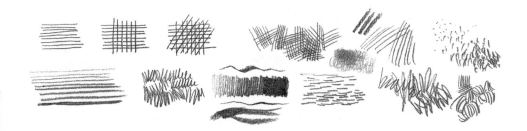

PENCIL AND GRAPHITE

Pencil is the most widely-used drawing medium as it is cheap and versatile. Besides the traditional wood-encased pencils, there are other types of pencils: graphites or leads (thin sticks, held in mechanical clutch pencils); waxy, lithographic pencils; water-soluble pencils; flat, carpenter's pencils; and very thin (micro) leads, held in propelling pencils.

Graphites are graded in a decreasing scale from 9H (the hardest) to H, and in an increasing scale from B to 6B (the softest). Beyond this grade (up to 9B) graphites are made in thick sticks for easier handling. HB is the medium grade, neither too hard nor too soft. Hard graphites, also called 'technical' leads, draw faint, clean, even lines, while the soft types are more 'artistic' and accurately represent the different levels of pressure in freehand drawing. A drawing's dark tones can be achieved either by increasing the graphite's pressure on the paper, or by drawing increasingly close lines over one another at right angles (cross-hatching). Tones can be blended into one another by smudging with a finger, with a wad of cotton wool or with a rolled paper stump.

EXAMPLES ON MEDIUM-TEXTURED CARD

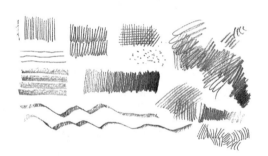
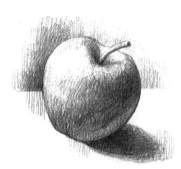

2H hard pencil or graphite

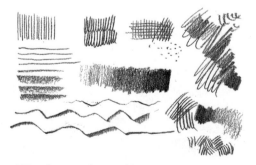
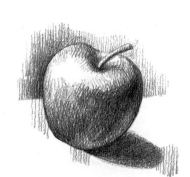

HB medium pencil or graphite

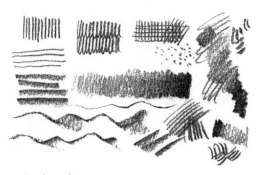
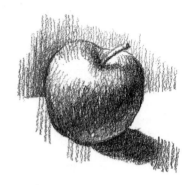

6B soft graphite

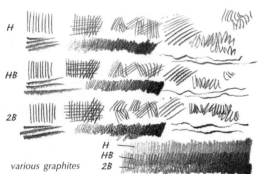
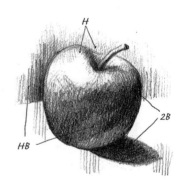

H

HB

2B

H
HB
2B

various graphites

H

2B

HB

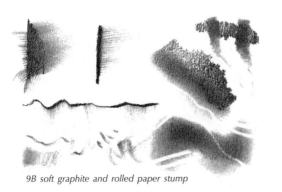
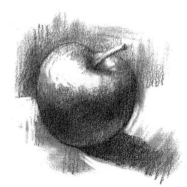

9B soft graphite and rolled paper stump

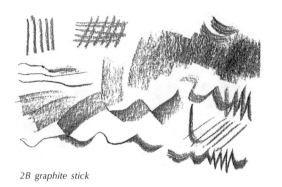

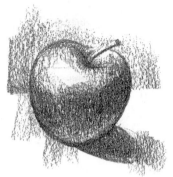

2B graphite stick

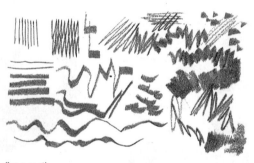

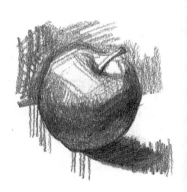

flat pencil

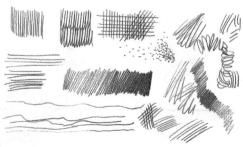

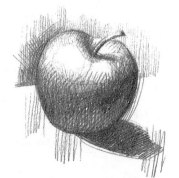

very fine lead

graphite dust and highlights added with an eraser

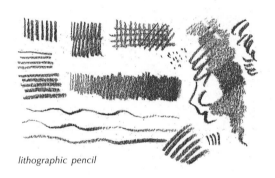

lithographic pencil

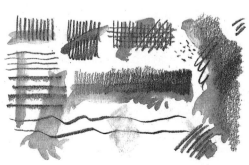
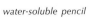
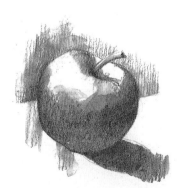

water-soluble pencil

The drawings shown on this page and the next are two portrait studies. They have been done from life on fairly smooth paper, 42 x 56cm (16˝ x 22in), using 2H pencil. Both drawings are fairly linear and a faint tonal grading has been achieved with a more or less intense and regular cross-hatching. The hard pencil (which I have kept well sharpened) has enabled me to complete the drawings in quite a pale tone showing little contrast, and made more intense by using increased pressure in places.

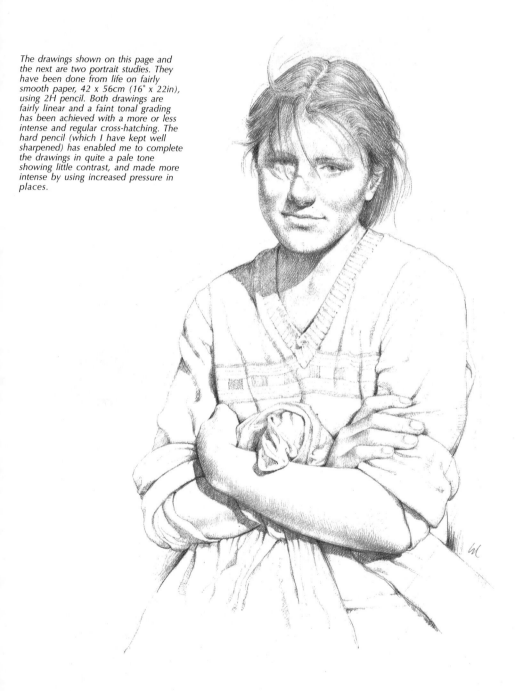

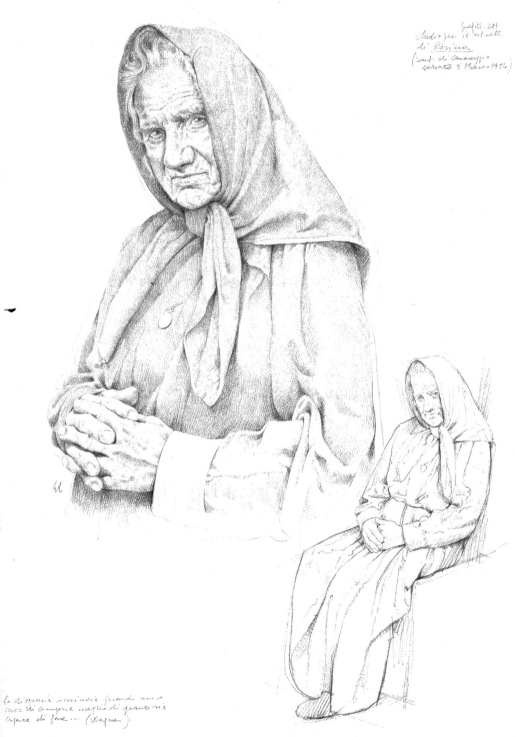

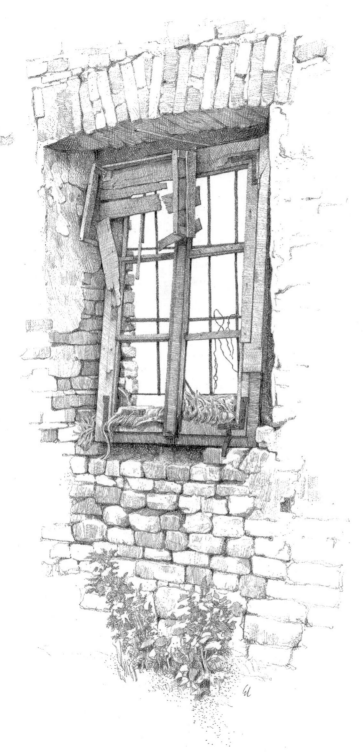

*H and 2H pencil on paper,
40 x 50cm (16 x 19 in).
This is a study for an etching.
The cross-hatching, with its even
strokes, mimics the traditional
etching process, and helped me
solve some tonal and
compositional problems before
tackling the copper plate. Its
size is, of course, much smaller:
20 x 30cm (8 x 12in). Dotting
can be used as well as hatching,
as you can see at the base of
the wall.*

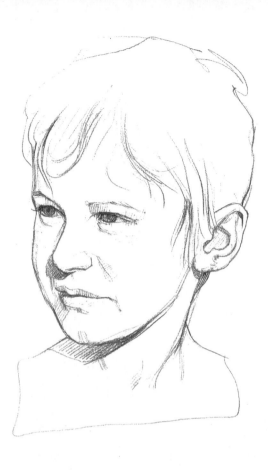

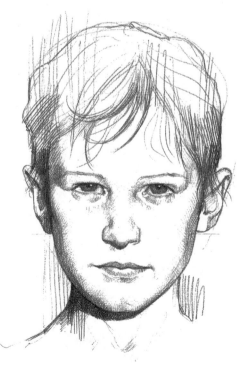

When commissioned to draw a portrait, I start by studying the appearance of the model. Above all, however, I study the model's character in order to understand whether the work holds some sort of human, as well as aesthetic, interest for me. The drawings on this page show how I proceed, at least initially. Some sketches are accurate; some rough and intuitive and done in a few minutes to catch the structure of the face, the attitude or the expression, the composition, and in the main ignoring chiaroscuro (the contrast between light and dark) effects. I have used HB pencil on two sheets of rough Fabriano paper, 33 x 43cm (13 x 17in).

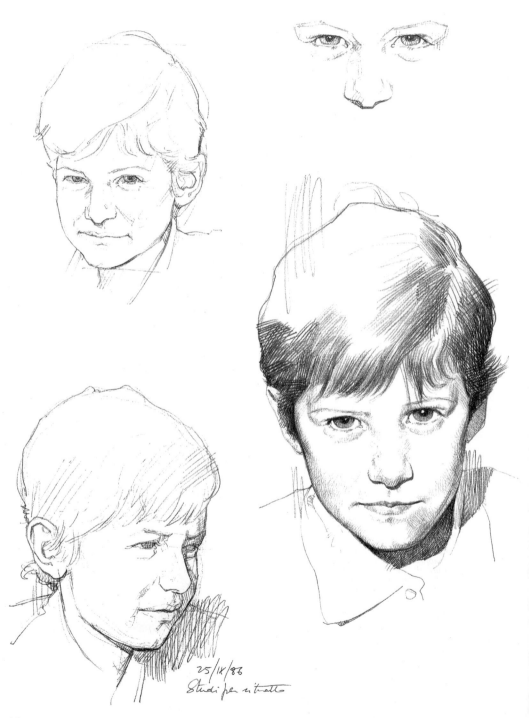

25/IX/86
Studi per ritratto

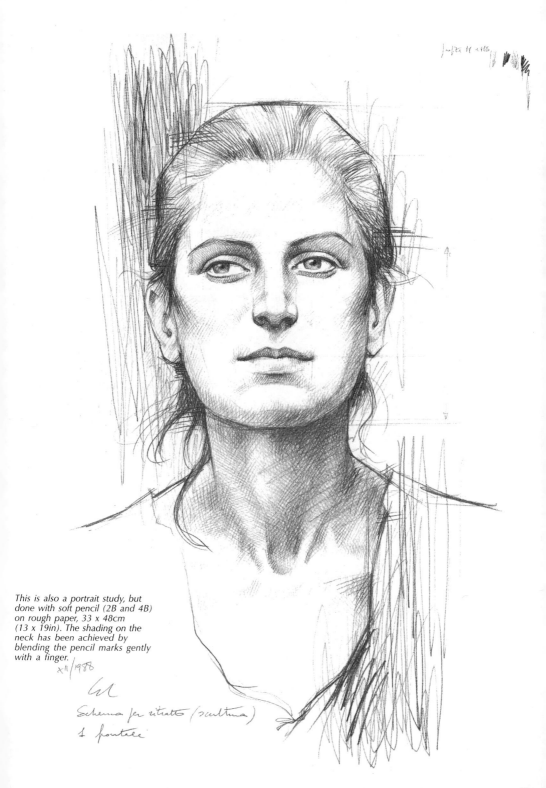

This is also a portrait study, but done with soft pencil (2B and 4B) on rough paper, 33 x 48cm (13 x 19in). The shading on the neck has been achieved by blending the pencil marks gently with a finger.

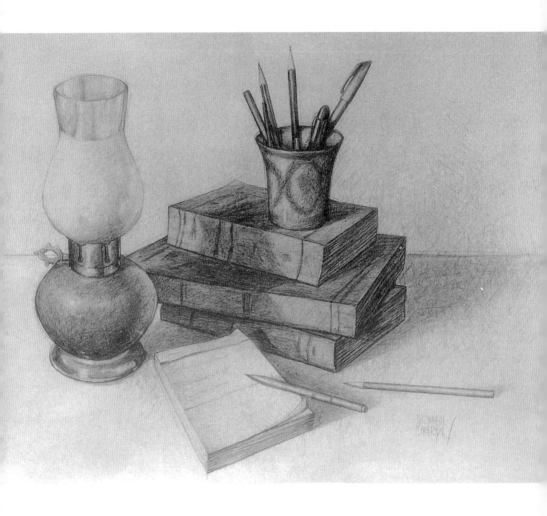

HB, 2B and 4B pencil on paper, 50 x 70cm (19˝ x 27˝ in).
'Lamp and books' and 'Tools', the two drawings shown on
these pages are examples of the type of exercises you do
early on in art school. Their aim is to train students to observe
reality and give them the opportunity to tackle simple
problems of composition, perspective and chiaroscuro. Both
drawings have been done by placing the paper vertically on
the easel and 'giving shape' to the objects by using light, but
irregular and fairly intense, cross-hatching. The monotony of
some areas has been achieved by dotting, in this case by
striking the sheet hard with the point of a soft pencil.

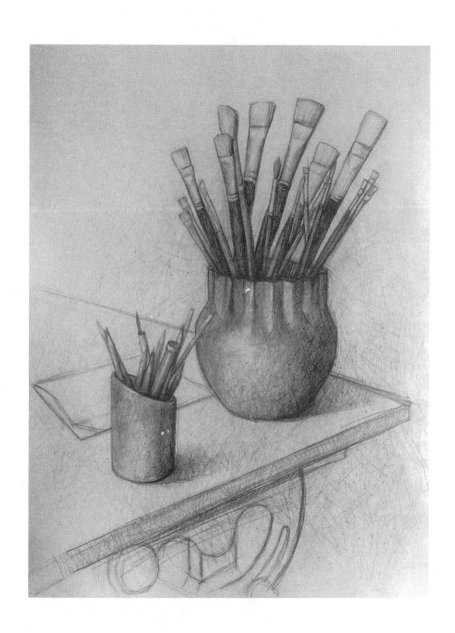

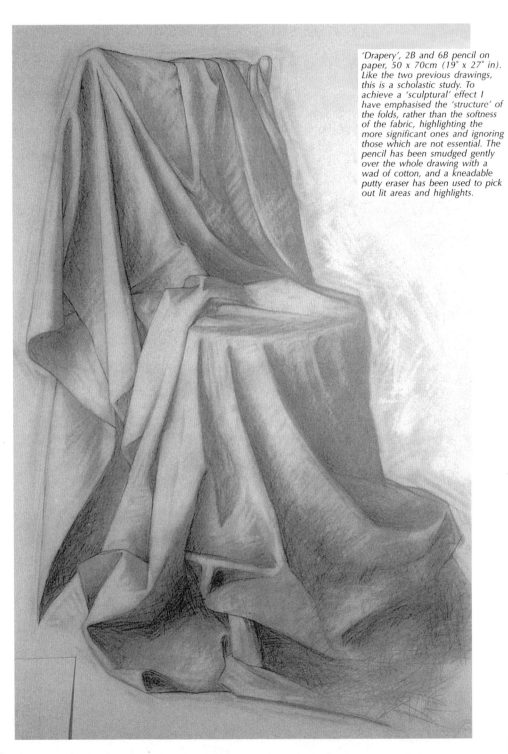

'Drapery', 2B and 6B pencil on paper, 50 x 70cm (19˝ x 27˝ in). Like the two previous drawings, this is a scholastic study. To achieve a 'sculptural' effect I have emphasised the 'structure' of the folds, rather than the softness of the fabric, highlighting the more significant ones and ignoring those which are not essential. The pencil has been smudged gently over the whole drawing with a wad of cotton, and a kneadable putty eraser has been used to pick out lit areas and highlights.

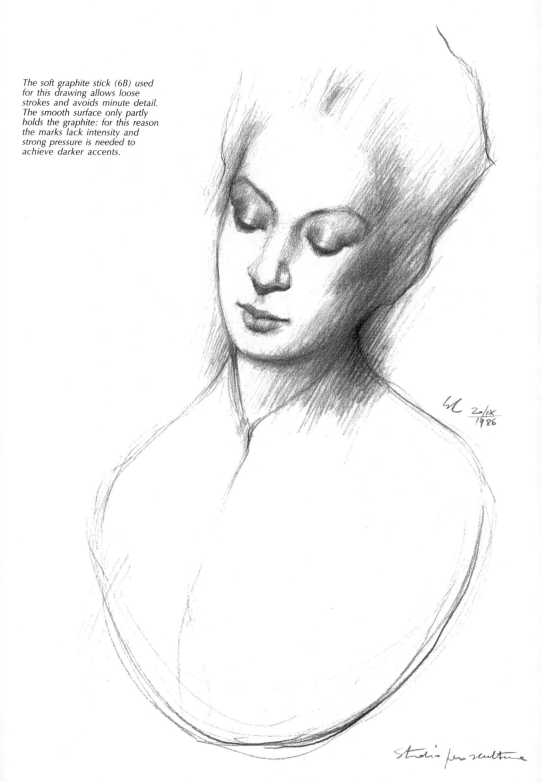

The soft graphite stick (6B) used for this drawing allows loose strokes and avoids minute detail. The smooth surface only partly holds the graphite: for this reason the marks lack intensity and strong pressure is needed to achieve darker accents.

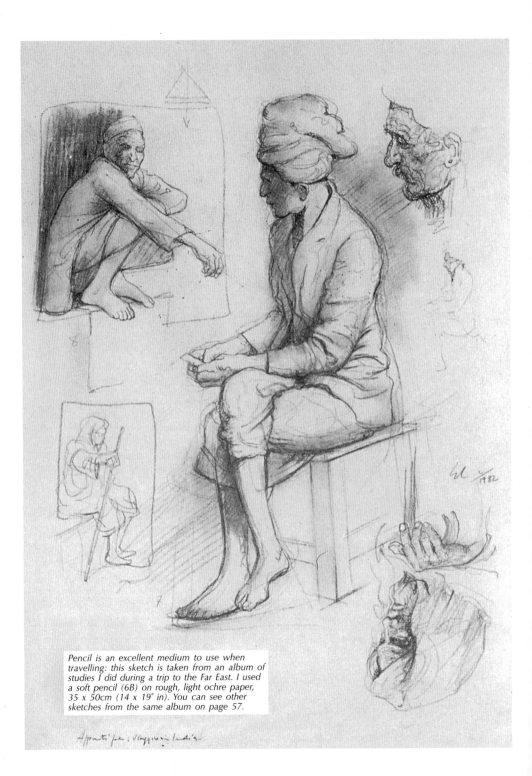

Pencil is an excellent medium to use when
travelling: this sketch is taken from an album of
studies I did during a trip to the Far East. I used
a soft pencil (6B) on rough, light ochre paper,
35 x 50cm (14 x 19° in). You can see other
sketches from the same album on page 57.

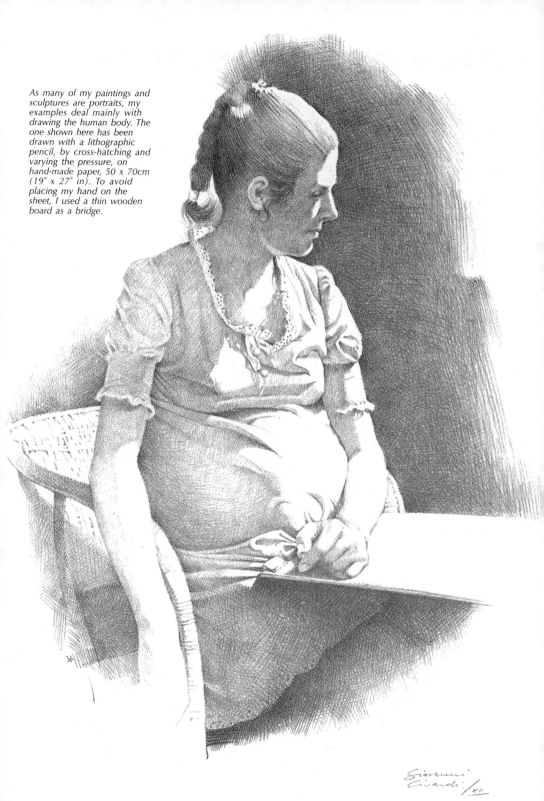

As many of my paintings and sculptures are portraits, my examples deal mainly with drawing the human body. The one shown here has been drawn with a lithographic pencil, by cross-hatching and varying the pressure, on hand-made paper, 50 x 70cm (19° x 27° in). To avoid placing my hand on the sheet, I used a thin wooden board as a bridge.

CHARCOAL, CHALK AND CARBON PENCIL

Willow charcoal is made by charring small twigs of willow: it is soft and leaves a dusty residue. Compressed charcoal (in stick or pencil form) is made from compressed coal dust and will give deep black strokes. Charcoal is ideal for fast, immediate drawings, with strong tonal contrast, but is less suitable for achieving minute detail. Smudging charcoal is even easier than graphite and the same methods are used, but be careful not to overdo it as you risk ending up with a drawing which lacks power, is photographic and structurally weak. Instead, it can be better to use a kneadable putty eraser to lighten or vary tones and 'carve' the lights. A type of charcoal often used for figure and landscape studies is 'sanguine', which has a particularly bright and warm colour.

EXAMPLES ON MEDIUM-TEXTURED CARD

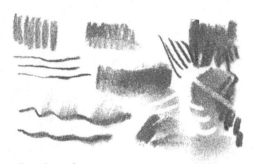
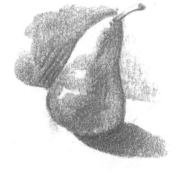

willow charcoal

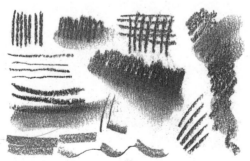

compressed charcoal

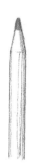
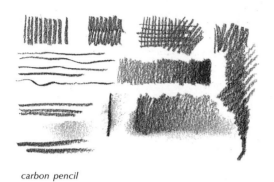
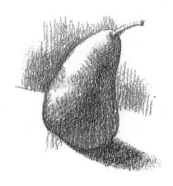

carbon pencil

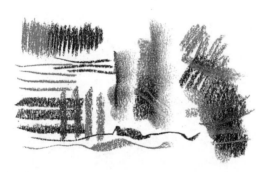
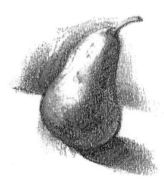

black, grey and white chalk

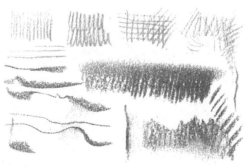

sanguine

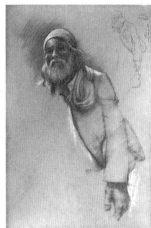

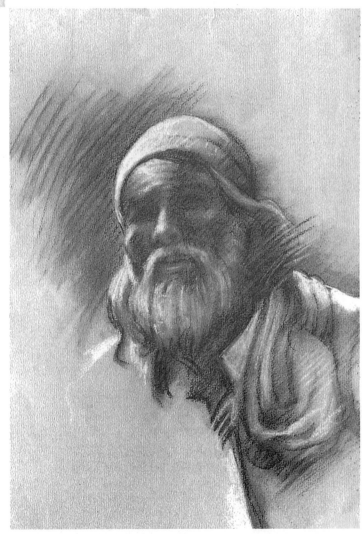

Study in black compressed
charcoal, sepia pastel and white
pastel on rough grey paper,
50 x 70 cm (19° x 27° in).
Use the charcoal to highlight
the tonal shapes rather than
the detail, and exploit the
paper's rough texture to
achieve expressive and
immediate effects.

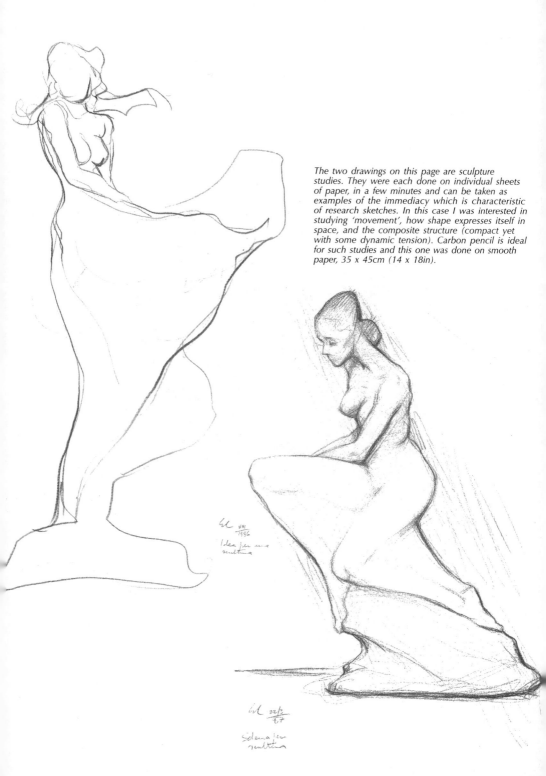

The two drawings on this page are sculpture studies. They were each done on individual sheets of paper, in a few minutes and can be taken as examples of the immediacy which is characteristic of research sketches. In this case I was interested in studying 'movement', how shape expresses itself in space, and the composite structure (compact yet with some dynamic tension). Carbon pencil is ideal for such studies and this one was done on smooth paper, 35 x 45cm (14 x 18in).

Even a simple sketch, a sort of visual note, can be
interesting and expressive. Practise drawing quickly
and concisely. First study the subject's shapes and
proportions carefully but then be spontaneous and
inquiring, and make the drawing an interpretation
rather than a pedestrian and formal replica of the
model. For this sketch I used sanguine for the medium
tones and compressed charcoal for the supporting
lines, on rough wrapping paper. For the small sketch
above I used a well-sharpened carbon pencil.

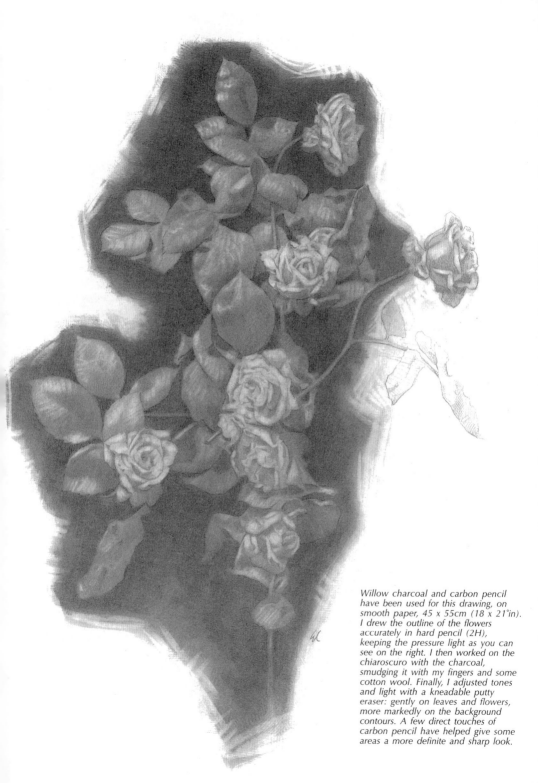

Willow charcoal and carbon pencil
have been used for this drawing, on
smooth paper, 45 x 55cm (18 x 21°in).
I drew the outline of the flowers
accurately in hard pencil (2H),
keeping the pressure light as you can
see on the right. I then worked on the
chiaroscuro with the charcoal,
smudging it with my fingers and some
cotton wool. Finally, I adjusted tones
and light with a kneadable putty
eraser: gently on leaves and flowers,
more markedly on the background
contours. A few direct touches of
carbon pencil have helped give some
areas a more definite and sharp look.

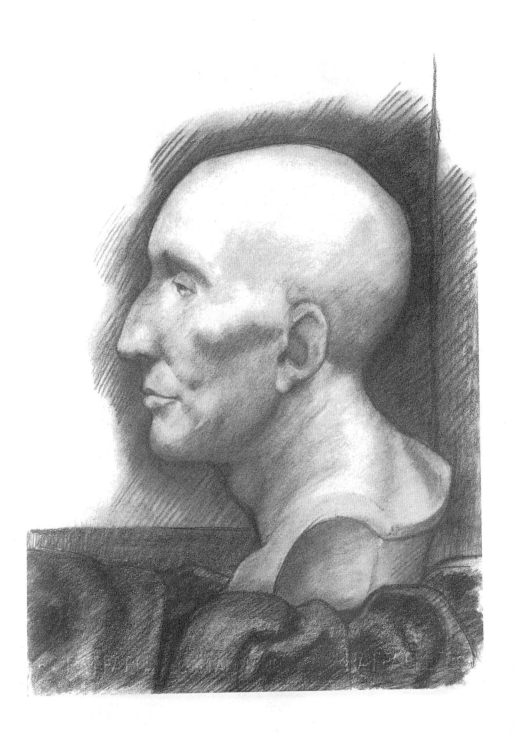

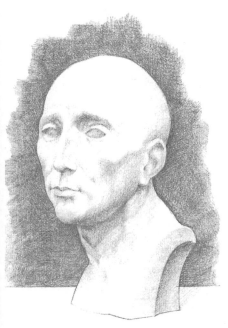

On these two pages you can see the sort of scholastic and academic drawings which used to be (and unfortunately, still are) typical of art schools. I say 'unfortunately' because copying casts and prints offers little stimulation, and does not teach you much. It is certainly better to study the figure from life. This is not always possible, however, and then casts can in part compensate as they allow you to study lights and shadows accurately, without moving. They can therefore, at least at the beginning, provide the opportunity to practise your technique patiently. Each of the three drawings shown here has been rendered on smooth paper, 40 x 50cm (16 x 20in), with willow charcoal and carbon pencil gently smudged with a finger, using a kneadable putty eraser to add highlights.

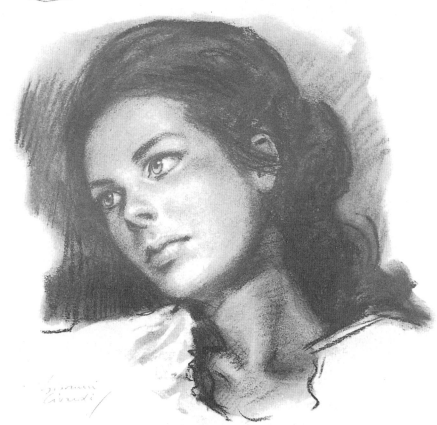

Lombardy Landscape. Carbon pencil on paper, 30 x 40cm (12 x 16in).

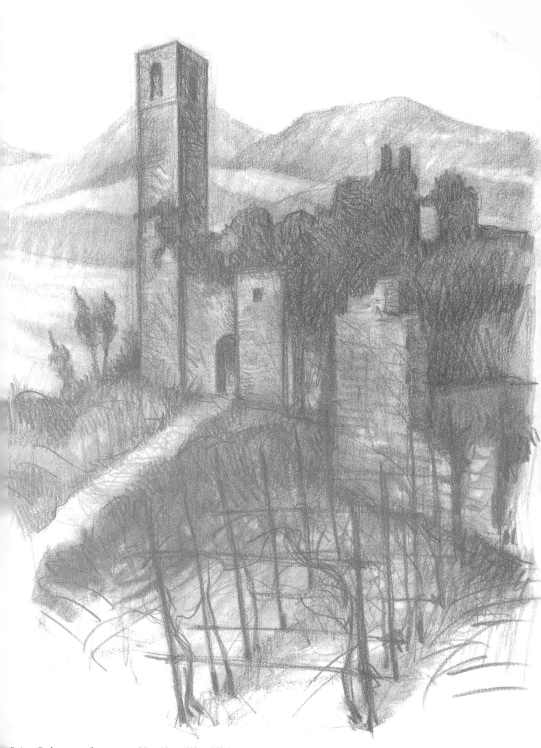

Ruins. Carbon pencil on paper, 30 x 40cm (12 x 16in).

Although main ink (black or brown) is most commonly used for drawing, coloured and water-soluble inks, which spread when moistened with the tip of a brush, are also very useful. Ink drawings can be done with a variety of tools: nibs of different shapes and sizes; fountain pens; ballpoint or technical pens; brushes and pointed bamboo reeds. It is better to use fairly heavy, smooth, good-quality paper. Dark tones are created by increasing the density of hatching, cross-hatching or dotting.

EXAMPLES ON MEDIUM-TEXTURED CARD

fountain pen

 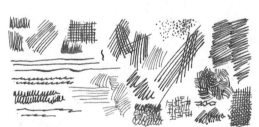

Indian ink and fine nib

 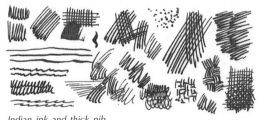

Indian ink and thick nib

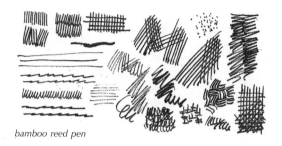

bamboo reed pen

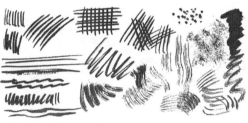

Indian ink and brush

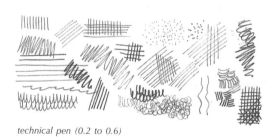

technical pen (0.2 to 0.6)

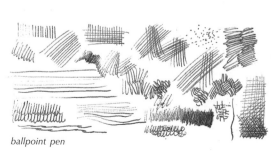

ballpoint pen

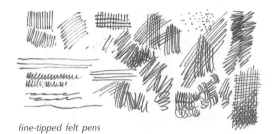

fine-tipped felt pens

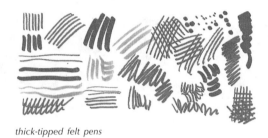

thick-tipped felt pens

felt pens with chisel-shaped tips and regular felt pens

pen, brush and water-soluble ink

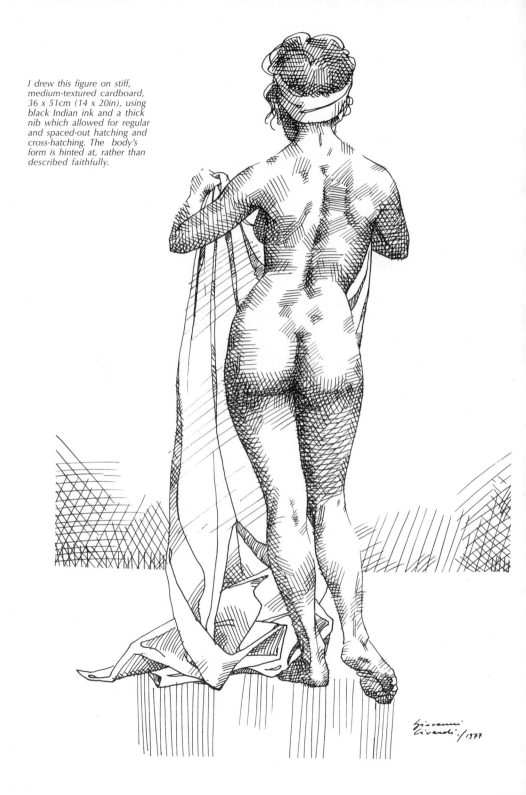

I drew this figure on stiff, medium-textured cardboard, 36 x 51cm (14 x 20in), using black Indian ink and a thick nib which allowed for regular and spaced-out hatching and cross-hatching. The body's form is hinted at, rather than described faithfully.

Giovanni
Civardi / 1977

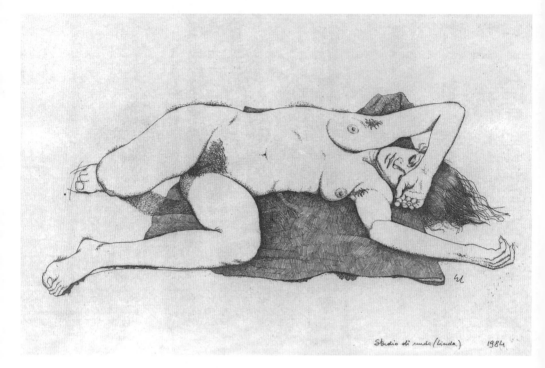

Studio di nuda (Linda) 1984

The figure study shown here, unlike the one on the previous page, has been drawn on smooth cardboard, 18 x 25cm (7 x 10in), using black Indian ink and a very thin nib. I have drawn the cloth and its folds using dense parallel strokes in different directions, while for the body I have used a series of little dots of varying intensity. After finishing the drawing, I erased the faint preliminary pencil lines with a kneadable putty eraser.

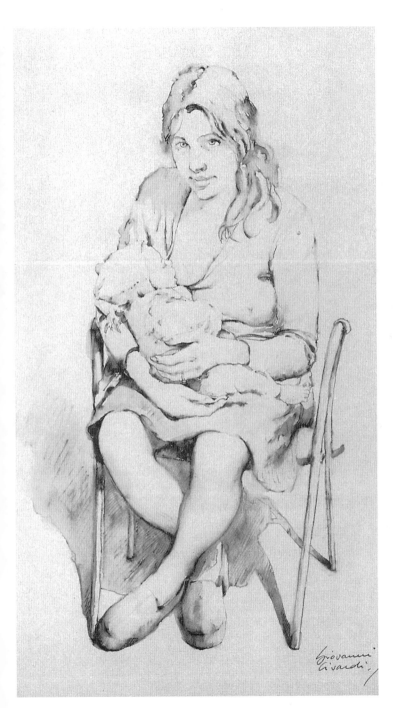

Water-soluble ink is very well suited to quick tonal studies from life. I drew 'Valeria breast-feeding' on stiff medium-textured card, 27 x 45cm (10° x 18in), with a normal fountain pen filled with black 'Parker' ink. Using a medium-size brush (No. 6 round) I moistened and dissolved the ink in the shaded areas and wherever I wanted a softer stroke. You need to be very careful when doing this, as too much water may make the ink spread excessively and spoil the whole drawing. On the other hand, accidental effects often turn out to be interesting. I would therefore advise you to conduct a few tests to master this simple, yet difficult, technique. You might also like to try water-soluble colour inks. Bear in mind that Indian ink is not suitable for this technique as it is permanent, and strokes do not therefore dissolve in water.

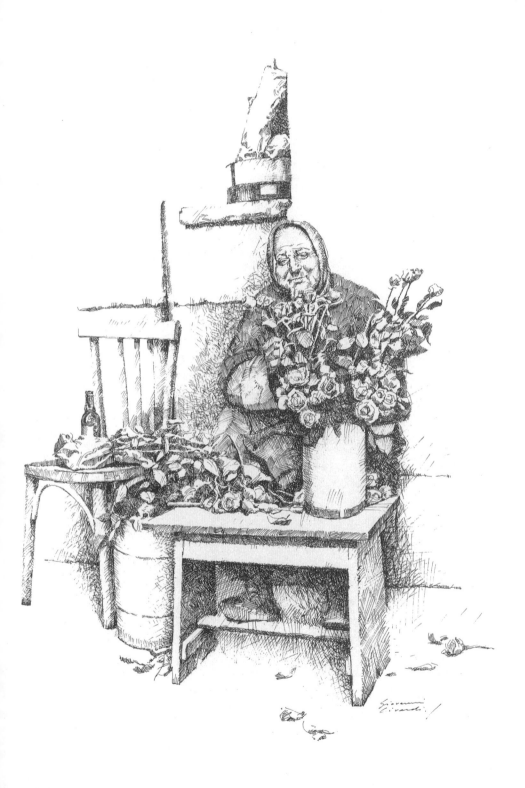

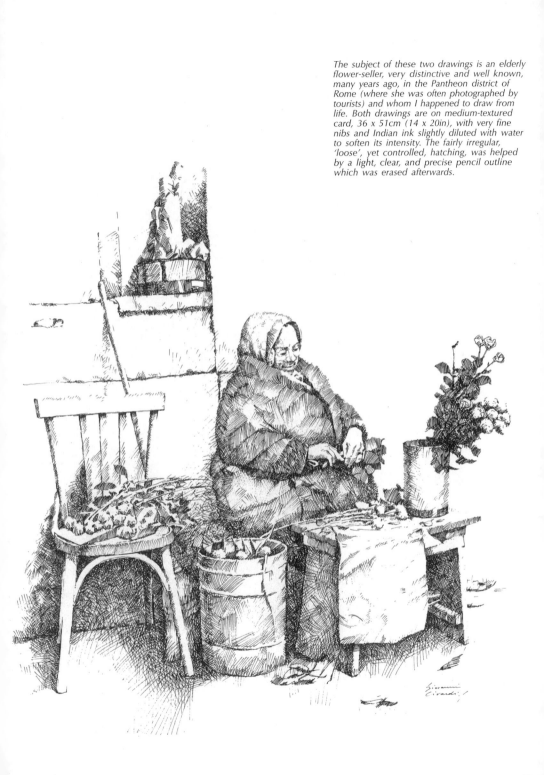

The subject of these two drawings is an elderly flower-seller, very distinctive and well known, many years ago, in the Pantheon district of Rome (where she was often photographed by tourists) and whom I happened to draw from life. Both drawings are on medium-textured card, 36 x 51cm (14 x 20in), with very fine nibs and Indian ink slightly diluted with water to soften its intensity. The fairly irregular, 'loose', yet controlled, hatching, was helped by a light, clear, and precise pencil outline which was erased afterwards.

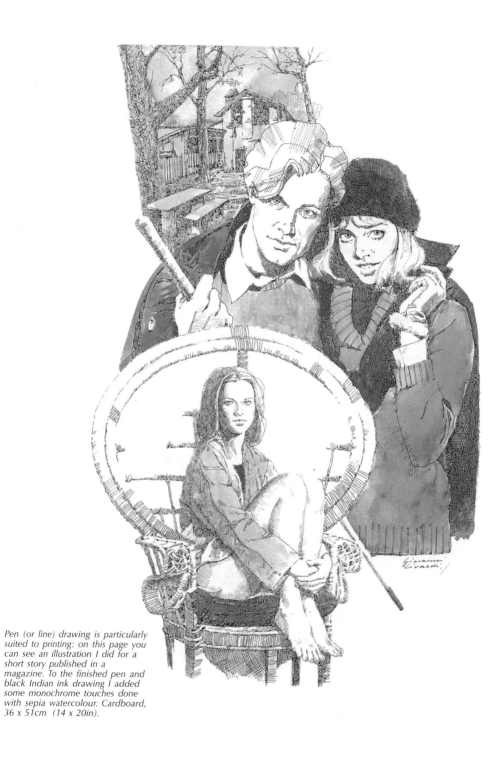

Pen (or line) drawing is particularly
suited to printing: on this page you
can see an illustration I did for a
short story published in a
magazine. To the finished pen and
black Indian ink drawing I added
some monochrome touches done
with sepia watercolour. Cardboard,
36 x 51cm (14 x 20in).

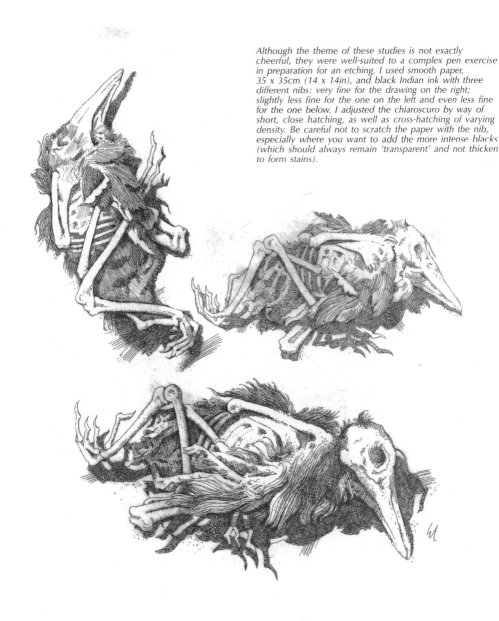

Although the theme of these studies is not exactly cheerful, they were well-suited to a complex pen exercise in preparation for an etching. I used smooth paper, 35 x 35cm (14 x 14in), and black Indian ink with three different nibs: very fine for the drawing on the right; slightly less fine for the one on the left and even less fine for the one below. I adjusted the chiaroscuro by way of short, close hatching, as well as cross-hatching of varying density. Be careful not to scratch the paper with the nib, especially where you want to add the more intense blacks (which should always remain 'transparent' and not thicken to form stains).

VEXPOS (Cadaverino) VII/1985

Ci sono ricchezze che distruggono se non si possono dividere con gli altri

WATERCOLOUR, TEMPERA AND MIXED MEDIA

'Wet' techniques, in which inks or pigments are diluted with water, are widely used in artistic drawing, although they are not strictly speaking, 'graphic', and achieve a look which is closer to painting. Monochrome watercolours (usually in dark shades such as sienna and sepia) and water-soluble ink have been used for a very long time; when applied with a brush, directly or to complement a pen drawing, they enable you to achieve a wide range of tones and very smooth rendering. Mixed media is the simultaneous and combined use in the same drawing of different media. The examples on the following pages show only some of the many possibilities, and I suggest you experiment to find your own, in sympathy with the aesthetic and expressive results you aim to achieve, and taking advantage of unintentional effects.

EXAMPLES ON MEDIUM-TEXTURED PAPER

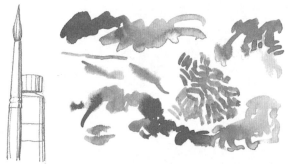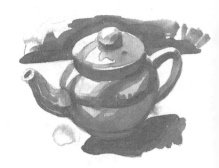

watercolour or water-soluble ink

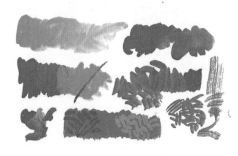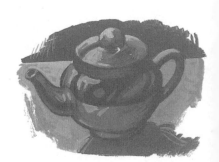

white and black tempera

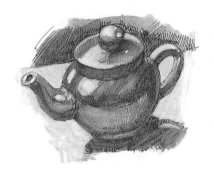

ink, acrylic, white tempera

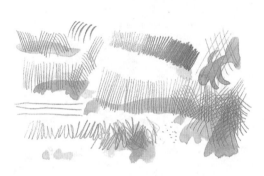

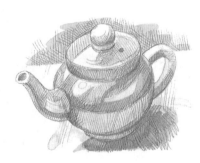

pencil and watercolour (or water-soluble ink)

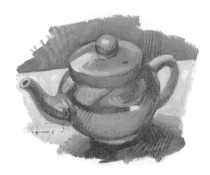

oil and carbon pencil

The examples shown in this section are drawings done with mixed media, i.e. combining different media to achieve particular graphic effects. They are, therefore, slightly removed from the traditional concept of 'drawing', but I have included them here hoping that they will encourage you to experiment.

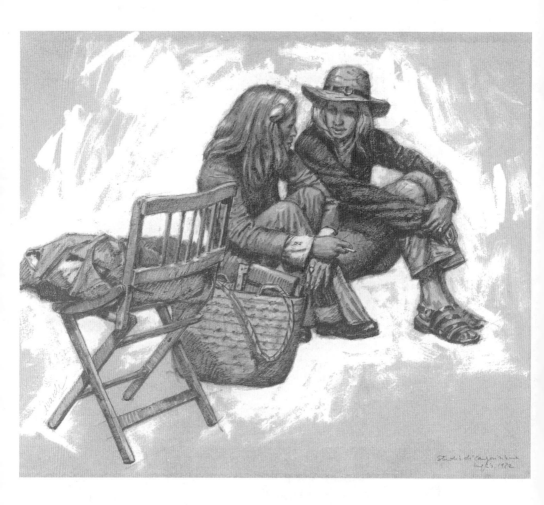

This drawing was done in dry brush (black Indian ink applied with a round bristle brush which had become almost dry by resting it on blotting paper). The background was highlighted and retouched with fairly thick white tempera. Grey card, 35 x 40cm (14 x 16in).

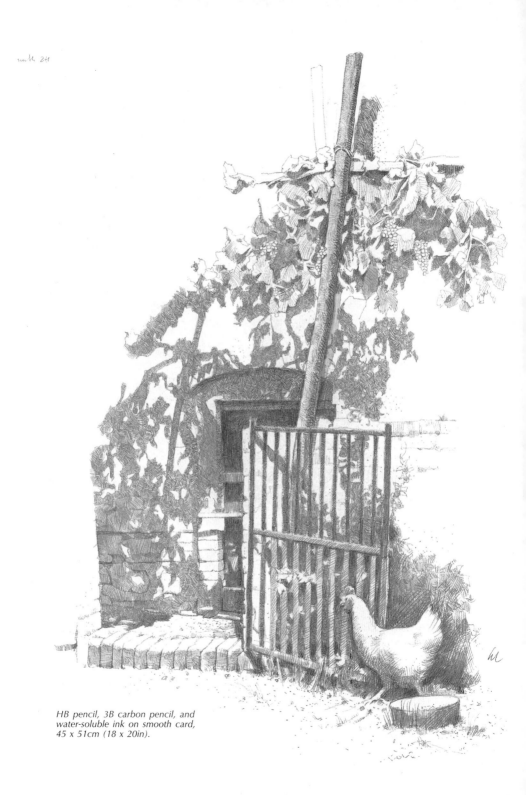

HB pencil, 3B carbon pencil, and water-soluble ink on smooth card, 45 x 51cm (18 x 20in).

Pen and sepia Indian ink, sepia tempera and white tempera on stiff cardboard, 35 x 35cm (14 x 14in).

Water-soluble ink applied with a round No. 6 bristle brush on medium-textured stiff cardboard, 20 x 30cm (8 x 12in).

Study for an illustration. White and
black tempera, 2B carbon pencil and
white pastel on grey-green cardboard,
36 x 51cm (14 x 20in).

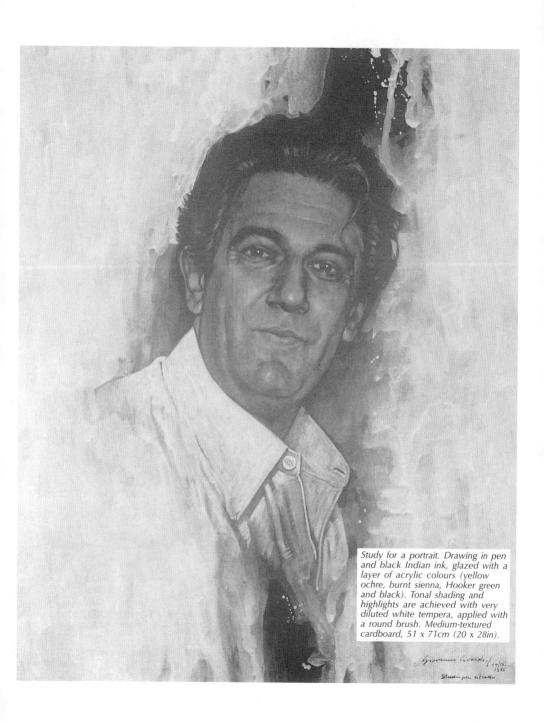

Study for a portrait. Drawing in pen and black Indian ink, glazed with a layer of acrylic colours (yellow ochre, burnt sienna, Hooker green and black). Tonal shading and highlights are achieved with very diluted white tempera, applied with a round brush. Medium-textured cardboard, 51 x 71cm (20 x 28in).

*Preliminary drawing in pen, tempera and
sepia Indian ink on smooth cardboard,
15 x 20cm (6 x 8in). The colour is partially
removed with a small damp sponge.*

*Monochrome grey watercolour applied with a
round bristle brush (No. 8) on smooth card,
20 x 25cm (8 x 10in).*

54

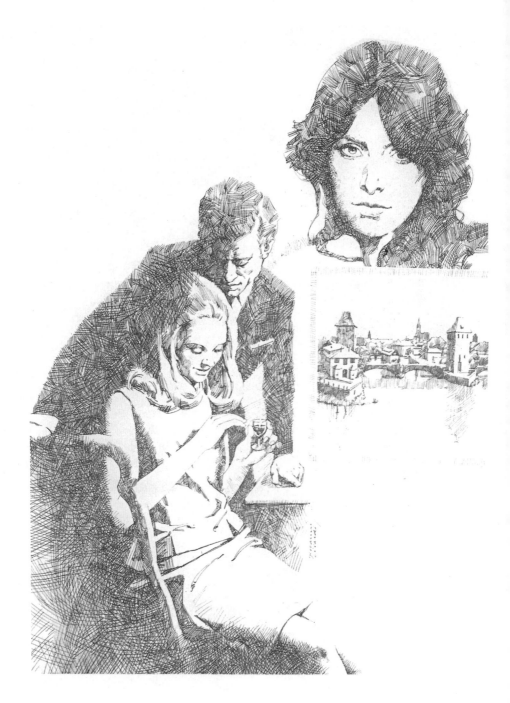

Illustration, on medium-textured cardboard,
36 x 51cm (14 x 20in). Drawing in pen and sepia
Indian ink, glazed with very dilute Veronese green
acrylic and touched up with white tempera.

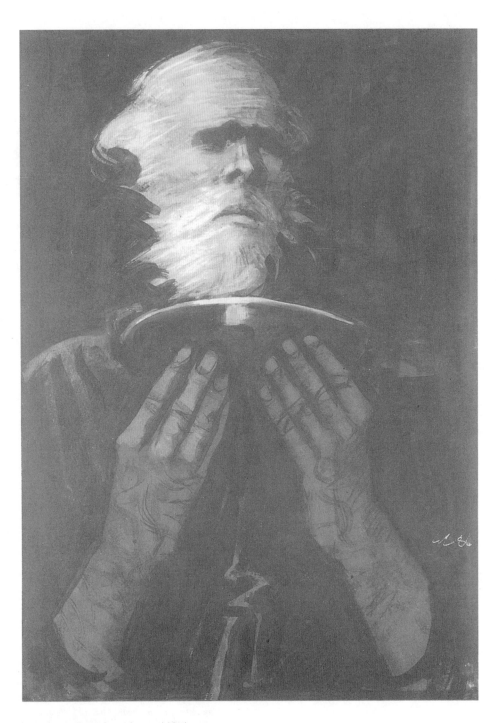

Study for an illustration. White and black tempera on grey-green cardboard, 25 x 36cm (10 x 14in).

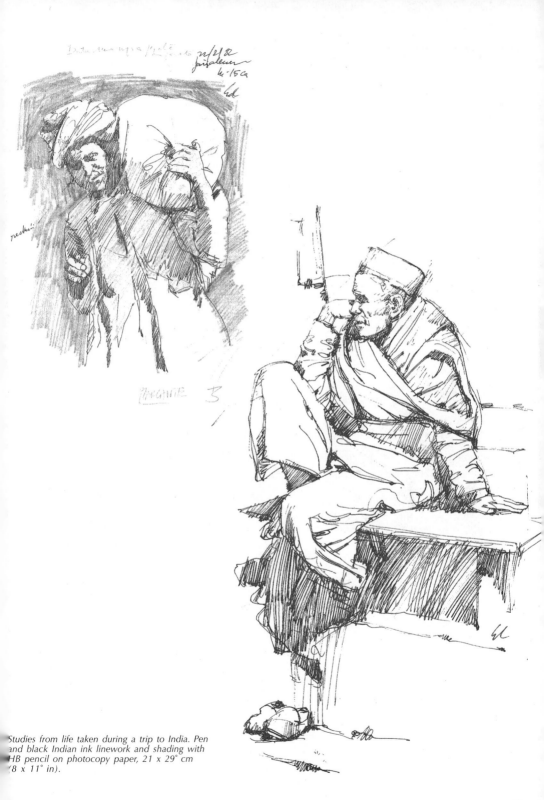

Studies from life taken during a trip to India. Pen
and black Indian ink linework and shading with
HB pencil on photocopy paper, 21 x 29° cm
(8 x 11° in).

DRAWING FROM LIFE

To conclude this section I would like to share with you some drawings done by Vittorio Menotti, an engineer and amateur painter, in the early 1900s. They are an example of how the study of drawing was seen a century ago, and compared to today's drawing you can see that methods have not changed much. Drawing from life (landscapes, people, still life) remains the main way of exploring techniques in order to master them, without worrying too much, initially, about aesthetic matters. Of course, tastes have changed: nowadays we appreciate immediate and impetuous drawing, rather than the 'academic' reproduction of reality; however, it is almost always worthwhile to go through this rigid experience before you can achieve a freer and more personal language.

Window of the Sforza Castle, Milan. Pen and sepia ink on paper, 8 x 10cm (3 x 4in).

View of the Sforza Castle, Milan. Pen and sepia ink on paper, 9 x 11° cm (3° x 4° in).

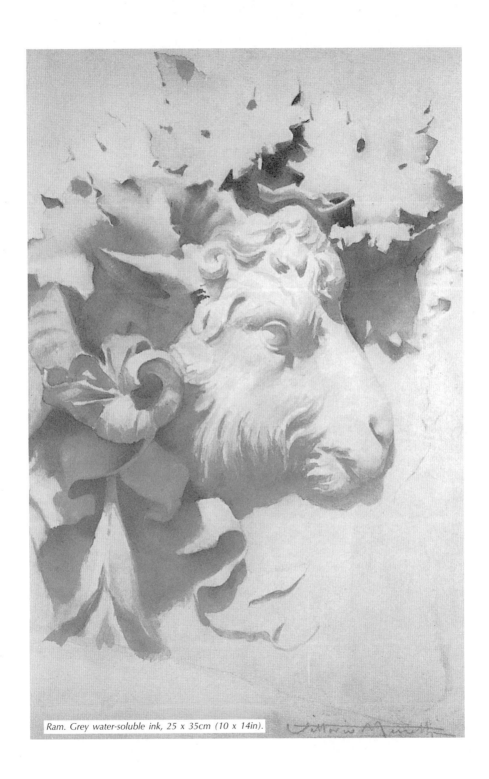

Ram. Grey water-soluble ink, 25 x 35cm (10 x 14in).

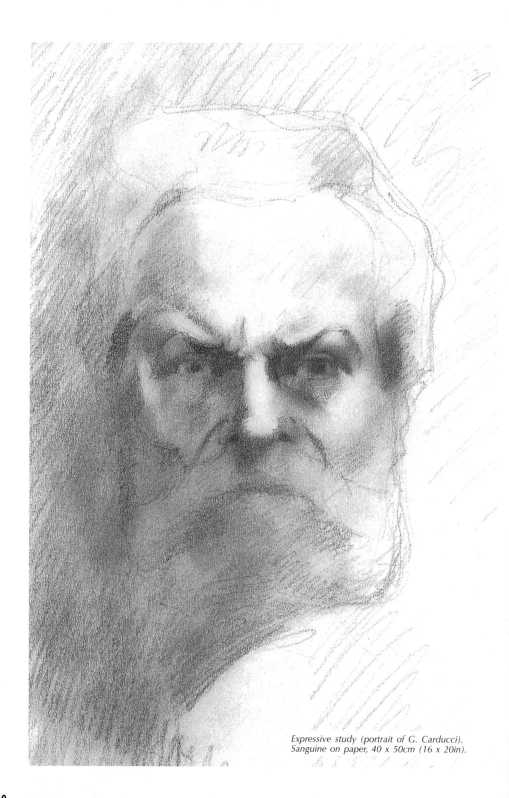

Expressive study (portrait of G. Carducci). Sanguine on paper, 40 x 50cm (16 x 20in).

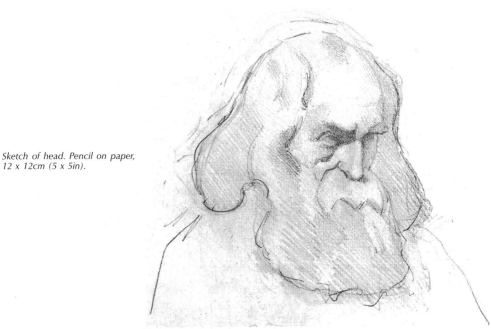

Sketch of head. Pencil on paper, 12 x 12cm (5 x 5in).

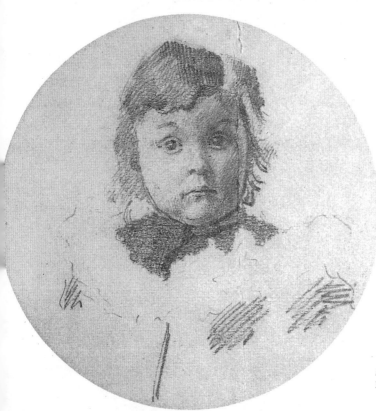

Portrait of young girl. Pencil on pale yellow paper, 11cm (4in) diameter.

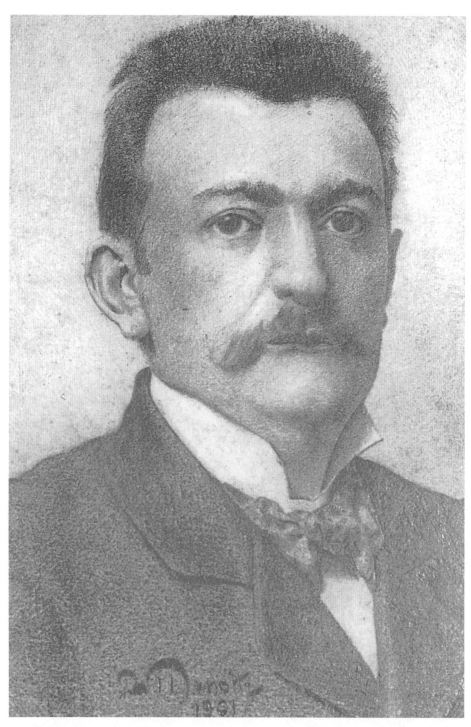

*Portrait. Pencil, charcoal and highlights in white
pastel on grey paper, 11 x 15cm (4 x 6in).*

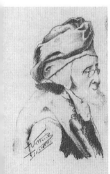

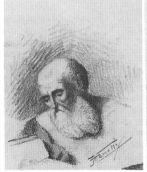

Studies of expressive heads.
Always carry a little sketchpad on which to make
visual notes and which will teach you to 'see' and
become aware of the 'graphic' aspects of reality.

PRACTICAL ADVICE

LIGHTING

The quality of lighting and the surface on which one draws are very important for working comfortably. Studio lighting must be bright enough not to tire one's eyes, come from just one source (a window, if daylight, or a lamp if artificial) and its position must be such that it doesn't create ugly shadows on the page. When outdoors, avoid direct sunlight as this alters tonal relationships.

SUPPORTING YOUR DRAWING

The drawing surface can be vertical, e.g. an easel, as this position reduces perspective distortion, and is suitable for drawing on a large-size sheet and studying the figure from life. More often you will work on tables of varying inclination. In both cases it is useful to have a seat set at the correct height to allow you to draw comfortably and, above all, to avoid incorrect positions which can be damaging to the body. Avoid, wherever possible, horizontal tables.

To draw from life outdoors, you will need a stiff folder or a small board to rest on your knees. If you use a sketchbook, you won't need any other support, otherwise you can fasten a sheet on to the board with some masking tape or pins. MDF, with its smooth surface, provides good support, but make sure you place a few sheets between it and your drawing paper (especially if you are using a pencil) to make the strokes less hard.

PAPER

Try various types of paper: smooth, rough, textured, coloured, of different thickness and weight. Pencil, especially if soft, and charcoal require rather rough and stiff paper; pens flow more easily on smooth non-absorbent paper; mixed media and diluted ink work better on fairly stiff card. Always choose the best quality paper you can afford as the mediocre or poor-quality type may indeed free you from the inhibition one feels when faced with a blank sheet (whereby we don't care if we waste it as it is cheap) but almost invariably yields disappointing results.

For little sketches or composition studies you can use run-of-the-mill photocopy paper. However, what I said doesn't mean that you can't draw good sketches on wrapping paper or newsprint.

HOLDING A PENCIL

The way you hold the pencil (whether you are right- or left-handed) is strictly personal. The usual way to hold it is as if you were writing, but when drawing you should bear in mind a few things: hold the pencil (or pen, or brush) with your fingers not too close to the tip, at least 2° cm (1in) from it, so that you control it well, both manually and visually; do not hold it too tight to avoid getting tired; when drawing it should be your wrist that moves, rather than just your fingers and it should be in a decisive motion; vary not just the pressure but also the angle of the pencil on the paper to achieve different degrees of thickness and stroke variation.

The usual position is comfortable only when drawing on a tilted plane but becomes difficult to maintain if the sheet you are working on is in a vertical position. In this case, especially with charcoal, the drawing tool can be kept in the hand, arm almost stretched, in a movement embracing the whole limb. You'll soon master these positions as they come fairly naturally; however, practise them in order to assume the correct pose from the start.

DRAWING WITH PENCIL

Pencils can be sharpened mechanically with an appropriate sharpener (besides the conventional blade sharpeners, table, hand-held or electrical types are also available), but the best way is to use a sharp knife to make a gradual taper to the lead giving it a long or short point. While a long point is fine for hard grade graphite, the soft grade type breaks easily even with light pressure and must, therefore, be supported by the surrounding wood. With a little practice you will learn to cut away the wood correctly. You can make the points of all types of graphites and

charcoal very sharp by rubbing and rolling them on a strip of fine sandpaper. Very thin leads don't need sharpening.

A trick to avoid smearing the surface on which you are drawing on in pencil or ink, is to protect it by placing a sheet of tracing paper under the hand you are using.

Use erasers as little as possible because even the softest is abrasive and damages the paper's surface. Use them, instead, to draw, i.e. to lighten tones, to outline contours and highlights, or to hatch an area in pencil or charcoal.

DRAWING WITH CHARCOAL

Both willow and compressed charcoal are rather crumbly and leave dusty tracks on the drawing surface. To get rid of excess coaldust you just need to blow on it, but you can also keep the sheet vertical so that your hand won't accidentally touch it causing the dust to fall. When you have finished working you can remove charcoal or graphite residues with a kneadable putty eraser, taking care not to erase too hard but, rather, blotting gently.

Protect soft graphite and, especially, charcoal drawings by applying repeated, even layers of fixative. Cans which spray evenly and reliably are available. Keep the drawing vertical, and hold the can 30-40cm (12-16in) away and spray first vertical then horizontal bands, rather quickly, without stopping or lingering to avoid bright halos. If you want to fix large drawings or technical studies, you can use conventional hairspray, which is cheaper and reasonably effective. When spraying the fixative make sure there are no objects close by which could be damaged by the lacquer. It is best to do the job in a sheltered corner outdoors to avoid breathing in the fumes.

DRAWING WITH INK

When using pen and ink first draw a rough and very light pencil sketch with a hint of hatching. This will help you when you go over it with Indian ink but it should not constrict you to the point of making the drawing even, almost mechanical, and lacking in freshness. Pencil strokes can be deleted with a kneadable putty eraser when the work is completed, making sure the ink is dry first. Practise drawing with a pen straight away, without worrying too much about possible inaccuracies, as only by doing this will you achieve the spontaneity, the confident strokes and the immediacy which characterize this technique.

Pens, which should be kept tilted at about 45°, flow easily on smooth paper, while they catch on a rough surface. However, you can draw on rough surfaces using nibs with a thick, slightly rounded point or bamboo reeds. Unless you are trying to achieve frayed effects avoid any absorbent papers as they make working with pens difficult.

Bear in mind that ink (especially Indian ink) will become concentrated and more difficult to use if its container is left open as its water component evaporates. To offset this, add, every now and then one or two drops of water, preferably distilled, making sure that these additions do not make the ink too light.

Clean nibs thoroughly and frequently while working, getting rid of ink deposits with a damp cloth: don't use paper as it will leave filaments which may make the stroke less sharp. Any unwanted stains or smears can be removed with a blade kept perpendicular to the sheet, or with an appropriate eraser, paying attention not to damage the paper. Alternatively, you can hide them with white tempera or typist's correction fluid.

DRAWING PORTRAITS

A portrait is commonly perceived as the representation of a human being's features, whether the face, head and shoulders or the whole body. It has always been an important theme in figurative arts and a favourite with artists, who have found in it, not just a professional genre well rewarded and socially appreciated for its symbolic or celebratory value, but also an interesting opportunity to investigate the human condition in its physical and, most of all, psychological aspects. It is this latter aspect which tends to predominate nowadays, as photography has greatly undermined the function of the drawn and painted portrait as the only way to reproduce and hand down for posterity an individual's physiognomic features. But this 'documentary' aspect was, of course, only one of the features of the artistic portrait.

Using my experience as a portrait painter, illustrator and teacher, I have tried to simplify and sum up the main problems one usually comes across when first tackling a 'generic' head drawing and, subsequently, and actual portrait or likeness.

I have divided the short sections in this chapter and the accompanying sketches according to a sequence which I have found of practical help in teaching the rudiments of portrait technique. I have found this approach quickly leads to satisfying results. The chapter covers tools, techniques, practical considerations, anatomy, details of the face, composition, lighting and actual method, stressing the overall view of the head.

These basic technical principles can only direct you in your first experiences and should be seen as suggestions on which to build your own study. Your subsequent artistic development will depend on how committed you are to observation and how regularly you practise drawing. To this purpose, you can, when you approach your first drawings, resort to observing drawings done by other artists and taking photographs of your subject. However, as soon as you feel confident in sketching the basic outlines of the head, I advise you to try and draw from life, getting a patient friend to sit for you. In the last section of this chapter I have put together some portrait studies which I have drawn at different times and which give an indication of how to go about tackling different subjects.

TOOLS AND TECHNIQUES

You can draw a portrait using any of the popular media: pencil, charcoal, pastel, pen and ink, watercolour, felt-pen, etc. Each one of them, however, will produce different effects, not only due to the specific characteristics of the medium and the technique used, but also in relation to the characteristics of the surface on which it is drawn: smooth or rough-textured paper, card, white or coloured paper, etc. The drawings shown on these two pages demonstrate how different media effectively render the complex tonal values of the human face and body.

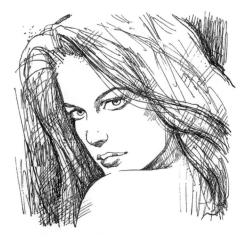

Pen and black Indian ink on smooth paper

Ink is widely used by artists. It can be applied either with a brush or with a pen, but special effects can be achieved using bamboo reeds, large nibs, fountain pens, technical pens, felt-pens, or ball-point pens. Tones can usually be graded by drawing more or less dense lines over one another at right angles (cross-hatching). It is advisable to draw on smooth, good quality paper or card, so that the surface won't fray or absorb ink irregularly.

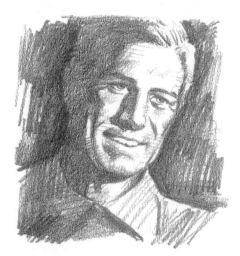

Pencil (B and 2B) on rough-textured paper

Pencil is the most widely used medium for any type of drawing and, in figures and portraits, it allows you to be spontaneous and is convenient to use. It can be used for very complex drawings or for small studies and quick reference sketches: for the latter very fine leads are suitable, while for the former you can use thicker and softer-grade graphites. Graphites (leads that are held in mechanical, clutch pencils) as well as pencils (wood-encased graphites) are graded according to their consistency: from 9H, the hardest, which traces thin and faint lines, to 6B, very soft, which traces thick and dark lines with ease.

Compressed charcoal on paper

Charcoal is perhaps the ideal medium for portrait study as it is very easy to control when applying tones but also allows you to achieve fairly sharp detail. It should, however, be used 'broadly', concentrating on the overall rendering of the 'shapes': this exploits its greatest assets, as it is both versatile and evocative. You can use either compressed charcoal or willow charcoal but be careful, in either case, not to smudge the sheet. Charcoal strokes can be blended and smudged by gently rubbing with a finger, and tones can be softened by blotting with a soft eraser (kneadable putty eraser). The finished drawing should be protected by spraying with fixative.

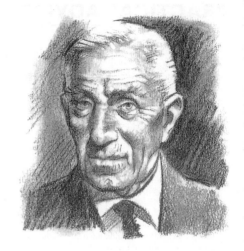

Monochromatic watercolour on medium-textured paper

Watercolours, water-soluble inks, and water-diluted Indian ink are ideal for portrait study, although they are closer to painting than to drawing, as they are applied with a brush and require a tonal vision which is both concise and expressive. For quick studies you can use water-soluble graphites or colour pencils (to blend strokes easily, wipe them with a water-soaked brush) and it is advisable to use heavy card so that the moisture will not cause the surface to cockle and become irregular.

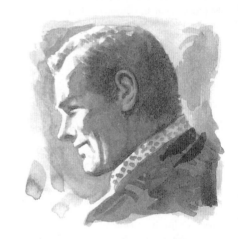

Pen and ink, watercolour, white pastel on coloured paper

'Mixed' media involves using different materials to achieve a drawing with unusual effects. Although still 'graphic' materials, their more complex application requires good control and a good knowledge of the media themselves if we are to avoid muddled results of little aesthetic meaning. Mixed media are very effective on textured and coloured, or dark, supports.

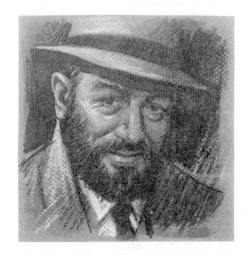

PRACTICAL ADVICE

It is useful to outline very briefly some advice on portrait 'practice'. In the subsequent chapters some of these subjects will be developed with the help of diagrams and graphic examples.

TYPES OF PORTRAIT

Given the great variety of poses a human being can take on and the psychological wealth which characterizes every personality, the artist has to assess what 'pose' to suggest to the model so that these elements are displayed in the most suitable way to achieve a likeness.

In addition, all individuals have their own characteristic posture and typical movements which are part of their 'being'. On the other hand, there are elements of physical behaviour and social convention which allow us to place the subject in the profession and 'status' they belong to or aim for. One can therefore differentiate between two types of portrait: 'formal', where the subject's pose follows traditional patterns, and where a lot of attention is paid to composition, the environment and the, at times symbolic, décor; and 'informal', where the model's pose is spontaneous as he or she is captured in a casual pose or while carrying out some regular activity in a normal environment. It is an effective and modern way of portraying people which is a legacy of 'instant' photography and requires a lot of skill and good taste from the artist. To this category belong also 'expressive' portraits, that is those where the subject is, for instance, caught smiling or in motion.

FRAMING

Whatever type of portrait, you need to choose how to represent the subject. You can, in fact, draw just the head (or part of the face) or the whole figure. To make the portrait more expressive it can be useful to draw just part of the body including, for instance, not just the head but also the shoulders, the torso and the hands. Draw a lot of sketches to find the best pose (see page 88) and a composition which is effective, well balanced, and not monotonous. Avoid dispersing the visual interest of the viewer and bear in mind that the focal point will have to be the face and, above all, the eyes. Note that the hands can be as expressive as the face, because of their 'movement', as well as their shape and their role in the composition. Therefore, if you think your model's hands have character, do not hesitate to include them in the drawing.

SUBJECTS

To portray a human being you need not just to be able to capture and draw their features, but also to hint at the character and the mood of the model: this encapsulates the artistic quality of a portrait. I thought it useful to include some advice specific to the different types of subjects you will often draw. Always obtain from your subject permission to portray them or, if need be, to exhibit the drawings you have done.

Children (See page 111). A child's head is proportionally bigger than that of an adult, especially in the skull which is far bulkier than the face. Eyes and ears look big but the nose is small and upturned; the bone structure is minute and the jaw rounded. Drawing children is difficult because they are restless and don't like being watched. In many instances you will find a photograph taken by surprise to avoid 'grimaces', useful. Children's delicate features need weak and diffused lighting: strong artificial light or direct sunlight create strong shadows which may alter the physiognomy and cause them to half-close their eyes.

Women In portraits of women, as well as searching for the subject's personality there is also a tendency to enhance the aesthetic aspect. Choose informal poses, spontaneous if the subject is young or more austere and serene if she is more mature. Avoid, however, affected or excessively 'theatrical' poses. In many cases you will find it useful to draw the whole figure so that clothes and background can help to convey the subject's personality.

Men The male portrait was traditionally more formal, representing an 'official' image linked not just to the subject's physical features, but also to their social standing. Sometimes side lighting, with its interesting contrasts, helps characterise the features and shapes of the male face. Young subjects often turn out better if drawn in spontaneous poses and expressions, while mature men are better suited to more composed and 'dignified' poses. Make sure that the model does not cross his arms in front of him or appear authoritarian and off-putting.

Self portrait (See page 108). Almost all artists have drawn, painted or sculpted their own portrait. If you do the same, you will find that it will help to considerably improve your portraiture skills. Position yourself in front of a mirror and study your reflected face experimenting with different types of lighting and poses and then choose the pose you find most comfortable and which shows the 'real you'. Follow the procedure I outline on page 96.

The elderly Elderly people, both men and women, are very interesting to draw because their faces, marked by the passage of time and characterised by their everyday expressions, tell a 'story' of life and experiences. For this reason it is easier to capture their physiognomic traits, than it is with young people, and achieve a true likeness. Choose poses suited to the wisdom and tolerance which should come with old age.

Avoid strong and direct light on the model. Even if effective, it can easily lead you to draw an unflattering portrait and can unpleasantly emphasize any irregularities of the skin. Note the 'anatomic' changes in elderly people's heads: wrinkles on the forehead, near the eyes and the mouth, and on the neck; whitening and thinning of the hair; hollowing of the eyeballs; lengthening of the ears, and so on.

THE SIZE OF THE DRAWING

In a portrait drawing the dimensions of the face should not be more than two-thirds of the real face to avoid altering the proportions. You should use a maximum size of 40 x 50cm (16 x 20in) for the drawing surface, when portraying just the head, and 50 x 70cm (20 x 27°in) for the whole figure. Make sure the face is not at the very centre of the drawing surface, but slightly higher and to one side (see page 88).

CHOOSING THE POSE

(See page 89). Usually, a portrait reproduces head and shoulders, i.e. the torso, but it could also include the arms, the hands or the whole body.

If you draw from life make sure the model sits in a natural and comfortable position, and that their face is more or less level with yours. The pose should be relaxed, but clearly convey the subject's character to enable you to capture the psychological, as well as the physical likeness. It's better to choose a pose which highlights the somatic characteristics of the subject, so place yourself at a distance of about 2m (6° ft) to offset any foreshortening effects. As a rule, the three-quarter view is considered the most effective but profile or full face can also be interesting.

LIGHTING

(See page 94). Lighting should be gently diffused, and from just one source (window or lamp) positioned slightly higher than the subject and from the side. This will highlight facial features, but will do so gently, preventing the formation of ugly shadows under the nose, the lips and around the eyes. Avoid intense artificial light (for instance, from a spotlight) as well as direct sunlight which create such effects; they emphasize the tiniest creases in the skin and affect the subtlety of the modelling. In addition, they force the model to contract their facial muscles giving a frozen, unnatural expression.

CLOTHING

Clothes have considerable importance, particularly in a full-figure portrait, both for their compositional and aesthetic function, and because they not only supply information about the personality, social status, and emotional state of the subject, but also about the era and background. Therefore, leave your model free to choose what to wear and limit yourself to suggesting some items of clothing which, because of their shape and arrangement, can make the composition of the drawing more effective. Arrange the folds and notice how different they look depending on whether the fabric is light and soft (lots of little folds) or heavy and stiff (a few thick folds), although in both cases they radiate from the top of the 'centres of tension': shoulders, elbows, knees, etc. Draw the folds which, due to their direction and size, are the most significant and ignore the minor ones which could create confusion. In some circumstances, partial nudity (shoulders, breast or back, for instance) can enhance the portrait of female subjects with a particularly vivid and strong personality (see page 120).

HAIR

Hair (as a whole and in relation to colour, quantity, and quality of the cut) is essential to characterise a face. The artist can use its look to improve the composition of a portrait, by weakening or enhancing, by contrast, the model's physiognomic traits.

If you draw female subjects (whose hair is usually thick) go for simple, tidy, well-cut hair. Hair should be treated as a whole. Capture its colour and overall form and try to pick out the most significant locks. Of these, assess areas of shadow and light, and lines of separation and disregard small, insignificant highlights and single hairs - you will need just a few fine and sharp strokes to suggest them. Use a fairly soft pencil to draw thick confident strokes, in various directions, to achieve unusual 'weave-like' effects. Draw the hairline very carefully, making it irregular and soft and pay particular attention to the forehead and the temples.

THE BACKGROUND

A portrait requires a background which is plain and unobtrusive, in shades which don't clash with one another or weaken the subject's appearance. Before you start, decide whether a light background (the white of the paper, for instance) or a dark one is suitable. In some cases the subject's surroundings (workplace, house, garden, etc.) can act as background - treat it as if it were a landscape or an interior - making sure, however, that it doesn't overshadow the face or the figure.

HOW TO GET A LIKENESS

As we know, portraying a human subject means perceiving and representing both the physical and the psychological aspect of the model. To achieve a physical likeness (see page 96), pay particular attention to the overall shape of the head (drawing 'from the general to the particular') and exactly evaluate your subject's proportions, both in the face as a whole and between its elements (eyes, nose, mouth, etc.). To achieve a psychological likeness, converse with your model, try to understand their character, preferences, habits, and observe the environment where they live and work. Of course this is not always possible, but it can be very useful to give you an idea of the most suitable pose and which aspects of their character are worth highlighting or bringing to the fore.

TECHNICAL AIDS

Photography

Photography is useful to record spontaneous and fleeting images of the subject, to have a point of reference when it isn't possible to organise sittings, and to portray children.

Take photographs yourself (modern automatic cameras make this easy even if you are not an expert) as they should be a term of reference rather than images to copy passively. Allow for perspective distortion and, to avoid or reduce it, do not get too close to the subject. Use, if possible, natural lighting and avoid flash which is unsuitable for portraiture.

Sketches

Get used to doing plenty of little sketches to study the main lines of the face and figure of the subject you are drawing (especially if you are working from life). Gauge the best composition, the most suitable lighting, the most convenient dimensions, etc. by walking around your subject. These sketches, even if done quickly, require careful observation, almost a commitment to 'explore' the aesthetic possibilities offered by the model. It may be from them that a successful portrait depends. After you have become more experienced at drawing the face, you may want to start painting it; then you will find it useful to do a preliminary study, more complex than the sketches, to help you sort out any aesthetic problems and to note down all the information which you will need for the definitive work.

Enlarging

Whether you are planning an accurate drawing, or you are attempting to paint a colour portrait, you will need to trace on the definitive support (paper, canvas, card, etc.) the outline which will serve as a base for the work. To this effect, you can, at least to start with, take advantage of a number of devices to effortlessly enlarge a sketch or even a photograph to the desired dimensions. You can use an ordinary slide projector to magnify the image on to the support and trace the face or figure's main contours.

Alternatively, you can use an episcope: an optical tool which allows you to enlarge and project images from opaque supports (photographic prints, sketches or reduced photocopies of drawings and paintings, etc.). These are practical devices, almost 'tricks' which may even harm one's artistic growth if one becomes dependent on them. More appropriate, therefore, is the 'grid of squares' method, which is well known even at school level. Draw a grid of squares on the image to be enlarged (whether a drawing or photograph) and then transfer that same grid, with the same number of squares, enlarged, on to the larger surface. You can then easily transfer strokes within individual squares keeping them in proportion.

The working environment

If you have your own studio, or at least, a room in the place where you live and you are determined to devote yourself body and soul to portraiture, you will find some furnishing accessories rather useful. For example: a chair, an armchair or a small couch for the subject to be comfortable and relaxed on while posing; a lamp which will allow you to adjust the intensity of the lighting so that the model is properly lit; a radio or a small TV to make posing less of a burden for your sitter (and for you). Remember to allow for frequent breaks and to take advantage of these intervals to study your subject in different expressions and poses.

You can place your support on an easel or the tilting surface of a special table but, more often, it will be sufficient to place it on a stiff board (made of wood, cardboard or MDF), 50 x 60cm (20 x 23˚ in), and which you can rest on your knees. This simple equipment, together with your favourite drawing media, will come in useful when working outdoors, in public places or (and I hope this will happen soon) when going to the house of someone who has commissioned you to do a portrait.

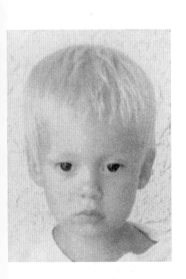

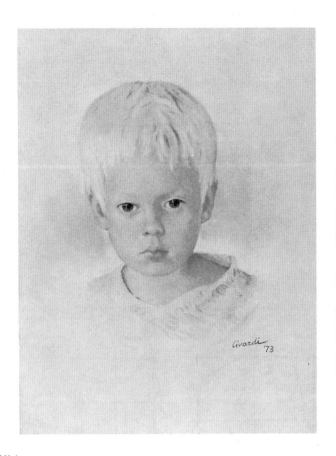

Portrait study, oil on canvas, 30 x 40cm (12 x 16in).
This portrait was not drawn from life but from the photograph on the left. Look carefully at the
two images to find out to what extent the photographic information has been adhered to,
highlighted or disregarded in the drawing.

DRAWING THE HEAD

PROPORTIONS

When drawing the head it is necessary to make sure that the proportions, i.e. the relative dimensions between its various constituent elements (eyes, ears, nose, mouth - which we will examine one by one later on) are indicated correctly and precisely. Of course, heads vary greatly in size and in the combination of characteristics, but they can all be reduced to a proportional diagram which helps to simplify the shapes, to recognise their peculiar three-dimensional aspect, and also to position details correctly in relation to one another. When drawing a portrait pay close attention to the overall structure of the head and evaluate its main characteristics as it is mainly from these that a good likeness depends. Details alone, even if minutely reproduced, almost invariably result in a vague and unsatisfactory portrait, when placed in a general context which lacks accuracy.

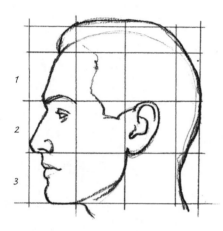

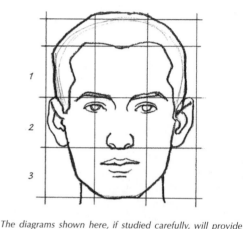

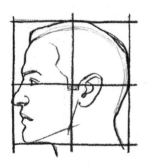

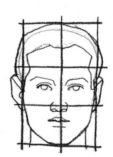

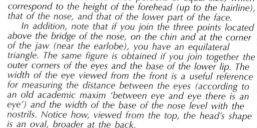

The diagrams shown here, if studied carefully, will provide you with the simple and essential elements of reference and proportion of a 'typical' head seen in frontal and lateral projections. Compare them with those of your model and assess whether they correspond or differ. The height of the face can be divided into three portions of equal size, which correspond to the height of the forehead (up to the hairline), that of the nose, and that of the lower part of the face.

In addition, note that if you join the three points located above the bridge of the nose, on the chin and at the corner of the jaw (near the earlobe), you have an equilateral triangle. The same figure is obtained if you join together the outer corners of the eyes and the base of the lower lip. The width of the eye viewed from the front is a useful reference for measuring the distance between the eyes (according to an old academic maxim 'between eye and eye there is an eye') and the width of the base of the nose level with the nostrils. Notice how, viewed from the top, the head's shape is an oval, broader at the back.

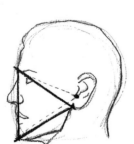

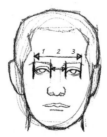

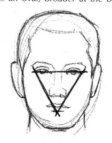

PERSPECTIVE

Perspective is a graphic method which helps to represent spatial depth on a flat surface. Therefore, to be represented correctly, the head too needs to be drawn (like any other object) bearing in mind the rules of perspective.

The diagrams shown below will be enough, I think, to remind you of some of the basic principles, such as the horizon line, the viewpoint and the vanishing points. If you imagine the head within a cube whose edges touch its most protruding points, you will find it easy to 'put in perspective', fairly correctly the details of the face. You can then conduct a more accurate study considering the 'geometrised' head represented by two ovoids and a cylinder (see diagrams on page 76).

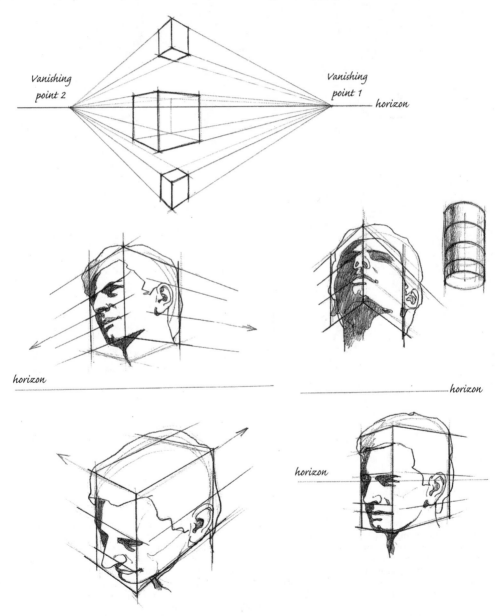

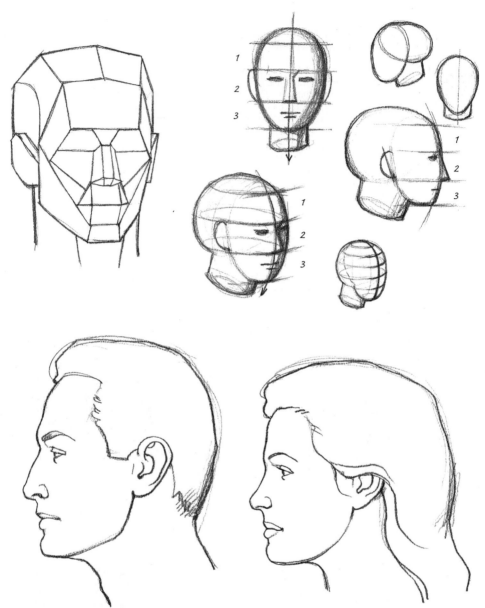

CONSTRUCTIVE SKETCHES

The head can be compared to the geometric shape of an ovoid and this, at the beginning at least, makes drawing it simpler, as far as proportions, as well as light and shadows are concerned. Notice how the two ovoids which represent the face and the skull can be superimposed. However, the roughly round shape of the head can also be divided into flat areas. As a whole, these 'surface planes', are useful for concisely shaping areas of light and shadow. Try drawing surface planes on to photographs which show heads in a variety of positions, and learn to recognize diagrams similar to the ones above.

When you first start drawing the head, which is a very complex shape, you are likely to encounter great difficulties and won't know where to start from. A traditional and scholastic, but very useful, approach is the one mentioned on these pages and which is developed further in the method chapter (see page 96). Bear in mind that in portraiture it is essential, first of all, to capture the overall individual characteristics of the model's head and then study the characteristics of the details and how they relate to one another.

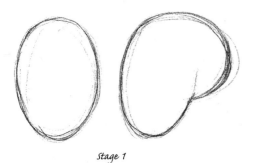

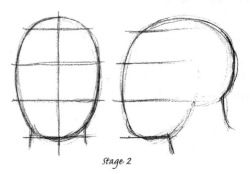

Stage 1

Stage 2

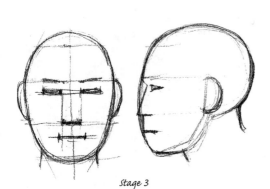

Stage 3

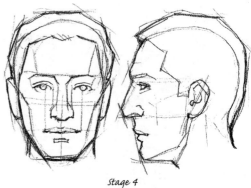

Stage 4

In these diagrams, limited to the front and side projections of a man's head, I have illustrated the various stages of construction.

Stage 1
Outline on the page the area you expect the head to occupy: draw a simple oval shape.

Stage 2
Indicate the proportions by way of four horizontal parallel lines more or less equidistant to suggest the three parts in which the face can be divided.

Stage 3
Carefully work out the position of the eyes, nose, mouth and ears by measuring their relative distances.

Stage 4
Thoroughly study how the elements of the head relate to one another, hinting at the 'planes', the hair, etc., coming close, little by little, to the natural shapes.

Stage 5
Continue to elaborate assessing also the light effects, that is, applying the 'chiaroscuro'.

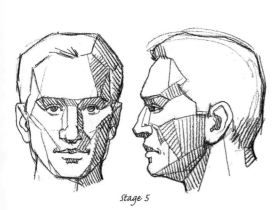

Stage 5

ANATOMY

A basic knowledge of the anatomy of the head and adjoining areas (and, if possible, the hands, too) is useful to help fully comprehend the external shapes even if it is not, by itself, enough to guarantee the successful rendition of a drawing.

THE BONES

The shape of the skull determines by and large the external morphology of the head and can be divided into two parts: the brain case and the facial block, which comprises several bones tightly joined together to achieve a solid structure. The only mobile bone is the jaw.

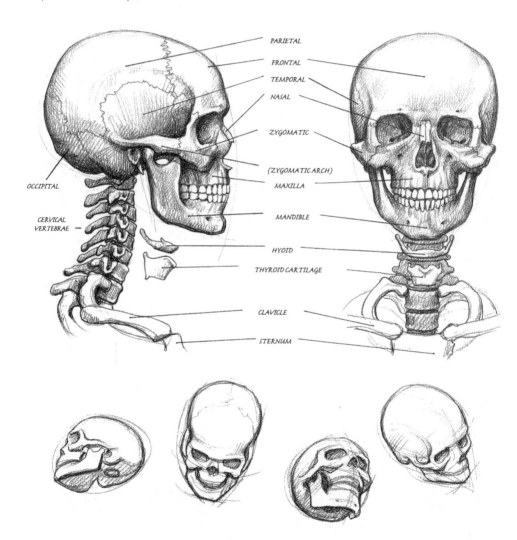

PARIETAL

FRONTAL

TEMPORAL

NASAL

ZYGOMATIC

(ZYGOMATIC ARCH)

MAXILLA

MANDIBLE

HYOID

THYROID CARTILAGE

CLAVICLE

STERNUM

OCCIPITAL

CERVICAL VERTEBRAE

If you get the opportunity to observe a real skull or to buy a plastic one, practise drawing its main outline. Render it from different visual angles, as I have shown in these quick sketches, and apply the principles of perspective and structural simplification.

THE MUSCLES

The muscles of the head are divided into two groups: the muscles of facial expression, responsible for physiognomic expressions; and the muscles of mastication, which move the jaw. They become stratified on the cranial bones whose external shape they follow pretty closely, as they are very thin. Also study the main neck muscles because, inevitably, they appear in nearly all portraits.

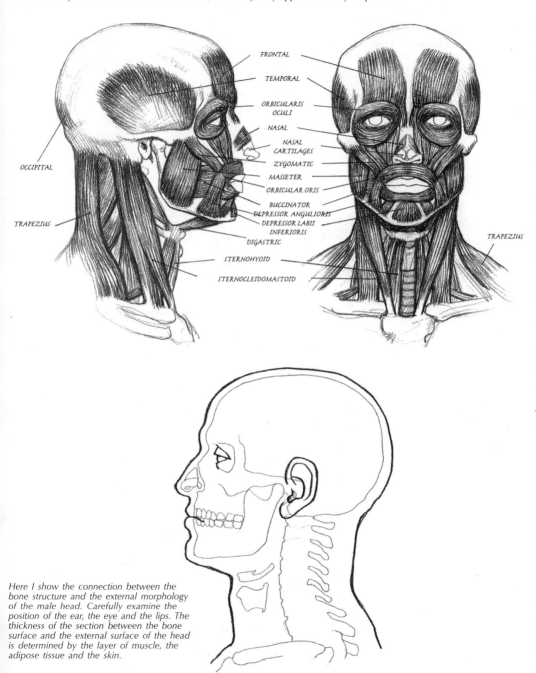

FRONTAL

TEMPORAL

ORBICULARIS OCULI

NASAL

NASAL CARTILAGES

ZYGOMATIC

MASSETER

ORBICULAR ORIS

BUCCINATOR

DEPRESSOR ANGULIORIS

DEPRESSOR LABII INFERIORIS

DIGASTRIC

STERNOHYOID

STERNOCLEIDOMASTOID

OCCIPITAL

TRAPEZIUS

TRAPEZIUS

Here I show the connection between the bone structure and the external morphology of the male head. Carefully examine the position of the ear, the eye and the lips. The thickness of the section between the bone surface and the external surface of the head is determined by the layer of muscle, the adipose tissue and the skin.

THE EYE

Once you have examined the overall structure of the head, you need to analyse carefully the individual details of the face, i.e. the nose, mouth, eyes and ears. It makes sense to be able to recognise the basic morphological, i.e. 'constructive' characteristics of each one, as by following them and precisely reproducing individual variations you will obtain a very good likeness.

 The eye is, perhaps, the most expressive element and it is therefore essential to draw it in the correct position and to the exact shape. Notice that the white section of the eyeball (the sclera) is not pure white but actually changes colour due to the effect of its own shadow and the one cast by the eyelid. Be careful to draw both eyeballs (and therefore both pupils) looking in the same direction as the expressiveness of the eyes depends on this.

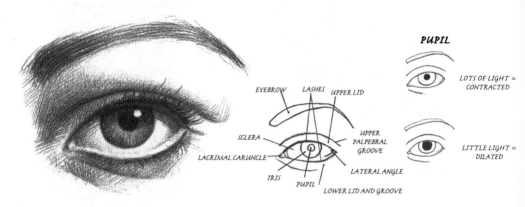

PUPIL

LOTS OF LIGHT = CONTRACTED

LITTLE LIGHT = DILATED

EYEBROW LASHES UPPER LID

SCLERA

LACRIMAL CARUNCLE

UPPER PALPEBRAL GROOVE

IRIS PUPIL

LATERAL ANGLE

LOWER LID AND GROOVE

The diagrams below should be sufficient to show the spherical structure of the eye, how the eyelids rest on it and, finally, the stages to go through to draw it correctly.

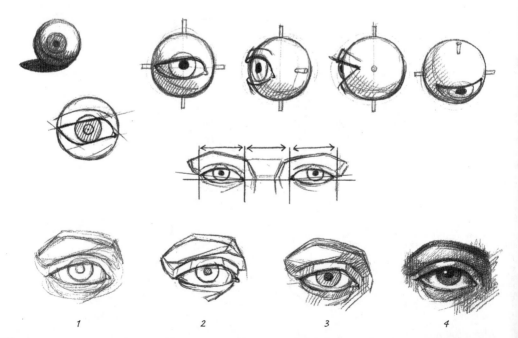

1 2 3 4

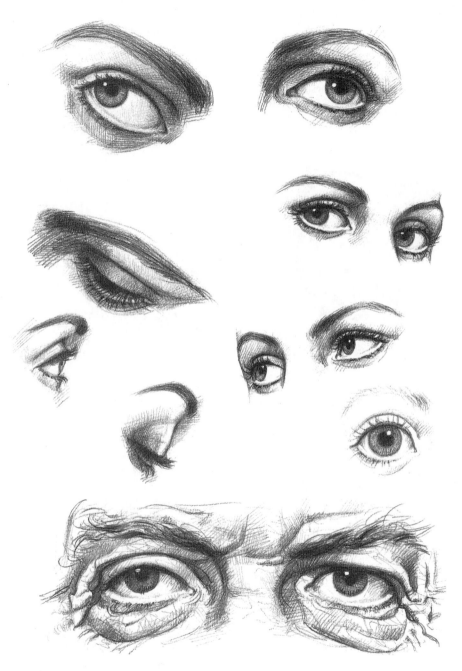

Practise drawing eyes in various positions and from different viewpoints, as shown by the examples on this page. The female eye usually has long and thick eyelashes, while eyebrows are well outlined and thin. The iris of a child looks very big compared to the eyelids.

Elderly people show several deep wrinkles radiating from the corners of the eyes, the lower eyelids become 'baggy', and eyebrows become irregularly thick and bushy.

THE EAR

The ear is supported mainly by thin cartilage arranged in circumvolutions. Although its morphological characteristics vary greatly, its overall shape recalls a seashell and is fairly similar in both sexes. Ears are often partly hidden by one's hair and their expressive character depends on their precise position on the sides of the head, as I have shown in the sketches below.

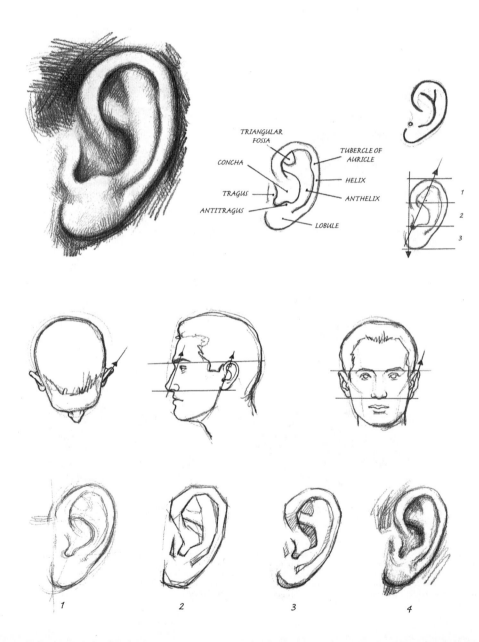

TRIANGULAR FOSSA

CONCHA

TRAGUS

ANTITRAGUS

TUBERCLE OF AURICLE

HELIX

ANTHELIX

LOBULE

1
2
3

1

2

3

4

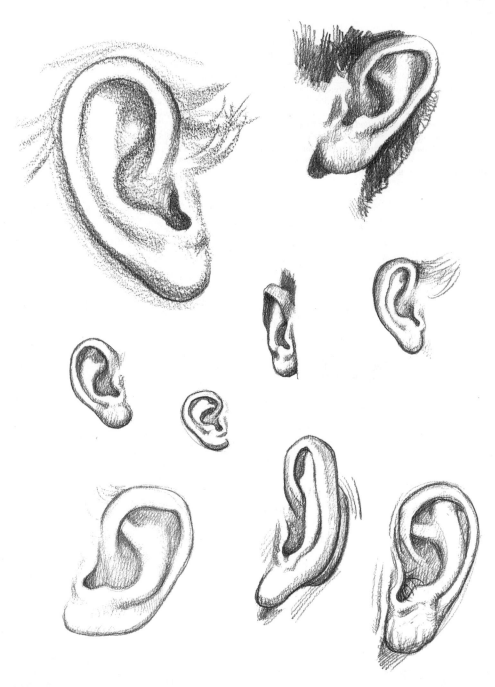

In an adult, the height of the ear corresponds, on average, to that of the nose; in a child it looks rather big in relation to the head; and in an elderly person it tends to lengthen because of the thinning and weakening of the cartilage tissue.

THE NOSE

The nose is rather difficult to represent as it sticks out of the face and therefore its appearance varies depending on the viewpoint. Its pyramid-like shape is partly due to two small, close together bones and partly to cartilages, and this can be seen clearly on its dorsum. Observe the sketches shown on these two pages and practise drawing the nose in various positions, referring to photographs if it makes it easier to understand its structure. Notice that the dorsum moves away from the bridge to reach maximum projection at the tip and its sides slope towards the cheeks. The triangular base hosts the nostrils, oval-shaped and slightly converging towards the tip, and delimited by the alae of the nose. Try to work out the most important areas of light and shadow (the maximum amount of light is usually on the dorsum and the tip, while the most intense shadow is at the base, near the nostrils) and indicate just those, to avoid making the drawing too 'heavy'.

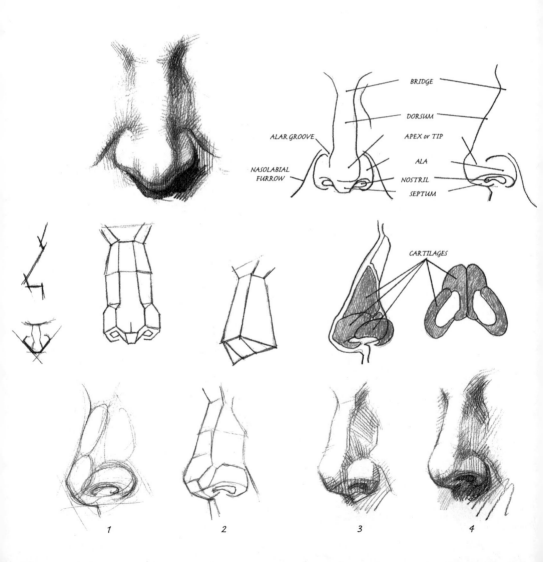

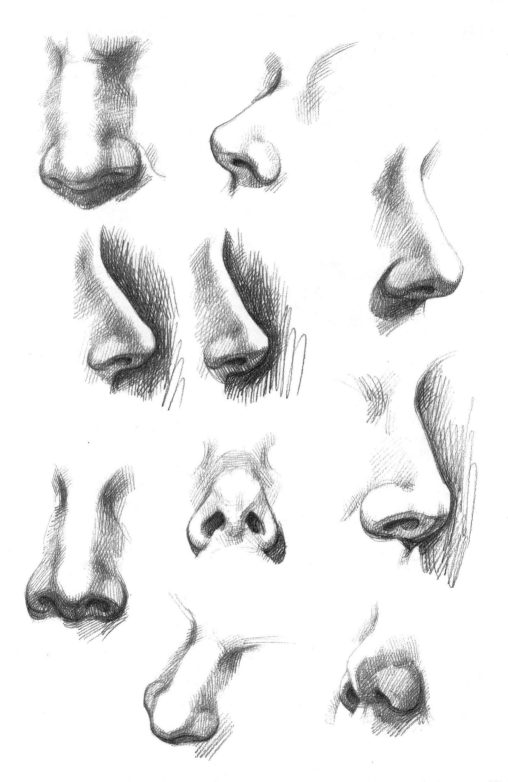

THE MOUTH

After the eyes the mouth is the second most expressive element of the face. The pinkish colour of the lips is due to the tissue they are made of, transitional between the mucous membrane (found inside the mouth) and the skin. When drawing the lips make sure that, above all, you carefully draw the line which separates them - ensure that it lies on the semi-cylindrical surface of the jaw bones and follows the rules of perspective I have already mentioned. The simple sketches shown below indicate some of the basic characteristics of labial morphology. Notice, for instance, that the upper lip is usually thinner and more protruding than the lower.

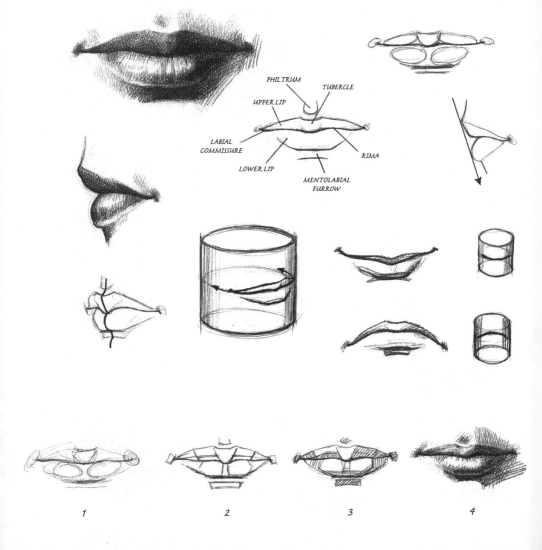

PHILTRUM
TUBERCLE
UPPER LIP
LABIAL COMMISSURE
RIMA
LOWER LIP
MENTOLABIAL FURROW

1 2 3 4

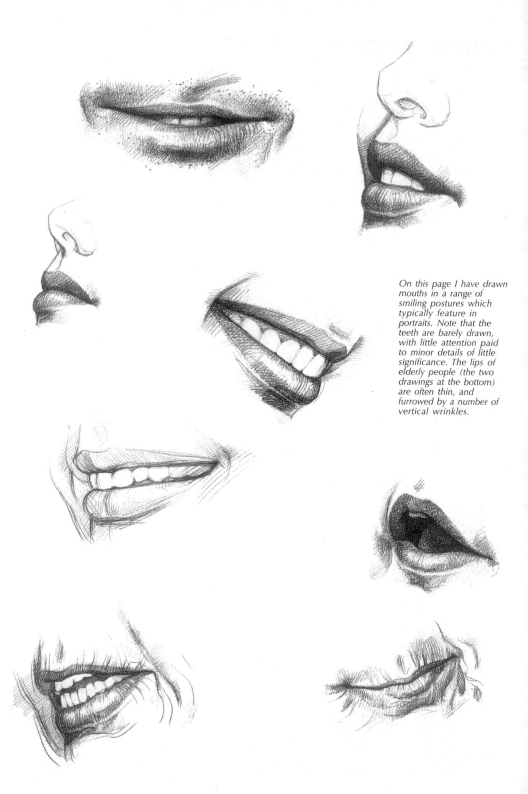

On this page I have drawn mouths in a range of smiling postures which typically feature in portraits. Note that the teeth are barely drawn, with little attention paid to minor details of little significance. The lips of elderly people (the two drawings at the bottom) are often thin, and furrowed by a number of vertical wrinkles.

PORTRAIT COMPOSITION

Composition involves arranging on the drawing surface the elements which make up the image we are set to represent. There are no firm rules (except, perhaps, the one concerning the 'golden section') but rather principles relating to our visual perception, i.e. unity, contrast and balance. Portrait composition dictates that we make some choices straight away: deciding whether to draw the full figure or just the head, and in this case, whether full-face, profile, three-quarter; deciding whether to place the model in some sort of setting or isolate them with a neutral 'background'; deciding the size of the drawing and whether it should be portrait- or landscape-style; and so on. You need to get used to doing lots of little sketches to evaluate these problems, as I suggest in the following pages. In the meantime look carefully at the sketches below, which use 'tricks of the trade' to direct you when you start, but don't allow yourself to be tied down by traditional and stereotyped formulas - do experiment with original and unusual compositions.

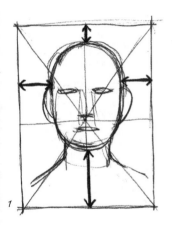

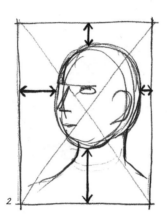

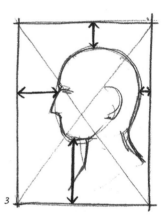

1 In a full face portrait you should not place the head right at the geometric centre of the page, but slightly higher, leaving more or less the same amount of space at the sides. Make sure, however, that the top of the head does not get too close to the edge of the page.

2 In a three-quarter portrait it's better to leave more room between the front of the face and the edge of the page, rather than at the back.

3 A profile portrait looks better if you leave lots of space in front of the face. Avoid, if possible, 'cutting' the head's back profile or making it fit with the edge of the page.

4 A bowed head can express a depressed mood.

5-6-7 A full-face portrait showing the subject in the foreground can radiate strength and self-confidence.

8 An image viewed from below can make the face look fierce and the attitude authoritarian. It is therefore not recommended for a portrait.

9 An unusual and evocative effect can be achieved by having the face take up the whole page.

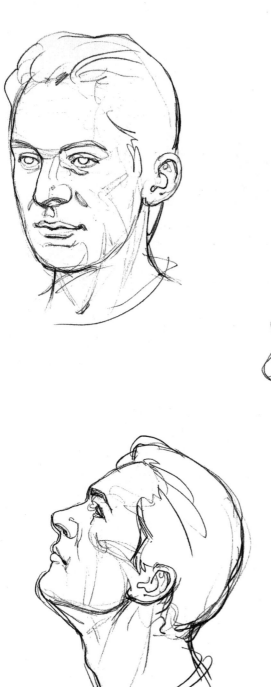

When working from life it is always useful to study the model thoroughly by sketching the head in various positions and from different viewpoints. This allows you to evaluate the overall somatic aspect and choose the pose and attitude which most faithfully and effectively represent the physiognomic features and the 'character' of the subject.

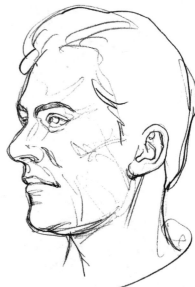

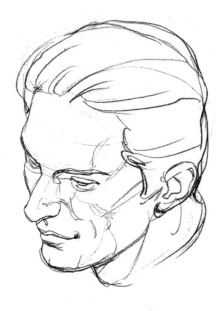

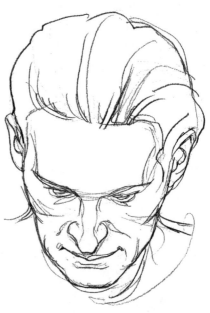

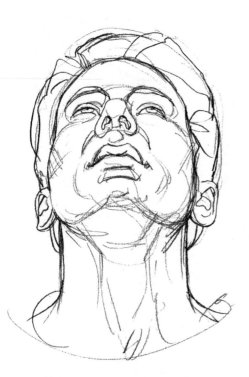

To work in a more relaxed way you can, to start with, use photographs but drawing from life is definitely more effective. In addition, it enables you to explore new compositional routes, 'going around' the model to catch every little expressive nuance and to master the overall shape, which is so important to achieving a likeness. Render these studies by way of simple, 'clean' strokes, aiming for the overall structure of the head rather than chiaroscuro effects.

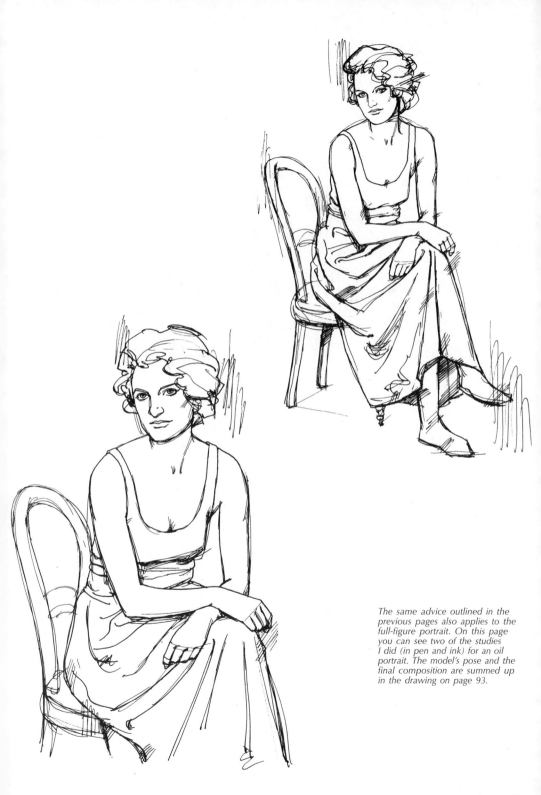

The same advice outlined in the previous pages also applies to the full-figure portrait. On this page you can see two of the studies I did (in pen and ink) for an oil portrait. The model's pose and the final composition are summed up in the drawing on page 93.

In full-figure portraiture the hands, as well as the face, have great importance and you need to find a pose which is expressive, yet conveys the whole. It is this latter aspect that I have tried to explore with the drawings shown on these pages.

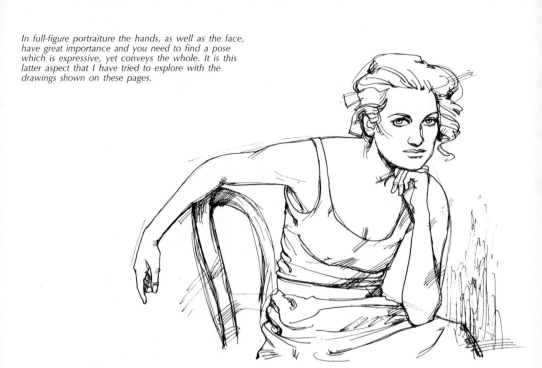

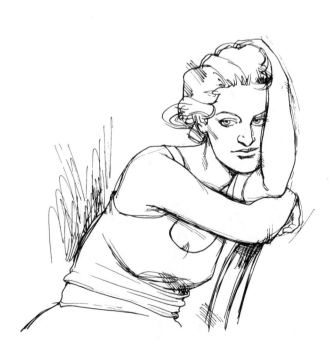

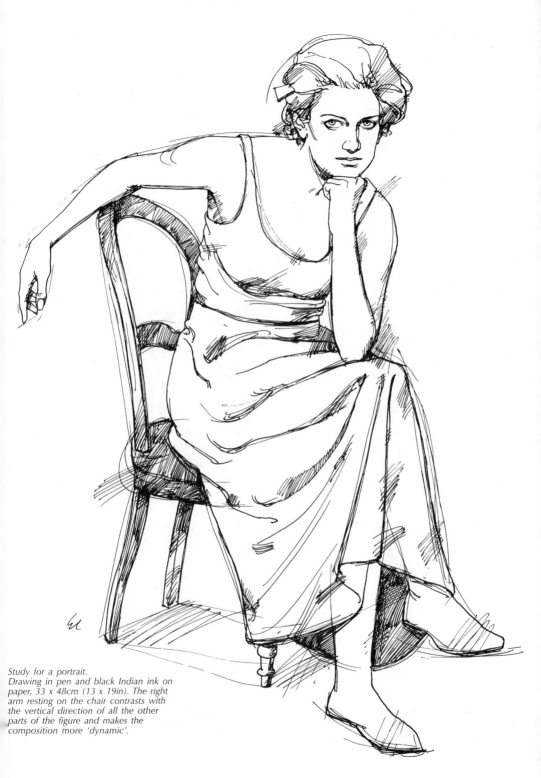

Study for a portrait.
Drawing in pen and black Indian ink on
paper, 33 x 48cm (13 x 19in). The right
arm resting on the chair contrasts with
the vertical direction of all the other
parts of the figure and makes the
composition more 'dynamic'.

LIGHTING

When drawing a portrait it is very important to consider the direction, quality and intensity of the light falling on the model as it is thanks to light and shadows that we get a sense of the shape and the plastic form of the face. Usually when drawing a portrait artificial light, which is easy to adjust and constant, is preferable to sunlight, which varies highly in intensity and direction. Good lighting must highlight as best as possible the physiognomic characteristics of the subject. Therefore avoid using a light source which is too intense and close. It is better to use slightly diffused lighting, which doesn't create dark shadows, especially under the nose, the lips and the eyes.

The photographic examples on these pages are of a sculpture I moulded and show situations which are slightly unusual or extreme, but are useful to highlight the effects, both positive and negative, of different lighting on the face. The most suitable lighting for a portrait has the source slightly higher than the subject and midway between the front and the side. To make the light more diffused you can place a finely frosted glass in front of the source or use one of the well known photographic devices.

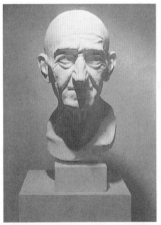

Top lighting

Is very effective but you have to be careful not to create excessively dark shadows under the eyebrows, the nose, and the chin. The surface-grazing light can exaggerate the reliefs and depressions of the skin.

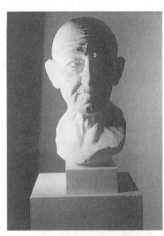

Side lighting

Is not suitable for portraiture as it divides the face into two contrasting halves: one lit, one in shadow. Sometimes it can be useful to convey strong relief.

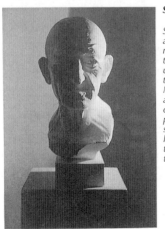

Side/back lighting

Should not be used for a portrait as it cancels most of the shape of the face. It can be used, however, when the head is in profile. Note, in this example, a device adopted in drawing - the dark part of the head is silhouetted against the light background and the light part against the dark background.

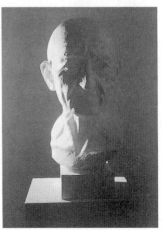

Almost back lighting

Also called 'effect lighting', is not used in portraiture as it makes the model's features hardly recognizable. The backlit image, however, can work for a portrait where the face is in profile.

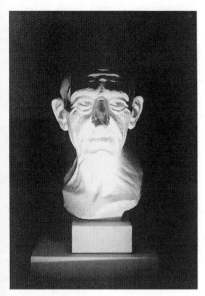

Lighting from below

Is very 'dramatic' and is hardly ever used in portraiture as it alters the likeness and distorts the characteristics of the face.

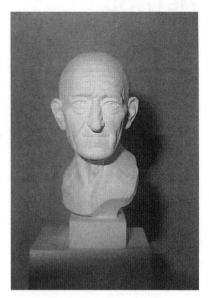

Front lighting

Is simple, but flattens the details of the face; it is very suitable, however, for 'linear' and decorative portraits.

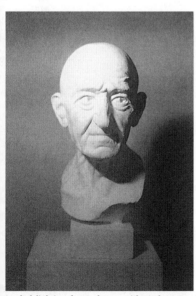

Angled lighting from above, midway between front and side: *is the type of lighting most widely used in portraiture as it properly highlights the physiognomic characteristics and effectively conveys the plasticity of the face. These two photographs vary slightly in the inclination and distance of the subject in relation to the light source.*

METHOD

In this chapter, up to page 101, I illustrate the stages one has to go through to draw a portrait. The method indicated is rather scholastic but useful to those new to portrait drawing. Once familiar with the elements which are essential to characterise a face, it will be easier and more spontaneous to move gradually from the first sketch to a more complex drawing and find your own, more immediate and personal, way forward. My advice is to do some of these exercises using live models and photographs, and to try to understand how each stage helps you tackle and solve a specific problem and how you get to draw a head correctly, at least from a formal point of view. Use sheets of white paper at least 30 x 40cm (12 x 16in) in size and pencils of various grades, as I have indicated.

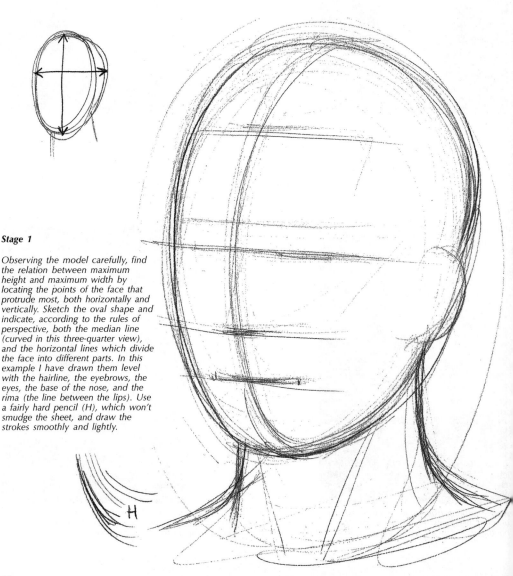

Stage 1

Observing the model carefully, find the relation between maximum height and maximum width by locating the points of the face that protrude most, both horizontally and vertically. Sketch the oval shape and indicate, according to the rules of perspective, both the median line (curved in this three-quarter view), and the horizontal lines which divide the face into different parts. In this example I have drawn them level with the hairline, the eyebrows, the eyes, the base of the nose, and the rima (the line between the lips). Use a fairly hard pencil (H), which won't smudge the sheet, and draw the strokes smoothly and lightly.

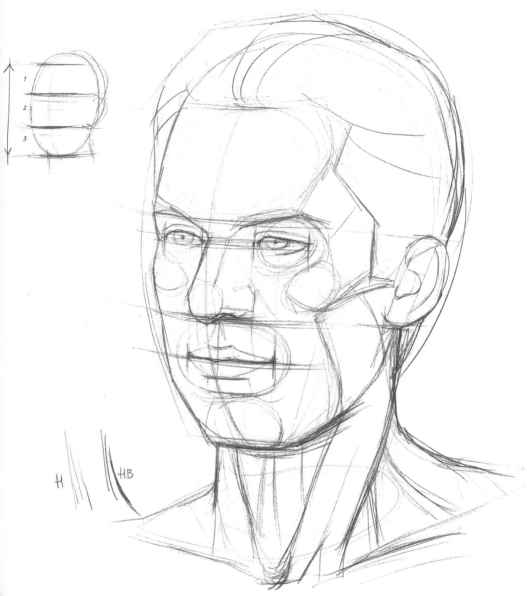

Stage 2

Continue to refine your sketch and carefully position the details of the face, i.e. the eyes, the nose, the mouth and the ears. Note that the subdivision of the face into three sections is just indicative. Try to find in each individual the specific relative proportions and stick to them to achieve a likeness. This stage is very important as it lays the ground for the subsequent development of the drawing. Also try to recognize and lightly sketch the main anatomic structures (the subcutaneous bones, the surface muscles, etc). Here, for example, I have indicated the protruding cheekbones and front bone, the position of the orbicularis oris, masseter and sternocleidomastoid muscles. Again, draw light strokes with an H pencil or, if you prefer an HB.

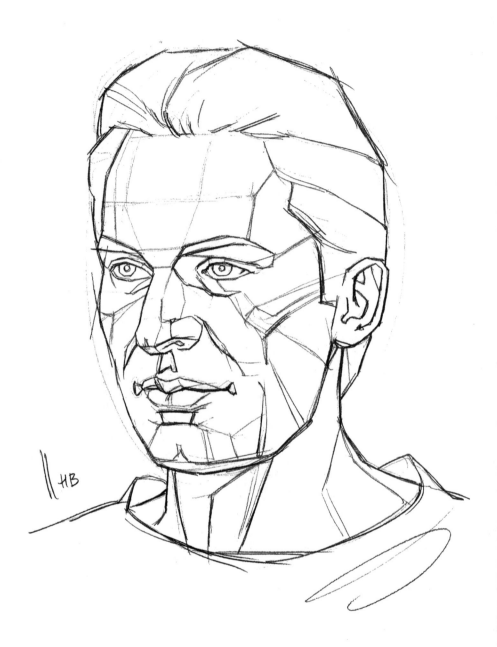

Stage 3

At this stage it's better to concentrate on recognizing the 'surface planes', i.e. those areas which are, in a barely noticeable way, distinguished by the different effect of the light. Concisely outline the areas (both lit and in shadow) which can, as a whole, help you give a feeling of solid volumetric construction to the drawing. Be careful not to overdo the straight strokes to avoid a 'hard', angular shape. However, a certain 'dryness' can help to simplify the tonal planes in view of the subsequent stages. Use a medium-grade pencil, such as HB.

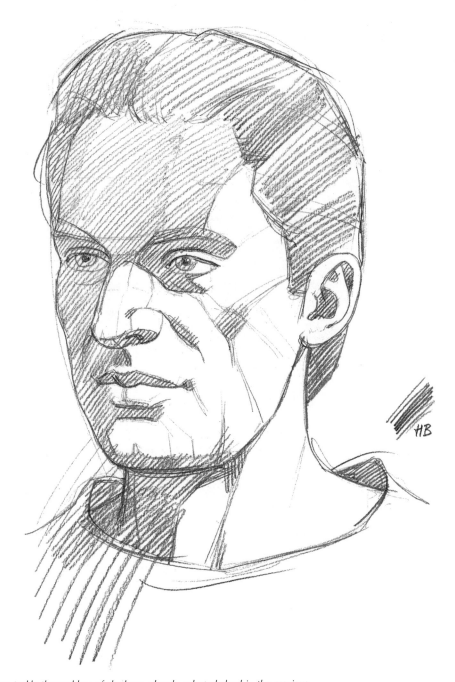

Stage 4

At this stage we tackle the problem of shadows, already acknowledged in the previous stage, and we show the larger, more intense and important ones. You will notice that the shadows on a face vary greatly in intensity and are extremely complex. For the simplified view needed at this stage, half close your eyes until you perceive just two tones on the model - that of the lit section of the face and that of the areas in shadow. Again use a HB pencil lightly and rather evenly.

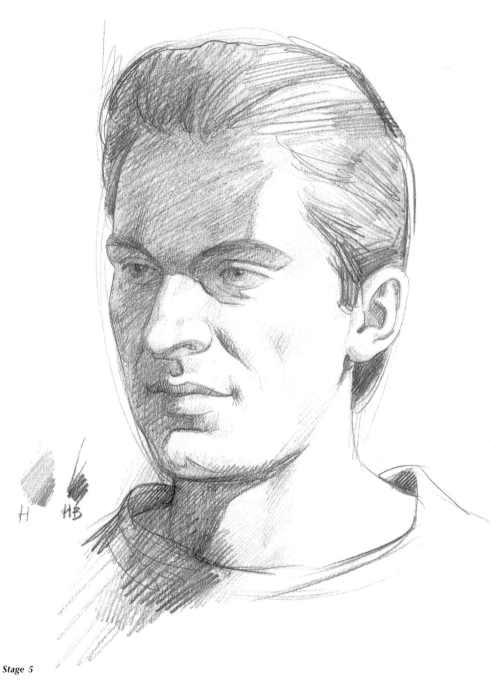

Stage 5

At this stage and, if necessary, in the next ones, proceed to fashion the surface shapes of the face, looking for the intermediate tones (which in the previous stage were left out and incorporated in the overall area of shadow). In addition, define the most significant details, for instance the eyes and the lips, enhancing or lightening the tonal values which define them. Again, use a HB pencil varying the intensity of the stroke by increasing or decreasing the pressure on the paper. H pencil can be used to indicate areas of very weak tone.

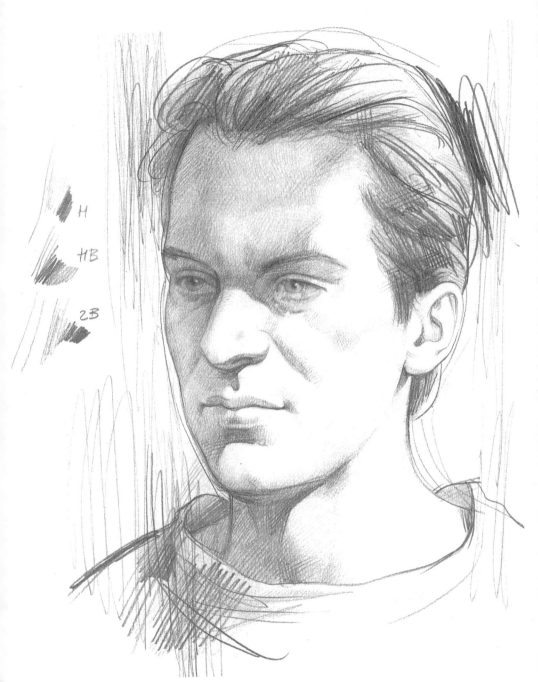

The drawing, now at an advanced stage, preserves traces of the previous stages. Do not erase them, rather 'soften them up', further perfecting the tones and blending them. It is impossible (and useless) to try to reproduce in a drawing all the tonal shades one finds in life. Therefore don't overdo the 'finishing touches' and the insignificant detail because a good drawing is always the result of careful selection and intelligent, sensitive simplification. Shadows can be intensified in places with a 2B pencil, which is rather soft.

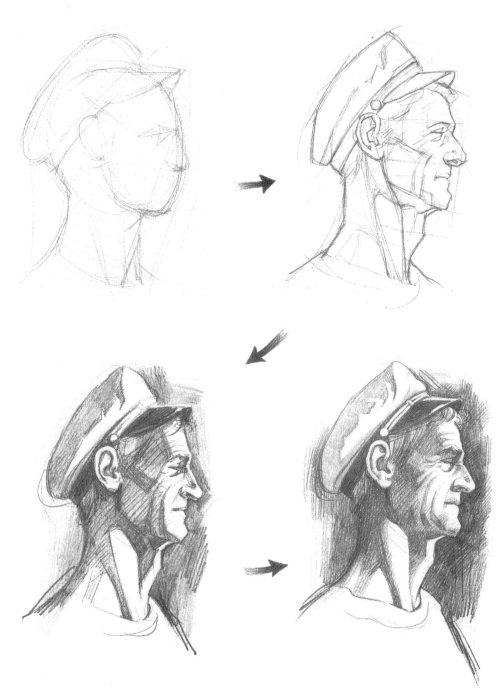

The sketches above are reconstructions (done 'afterwards' for the purpose of demonstration) of some of the stages which I follow as a rule, by now almost instinctively, when I draw a portrait.

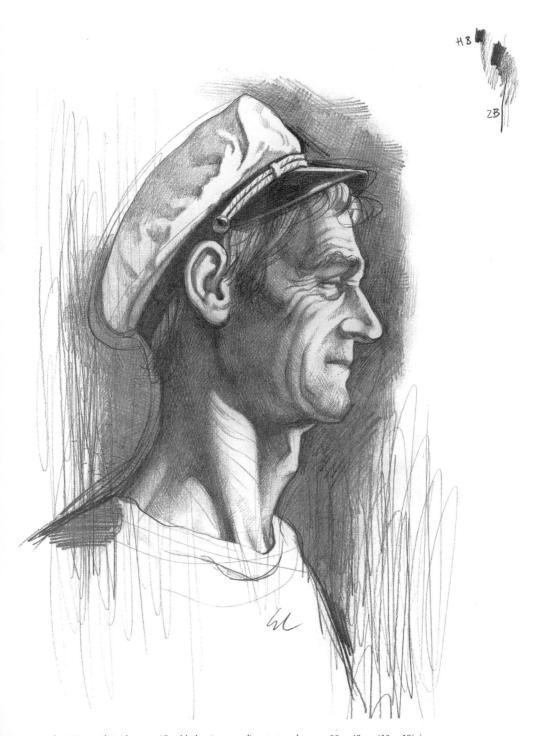

HB

2B

Portrait study: HB pencil (with some 2B added on) on medium-textured paper, 33 x 48cm (13 x 19in).

Charcoal is suitable for portraiture because it allows you to quickly and effectively tonally draw the face. The method is slightly different from that followed with a pencil: with a few light strokes outline the head, then fill and blend with your fingers or a wad of cotton wool (stage 1); exercising more pressure on the charcoal, darken the areas of the face which appear in shadow and blend again (stage 2); then gradually try to find the different tones of chiaroscuro, darkening some areas, lightening others more exposed to the light (stages 3 and 4). To erase or lighten tones use a kneadable putty eraser, gently pressing it and rubbing lightly. Do not grade the shading excessively or you will 'weaken' the drawing and give it a photographic, affected look. Rather, pay attention to the big masses and the main features of the face.

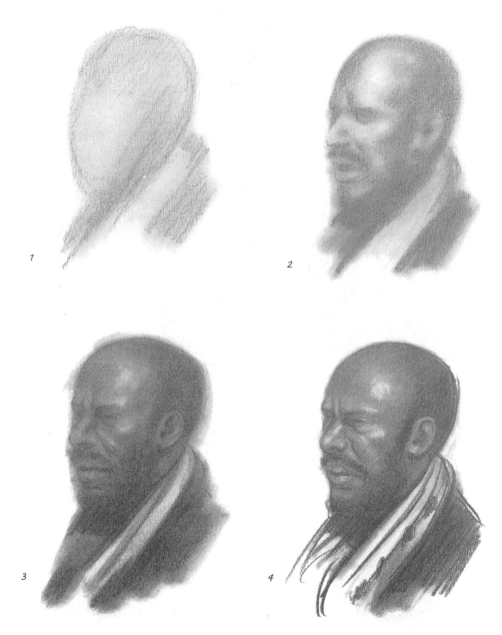

1

2

3

4

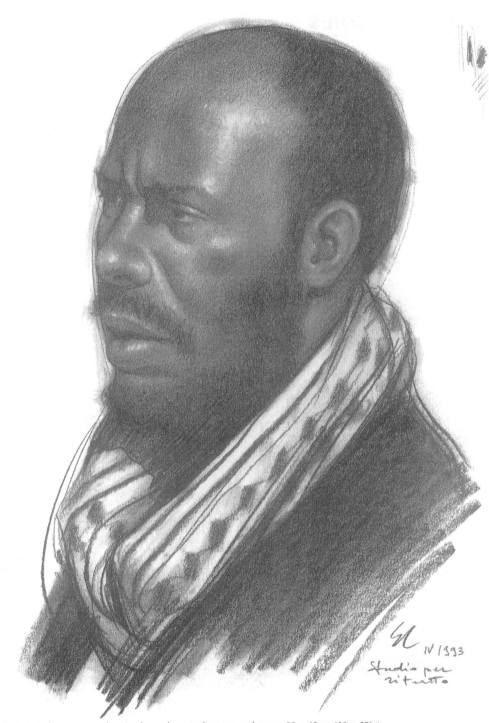

Portrait study: compressed sepia charcoal on medium-textured paper, 33 x 48cm (13 x 19in).

PORTRAIT STUDIES

In this chapter I have put together a series of portraits, some of which were done specially for this book, and others which were drawn previously. Almost all of them are studies for oil paintings or for more elaborate drawings and I chose them because the intermediate stages of implementation, more than the 'finished' works are the ones which show how to recognise and tackle the problems of composition, pose, anatomy and working technique.

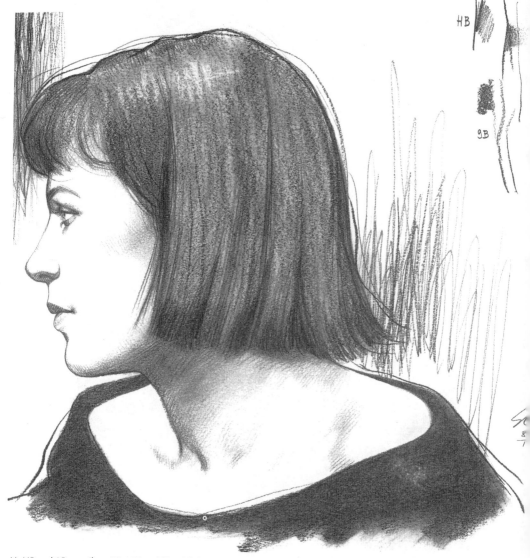

H, HB and 9B pencil on 30 x 40cm (12 x 16in) paper.
The portrait in profile works well with young subjects, especially female. The hair contrasts with the features and creates interesting 'graphic' effects of composition. For the hair I used HB pencil, lightly blended with a finger, and added darker accents with a 9B, drawing some 'flat' strokes, that is, using the side of the point.

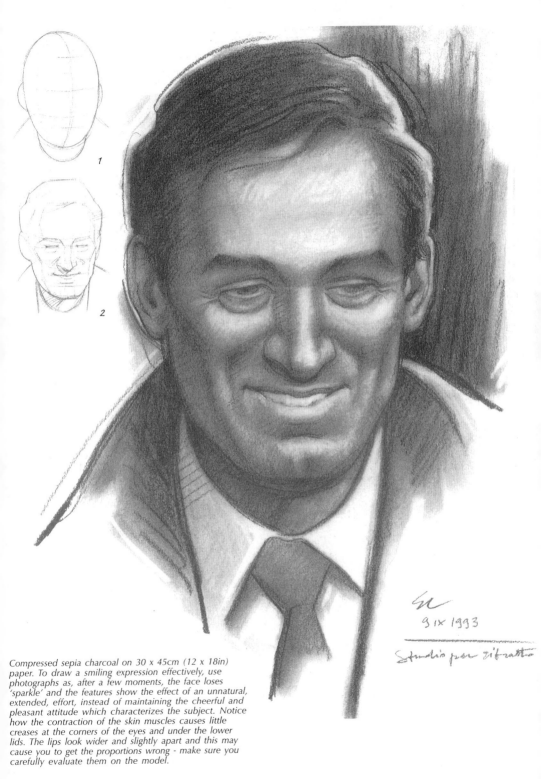

1

2

Compressed sepia charcoal on 30 x 45cm (12 x 18in) paper. To draw a smiling expression effectively, use photographs as, after a few moments, the face loses 'sparkle' and the features show the effect of an unnatural, extended, effort, instead of maintaining the cheerful and pleasant attitude which characterizes the subject. Notice how the contraction of the skin muscles causes little creases at the corners of the eyes and under the lower lids. The lips look wider and slightly apart and this may cause you to get the proportions wrong - make sure you carefully evaluate them on the model.

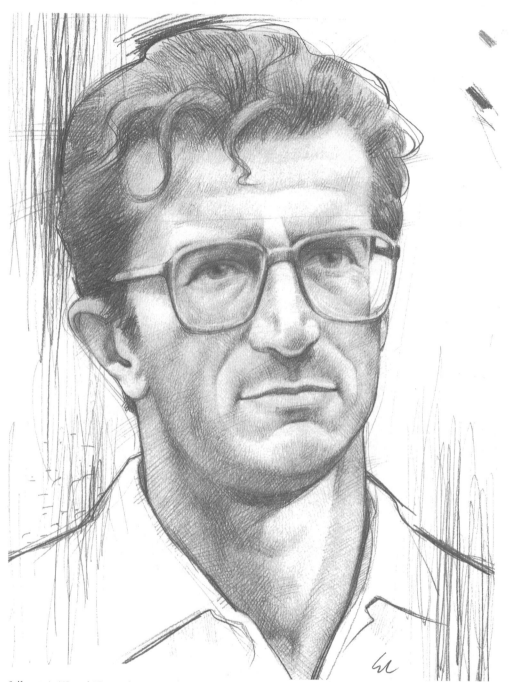

Self-portrait. HB and 2B pencil on paper, 33 x 48cm (13 x 19in).
The one model you can study whenever you like and in any condition is the one you see when you look at yourself in the mirror. Practise drawing your mirror image and don't worry too much if, in the end, you won't be able to recognize yourself fully in that self-portrait. Posing is tiring and, after a short while, your usual expression will look 'drawn' and hard. You could, of course, use photographs, as with any other portrait, but if you draw from life the result is more gratifying. Above all try to get the relative proportions of the whole head and then insert the details. Glasses, if worn all the time (as in my case), become part of the physiognomy of the face and can significantly characterize it. Lenses can distort the size and shape of the eyes, enlarging them or making them smaller. Also bear in mind the shadows cast by the frame.

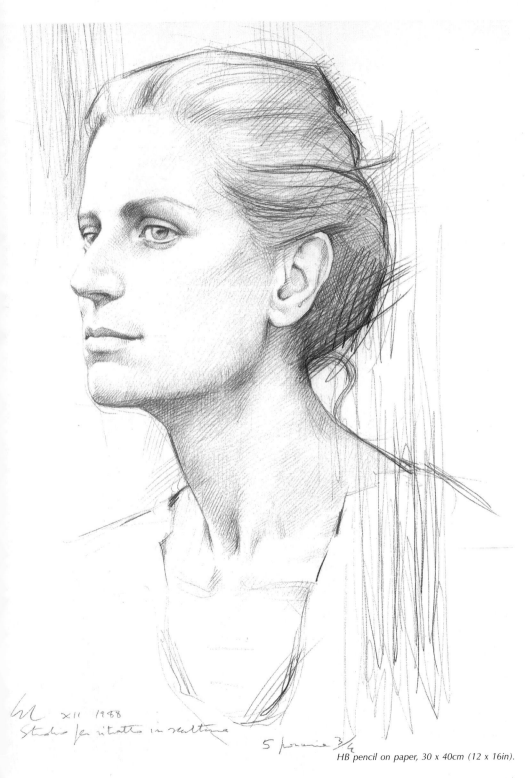

XII 1988
Studio per ritratto in scultura

5 persone 3/4

HB pencil on paper, 30 x 40cm (12 x 16in).

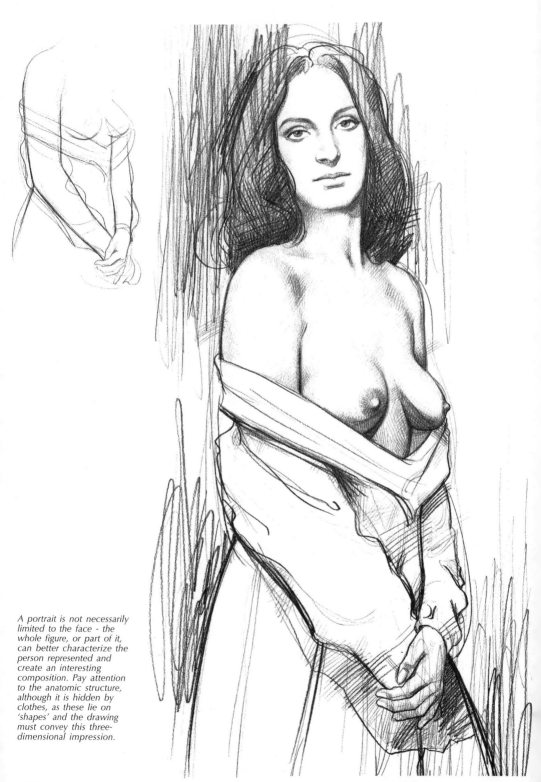

A portrait is not necessarily limited to the face - the whole figure, or part of it, can better characterize the person represented and create an interesting composition. Pay attention to the anatomic structure, although it is hidden by clothes, as these lie on 'shapes' and the drawing must convey this three-dimensional impression.

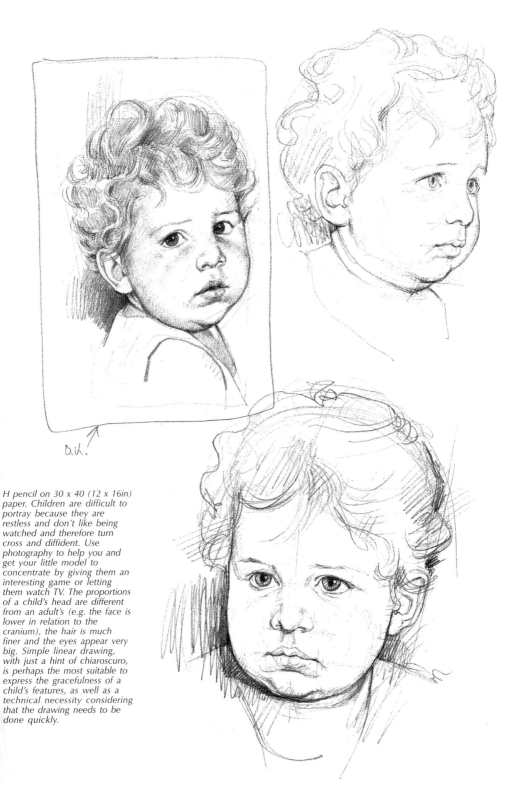

H pencil on 30 x 40 (12 x 16in) paper. Children are difficult to portray because they are restless and don't like being watched and therefore turn cross and diffident. Use photography to help you and get your little model to concentrate by giving them an interesting game or letting them watch TV. The proportions of a child's head are different from an adult's (e.g. the face is lower in relation to the cranium), the hair is much finer and the eyes appear very big. Simple linear drawing, with just a hint of chiaroscuro, is perhaps the most suitable to express the gracefulness of a child's features, as well as a technical necessity considering that the drawing needs to be done quickly.

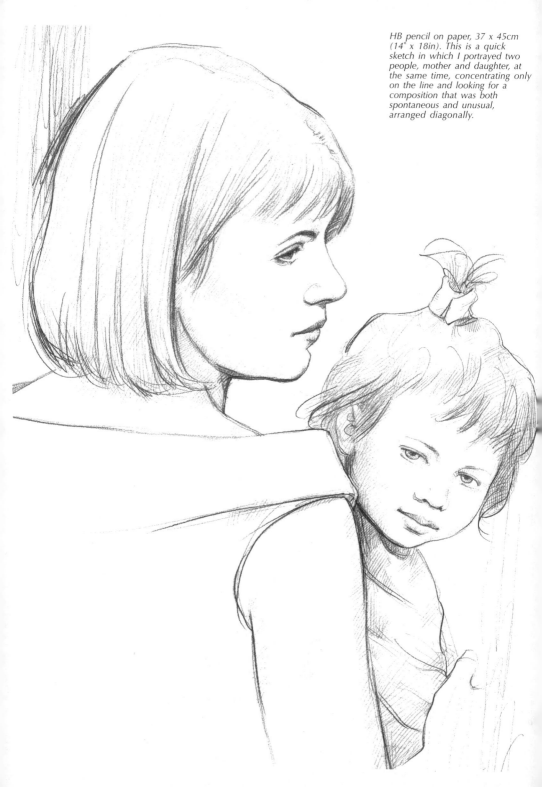

HB pencil on paper, 37 x 45cm
(14 x 18in). This is a quick
sketch in which I portrayed two
people, mother and daughter, at
the same time, concentrating only
on the line and looking for a
composition that was both
spontaneous and unusual,
arranged diagonally.

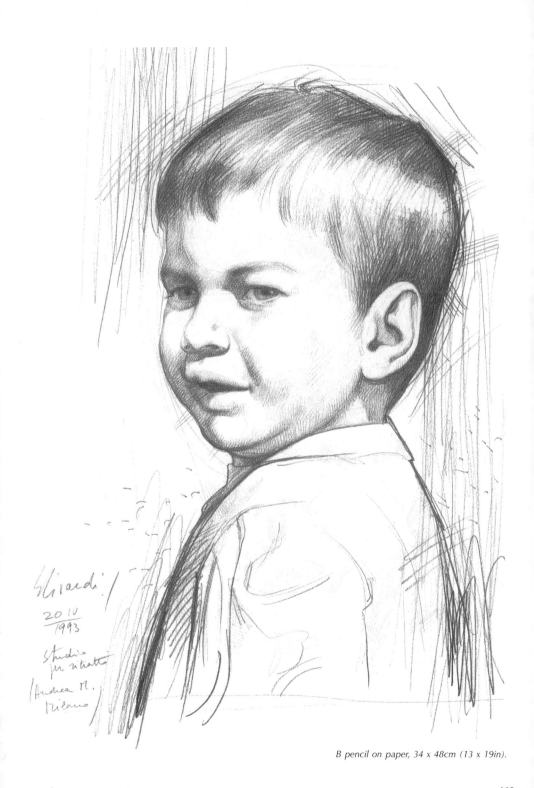

B pencil on paper, 34 x 48cm (13 x 19in).

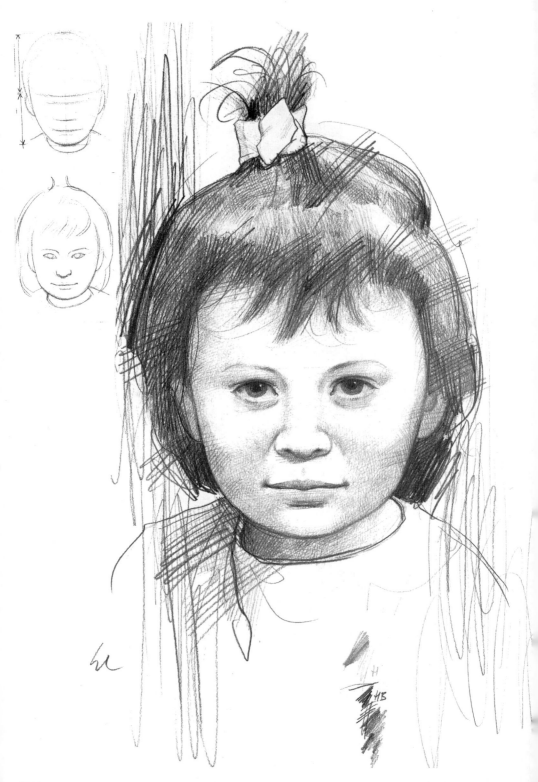

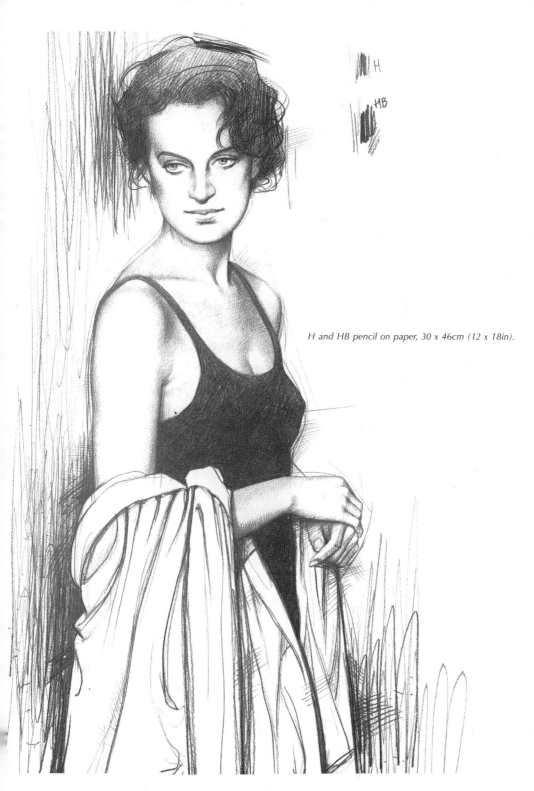

H and HB pencil on paper, 30 x 46cm (12 x 18in).

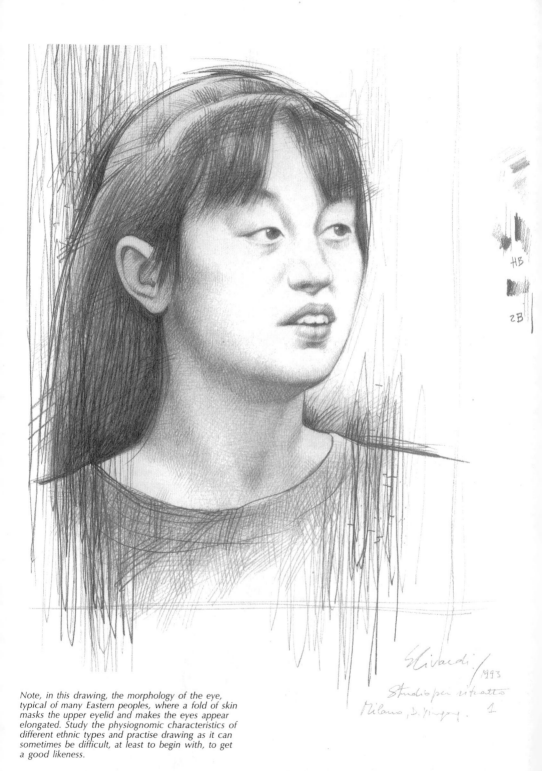

HB

2B

Note, in this drawing, the morphology of the eye, typical of many Eastern peoples, where a fold of skin masks the upper eyelid and makes the eyes appear elongated. Study the physiognomic characteristics of different ethnic types and practise drawing as it can sometimes be difficult, at least to begin with, to get a good likeness.

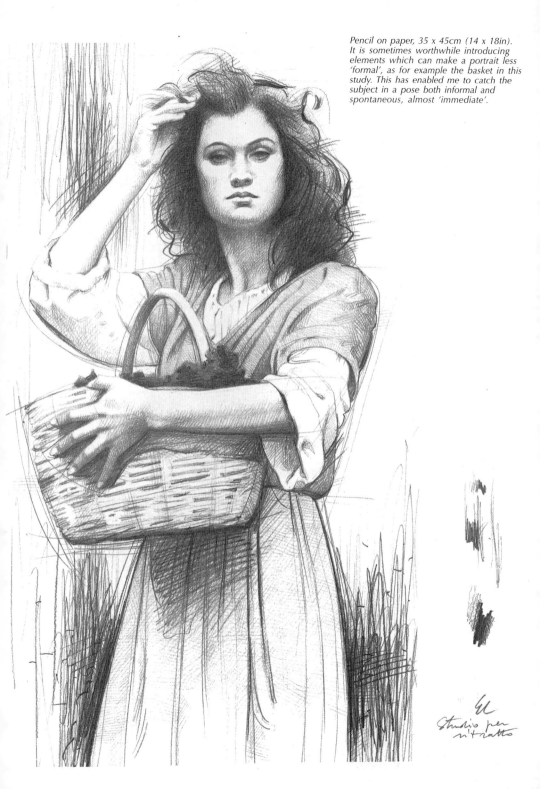

Pencil on paper, 35 x 45cm (14 x 18in). It is sometimes worthwhile introducing elements which can make a portrait less 'formal', as for example the basket in this study. This has enabled me to catch the subject in a pose both informal and spontaneous, almost 'immediate'.

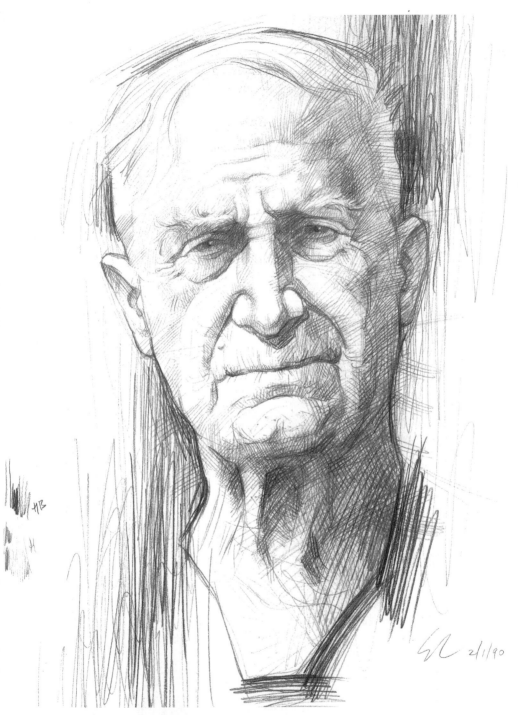

The drawings on these two pages are studies which I drew from life for a carved portrait. I walked around the model observing his features from different viewpoints (you can see the profile on page 122), and I partly neglected the chiaroscuro effects as I was interested, most of all, in understanding the volumetric structure of the head.

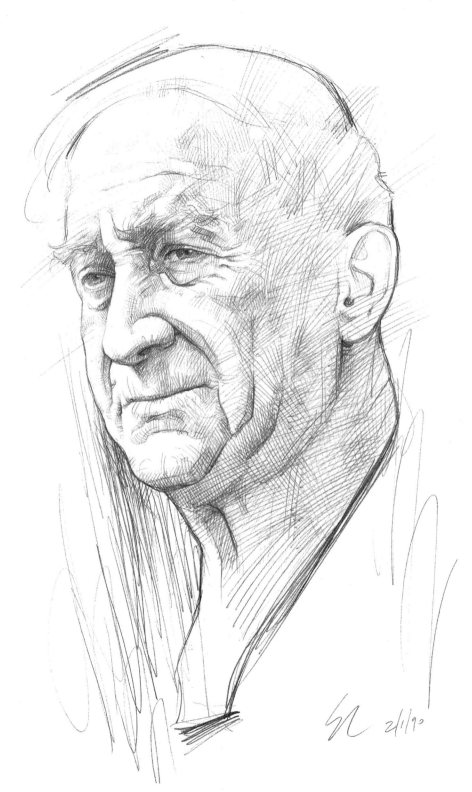

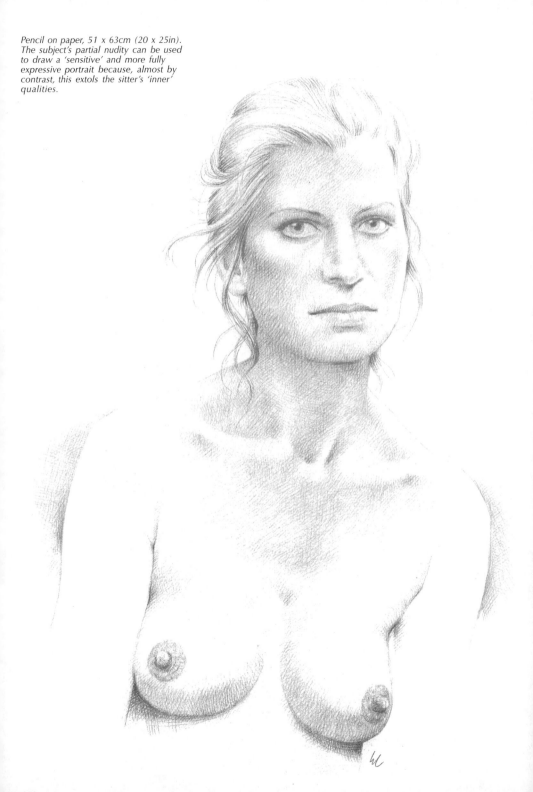

Pencil on paper, 51 x 63cm (20 x 25in).
The subject's partial nudity can be used
to draw a 'sensitive' and more fully
expressive portrait because, almost by
contrast, this extols the sitter's 'inner'
qualities.

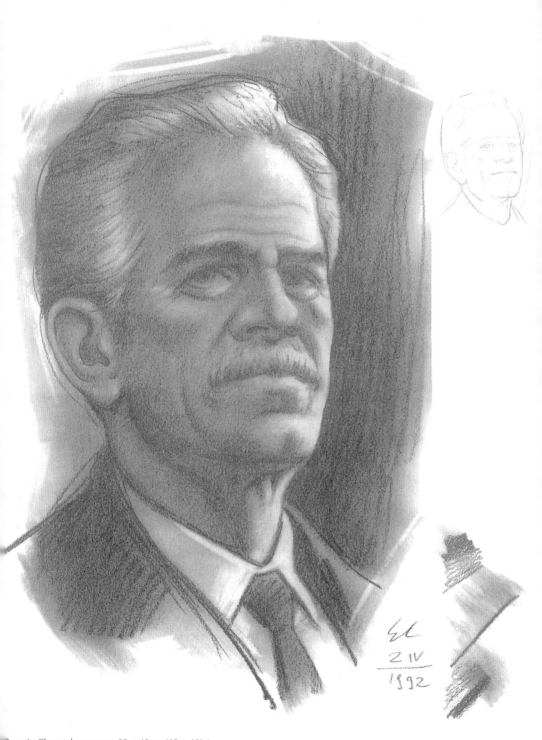

Portrait. Charcoal on paper, 33 x 48cm (13 x 19in).
To draw this study I used weak side lighting as it seemed particularly suited to highlighting the 'severe'
character of the subject. The sketch shown on top indicates the basic lines drawn to find the proportions.

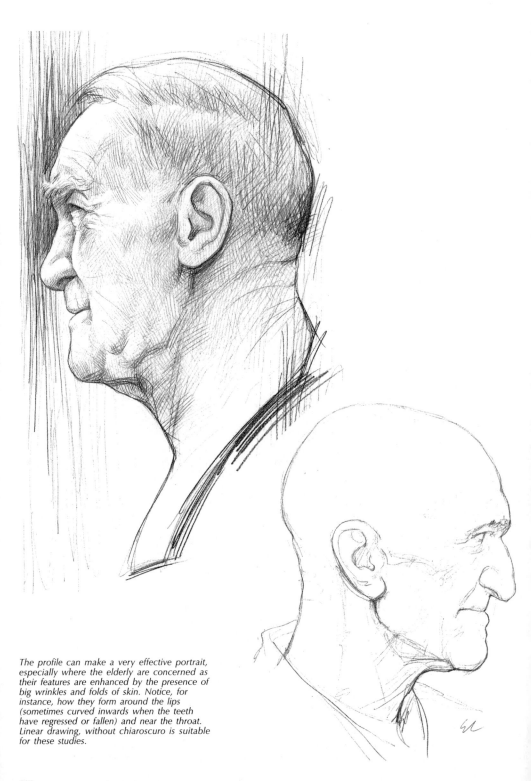

The profile can make a very effective portrait, especially where the elderly are concerned as their features are enhanced by the presence of big wrinkles and folds of skin. Notice, for instance, how they form around the lips (sometimes curved inwards when the teeth have regressed or fallen) and near the throat. Linear drawing, without chiaroscuro is suitable for these studies.

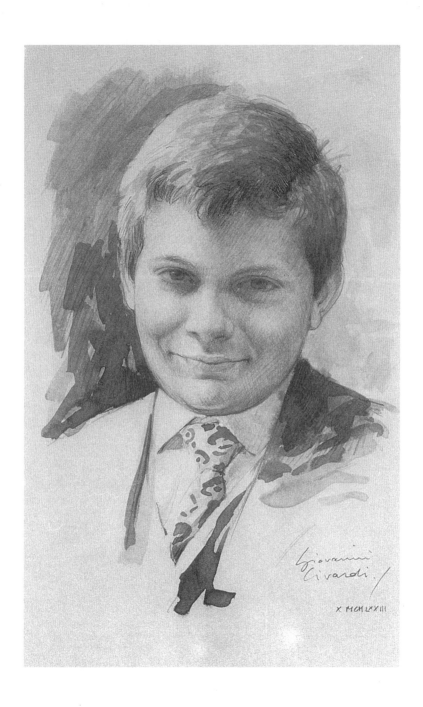

*This portrait study was drawn with HB graphite on card, 15 x 20cm (6 x 8in).
I enhanced some shadow areas with water-diluted Indian ink applied with a round
brush. Finally, I 'glazed' the whole surface in order to soften and even the tones.*

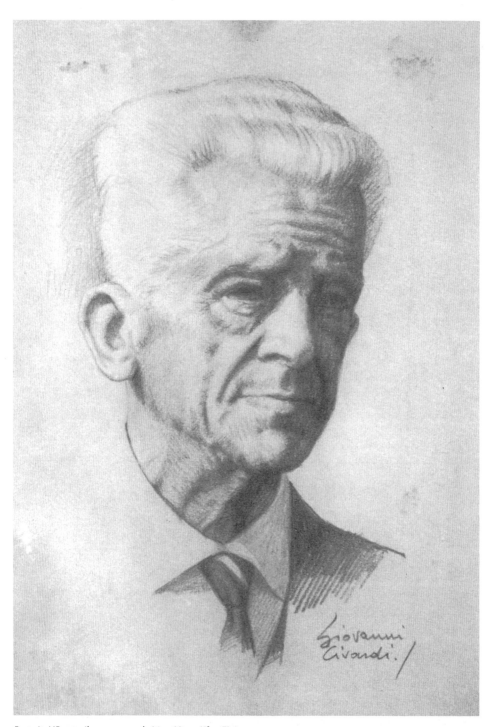

Portrait, HB pencil on grey card, 14 x 18cm (5° x 7in).

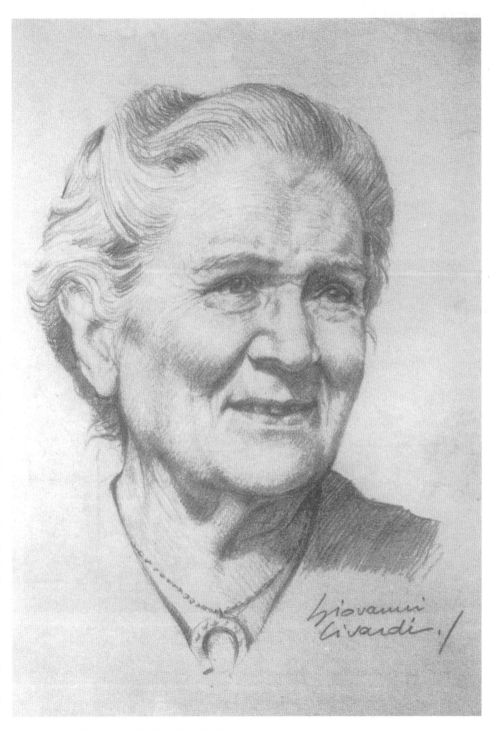

Portrait, HB pencil on grey card, 13° x 18cm (5 x 7in).

MIXED MEDIA

On these last pages I thought it useful to show some portraits rendered with more complex techniques than those presented in the previous chapters. They can be classified as 'mixed media' (see page 5) and are ideal for evocative and interesting works yet at the same time they leave one free to resort to purely graphic or more markedly pictorial methods to achieve effects which are unusual and very expressive.

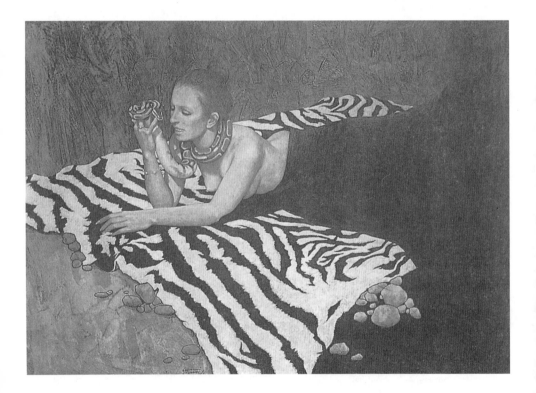

For the drawing you see here (in its entirety on this page while a detail is shown on the next) I have used pen and inks, acrylic colours, pastels, carbon pencils and white tempera on card, 51 x 71cm (20 x 28in). The portrait commissioned was published to illustrate an interview the subject herself gave to a magazine. Knowing it would be used this way I left a large dark area to the right (the dress and the background) to allow the white of the titles and part of the text to stand out.

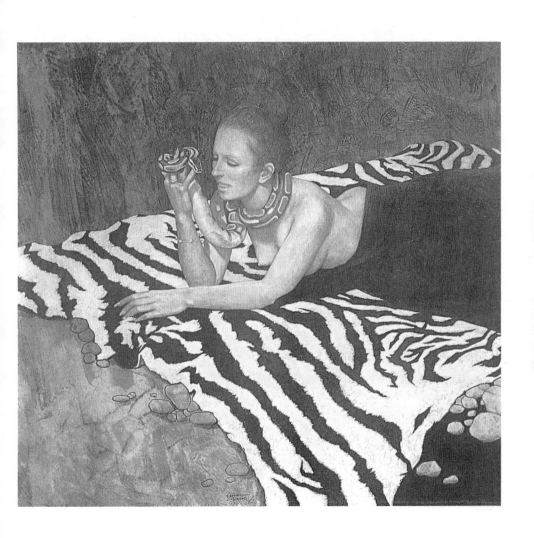

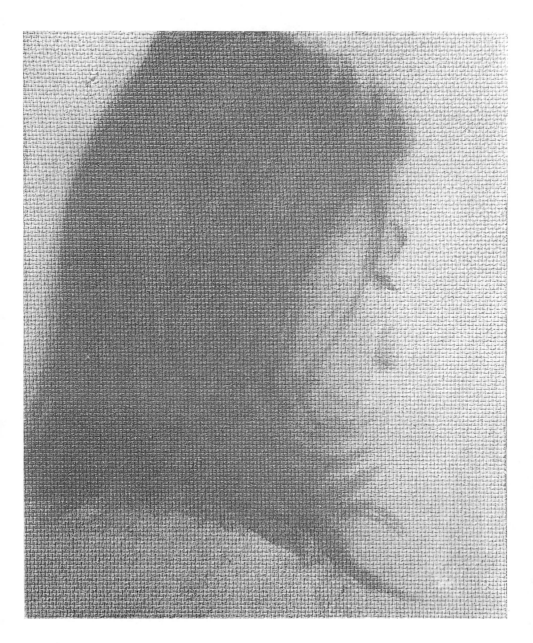

This portrait, where the hair is more prominent than the facial features, is
unusual, but is a good likeness, in spite of being almost a back view.
It was painted with very diluted acrylic colours on the rough surface of
fibre board, 18 x 21cm (7 x 8in), prepared with acrylic chalk.

DRAWING THE CLOTHED FIGURE

At art schools, at academies or even on each painter's or sculptor's individual academic journey, drawing the human figure from life has always been considered an essential cornerstone. Even nowadays, when the most varied and antithetical trends in art and expression coexist, the artists who seriously wish to base their own 'freedom' on sound technical training often choose to devote a considerable part of their research to drawing the human body, one of the most important subjects for artists since way back in time.

When we talk about studying the figure, we mainly mean the nude figure, but although this is the universal assumption it is also clear that, except in certain circumstances, there are many more opportunities to witness and study clothed or partly clothed figures than nude ones. And the field of artistic expression is even wider in this respect: just think about portraits, photography, comic strips, illustrations, and so on. In all these areas it is obvious to note that clothes cover – and are influenced by – anatomical shapes and movement.

I thought it appropriate therefore to suggest with this chapter a rather difficult, but very interesting, theme: that is, drawing what used to be sometimes classified as 'genre' scenes. Characters caught in various situations in everyday life, in our surroundings, in places we usually frequent or that we happen to visit, subjects found in the home, in the street, on means of transport or in public places.

Drawing is the most immediate art form, the one that most easily enables us to portray quickly what we see. In order to draw well, we especially need to know how to observe carefully, interpret according to our style and our sensitivity, and combine facts with fantasy. Indeed, a drawing from life, done quickly, or a simple sketch, does not require much processing of details but, rather, the ability to know how to pick out the essential elements that seem the most meaningful for portraying the subject. When drawing figures, whether nude or clothed, it is then necessary to consider them as a combination of simple shapes (but strictly correlated in the overall shape), to assess their proportions, balance, the type of attitude, and so on.

In this chapter I have tried to suggest at least some subjects for reflection and practice which, I hope, will inspire you and be of help in honing your observation skills, by applying them to a topic that is sometimes complex but, precisely because of this, always rewarding and useful.

TOOLS AND TECHNIQUES

To draw rapid portraits of characters or make sketches of figures, especially if you are working from life, you can use the simplest and most well-known tools: pencils, charcoal, pastels, pen and ink, watercolours, felt pens, etc.

Each of these produces different effects not only because of the specific nature of the material and technique, but also because of the characteristics of the medium on which it is used: smooth or rough paper, card, white or coloured paper, etc. The drawings shown on this page and the next have been produced using some tools that are commonly used, but suitable for depicting, efficiently and with good effect, the scenes that we happen to find in the street, in public places, on our travels or in various surroundings frequented socially.

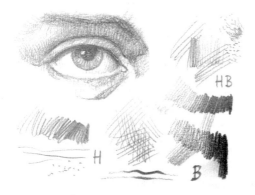

Pencil and graphite leads (H, HB, B) on rough paper

Pencils are the most commonly used tool for any type of drawing and, for the clothed figure and portrait, they can be used expressively and creatively, and are convenient implements. They can be used for very elaborate drawings or for short studies and brief reference sketches; for the latter, micro leads are suitable, whereas for the former you can choose graphite leads with a large diameter and softer gradation. Graphite leads which can be used by inserting them in push-button holders, like pencils (graphite leads inserted in the wood casing), are graduated according to consistency: from 9H, very hard, which draws fine faint lines, to 6B, very soft, which easily draws thick, dark lines.

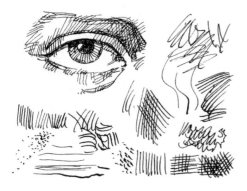

Pen, nib and black China ink on semi-rough paper

Artists frequently use ink. It can be applied either with the brush or the nib, but special effects can be obtained by using, for example, bamboo cane, nibs with a thick point, fountain pens, 'technical' (Rapidograph) pens, felt pens and ballpoint pens. The tonal intensities are usually graduated by criss-crossing the nib strokes more or less densely and, therefore, it is advisable to draw on paper or card that is rather smooth and of good quality, to prevent the surface from fraying and the ink from being irregularly absorbed.

Compressed charcoal on paper

Charcoal is perhaps the ideal means for sketching figures from life because it is very easy to control when shading and can also help achieve very clear details. It must, however, be used quickly, concentrating on conveying the overall tonal and volumetric masses. In this way it can express its best qualities as a versatile and suggestive tool. You can use compressed charcoal or wood charcoal, paying attention in both cases not to dirty the sheet. The charcoal strokes merge and blend together when rubbed lightly, for example, with a finger and the shading can be toned down by applying a soft rubber. The finished drawing must be protected by spraying it with a fixative.

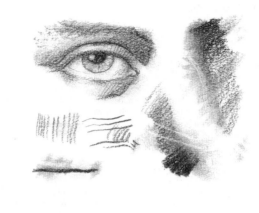

Monochrome watercolours (washes) on semi-rough paper

Watercolours, water-soluble inks and China ink diluted with water are very suitable for studying figures and drapery, although they are more like painting than drawing, given that they are applied with a brush and require synthetic and expressive tonal vision. For quick studies from life you can use graphite leads or water-soluble coloured pencils, whose strokes are easily merged by going over them with a brush dipped in water. In this case, it is preferable to use thick cards or cardboards so that the moisture does not make the surface wavy and irregular.

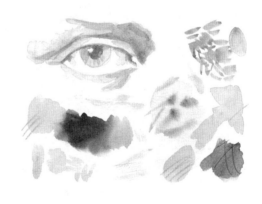

Pencils, inks, white tempera on rough paper

Techniques are 'mixed' when different tools are used to produce a drawing and look for unusual effects. They are always graphic means of expression, but their use requires careful control and a good knowledge of the tools, so as to avoid confused outcomes with poor aesthetic meaning. Mixed techniques are very effective if used on mediums that are rough, coloured or at least dark tonality.

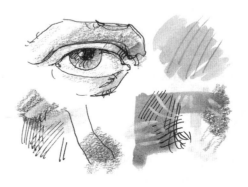

PRACTICAL CONSIDERATIONS

WHERE TO FIND 'MODELS'

When studying clothed figures subjects can be found anywhere, of course a lot more often than you find semi-clothed or even nude figures, which you find only in appropriate circumstances and places.

First find, then seek

JEAN COCTEAU

All it takes is to look around a bit, carefully and inquisitively, to discover an almost unlimited series of suitable opportunities to practise drawing the human figure in everyday poses and actions: in the streets, in public places (gardens, parks, stations, restaurants and bars, offices, theatres, exhibitions, public transport) and, above all, in the actual environment in which we live (our relatives, friends, work or academic colleagues, etc.).

The opportunities, in short, are so frequent and common that we are almost spoilt for choice.

WHAT TYPE OF DRAWING TO DO

We need to distinguish schematically between two broad areas of 'research':

a) The rapid, immediate, sketch from life, which is almost a quick graphic note focused on the attitude, the 'character', the gesture, etc. of the subject we are observing (see page 169). It is a drawing produced with few lines and in a short space of time (taking not more than a few minutes), catching the precariousness or the fleetingness of the attitude that attracted us. It also usually presupposes small dimensions (those of a pocket-size notebook or sketchpad), a simple, agile tool (pencil or ballpoint pen) and a lot of discretion, because the model must be captured almost without his or her knowledge (many subjects, luckily for us, pretend not to notice…). The drawing should be made from a certain distance, or else we lose the naturalness and spontaneity of the attitude.

b) The study from life, which is the one distinguishing many of the drawings proposed in this book and which is technically a bit more elaborate (although it still retains the appearance of a rather rapidly produced and synthetic drawing, without superfluous details). It takes slightly longer to draw (about ten minutes), has larger dimensions and, above all, is made with the agreement of the people depicted. Unless you take snapshots which, you could say are 'stolen', it is actually a matter of producing a sort of 'portrait' and, therefore, the model is well aware of what we are doing. It is obviously appropriate to ask the model's permission to be drawn, but it is also necessary (unlike the portrait in the common sense) to maintain the spontaneity of the attitude that attracted our attention.

In these circumstances it can be useful to take some photos as well, so that we have some reference documents in case, later on, we happen to want to complete or add to the study from life in a more elaborate painting. Whatever the circumstances, it is appropriate to explain things clearly to our chance models and obtain their permission, assuring them that our drawing is for academic and not commercial use only.

Photographs, moreover, are almost irreplaceable when portraying very small or lively little children and for catching moving attitudes and interesting but complex scenes.

EQUIPMENT AND TOOLS OF THE TRADE

Even if you wish at some point to produce a slightly more elaborate study of the simple sketch it is advisable to have with you suitable tools and equipment for a job that can nevertheless be done quickly: pencils of various gradations, felt pens, coloured pencils, charcoal, some watercolours, etc. (see page 130); a medium-sized sketchbook about 40 x 50cm (16 x 20in); a small bag with some emergency equipment (a paper cutter, some rags or paper serviettes, a kneaded rubber, a container for water, etc.); and a camera, to obtain the reference material or documents that cannot be 'captured' any other way – an instant camera (Polaroid) is very good, but so is a digital one because it usually allows one to check, on a small scale at least, the effect of the composition and the effectiveness of the viewpoint.

For nearly all the drawings produced for this book I used graphite leads of various gradations, and some brown watercolour tempera brush strokes; it is a simple technique that I find suitable for nimbly adding some rapid tonal notes.

LEARNING TO OBSERVE AND SIMPLIFY

It is important in this type of drawing to learn to simplify, that is, reduce to the most essential and meaningful the many elements that describe the human figure, particularly if clothed. Consequently, it is advisable to focus our attention on the attitude and overall shapes, on the position assumed (which must appear fairly spontaneous, casual, as if taken by surprise, in an instant, and not 'studied'). It would mean avoiding as far as possible giving the impression that it is a conventional, posed 'portrait', unless this is what you really want (see, for example the drawings on pages 147, 150, 151 and 156).

It would also be good to make the figure stand out from the surrounding elements, closely examine the figure's clothes, their style, the creases they form, consider how to arrange the various segments of the body in the space, how they fit together in the composition and the lightest and darkest tones, the play of the most intense areas of light and shade, etc.

FIGURE AND BACKGROUND

Nonetheless, making the figure stand out should not overlook the fact that there is still a background surrounding it. 'Isolating' the figure is allowed and often to good effect, but in many cases it is appropriate to consider, for example, that next to a person there can be other people and that therefore our interest can be drawn not by a single figure, but by the way in which the group is arranged. Or, it would be useful for us to add, next to the figure, some elements of the background or some objects relating to the action taking place (see page 178). This integration is useful for the purpose of further clarifying the representation and making the figure less isolated or uprooted from the scene of 'life' that is happening and that attracted our attention, arousing our artistic sensitivity and our desire to draw it.

Illustration for a 1992 "Confidences" story, acrylic colours on masonite, 35 x 50cm (13¾ x 19¾in)

PROPORTIONS AND ANATOMY

Knowledge (brief, but not approximate) of human anatomy is useful to artists because it enables them to depict the body, both nude and clothed, correctly and effectively, with regard to the aesthetic and stylistic purposes they are hoping to achieve. The observation of the live model can be completed by studying the most superficial anatomical structure of the human body, which is important for describing the outer shapes and is represented by the muscle mass supported by the skeleton with its joints and skin covering.

The proportions can be understood as the harmonic relationships between the various parts of the human body; from these relationships it is possible to deduce a set of rules, a standard, that can help the artist portray human beings, based on natural details or adapting these details to the requirements of an aesthetic ideal.

In this sketch I have summarised the main morphological differences between the male body and the female body, considered at adult age. This mainly concerns the skeletal structure, the muscle mass, the location of the subcutaneous fat tissue, the body hair, etc. Comparing the two skeletal structures we see, for example, the usually shorter stature of the woman compared with the man and the wider female pelvis. Other differences are well known and noticeable in a woman compared with a man: the development of breasts, the larger buttocks, the greater inclination of the axis of the arm and that of the thigh, etc.

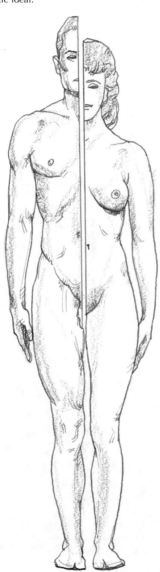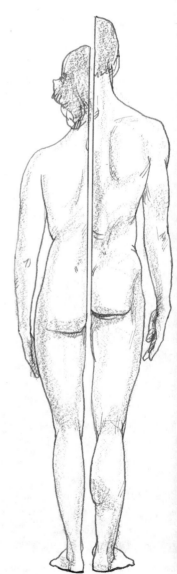

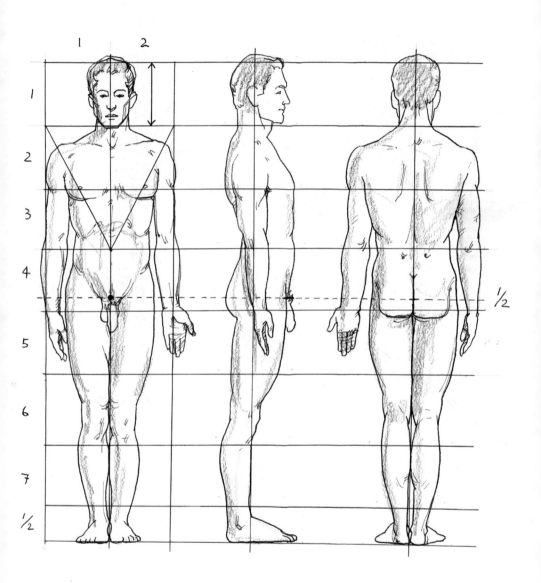

useful criterion for the naturalistic portrayal of the human figure is the 'scientific' one,
illustrated here with reference to the male body. The unit of measurement chosen is the
height of the head: the height of the body corresponds to about seven and a half times the
unit of measurement; the maximum width, at the shoulders, is equal to two units of
measurement, etc. The halfway point of the body height is situated roughly level with man's
pubic symphysis, a bit above for a woman. The grid superimposed on the frontal projection
of the figure shows clearly enough the relationship between the proportional levels and the
relative references on the body.

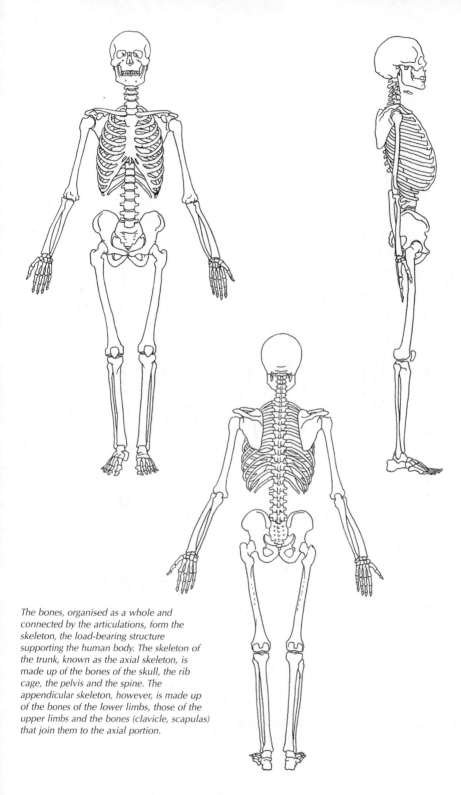

The bones, organised as a whole and connected by the articulations, form the skeleton, the load-bearing structure supporting the human body. The skeleton of the trunk, known as the axial skeleton, is made up of the bones of the skull, the rib cage, the pelvis and the spine. The appendicular skeleton, however, is made up of the bones of the lower limbs, those of the upper limbs and the bones (clavicle, scapulas) that join them to the axial portion.

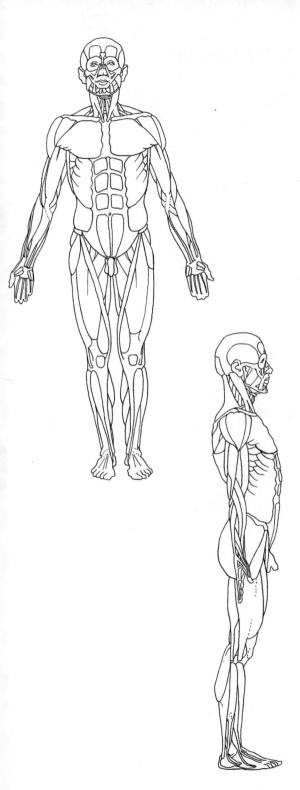
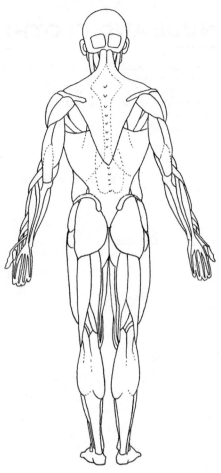

The skeletal muscles contribute to a large extent to defining the outer shapes of the body and, given that they shorten and grow bigger when contracted, they also vary depending on the action carried out and the intensity with which it is performed. The muscles of greater immediate interest to the artist are situated in the superficial layer, below the skin. With the help of an anatomical atlas it will be easy for you to identify and learn some of the characteristics of the many muscles depicted in the brief sketch I have reproduced here.*

NUDE AND CLOTHED: DRAPERY

Studying drapery enables us to analyse and portray in the most effective way the creases that form in different types of material and to observe how they are arranged on the human body. It is easy to see that clothes adapt to the body, still allowing us to sense the anatomy of the body as the drapery covers the points of tension (usually, the articular regions) and creases in the areas of flexion.

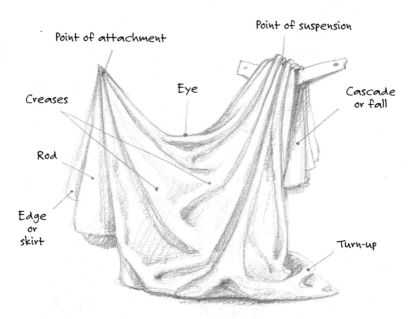

In the schematic drawing shown above I have shown the position that a piece of cloth, hanging from two points, can assume. Depending on the density of the fabric and its textural characteristics, these creases may be more or less evident, simplified or plentiful.

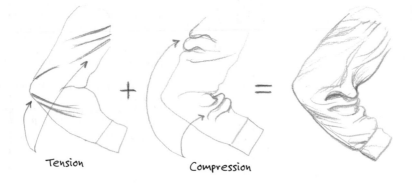

A shirt sleeve provides a clear example of how the creases that form when bending the arm are the result of combining tension lines (which usually radiate from the side when extending an articular joint) with the fabric's curling or thickening created in the areas towards which the limb is flexing.

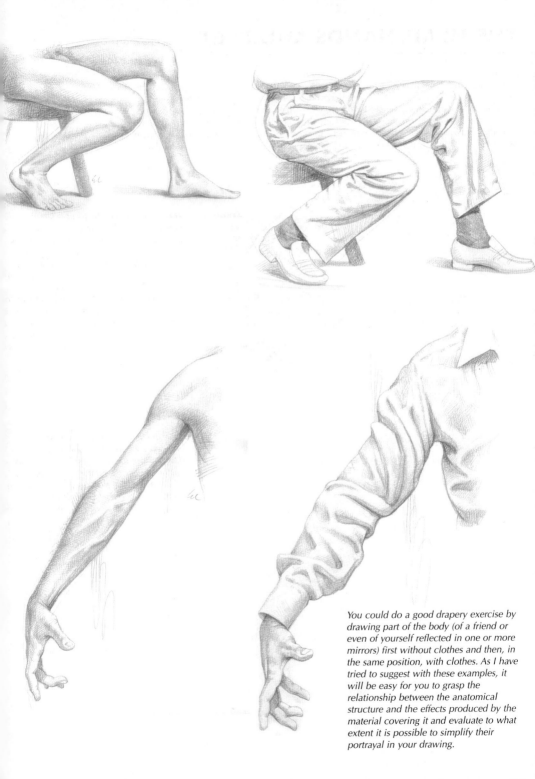

You could do a good drapery exercise by drawing part of the body (of a friend or even of yourself reflected in one or more mirrors) first without clothes and then, in the same position, with clothes. As I have tried to suggest with these examples, it will be easy for you to grasp the relationship between the anatomical structure and the effects produced by the material covering it and evaluate to what extent it is possible to simplify their portrayal in your drawing.

THE HEAD, HANDS AND FEET

Sketches of figures from life often include a sort of portrait even when, due to pressures of time or by choice, the actual likeness is not sought. Nevertheless, one must correctly portray parts of the body that, usually, our clothing leaves uncovered: above all, the head and the hands. However, these parts can sometimes be covered by garments or accessories, such as hats or gloves. Shoes, moreover, are almost always worn. It is therefore important, in these cases and similarly in the one I suggested for the drapery, to examine properly the relationship between the anatomical structure and the clothes covering it, perhaps in the way shown by the drawings on page 141.

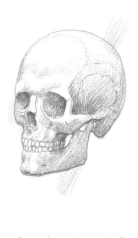
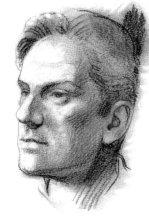

The outer shape of the head is largely determined by the form of the skull, especially in areas where the 'soft' tissues covering it are of very reduced thickness. For example: the forehead, the bridge of the nose, the cheekbones, the chin and the jaw line. We can feel the different consistencies just by touching these parts of our face with our fingers and comparing them with the parts just around them.

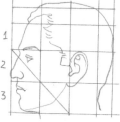
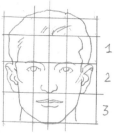

The human head has very precise proportions, and it is the slightest deviations in the relationship between its parts that cause the differences in each individual's facial features. From the sketch reproduced here is easy to deduce, for example, that the height of the face can be divided into three horizontal bands of equal size and that the distance between the pupils is a bit wider than the width of the lips, and so on.

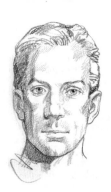
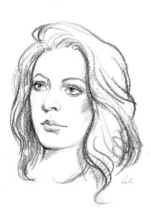

The shape of the male head and that of the female head are slightly different. For example: the male head has slightly larger dimensions; the structure of the male face is heftier and more angular than the female one, which is rounder, more oval.

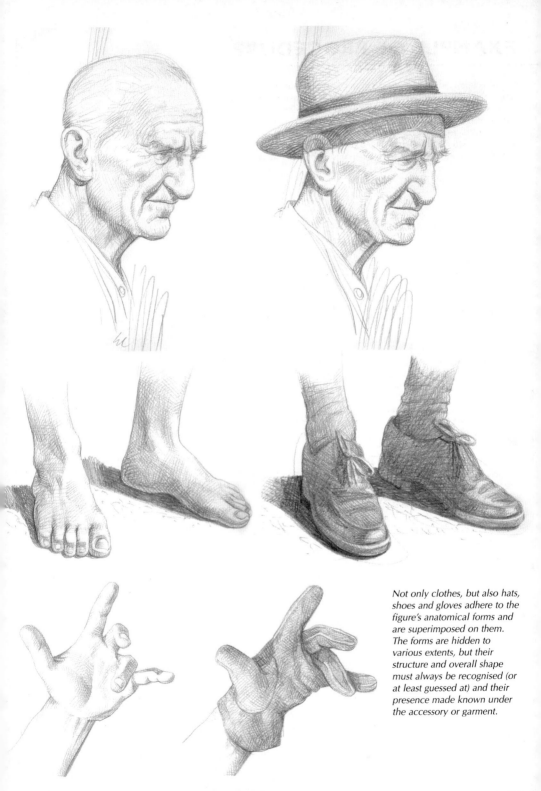

Not only clothes, but also hats, shoes and gloves adhere to the figure's anatomical forms and are superimposed on them. The forms are hidden to various extents, but their structure and overall shape must always be recognised (or at least guessed at) and their presence made known under the accessory or garment.

EXAMPLE OF PROCEDURE

In this section I thought it appropriate to show the sequence of the most important stages of a simple procedure (there are others, of course), for drawing a model. It may be a bit academic, but it is useful for sharpening our observation skills with a natural model, and for training the hand to draw rapid and effective sketches of figures from life. The stages have been picked out and reconstructed, for demonstration purposes, but it is obvious that they progressively come together, one to the other, until they achieve the desired effect or the study whereby we consider our drawing finished, which, in this example, is shown on page 147.

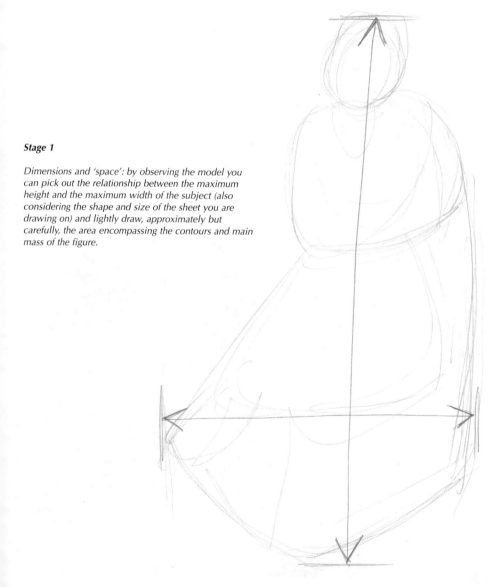

Stage 1

Dimensions and 'space': by observing the model you can pick out the relationship between the maximum height and the maximum width of the subject (also considering the shape and size of the sheet you are drawing on) and lightly draw, approximately but carefully, the area encompassing the contours and main mass of the figure.

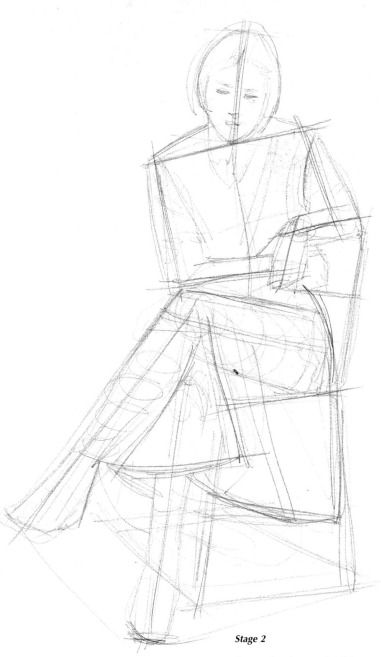

Stage 2

Structural and proportional lines: continue to define further the most relevant shapes of the figure by drawing, for example, the main axes of the limbs, the angles by which the various body segments are connected, and the inclination of the axis between the shoulders. At this stage it is preferable to draw, very lightly, the 'decisive', schematic lines that show the geometric structure, in order to capture the overall attitude of the figure and suggest the anatomical shape below the clothes, as if the clothes were transparent.

Stage 3

Outlining: make the schematic lines begun in the previous stage smoother, more natural and spontaneous, and further define the essential contours of the various parts that make up the figure: the head, the arms, the shod feet, the clothing, the chair, etc. For example, mark the main creases in the skirt and blouse and also suggest the approximate outline of the areas where the shadow appears more intense.

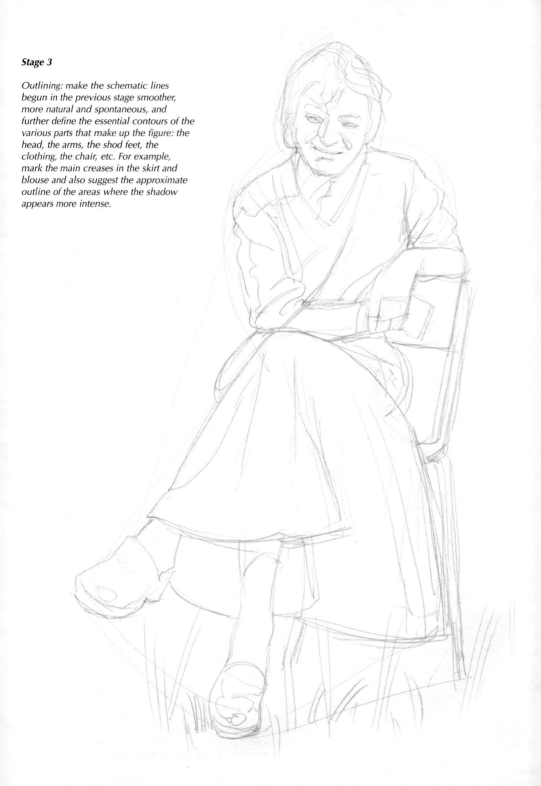

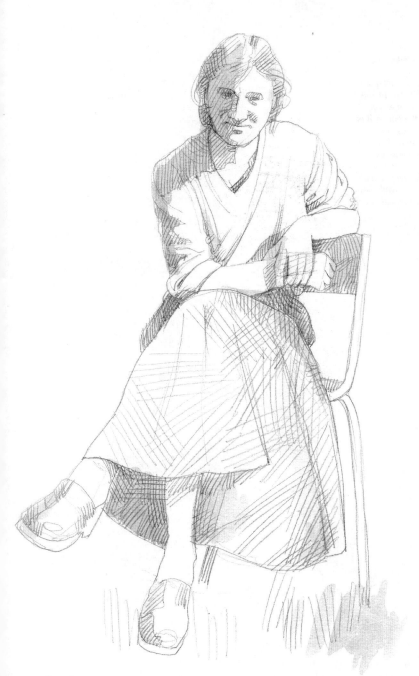

Stage 4

Marking the main shadows: draw the outlines of the various parts more carefully and suggest the 'volumetric' characteristics of the drawing, adding the more extensive and darker areas of shadow and, for now, only some intermediate tones. In this case, apart from a quick, loose, pencil sketch, I have added some brush strokes of very diluted brown tempera.

Stage 5

*Drawing shadows and modelling the
figure: gradually the drawing is
approaching the final version (although
maintaining the nature of a sketch): the
more delicate pencil sketch of varying
density tends to improve the portrayal of
the body volumes, the creases in the
clothes, the intermediate tonal shifts, the
grass in the meadow. Using washes (see
page 131) seems useful and effective,
especially when I draw this type of figure
sketch, necessarily quick and synthetic,
almost a visual and compositional 'memo'.*

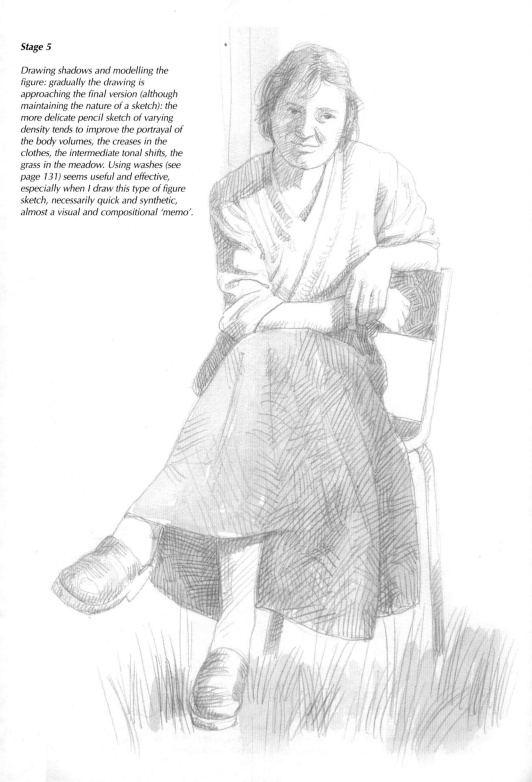

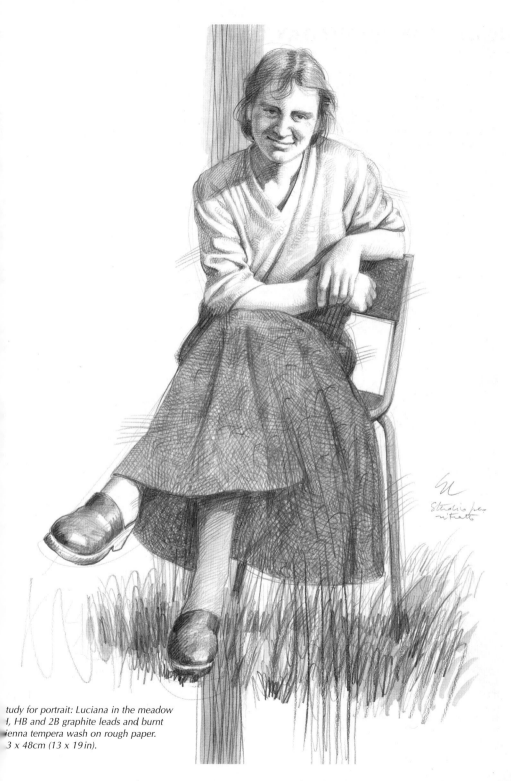

Study for portrait: Luciana in the meadow
H, HB and 2B graphite leads and burnt
Sienna tempera wash on rough paper.
33 x 48cm (13 x 19in).

FIGURES IN EVERYDAY LIFE

In the town or country, wherever you live or happen to be staying, it won't be difficult for you to find people willing to pose for your drawings, if you have the wisdom not to abuse their availability. For example, you can portray relatives or friends while they are carrying out their domestic, work-related or recreational activities, or you can stop at places frequented by tourists, whose spontaneous and relaxed positions are sometimes maintained long enough to allow you to make a sufficiently elaborate study (see pages 149, 154, 159).

If you happen to portray children, you will find that the situation is often complicated by their restlessness: sometimes, with some cunning (for example, pretending they are taking part in a game), you can manage to keep them quiet for a while.

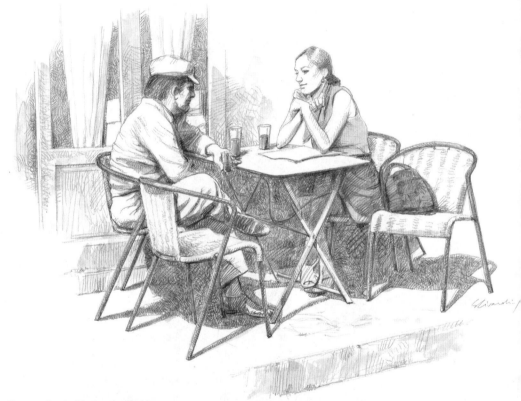

Conversation in Montmartre (Paris)
H, HB graphite leads and sepia tempera on rough paper, 33 x 48cm (13 x 19in).

If people are engaged in conversation, sitting at tables outside a café in a tourist spot, they will usually stay there for quite a long time, so it is possible to portray them with some ease, if rapidly. In this case, the drawing has been made in two stages: in the first I sketched the figures; in the second (with more calm and certainty about them staying put) I drew the complex structure of the chairs and tables, objects always on view outside the café. The direct light of the sun produces intense, well-defined shadows, which suggest spatial depth; with the contrasts and balances of the tonal masses, they make the profiles of the figures stand out.

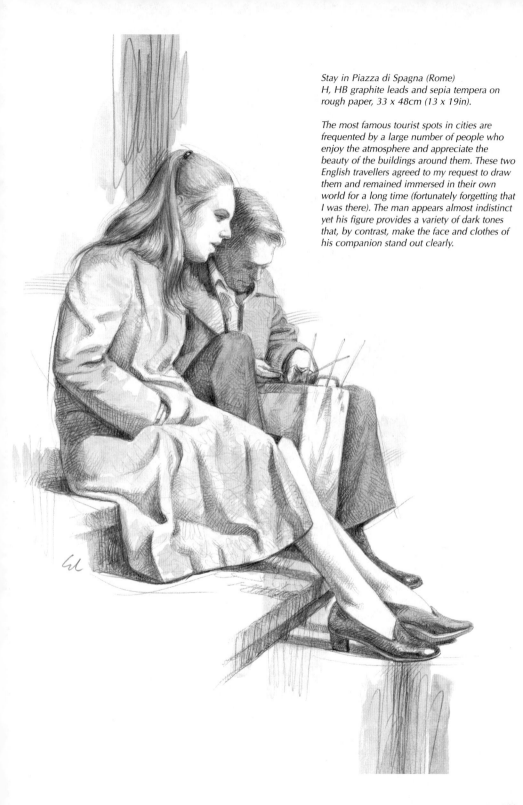

Stay in Piazza di Spagna (Rome)
H, HB graphite leads and sepia tempera on
rough paper, 33 x 48cm (13 x 19in).

The most famous tourist spots in cities are
frequented by a large number of people who
enjoy the atmosphere and appreciate the
beauty of the buildings around them. These two
English travellers agreed to my request to draw
them and remained immersed in their own
world for a long time (fortunately forgetting that
I was there). The man appears almost indistinct
yet his figure provides a variety of dark tones
that, by contrast, make the face and clothes of
his companion stand out clearly.

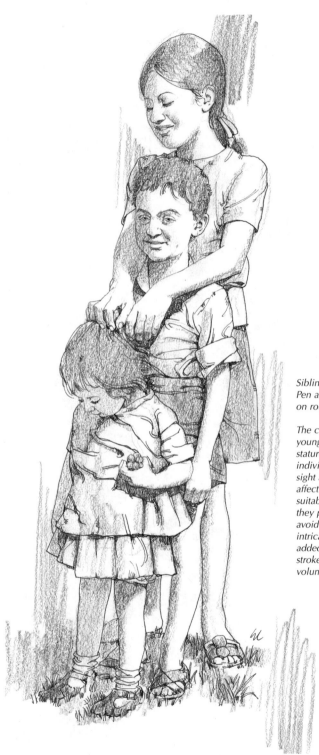

Siblings: scale
Pen and black China ink, 6B graphite lead
on rough paper, 33 x 48cm (13 x 19in).

The curious arrangement of these three
young children, descending in age and
stature, although well distinguished
individually, makes them appear at first
sight almost fused together in a delicate,
affectionate attitude. Pen and ink are
suitable in these circumstances because
they produce well-defined fine lines and
avoid the risk of confusion in very
intricate details. With some soft graphite
added the few dark tonal background
strokes necessary to give at least a hint of
volumetric consistency to the forms.

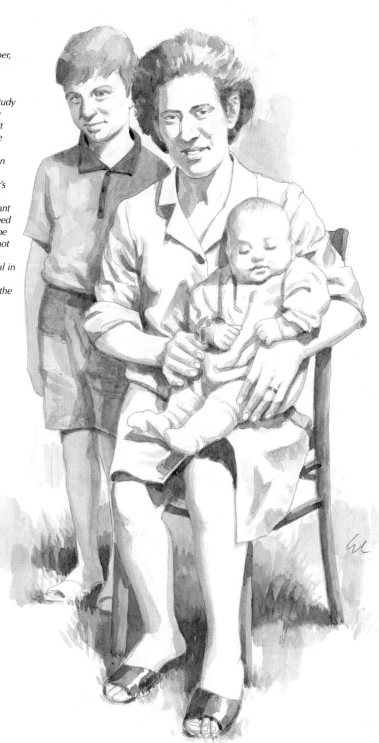

Little family
Black watercolour on rough paper,
33 x 48cm (13 x 19in).

This drawing has all the
characteristics of a preparatory study
for a portrait (which was actually
produced, using oil on canvas). It
enabled me to assess and resolve
some problems with perspective
more easily than if I had relied on
observation, for example, the
apparent shortness of the mother's
legs or the chair's lack of depth.
These would have been unpleasant
if retained in the final work. Indeed
drawing from a model can also be
used precisely for this purpose: not
everything that seems to appear
volumetrically correct and natural in
real life then maintains its
effectiveness once transferred to the
flat surface of the sheet.

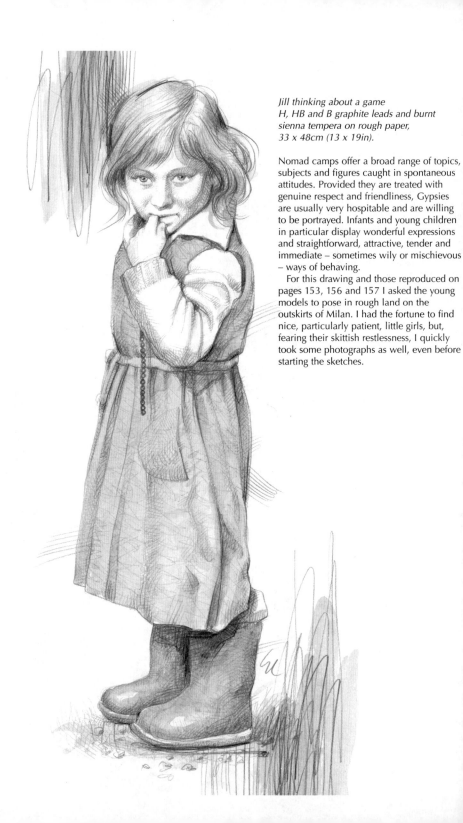

Jill thinking about a game
H, HB and B graphite leads and burnt
sienna tempera on rough paper,
33 x 48cm (13 x 19in).

Nomad camps offer a broad range of topics, subjects and figures caught in spontaneous attitudes. Provided they are treated with genuine respect and friendliness, Gypsies are usually very hospitable and are willing to be portrayed. Infants and young children in particular display wonderful expressions and straightforward, attractive, tender and immediate – sometimes wily or mischievous – ways of behaving.

For this drawing and those reproduced on pages 153, 156 and 157 I asked the young models to pose in rough land on the outskirts of Milan. I had the fortune to find nice, particularly patient, little girls, but, fearing their skittish restlessness, I quickly took some photographs as well, even before starting the sketches.

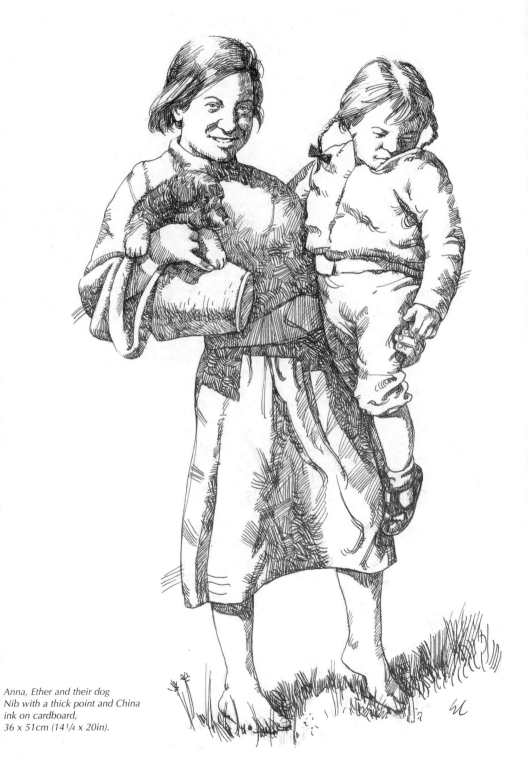

Anna, Ether and their dog
Nib with a thick point and China
ink on cardboard,
36 x 51cm (14 1/4 x 20in).

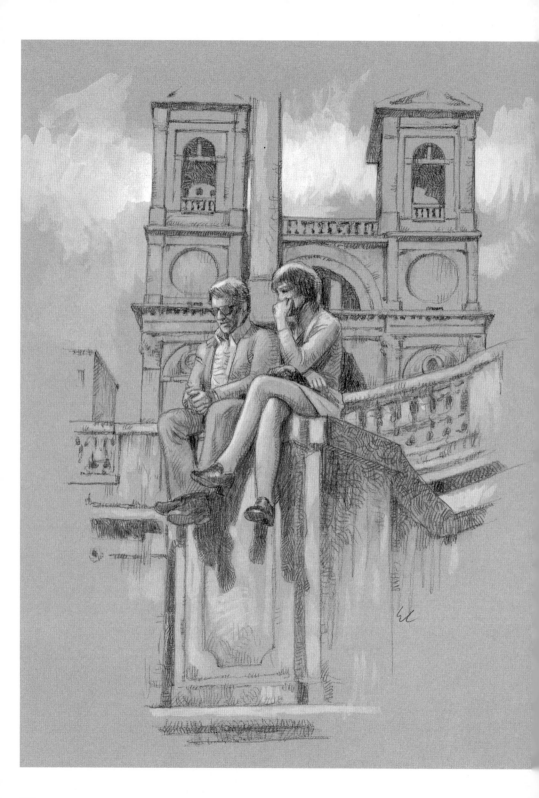

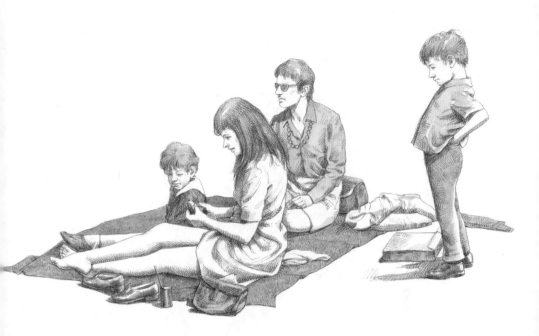

Picnic in Central Park (New York)
HB and B graphite leads and burnt sienna tempera on rough paper,
33 x 48cm (13 x 19in).

This small group of people was drawn only partly directly from life, on the shore
of a small lake in the park. The boy on the right, although part of the company,
was moving too quickly and often, so much so that it made it impossible to
sketch his boisterous gestures on the paper. So I photographed him in some
strange poses and, later, I completed the drawing inspired by an attitude that
seemed to fit in with the composition.

Page 28

Trinità dei Monti (Rome)
B graphite lead, white and burnt sienna tempera on sand-coloured paper,
32 x 45cm (12¹/₂ x 17³/₄in).

When the background represents a predominant part of the drawing and is
very complicated it is advisable to draw it very briefly and instead devote all
the available time to the figures. At a later stage it will almost always be
possible to complete the background details by returning to the place or
referring to photographs.

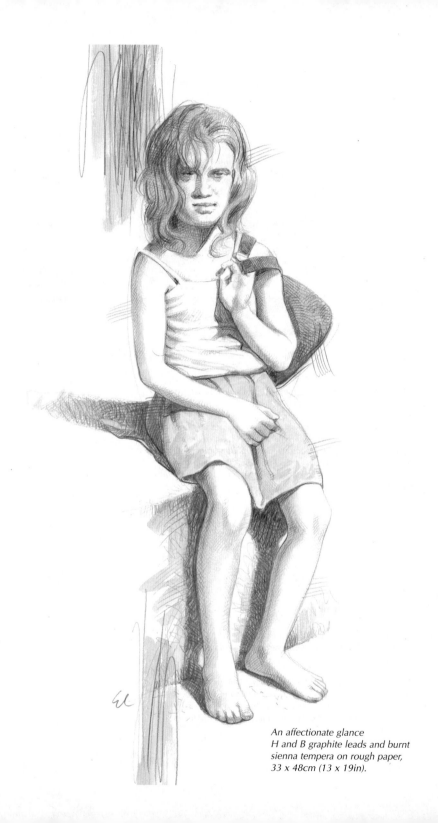

An affectionate glance
H and B graphite leads and burnt
sienna tempera on rough paper,
33 x 48cm (13 x 19in).

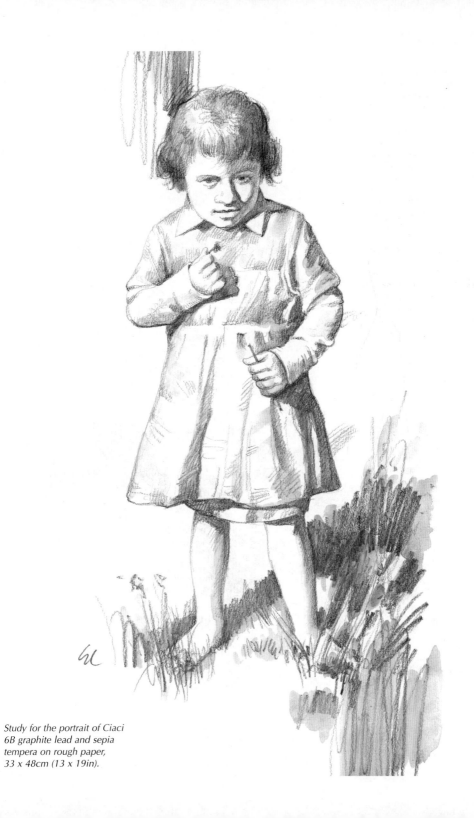

Study for the portrait of Ciaci
6B graphite lead and sepia
tempera on rough paper,
33 x 48cm (13 x 19in).

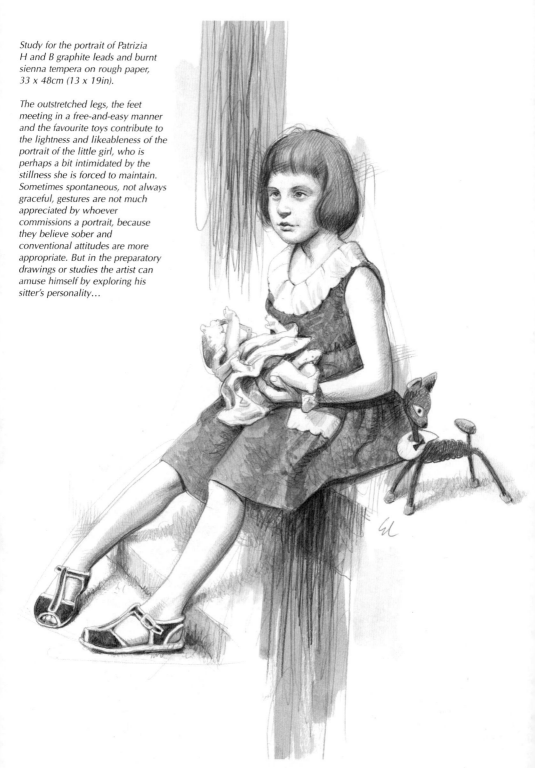

*Study for the portrait of Patrizia
H and B graphite leads and burnt
sienna tempera on rough paper,
33 x 48cm (13 x 19in).*

*The outstretched legs, the feet
meeting in a free-and-easy manner
and the favourite toys contribute to
the lightness and likeableness of the
portrait of the little girl, who is
perhaps a bit intimidated by the
stillness she is forced to maintain.
Sometimes spontaneous, not always
graceful, gestures are not much
appreciated by whoever
commissions a portrait, because
they believe sober and
conventional attitudes are more
appropriate. But in the preparatory
drawings or studies the artist can
amuse himself by exploring his
sitter's personality…*

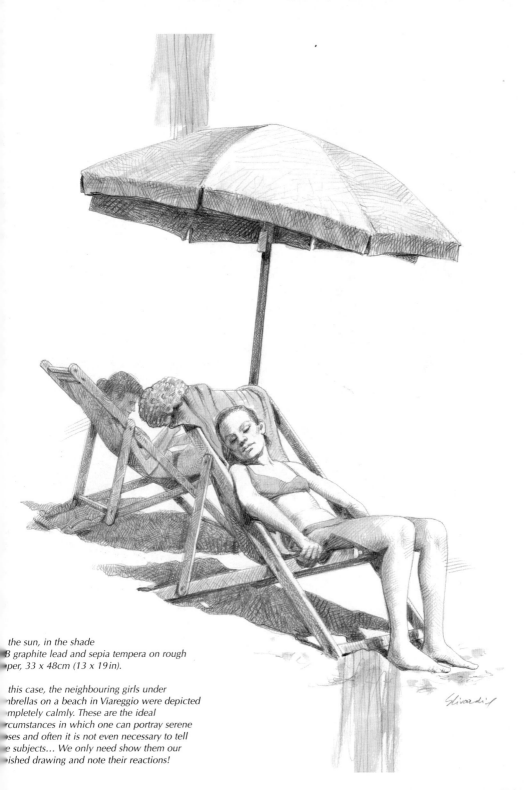

the sun, in the shade
B graphite lead and sepia tempera on rough
per, 33 x 48cm (13 x 19 in).

this case, the neighbouring girls under
nbrellas on a beach in Viareggio were depicted
mpletely calmly. These are the ideal
rcumstances in which one can portray serene
ses and often it is not even necessary to tell
e subjects... We only need show them our
ished drawing and note their reactions!

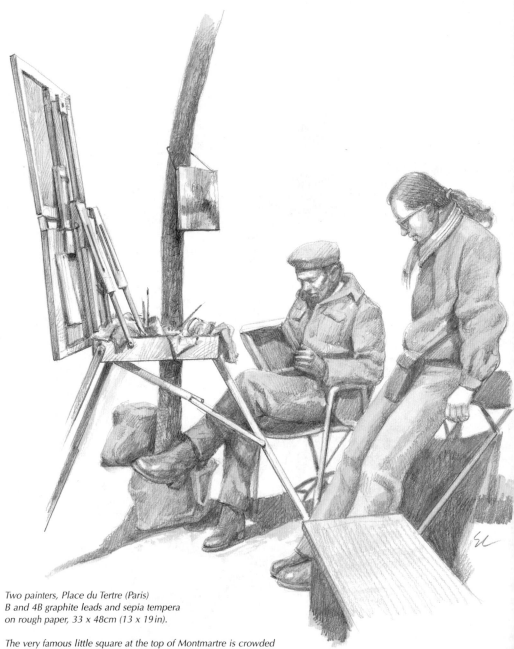

Two painters, Place du Tertre (Paris)
B and 4B graphite leads and sepia tempera
on rough paper, 33 x 48cm (13 x 19 in).

The very famous little square at the top of Montmartre is crowded
throughout most of the year with slightly eccentric-looking painters as
well as tourists who wander about between trees, easels and chairs at
open-air restaurants. It is a strange experience, then, to portray other artists
who make their living from drawing portraits. Usually they are very willing (perhaps they're
not afraid of the competition) and, more often than not, their comments can be instructive.

In this drawing I preferred to isolate some subjects of interest from the background, concen-
trating on the dovetailed shapes and elements that stand out, that are connected and superim-
posed on each other and thus draw the viewer's gaze to the central figure.

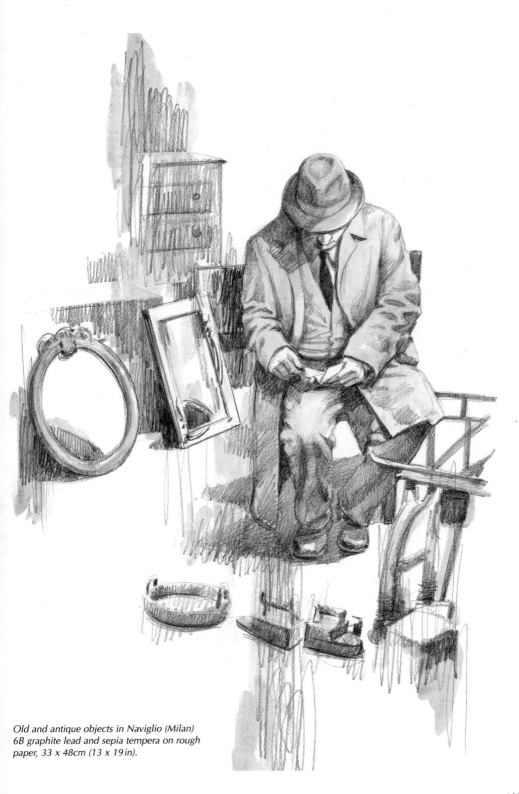

*Old and antique objects in Naviglio (Milan)
6B graphite lead and sepia tempera on rough
paper, 33 x 48cm (13 x 19in).*

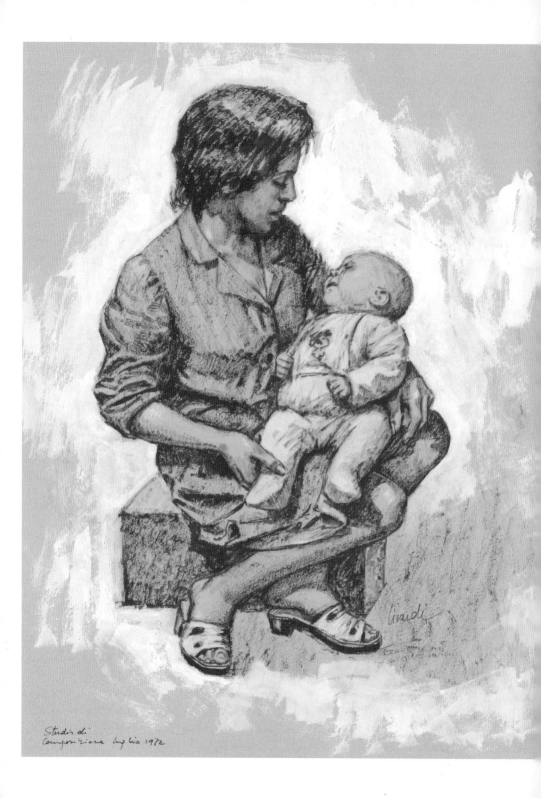

Studio di
Composizione luglio 1972

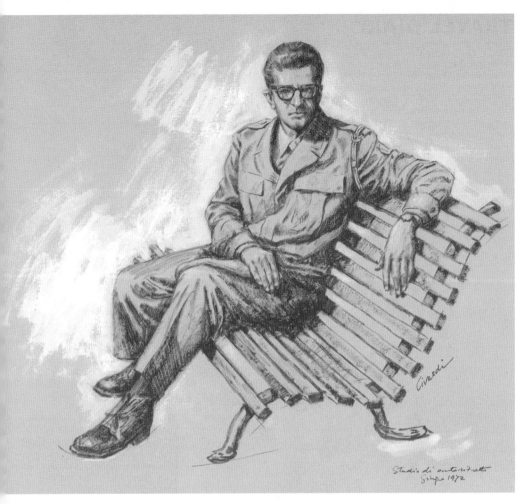

Study for self-portrait
Dry-brush, ink and white tempera on grey card, 32.5 x 36cm (12³/4 x 14¹/2in)
(from a photograph).

Page 36

Composition study
Dry-brush, ink and white tempera on grey card, 32 x 43cm (12¹/2 x 17in).

The drawings reproduced on these two pages were made many years ago. In both I used the dry-brush technique to apply the broken, fringed, black China ink strokes. The technique is easy: dip a medium-sized soft-hair brush in the ink; dry it a bit on some cloth and then lightly apply the various strokes on a fairly rough sheet of paper. The effect is obtained quickly and is particularly effective for figure drawings where the parts in the shade form a definite contrast with those that are illuminated.

TRAVEL DIARY

When travelling, many artists are accustomed to taking with them (as well as their cameras) a sketch book for jotting down their visual experiences in the places they are visiting: foreshortenings of landscapes or architecture, people's attitudes, notes about colour or composition, etc. Anything that attracts our attention is portrayed with quick sketches and kept for possible future elaboration. On these pages I have reproduced some drawings that I did during a trip to Northern India; although they were produced in a short space of time, some of them, thanks to the patience of the 'models' (rewarded with a few rupees) or favourable circumstances, were comparatively thoroughly made. However, many others (and they are the majority of those I did) are mere graphic notes, drawn in a few moments (page 169) and therefore can be included in the category of sketches referred to on page 133.

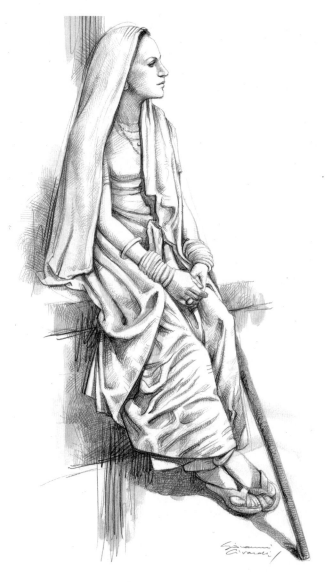

Lady at the market, in Jaisalmer
2B graphite lead and burnt sienna
tempera on rough paper,
33 x 48cm (13 x 19in).

This drawing and those reproduced up to page 169 were made over several days in some markets in the Indian city of Jaisalmer and in fairly uncomfortable conditions – surrounded (not to say crushed) by a small, curious, loud crowd. But the discomfort was amply compensated for by the extreme willingness of the people who agreed – and were happy – to be portrayed (and certainly welcomed some rupees…).

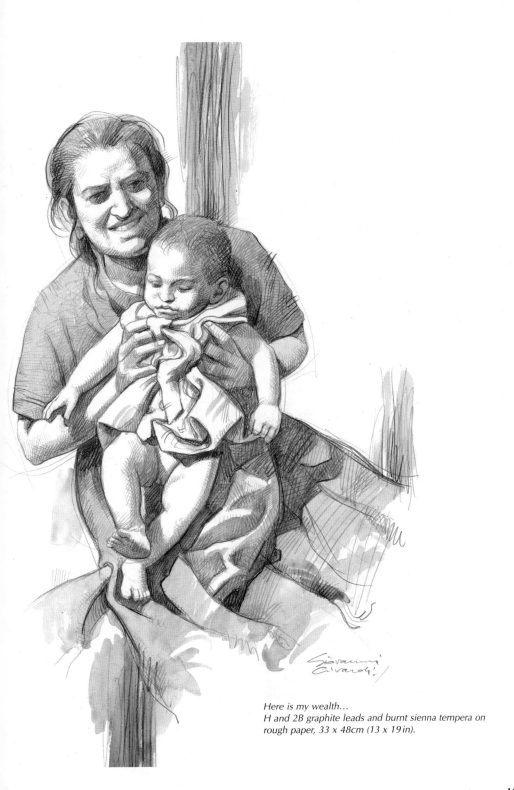

Here is my wealth…
H and 2B graphite leads and burnt sienna tempera on
rough paper, 33 x 48cm (13 x 19 in).

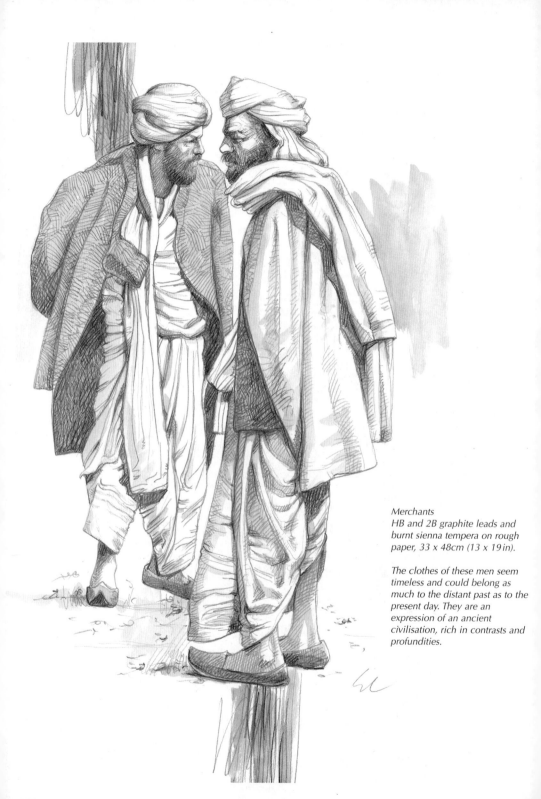

Merchants
HB and 2B graphite leads and
burnt sienna tempera on rough
paper, 33 x 48cm (13 x 19in).

The clothes of these men seem
timeless and could belong as
much to the distant past as to the
present day. They are an
expression of an ancient
civilisation, rich in contrasts and
profundities.

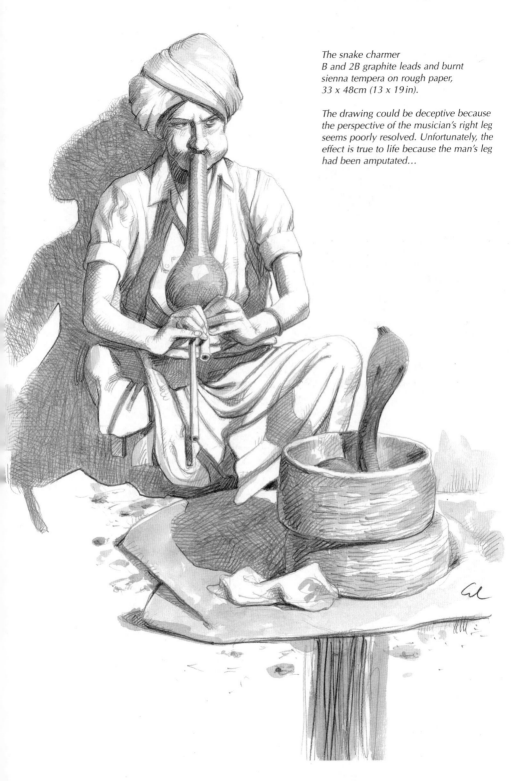

The snake charmer
B and 2B graphite leads and burnt
sienna tempera on rough paper,
33 x 48cm (13 x 19 in).

The drawing could be deceptive because
the perspective of the musician's right leg
seems poorly resolved. Unfortunately, the
effect is true to life because the man's leg
had been amputated...

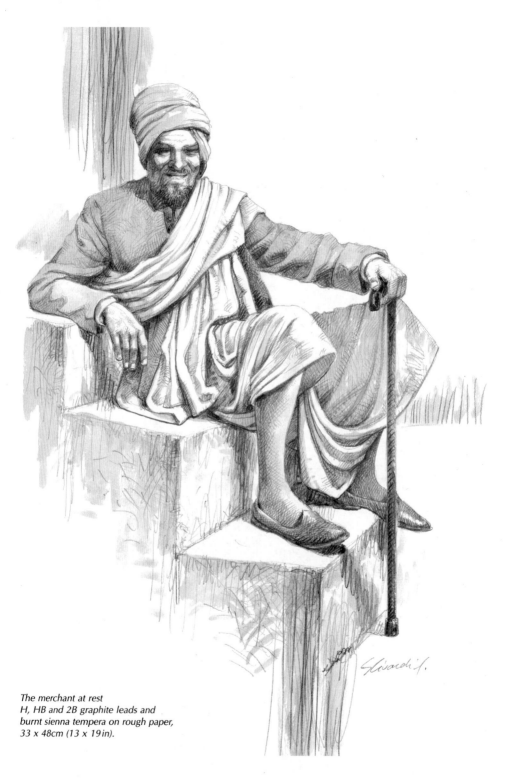

The merchant at rest
H, HB and 2B graphite leads and
burnt sienna tempera on rough paper,
33 x 48cm (13 x 19in).

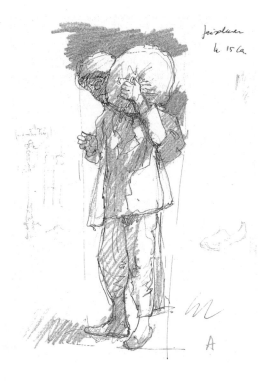

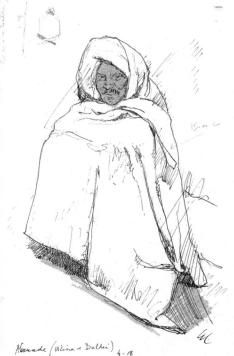

Pages from the travel diary
Pen and black China ink, 2B graphite lead each
drawing 20 x 30cm (7¾ x 11¾in).

Unlike the drawings shown on the previous pages
(and in nearly the whole book), these are typical
examples of sketches done very quickly – simple
visual notes (similar, in some respects, to
'snapshots') which capture only the tension of the
movement or the overall appearance of the gesture
and attitude (see page 133).

OLD-FASHIONED COSTUMES

The clothes in fashion in the past, let's say until the beginning of the 20th century, offer many interesting opportunities for any artist who loves to portray the figures wearing them. For example, there is a wide variety of styles, colours, accessories and decorative elements, and a broad range of creases in the ample, abundant fabrics. These stand out through the intense contrasting and intersecting of parts in light and shade. I did some of these drawings inspired by photographs taken during the medieval and Renaissance costume parades held in Asti each year, during the Palio. In fact, except for the drawings shown on pages 173, 175 and 177 (for which the paraders posed for some time on the day of the trials before the Palio), the sketches depict attitudes that are too fleeting or complex to be able to capture them fully. In these cases, it is very useful to combine a rapid sketch from life with some supporting, reference photographs.

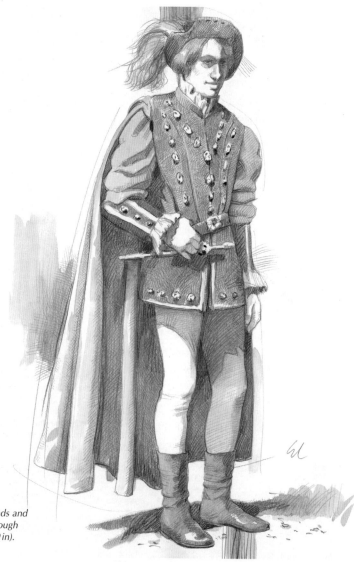

Parader in old-fashioned costume
H, HB and 2B graphite leads and burnt sienna tempera on rough paper, 33 x 48cm (13 x 19in).

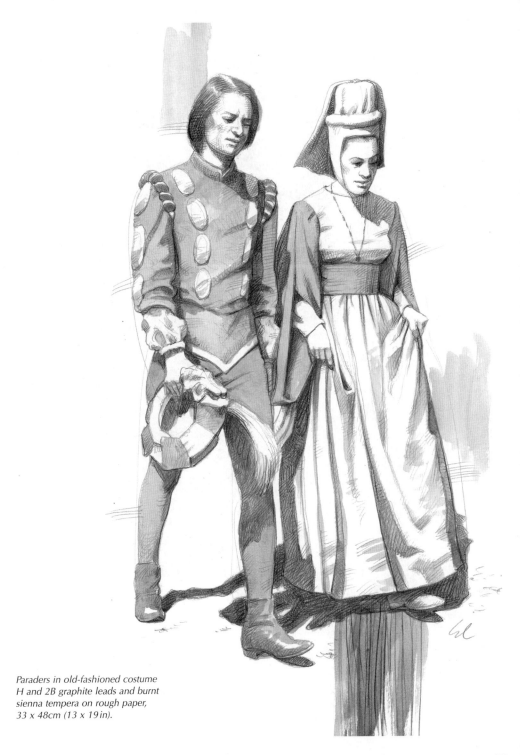

*Paraders in old-fashioned costume
H and 2B graphite leads and burnt
sienna tempera on rough paper,
33 x 48cm (13 x 19in).*

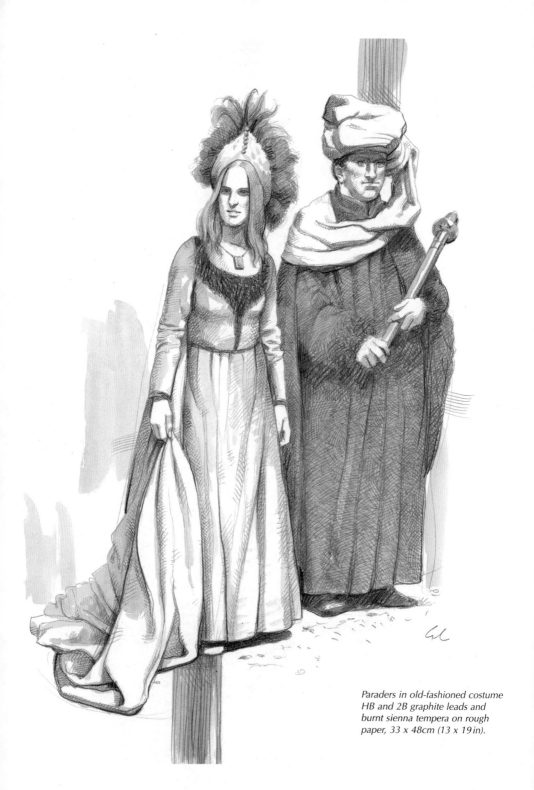

Paraders in old-fashioned costume HB and 2B graphite leads and burnt sienna tempera on rough paper, 33 x 48cm (13 x 19in).

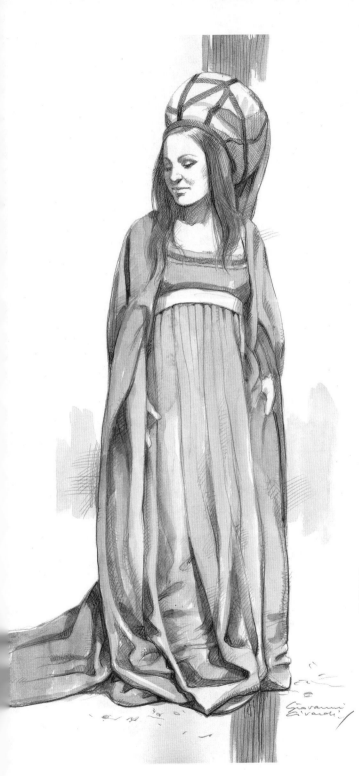

*Parader in old-fashioned costume
HB and 2B graphite leads and
burnt sienna tempera on rough
paper, 33 x 48cm (13 x 19 in).*

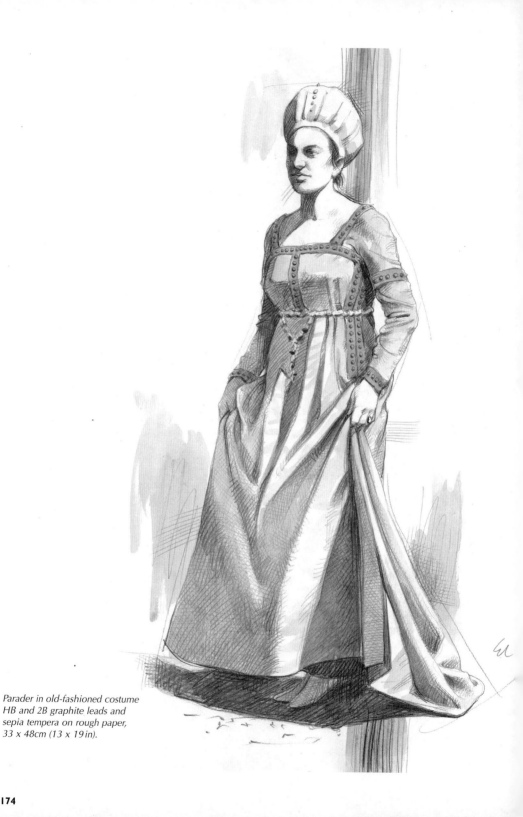

Parader in old-fashioned costume
HB and 2B graphite leads and
sepia tempera on rough paper,
33 x 48cm (13 x 19in).

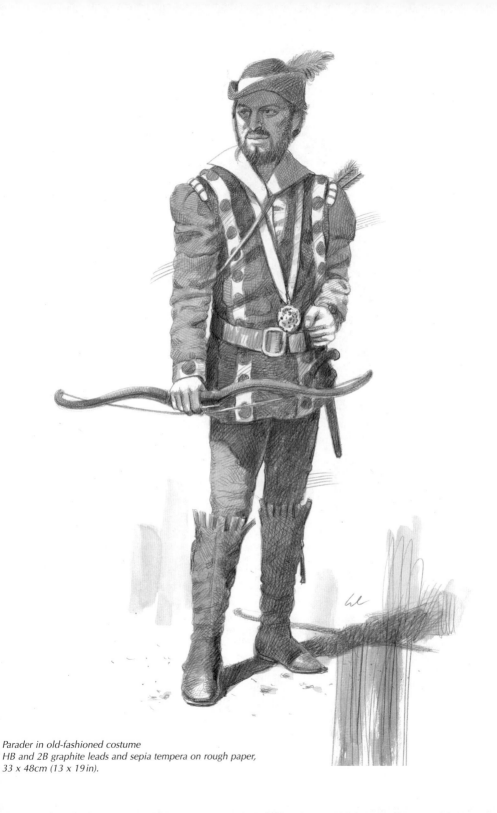

Parader in old-fashioned costume
HB and 2B graphite leads and sepia tempera on rough paper,
33 x 48cm (13 x 19 in).

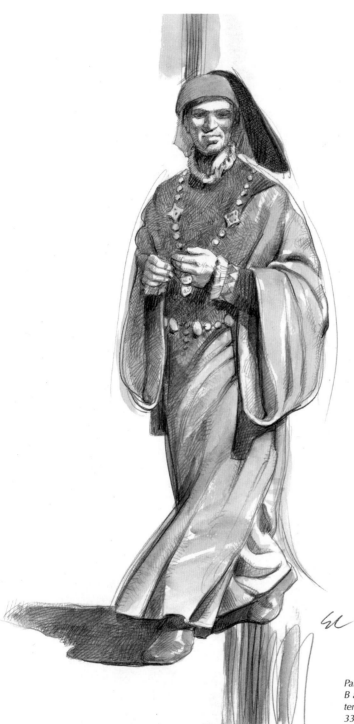

Parader in old-fashioned costume B and 2B graphite leads and sepia tempera on rough paper, 33 x 48cm (13 x 19in).

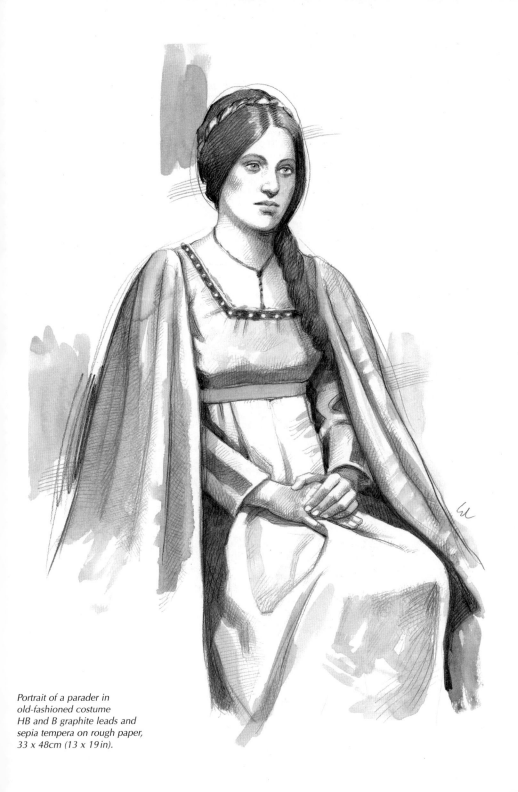

*Portrait of a parader in
old-fashioned costume
HB and B graphite leads and
sepia tempera on rough paper,
33 x 48cm (13 x 19 in).*

GROUPS OF FIGURES

Parks, public gardens, squares in art cities, markets or shopping centres, playing fields, restaurants… These are the sort of places whose people meet or arrive in groups, and provide useful opportunities for artists. They should use this opportunity to practise portraying people doing something together or simply when they are near each other in a relaxed and casual way. They are composition exercises which means that by taking advantage of the spontaneous and casual appearance of a group it is possible (just by doing a simple sketch) to select the most meaningful aspects of the surroundings and characters. In fact, if after some time you examine your drawings not from a purely aesthetic point of view (it is obvious that they are rough, incomplete sketches), but with regard to how the figures have been arranged on the sheet, you will discover some very curious and educational things about the intuitive way in which you managed to arrange the 'background portrait'.

Gypsy family
2B and 6B graphite leads and sepia tempera on rough paper, 33 x 48cm (13 x 19in).

This group of sisters was captured in a serene, relaxed attitude so I was able to draw them with some degree of calm. The figures are not arranged symmetrically, but the casual, spontaneous composition has a certain dynamic balance, rich in tensions and contrasts (the verticality of the arms, the inclination of the heads, etc.). The creases in the clothes suggest and complete the foreshortening effects and help give the individual figures a volumetric appearance.

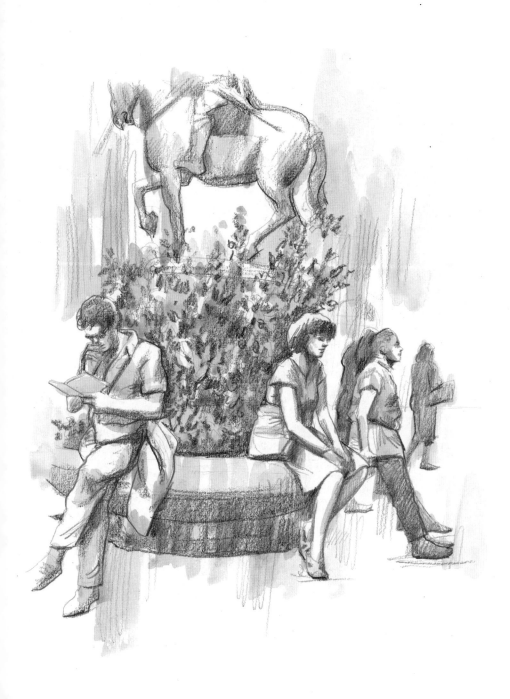

Tourists in Piazza della Signoria (Florence)
6B graphite lead and sepia tempera on rough paper, 33 x 48cm (13 x 19 in).

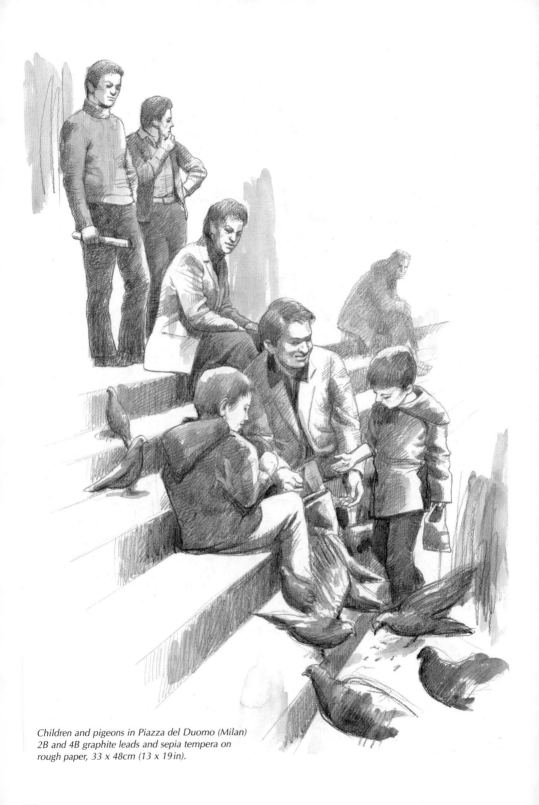

*Children and pigeons in Piazza del Duomo (Milan)
2B and 4B graphite leads and sepia tempera on
rough paper, 33 x 48cm (13 x 19in).*

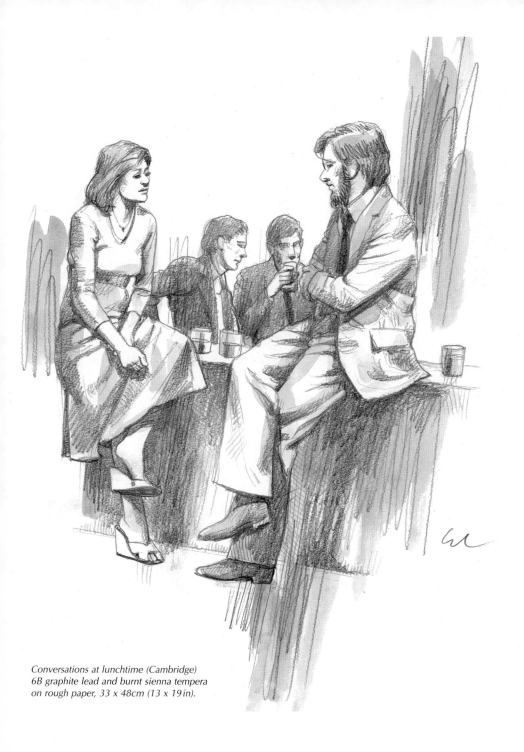

Conversations at lunchtime (Cambridge)
6B graphite lead and burnt sienna tempera
on rough paper, 33 x 48cm (13 x 19in).

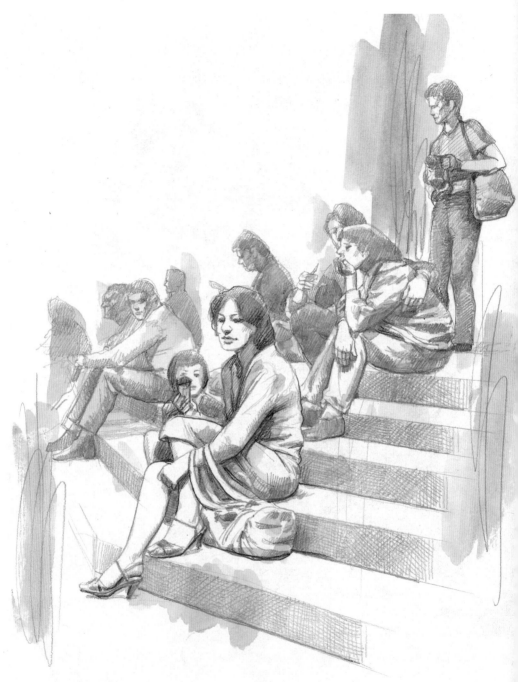

In front of Palazzo Vecchio (Florence)
H and 2B graphite leads and sepia tempera on rough
paper, 33 x 48cm (13 x 19 in).

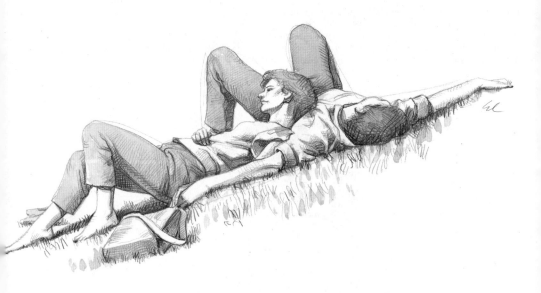

First sun
2B and 4B graphite leads and sepia tempera on rough paper, 24 x 33 cm (9 1/2 x 13in).

The diagonal arrangement of these two figures who are resting quietly and in an attitude of delicate affection in a meadow in Villa Borghese, Rome, immediately interested me. Maybe because during the many years I worked as an illustrator of romantic novels, I became more sensitive to this type of situation.
 The clothing is represented in a very synthetic way: we only need introduce a few creases at the crucial, important points (knees, shoulders, etc.) to suggest the state of the materials and the underlying anatomical structure.

CHOICE OF VIEWPOINT AND ATTITUDE

It is not true to say that a figure whose attitude attracted your attention must be reproduced exactly from the visual angle from which you discerned it. If it is a position that the subject promises to hold for long enough (and even before you inform them of your artistic intentions), try to walk round the model or, at least, move a few steps away, so as to see them from a different viewpoint, for example, their profile as well as from the front. Or wait until the model shifts a bit, poses slightly differently, perhaps in a more interesting and meaningful way. There is also the risk that the model will go way, but don't worry too much: you will have lost the chance of a drawing from life, and yet the attention paid to the situation and your visual memory will leave just as useful an impression in your experience. The spontaneity of the gesture, if associated with a good compositional effect, can produce a drawing or sketch perhaps worthy of being transferred to a more complex and demanding work.

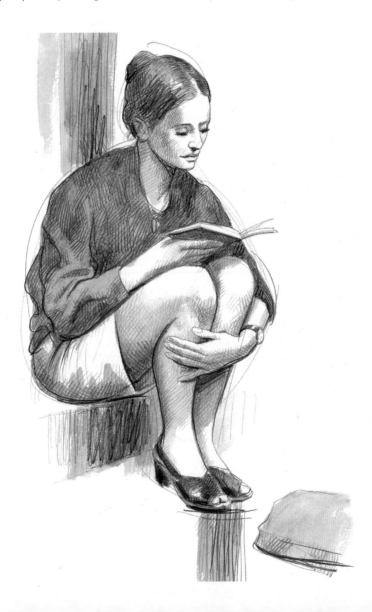

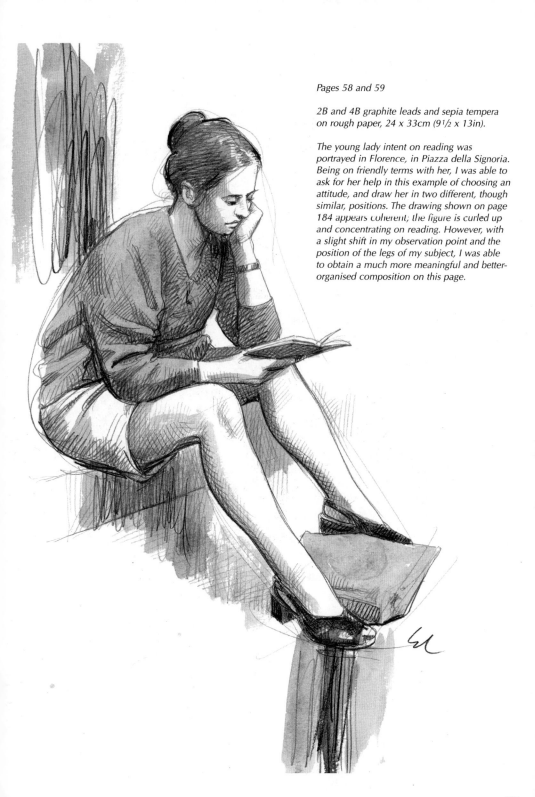

Pages 58 and 59

2B and 4B graphite leads and sepia tempera
on rough paper, 24 x 33cm (9 1/2 x 13in).

The young lady intent on reading was
portrayed in Florence, in Piazza della Signoria.
Being on friendly terms with her, I was able to
ask for her help in this example of choosing an
attitude, and draw her in two different, though
similar, positions. The drawing shown on page
184 appears coherent; the figure is curled up
and concentrating on reading. However, with
a slight shift in my observation point and the
position of the legs of my subject, I was able
to obtain a much more meaningful and better-
organised composition on this page.

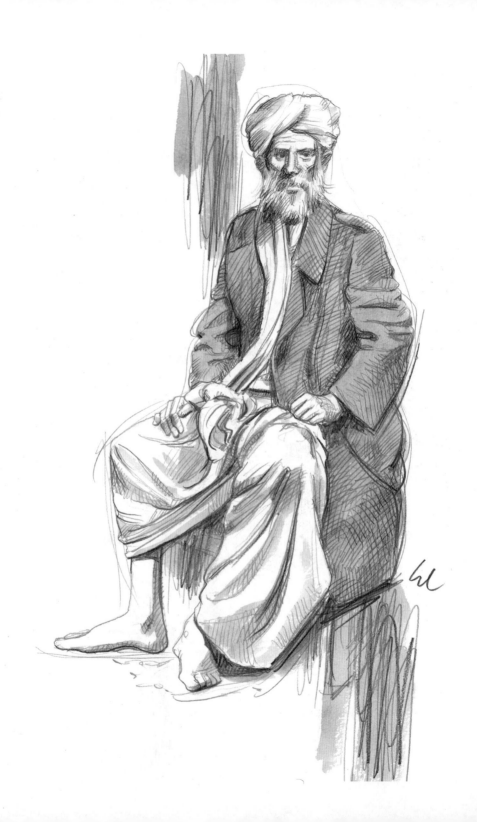

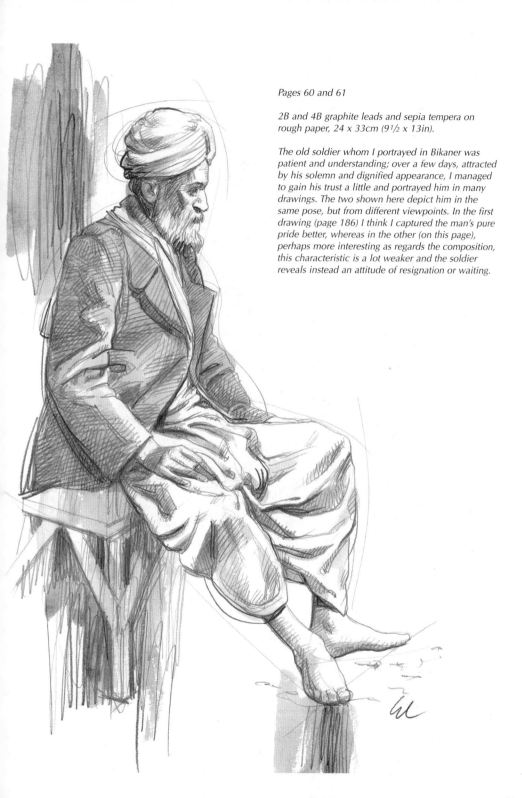

Pages 60 and 61

2B and 4B graphite leads and sepia tempera on rough paper, 24 x 33cm (9½ x 13in).

The old soldier whom I portrayed in Bikaner was patient and understanding; over a few days, attracted by his solemn and dignified appearance, I managed to gain his trust a little and portrayed him in many drawings. The two shown here depict him in the same pose, but from different viewpoints. In the first drawing (page 186) I think I captured the man's pure pride better, whereas in the other (on this page), perhaps more interesting as regards the composition, this characteristic is a lot weaker and the soldier reveals instead an attitude of resignation or waiting.

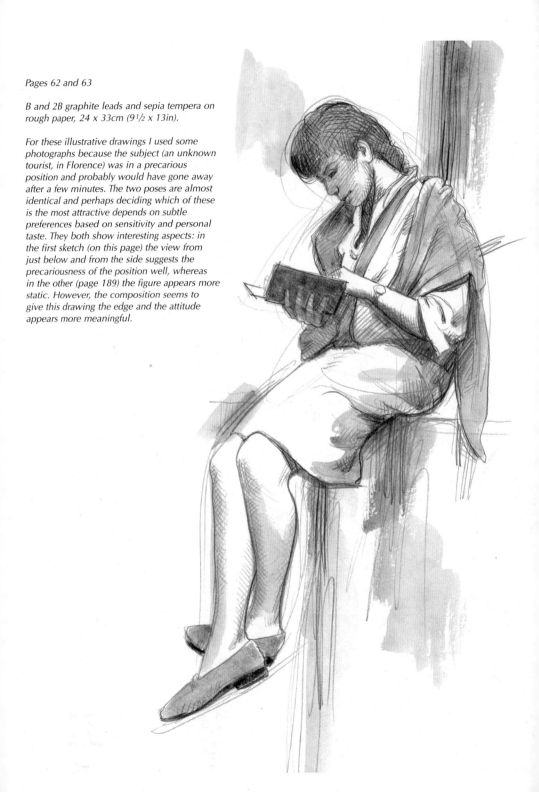

Pages 62 and 63

B and 2B graphite leads and sepia tempera on rough paper, 24 x 33cm (9¹/₂ x 13in).

For these illustrative drawings I used some photographs because the subject (an unknown tourist, in Florence) was in a precarious position and probably would have gone away after a few minutes. The two poses are almost identical and perhaps deciding which of these is the most attractive depends on subtle preferences based on sensitivity and personal taste. They both show interesting aspects: in the first sketch (on this page) the view from just below and from the side suggests the precariousness of the position well, whereas in the other (page 189) the figure appears more static. However, the composition seems to give this drawing the edge and the attitude appears more meaningful.

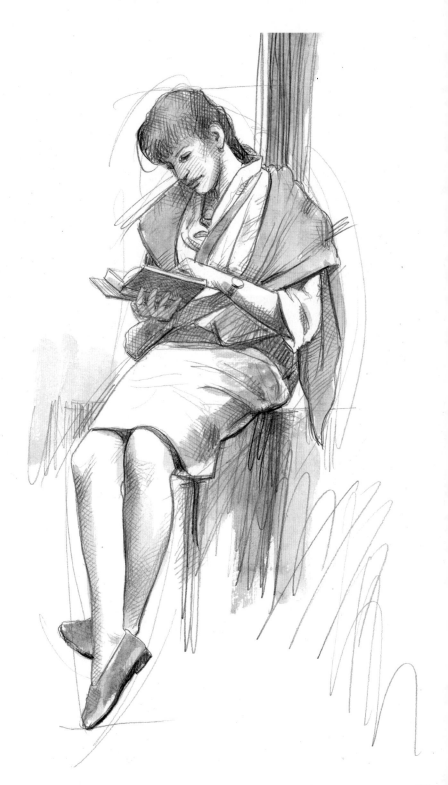

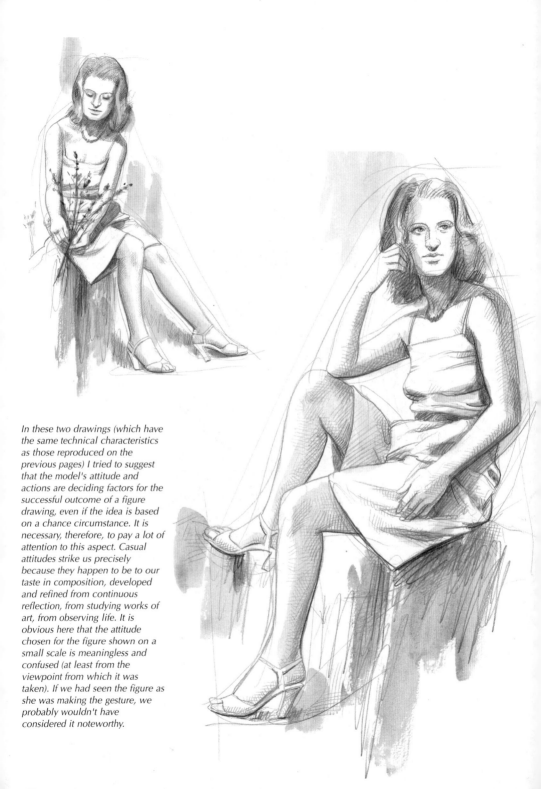

In these two drawings (which have the same technical characteristics as those reproduced on the previous pages) I tried to suggest that the model's attitude and actions are deciding factors for the successful outcome of a figure drawing, even if the idea is based on a chance circumstance. It is necessary, therefore, to pay a lot of attention to this aspect. Casual attitudes strike us precisely because they happen to be to our taste in composition, developed and refined from continuous reflection, from studying works of art, from observing life. It is obvious here that the attitude chosen for the figure shown on a small scale is meaningless and confused (at least from the viewpoint from which it was taken). If we had seen the figure as she was making the gesture, we probably wouldn't have considered it noteworthy.

DRAWING HANDS & FEET

The overall appearance of human hands differs slightly from individual to individual, for example they may be short, long, conic, spatula-shaped, strong or weak, and the shape of fingers and fingernails also varies. The hand is also modelled and identifiable by functions that it frequently carries out; for example, a hand that usually moves about energetically is larger than one that works less, even on the same person. The study of hands benefits to a large extent from these minute observations but, more scientifically, a doctor also studies the 'pathological' hand. During the course of evolution, the development of the opposable thumb is one of the more characteristic aspects of the human species because hands, free from locomotive tasks (humans having become bipedal and erect), adapted with complete success to gripping and handling.

It is no wonder, therefore, that the hand has always been considered one of the elements of the human body that is richest in meaning, and it even has symbolic meaning. If you skim through any book recounting the history of art, you will find some images of prehistoric rock painting in which handprints are frequently recognisable; the mysterious Gargas ones, for example, have great evocative power.

How can we understand the meaning of the gesture in life and art? Hands that indicate, touch, clutch, bless, recite, pray, work, offer and therefore suggest the most varied and subtle human feelings. Each era (and perhaps each great artist) has depicted hands with their own formal characteristics: just think of the differences between a 'Gothic' hand, a 'Renaissance' hand and a 'Cubist' hand, or even between a 'real' hand by Rodin, Caravaggio, Rembrandt or Schiele.

It is easy to understand why it is generally thought that hands and feet are the hardest parts of the human body to portray effectively in drawings, paintings and sculptures. And this is because of their complexity and the wide variety of attitudes they can assume. They are undoubtedly complex. And yet, if we practise observing hands and feel carefully and intelligently (and, why not? with love) and if we learn about the fundamental structure governing their shape and movement, I don't think we can say that the problems are insurmountable.

In this chapter, like the others in this book, I have tried to distribute in the various sections some basic elements useful for showing you how to begin the route to observing hands and feet, and to suggest some topics for consideration or practice that could help you draw (first in an objective and realistically plausible way, but then with increasing independence and freedom of personal style) such expressively meaningful components of the human body.

TOOLS AND TECHNIQUES

To draw human figures and parts of them (in our case, hands and feet), whether for making quick sketches or more elaborate studies, and especially if you are working from life, you can use the simplest and most well-known tools: pencils, charcoal, pastels, pen and ink, watercolours, felt pens, etc.

Each of these produces different effects not only because of the specific nature of the material and technique, but also because of the characteristics of the medium on which it is used: smooth or rough paper, card, white or coloured paper, etc. The drawings shown on this page and the next have been produced using some common tools, but all are suitable for depicting, efficiently and effectively, the regions of the human body in which we are now interested.

Pen and ink

Artists frequently use ink. It can be applied either with the brush or the nib, but special effects can be obtained by using, for example, bamboo cane nibs with a thick point, fountain pens, 'technical' (Rapidograph) pens, felt pens and ballpoint pens. Tonal intensities are usually graduated by criss-crossing the nib strokes more or less densely. Therefore, it is advisable to work on paper or care that is rather smooth and of good quality, to prevent the surface from fraying and the ink from being irregularly absorbed. Any ink stains or unwanted marks can be corrected or removed by delicately scraping them with the blade of a scalpel or a razor blade.

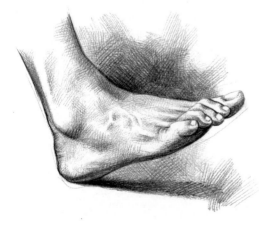

Pencils

Pencils are the most commonly used tool for any type of drawing because they can be used expressively and creatively, and are convenient implements. They can be used for very elaborate drawings or for short studies and brief reference sketches; for the latter, micro leads are suitable (diameter 0.5 to 0.7mm), whereas for the former you can choose graphite leads with a larger diameter and softer gradation. Graphite leads which can be used by inserting them in push-button holders, like pencils (graphite leads inserted in the wood casing), are graduated according to consistency: from 9H, very hard, which draws fine, faint lines, to 6B, very soft, which easily draws thick, dark lines.

Charcoal

Charcoal is perhaps the ideal means for studies of figures from life because it is very easy to control when shading and can also help achieve very clear details. It must, however, be used quickly, concentrating on the overall conveyance of the tonal and volumetric masses. In this way it can express its best qualities as a versatile and suggestive tool. You can use compressed charcoal or wood charcoal, paying attention in both cases not to dirty the sheet. The charcoal strokes merge and blend together when rubbed lightly, for example, with a finger and the shades can be toned down by applying a soft rubber to the surface. The finished drawing must be protected by spraying it with a fixative.

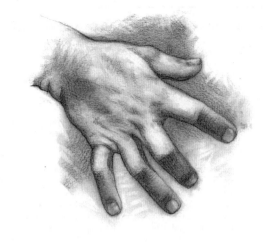

Watercolours

Watercolours, water-soluble inks and China ink diluted with water are very suitable for studying the human figure, although they are closer to painting than drawing, given that they are applied with a brush and require synthetic and expressive tonal vision. For quick studies from life you can use water-soluble coloured pencils or graphite leads, whose strokes are easily merged by going over them with a soft brush dipped in water. In this case, it is preferable to use thick card or cardboard so that the moisture does not make the surface wavy and irregular.

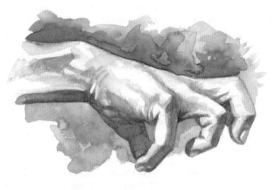

Mixed techniques

Techniques are 'mixed' when different tools are used to produce a drawing and look for complex and unusual effects. They are always graphic means of expression, but their use requires careful control and a good knowledge of the tools, so as to avoid confused outcomes with poor aesthetic meaning. Mixed techniques are very effective if used on mediums that are rough, coloured or at least of dark tonality. There are many technical combinations, for example, acrylics, pen and ink, white tempera, watercolours, charcoal, graphite, and so on.

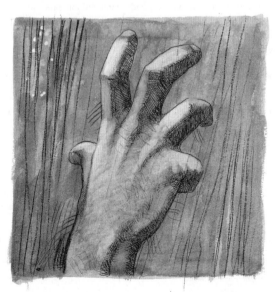

PRACTICAL ADVICE

SOME SUGGESTIONS ON HOW TO OBSERVE AND PROCEED

Try to pick out some basic common morphological characteristics by looking at your hands and feet, the parts we move for drawing, painting, modelling or running and walking. Parts of the body that we think we already know well.

Artists who seek perfection in everything are those who don't achieve it in anything

EUGÈNE DELACROIX

Then compare the hands of people you meet, those of your friends and acquaintances, but also those that you happen to see in crowded places (on public transport; in restaurants, swimming pools, gyms or dance schools; at places where artists and craftsmen work, such as theatres) in an infinite variety of nuances of shapes and attitudes.

Photographs, cinematic or television images, computer programmes and so on are certainly of great help for isolating and catching the movement and attitude of a hand or foot. However, don't neglect to practise making a lot of sketches directly from life, using a pencil and sketchpad: small, rapid sketches that, whatever the quality and completeness with which they are executed, retain a great evocative and emotional effect over time, and also enhance your creative abilities. Even if you focus your attention on a hand or foot, always consider that an authentic gesture is completed and expressed not only by an anatomical part – although this is very important – but by the attitude of the whole body.

Also become accustomed to assessing the morphological differences that occur, especially in hands, with age or after doing various jobs; in this way, you will gain valuable skills of observation that will be very useful, in some cases essential, to you when drawing a portrait or illustration, or when you have to invent a plausible hand, or even just when you want to understand and then express a human attitude effectively. This applies even more to anyone who intends to draw not in a blindly realistic way, but rather by interpreting the model and using this as a starting point for evoking the emotion experienced and adapting the shapes they see to their personal requirements.

Drawing your own hands and feet is the best way of studying them in depth. You will see that this will result in authentic studies on a par with – and perhaps even more meaningful than – those devoted to the face. However, if you limit yourself to looking at these parts directly, you will soon realise that you will only manage very few movements and a limited range of viewpoints. It is appropriate to use one or more mirrors and depict your hands and feet reflected in them, applying yourself to studying foreshortening, various lighting effects and different projections.

Studying the anatomy must go hand in hand with artistic expression and aesthetic requirements. In short, observe, understand and interpret.

Suggestion: each day, draw at least one hand or foot, from life or from works of art.

BRIEF ANATOMY OF THE HAND*

The hand is the fairly flat, end segment of the upper limb and its outer shape, especially that relating to the dorsal surface, is much influenced by the skeletal structure. The bones of the carpus and metacarpus correspond to the wrist and palm, respectively; the phalanges correspond to the fingers. The hand is joined to the forearm by means of the wrist joint and continues along the longitudinal axis of the limb.

It is useful to remember that, by convention, the anatomical description of a hand refers to the open hand, with the fingers close together and extended downwards, seen in the so-called anatomical position, with the palm facing forward (anterior plane), and the back towards the opposite (posterior) plane. In this position, the surface on the side of the little finger is defined as medial, and that on the side of the thumb as lateral.

The anterior surface of the hand (the palm) is slightly hollow in the middle, and raised along the edges because of the adipose muscle formations. The lateral, oblique, protrusion is

* It seems useful to add some more detailed notes about the structure and shape of the hand, apart from those given, for example, on pages 200–201 and 206–207, because it is the body part (together with the face) by far the most frequently portrayed in figure drawings. For the foot, a rarer artistic subject, the details given on pages 202–203 and 208–209 will suffice.

uated at the base of the thumb, is ovoid in shape, rather voluminous and made up of muscles
own as the thenar eminence, which act specifically on the thumb. The medial protrusion is
nger in shape, close to the lateral one near the wrist, but then more extended along the edge of
e hand next to the little finger. It is made up of the group of muscles from the hypothenar
inence, which act on the little finger. The transverse elevation situated at the boundary
tween the palm and the fingers is caused by the protrusion of the heads of the metacarpals,
vered and supported by three ovoid fat pads. Surrounded by these protrusions, in the middle of
e palm, there is the hollow of the hand, a permanent depression that is accentuated by bending
e fingers; it is determined by the strong adherence of the skin to the palmar aponeurosis, a
ck tendinous layer that completely covers the tendons of the flexor muscles of the fingers. The
n on the palm – clear because it lacks pigments (melanin), not very moveable, and without
ir and superficial veins – is crossed by some characteristic creases that are subject to individual
riability, but are constant and caused by the movements of flexion of the fingers and adduction
the thumb. There are four typical palmar creases, schematically arranged like the letter W; two
e situated transversally and two, situated at the base of the thumb, are roughly longitudinal.
imerous other, variable furrows form occasionally as a result of moving the fingers.
The medial edge of the hand is rounded because of the presence of the hypothenar muscles,
cker in the segment near the wrist, and thinner towards the little finger.
The lateral edge is occupied in the upper portion by the base of the thumb, whereas the lower
rtion consists of the metacarpophalangeal joint and the index finger. Between the two portions
the edge extends a large interdigital cutaneous crease.
The back (dorsal) surface of the hand is rather convex, faithfully modelled on the bone
ucture; this is why it is easy to see the protrusions of the heads of the metacarpals (knuckles),
here the tendons of the extensor muscles of the fingers originate and are arranged in a fan-
ape starting from the wrist. They are very prominent when the fingers are fully extended. It
ould be noted that there are two tendons leading to the index finger, placed side by side:
erally there is that of the common extensor muscle of the fingers, medially that of the index's
vn extensor. The skin on the back easily runs along the underlying planes and is more
oveable than that on the palm, is almost without any fat tissue, is strewn with hairs (especially
 men) and is crossed by an obvious superficial venous reticulum whose course can vary greatly
m person to person, although it follows a common pattern. The veins become much less
ominent or disappear altogether from view when the hand is raised high because the blood
ws out with the force of gravity.
The five fingers have an approximately cylindrical shape and originate from the transverse edge
the hand. While the first finger (the thumb) has only two free segments, missing the middle
alanx, each of the other fingers is formed by three segments, articulated between them and
rresponding to the phalanges. The dorsal surface of the fingers follows the conformation of the
alanges and is therefore rounded and slightly convex. It is interrupted by transverse wrinkles of
taneous abundance around the joints (they appear, in fact, when the fingers are bent) and
splays, on the first proximal phalanx, some thin hairs, especially on men. The back of the distal
alanx is distinguished by the presence of the fingernail. This is a laminar cutaneous addition, of
horn-like consistency and its shape is quadrangular or elliptical, slightly convex transversally. Its
posed part occupies roughly the end half of the phalanx and is surrounded on three sides by a
taneous projection whose peculiarities are easily noticeable in the flesh. The thumbnail is
ways larger than the others, which are in proportion to the volume of each finger in size. With
e exception of the thumb (which has its own characteristics, as it is formed by only two
alanges), the length of the fingers differs because of the dimensions of each finger and,
pecially, the different level of origin, since the heads of the metacarpals describe a notably
rved line with lower convexity. Usually, the third (middle) finger is longer, followed by the
urth (annular), the second (index) and the fifth (little). On the whole, these four fingers appear
nger on the dorsal surface than on the palmar, where the distal transverse prominence reaches
out half way up the proximal phalanx, forming creases of interdigital union. The anterior
rface of the fingers (volar surface) is thus divided into three convex sectors, consisting of fat
ds separated by three transverse flexion creases. The two distal ones of each finger, between
e distal phalanx and the middle one, and between that one and the proximal one, correspond
actly to the relative joints, although the upper one is not level with the joint between the
alanx and the metacarpus, but is formed about half way along the proximal phalanx. The
eases are usually double; they form two thin lines that are almost parallel and close together,
t usually that between the proximal and middle phalanges appears as a single one. The
ominence on the last phalanx, the digital pulp, has a convex, ovoid shape and has skin
rrowed by epidermal crests, whose individually characteristic and indelible design gives rise to
e fingerprints.

THE SIMPLIFIED FORM

The hand seems a very complex and very changeable shape because of its mobility. This also applies to the foot, although its structure, more compact and not expressive, intimidates the artist less. However, both structures can be simplified by reducing them to a few elements that are reminiscent of geometric solids. The hand is configured as the juxtaposition of two main masses: that of the palm (simplified as a wide, not very thick, quadrangular parallelepiped), and that of the fingers (where each of these is represented by superimposing three little parallelepipeds). Added to these two masses are, on one side, that of the thumb and its base.

The foot, however, can be broken down into a series of wedges joined together. At one time painters used to practise studying the shapes of the hands by also drawing, from life, articulated, wooden models, built and moulded precisely for these simulation purposes.

The drawings that are reproduced on pages 196 to 199 should be enough to suggest some of the stages in drawing a hand or foot, in whatever position you wish to depict them: first, a sketch showing very briefly (but faithfully) the position and attitude; second, the 'geometrisation' of the previous sketch, in order to convey the necessary anatomical and volumetric substance; third, the refinement of details and the particular outer shapes.

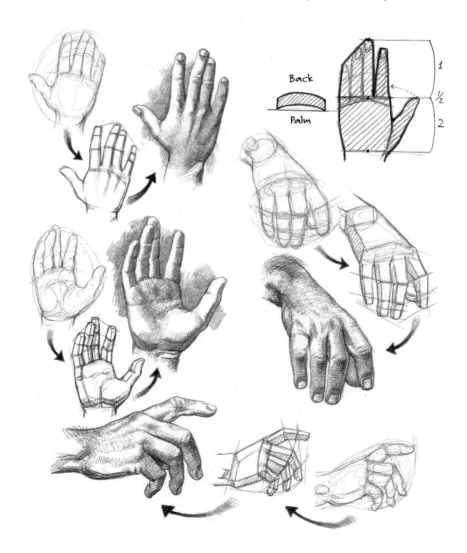

Back

Palm

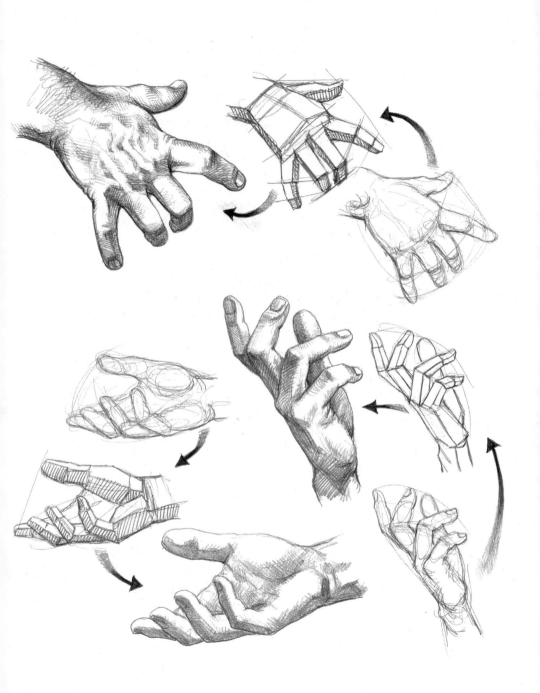

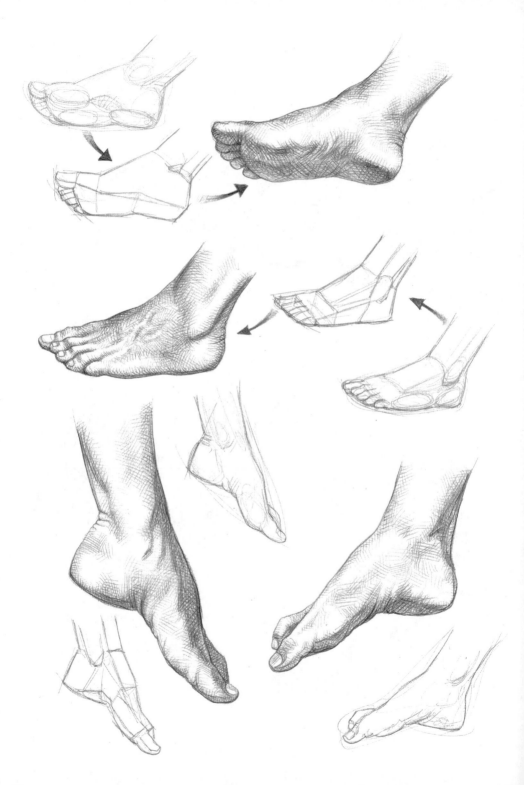

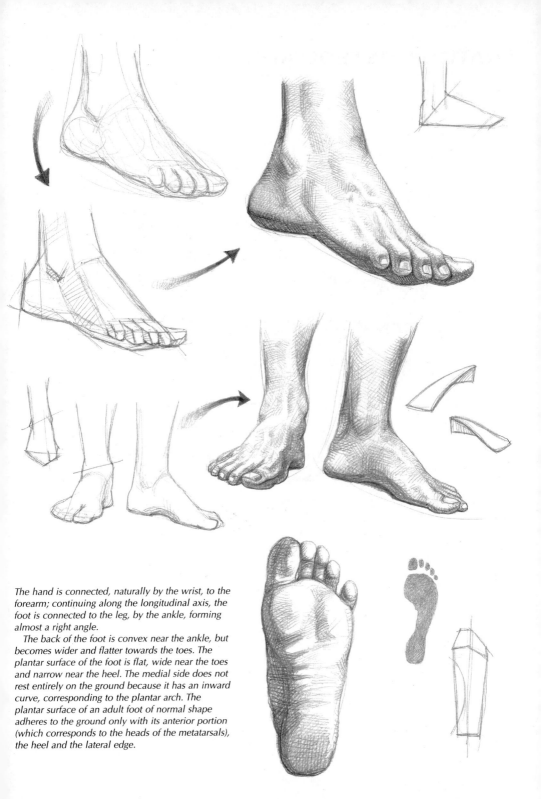

The hand is connected, naturally by the wrist, to the forearm; continuing along the longitudinal axis, the foot is connected to the leg, by the ankle, forming almost a right angle.

The back of the foot is convex near the ankle, but becomes wider and flatter towards the toes. The plantar surface of the foot is flat, wide near the toes and narrow near the heel. The medial side does not rest entirely on the ground because it has an inward curve, corresponding to the plantar arch. The plantar surface of an adult foot of normal shape adheres to the ground only with its anterior portion (which corresponds to the heads of the metatarsals), the heel and the lateral edge.

ANATOMY: OSTEOLOGY

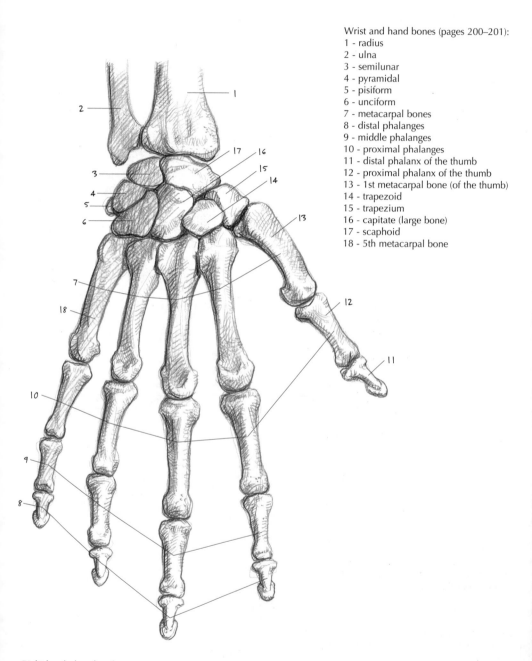

Wrist and hand bones (pages 200–201):
1 - radius
2 - ulna
3 - semilunar
4 - pyramidal
5 - pisiform
6 - unciform
7 - metacarpal bones
8 - distal phalanges
9 - middle phalanges
10 - proximal phalanges
11 - distal phalanx of the thumb
12 - proximal phalanx of the thumb
13 - 1st metacarpal bone (of the thumb)
14 - trapezoid
15 - trapezium
16 - capitate (large bone)
17 - scaphoid
18 - 5th metacarpal bone

Right hand: dorsal surface

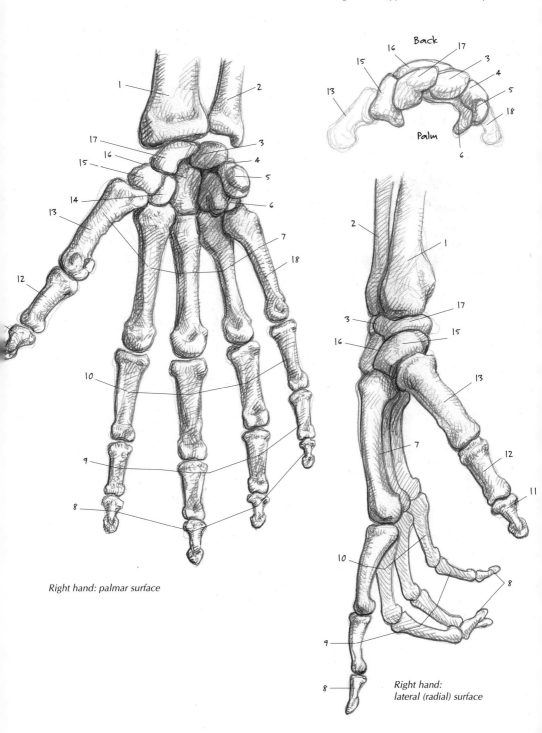

Right hand: upper surface of the carpus

Back

Palm

Right hand: palmar surface

*Right hand:
lateral (radial) surface*

Ankle and foot bones
(pages 202–203):
1 - astragalus
2 - heel
3 - scaphoid (navicular)
4 - 1st cuneiform (medial)
5 - 2nd cuneiform (intermediate)
6 - 3rd cuneiform (lateral)
7 - phalanges (proximal, middle,

distal) of the four toes
8 - 5th metatarsal
9 - cuboid
10 - distal phalanx of the big toe
11 - proximal phalanx of the big toe
12 - 1st metatarsal
13 - metatarsal bones
14 - tibia
15 - fibula

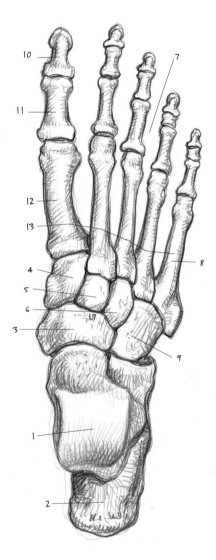

Right foot:
dorsal surface

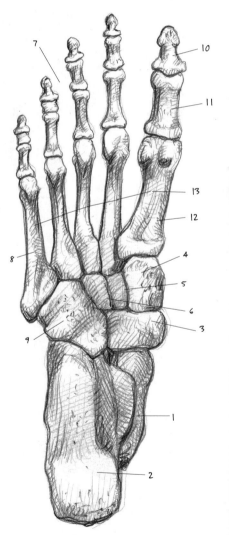

Right foot:
plantar surface

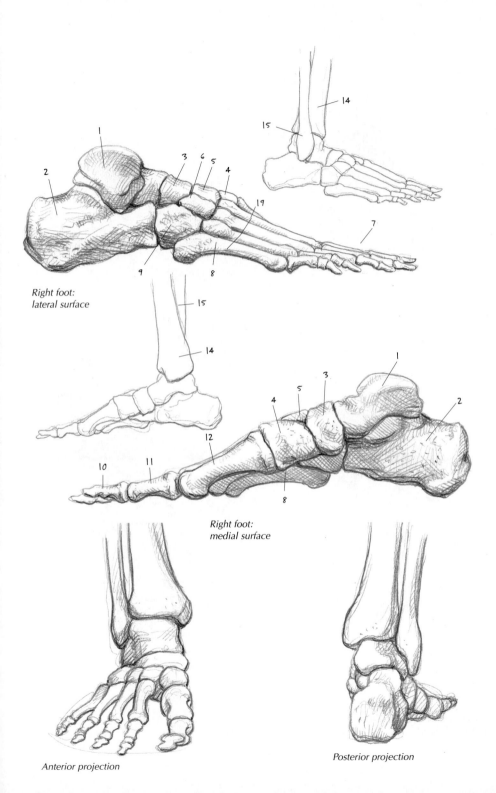

Right foot:
lateral surface

Right foot:
medial surface

Anterior projection

Posterior projection

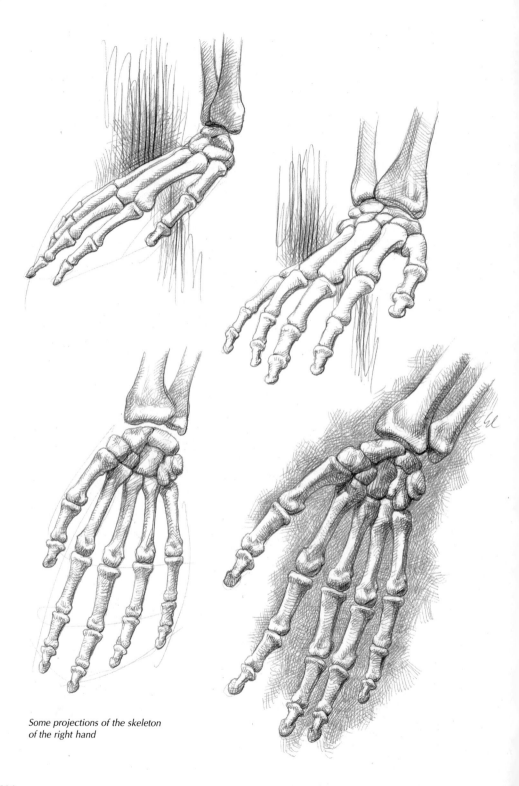

Some projections of the skeleton of the right hand

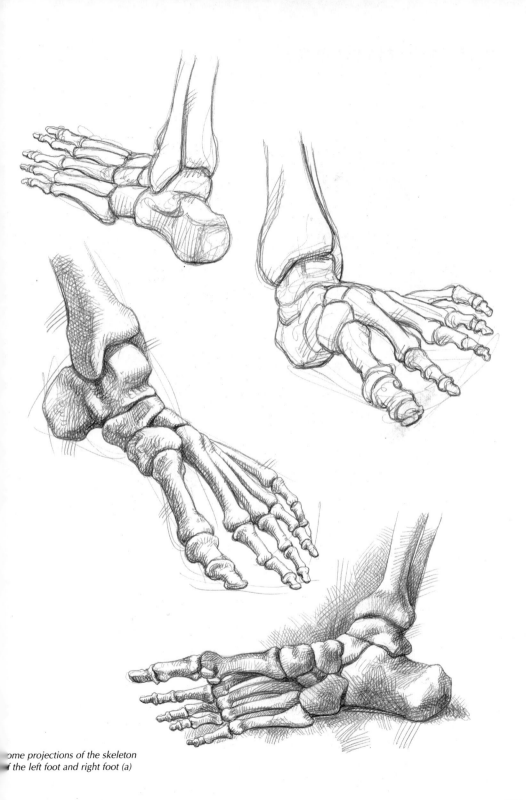

ome projections of the skeleton
f the left foot and right foot (a)

ANATOMY: MYOLOGY

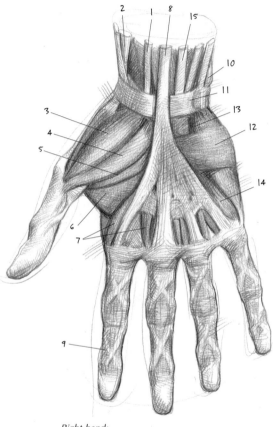

*Right hand:
palmar surface*

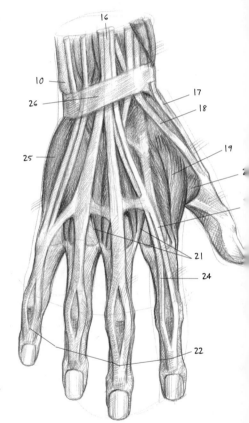

*Right hand:
dorsal surface*

Muscles of the hand:
1 - radial flexor of the carpus
2 - long abductor of the thumb
3 - short abductor of the thumb
4 - short flexor of the thumb
5 - long flexor of the thumb
6 - adductor of the thumb
7 - lumbrical
8 - long palmar (and its aponeurosis)
9 - tendons of the flexors
10 - ulna
11 - pisiform bone
12 - short palmar
13 - abductor of the little finger
14 - opposing muscle of the little finger
15 - superficial flexor of the fingers
16 - extensor of the fingers
17 - short extensor of the thumb
18 - long extensor of the thumb
19 - 1st dorsal interosseous
20 - adductor of the thumb
21 - dorsal interosseous muscles
22 - tendons of the extensors
23 - extensor of the fingers
24 - index's own extensor
25 - abductor of the little finger
26 - retinaculum of the extensors

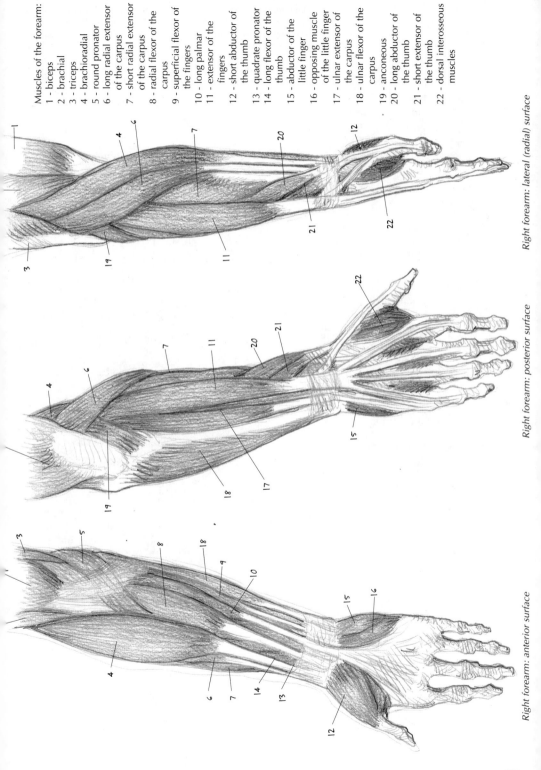

Muscles of the forearm:
1 - biceps
2 - brachial
3 - triceps
4 - brachioradial
5 - round pronator
6 - long radial extensor of the carpus
7 - short radial extensor of the carpus
8 - radial flexor of the carpus
9 - superficial flexor of the fingers
10 - long palmar
11 - extensor of the fingers
12 - short abductor of the thumb
13 - quadrate pronator
14 - long flexor of the thumb
15 - abductor of the little finger
16 - opposing muscle of the little finger
17 - ulnar extensor of the carpus
18 - ulnar flexor of the carpus
19 - anconeous
20 - long abductor of the thumb
21 - short extensor of the thumb
22 - dorsal interosseous muscles

Right forearm: lateral (radial) surface

Right forearm: posterior surface

Right forearm: anterior surface

207

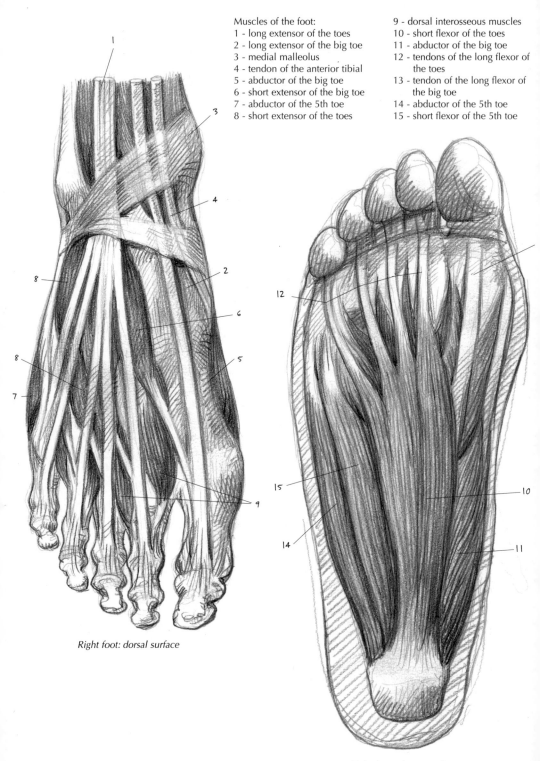

Muscles of the foot:
1 - long extensor of the toes
2 - long extensor of the big toe
3 - medial malleolus
4 - tendon of the anterior tibial
5 - abductor of the big toe
6 - short extensor of the big toe
7 - abductor of the 5th toe
8 - short extensor of the toes

9 - dorsal interosseous muscles
10 - short flexor of the toes
11 - abductor of the big toe
12 - tendons of the long flexor of
the toes
13 - tendon of the long flexor of
the big toe
14 - abductor of the 5th toe
15 - short flexor of the 5th toe

Right foot: dorsal surface

Right foot: plantar surface

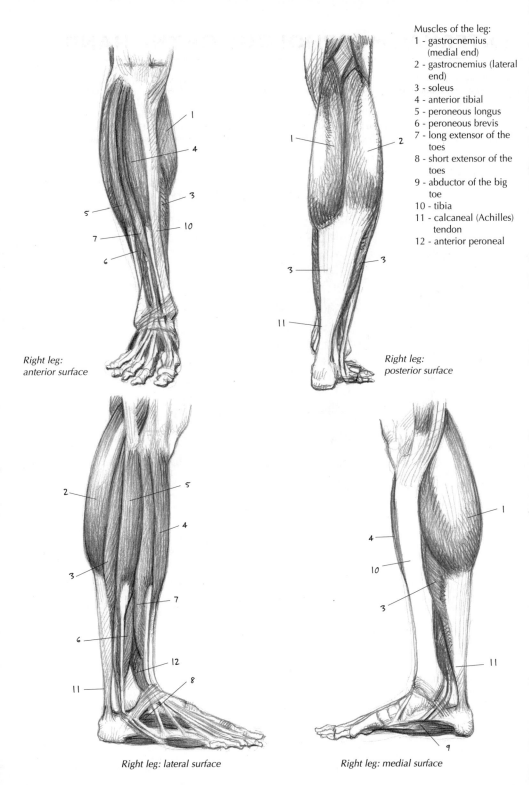

Muscles of the leg:
1 - gastrocnemius (medial end)
2 - gastrocnemius (lateral end)
3 - soleus
4 - anterior tibial
5 - peroneous longus
6 - peroneous brevis
7 - long extensor of the toes
8 - short extensor of the toes
9 - abductor of the big toe
10 - tibia
11 - calcaneal (Achilles) tendon
12 - anterior peroneal

Right leg: anterior surface

Right leg: posterior surface

Right leg: lateral surface

Right leg: medial surface

EXTERNAL MORPHOLOGY OF THE HAND

A short description of the external shapes of the hand has already been given on pages 194 and 195. It is very useful to study your own hands, viewed directly or reflected in the mirror, and then compare them with someone else's.

With this in mind, try to recognise the main osseous, tendinous and muscular components that determine the exterior form of the hand, in the anatomical position and in the various attitudes that it can assume. The comparison can also be made with various individuals according to sex, age, constitutional type and job.

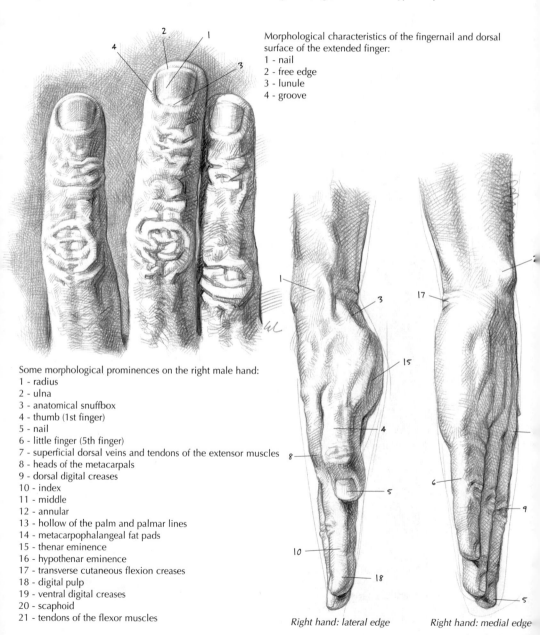

Morphological characteristics of the fingernail and dorsal surface of the extended finger:
1 - nail
2 - free edge
3 - lunule
4 - groove

Some morphological prominences on the right male hand:
1 - radius
2 - ulna
3 - anatomical snuffbox
4 - thumb (1st finger)
5 - nail
6 - little finger (5th finger)
7 - superficial dorsal veins and tendons of the extensor muscles
8 - heads of the metacarpals
9 - dorsal digital creases
10 - index
11 - middle
12 - annular
13 - hollow of the palm and palmar lines
14 - metacarpophalangeal fat pads
15 - thenar eminence
16 - hypothenar eminence
17 - transverse cutaneous flexion creases
18 - digital pulp
19 - ventral digital creases
20 - scaphoid
21 - tendons of the flexor muscles

Right hand: lateral edge

Right hand: medial edge

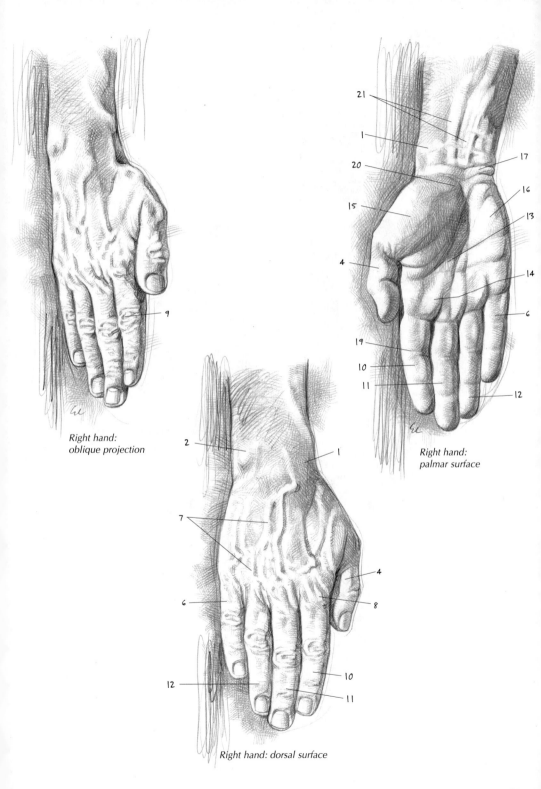

Right hand:
oblique projection

Right hand:
palmar surface

Right hand: dorsal surface

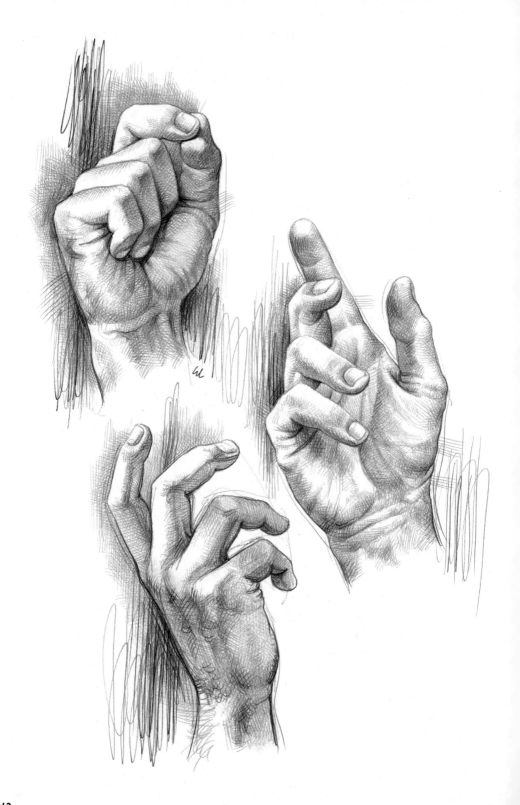

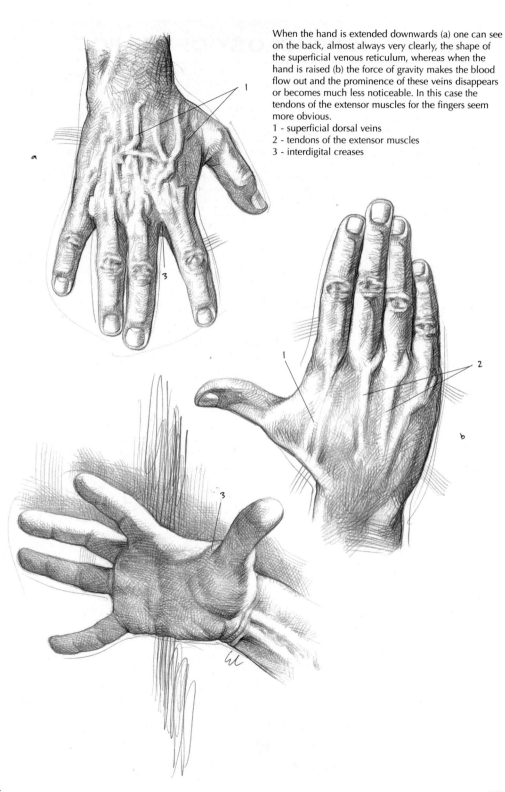

When the hand is extended downwards (a) one can see on the back, almost always very clearly, the shape of the superficial venous reticulum, whereas when the hand is raised (b) the force of gravity makes the blood flow out and the prominence of these veins disappears or becomes much less noticeable. In this case the tendons of the extensor muscles for the fingers seem more obvious.

1 - superficial dorsal veins
2 - tendons of the extensor muscles
3 - interdigital creases

EXTERNAL MORPHOLOGY OF THE FOOT

The external form of the foot reproduces the skeletal structure and displays a dorsal, medial and plantar surface. The dorsolateral surface is curvilinear and convex, decreasing and gradually diminishing towards the outer edge; it is highest near the ankle and then decreases, inclining in an anterior, lateral direction. It is crossed by the tendons of the extensor muscles of the toes and, just under the skin, by the superficial venous reticulum. The medial surface displays the inward curve corresponding to the plantar arch and, as a whole, is triangular in shape. The plantar surface only partly reproduces the osseous shape because it is altered by the presence of an adipose layer, the plantar aponeurosis and thick skin. The toes, except for the first (the big toe) are rather short and their size gradually decreases down to the fifth toe. Around the ankle (the 'neck' of the foot) it is necessary to consider the position and shape of the malleoli (the medial one has a rounded prominence, whereas the lateral one is quite pointed and situated below the controlateral one), the calcaneal (Achilles) tendon and the retromalleolar grooves.

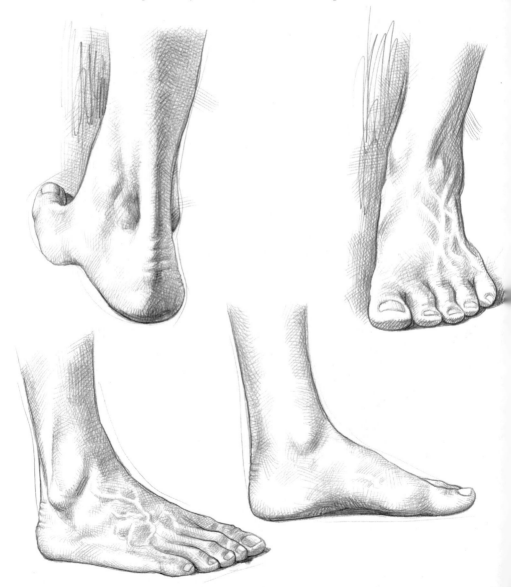

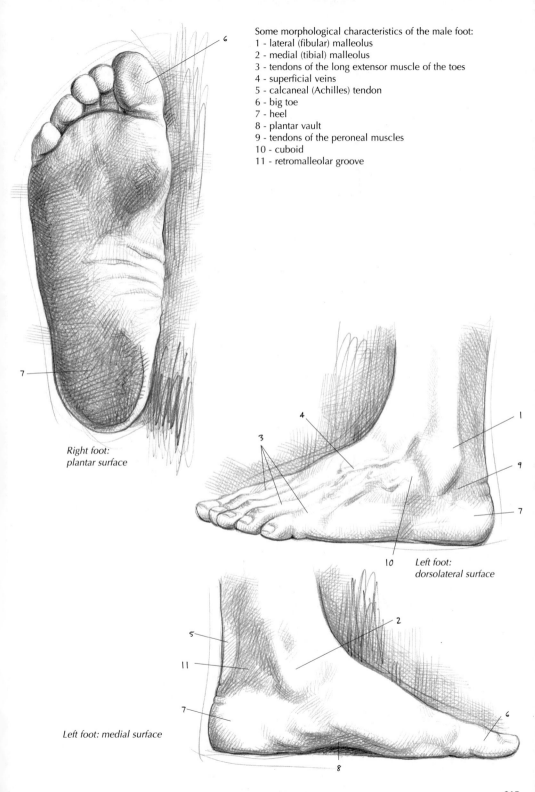

Some morphological characteristics of the male foot:
1 - lateral (fibular) malleolus
2 - medial (tibial) malleolus
3 - tendons of the long extensor muscle of the toes
4 - superficial veins
5 - calcaneal (Achilles) tendon
6 - big toe
7 - heel
8 - plantar vault
9 - tendons of the peroneal muscles
10 - cuboid
11 - retromalleolar groove

Right foot:
plantar surface

Left foot:
dorsolateral surface

Left foot: medial surface

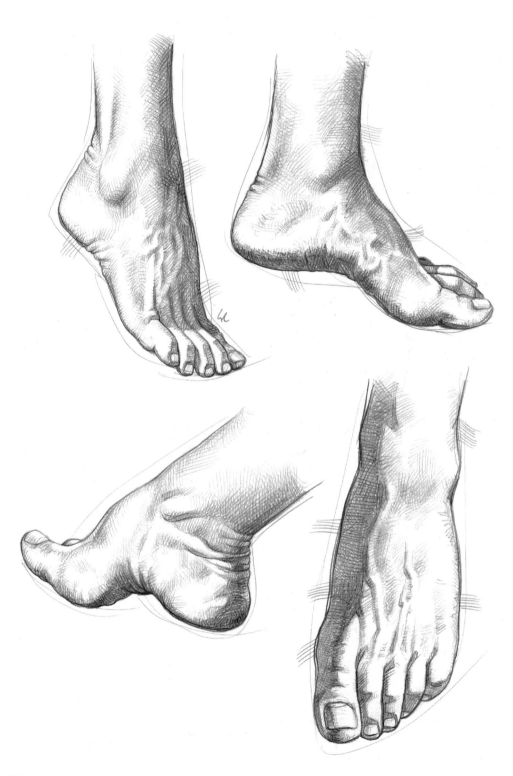

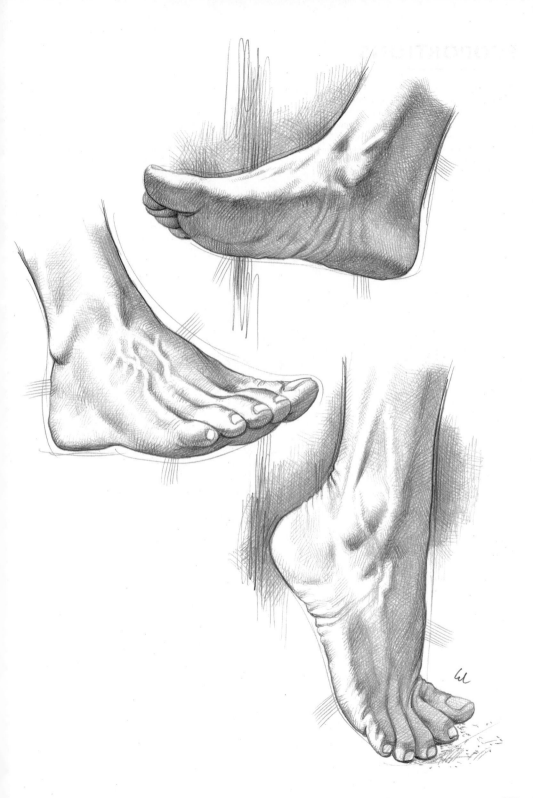

PROPORTIONS

The schematic drawings reproduced on these two pages summarise some of the main characteristics of proportional relationship for hands and feet, the dimensional relationship between the hand and foot, and the proportional relationship between the hand, the foot and the head. The sketches depict male anatomical parts, but the ratios also apply to female parts; bear in mind that a woman's hand and foot are usually comparatively smaller and in proportion to her normally shorter stature.

Study these ratios, compare them with yours or those of a model, do some rapid sketches, and consider the individual variations between adult subjects. Possibly look for other proportional relationships in order to succeed in drawing correctly (from an anatomical point of view) hands and feet in any position you happen to notice or imagine them in.

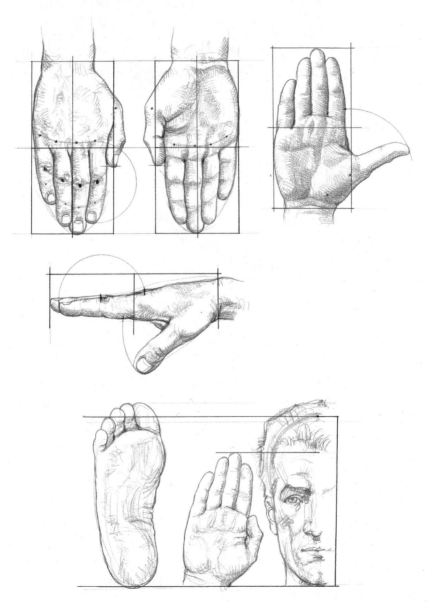

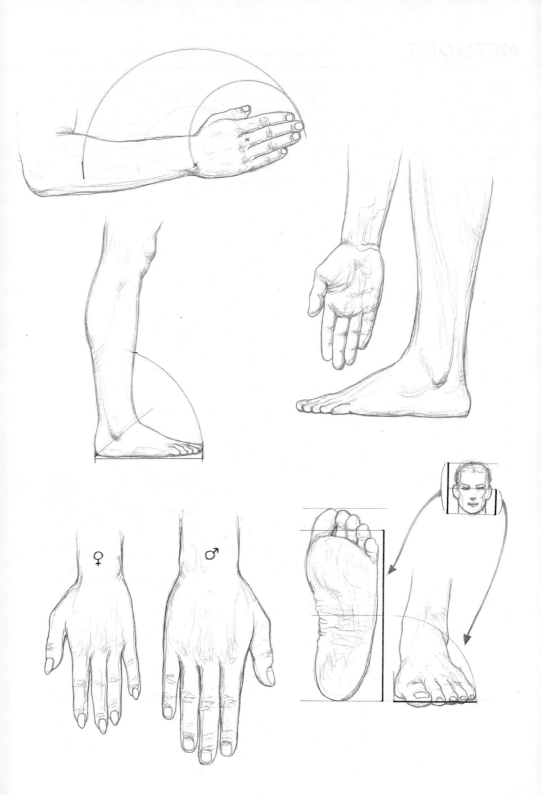

METHODS

In art, as in science, synthesis should precede analysis

The methods of drawing hands and feet, and indeed the human figure, are various, from the linear method (where the contours of the shapes are sketched), to the tonal method (assessing the relationships between the parts in the light and those in the shade), to the constructive method (identifying the load-bearing elements and their geometric simplification), to the structural one (recognising and contrasting the main and most essential masses). Each of these procedures has its advantages and disadvantages. Choosing one of them depends on the characteristics of the shape being drawn, which may call for a certain method of portrayal, as well as on the artist's pyschological attitudes or preferences. Don't stop at just one procedure, possibly the one you think is easiest, but experiment freely with others. Rather than making a rigid executive sketch, try to master all the methods and choose the one most suited to the individual circumstances and most in keeping with your expressive style.

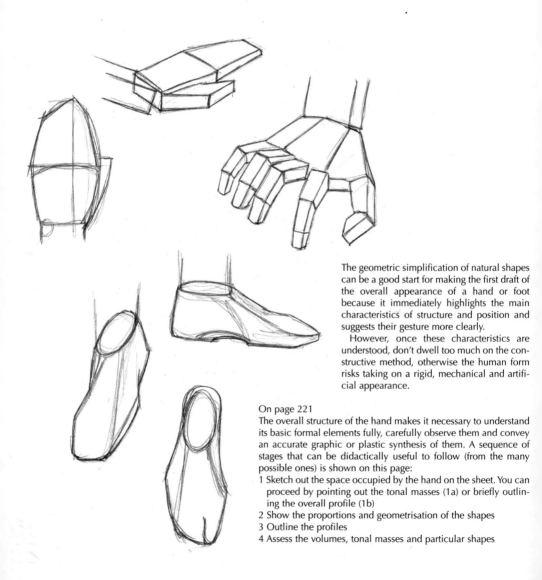

The geometric simplification of natural shapes can be a good start for making the first draft of the overall appearance of a hand or foot because it immediately highlights the main characteristics of structure and position and suggests their gesture more clearly.

However, once these characteristics are understood, don't dwell too much on the constructive method, otherwise the human form risks taking on a rigid, mechanical and artificial appearance.

On page 221
The overall structure of the hand makes it necessary to understand its basic formal elements fully, carefully observe them and convey an accurate graphic or plastic synthesis of them. A sequence of stages that can be didactically useful to follow (from the many possible ones) is shown on this page:

1 Sketch out the space occupied by the hand on the sheet. You can proceed by pointing out the tonal masses (1a) or briefly outlining the overall profile (1b)
2 Show the proportions and geometrisation of the shapes
3 Outline the profiles
4 Assess the volumes, tonal masses and particular shapes

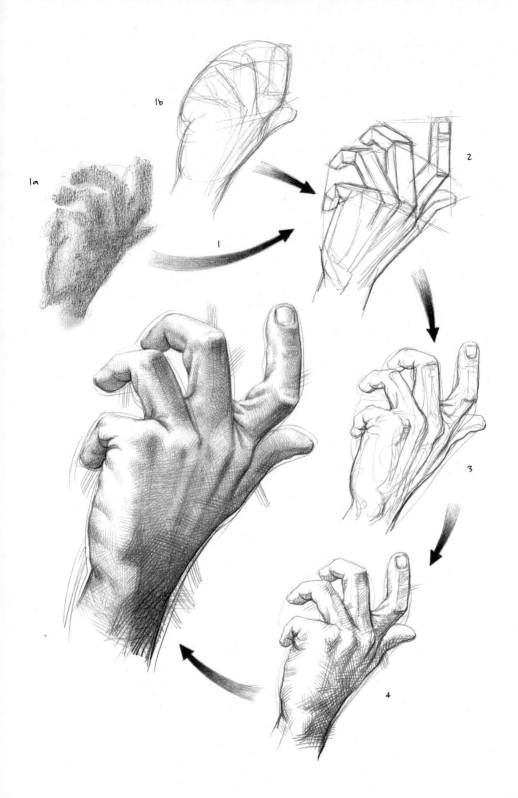

1a

1b

1

2

3

4

ARTICULAR MOVEMENTS

To draw the hand or foot in an anatomically correct way it is necessary to know at least some of the characteristics of the numerous articulations involved, the movements that these enable (especially their degree of extension) and their mechanical limit. In the foot the movements are very fine, connected with the requirements of walking and standing, but not too numerous and varied and their interpretation poses few problems for the artist. The hand is much more mobile and active as regards gesture and function; many of its articulations enable in particular the flexion and extension of the osseous segments they join.

However, their particular characteristics and the sum of the individual movements increase the range and enables very delicate, complex movements to be made, especially in the thumb. The actual hand movements are produced by the muscles of this body segment, but also by many other muscles that are situated on the forearm and, by extending the tendons up to the phalanges, act on the fingers (flexion and extension). At the wrist the articulation between the carpus, the ulna and the radius enables its pronation and supination as well as the flexion and extension of the hand.

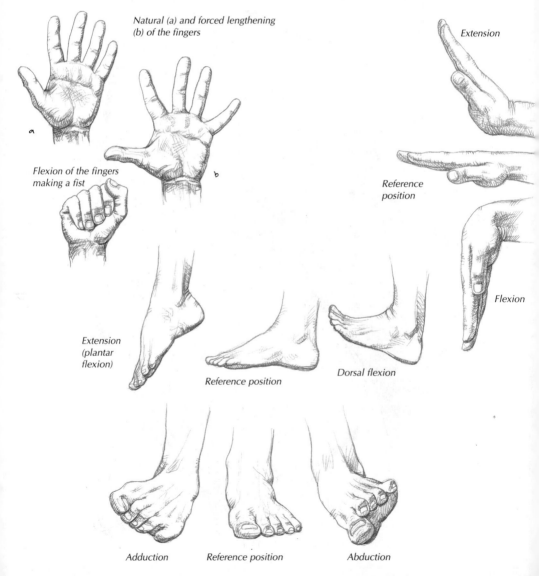

Natural (a) and forced lengthening (b) of the fingers

Flexion of the fingers making a fist

Extension

Reference position

Flexion

Extension (plantar flexion)

Reference position

Dorsal flexion

Adduction Reference position Abduction

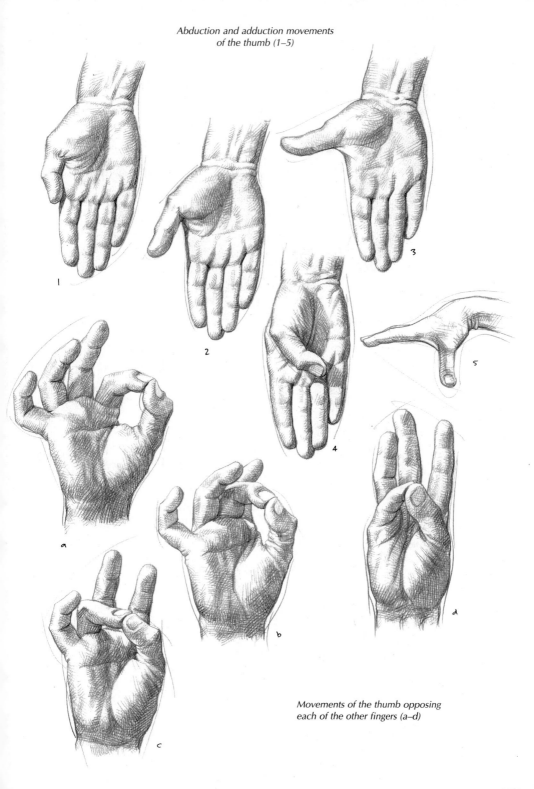

Abduction and adduction movements
of the thumb (1–5)

1

2

3

4

5

a

b

c

d

Movements of the thumb opposing
each of the other fingers (a–d)

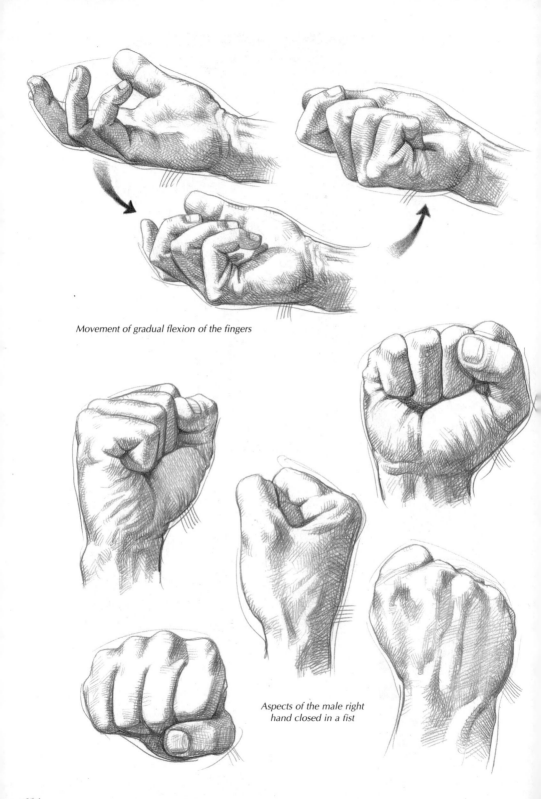

Movement of gradual flexion of the fingers

*Aspects of the male right
hand closed in a fist*

Lateral flexion
(abduction)

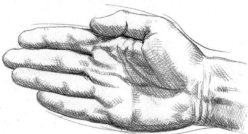

Reference position

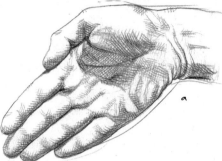

a

Medial flexion (adduction)

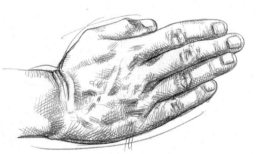

Lateral flexion (abduction)

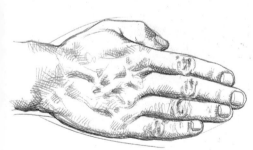

Reference position

b

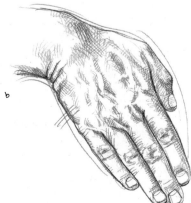

Medial flexion
(adduction)

Articular movements of the male right hand, at the wrist:
a - palmar surface
b - dorsal surface

GESTURE AND ACTION

It is well known that gestures are part of the body movement that accompanies an expression or the conveyance of a message. Sometimes they are tacit (a sort of non-verbal language), more often they accompany, accentuate, complete or enrich whatever is being said. The study of gestural meaning, whether universal or linked to local traditions or cultures, is carried out by human ethology and psychology; for the artist it can form an inexhaustible topic of observation. But the artist's attention is drawn mainly to the action that the hand or, to a lesser extent, the foot can do, by the attitude that it assumes when performing a certain operation. By combining the variety of the action, the morphological variability of the hand, the different conditions (of lighting, perspective viewpoint, etc.) in which it can be observed, the human hand offers an almost infinite source of inspiration. So as not to get confused, it is advisable to start studying these shapes by giving expression to your own hand or that of a model in simple, ordinary actions typical of everyday life, such as those exemplified in the drawings on these pages (except for the one of a hand holding a revolver, of course…)

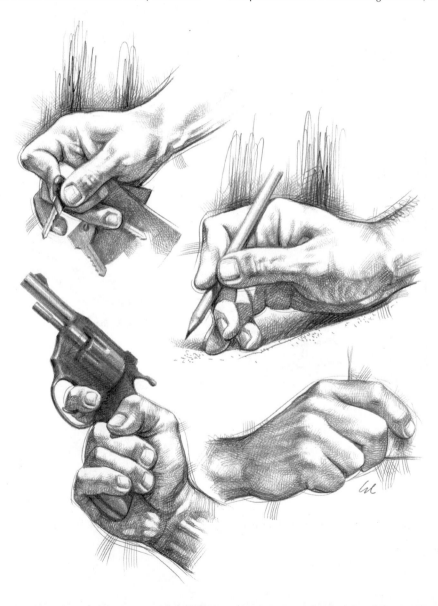

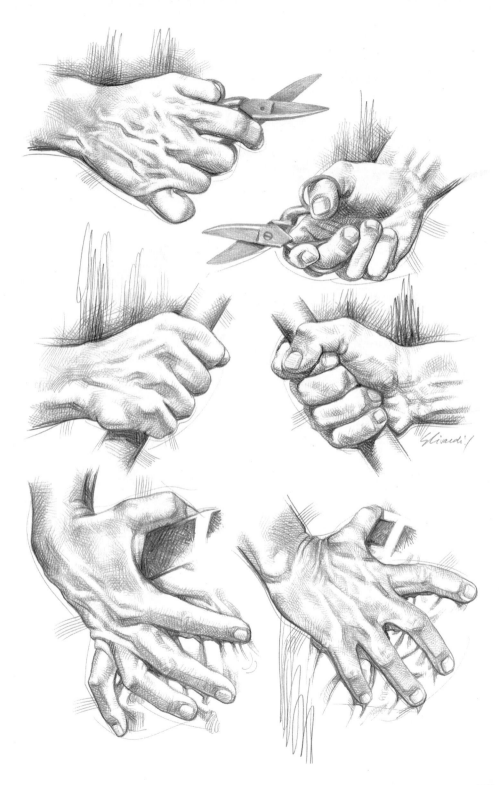

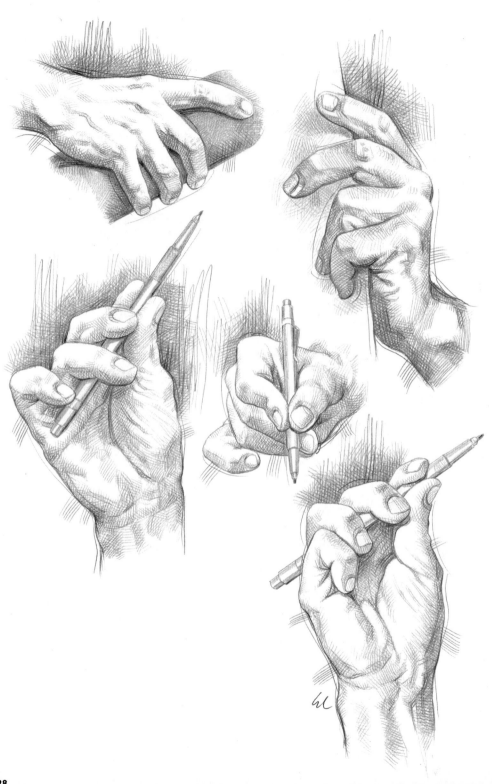

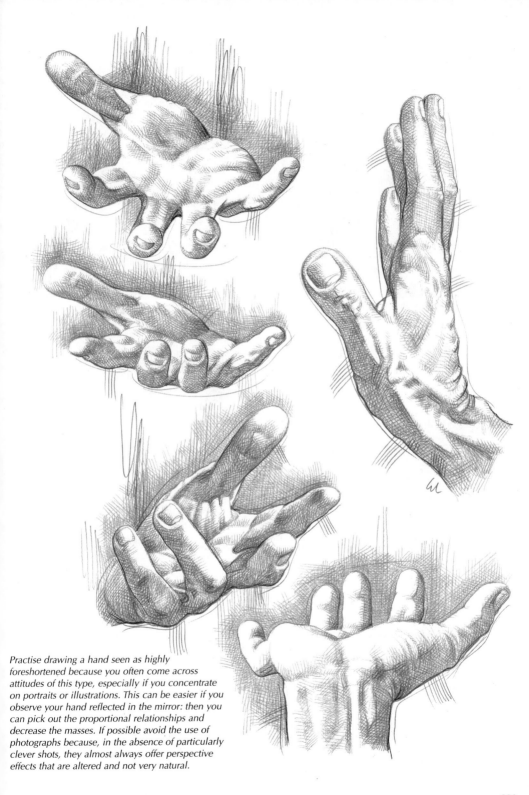

Practise drawing a hand seen as highly
foreshortened because you often come across
attitudes of this type, especially if you concentrate
on portraits or illustrations. This can be easier if you
observe your hand reflected in the mirror: then you
can pick out the proportional relationships and
decrease the masses. If possible avoid the use of
photographs because, in the absence of particularly
clever shots, they almost always offer perspective
effects that are altered and not very natural.

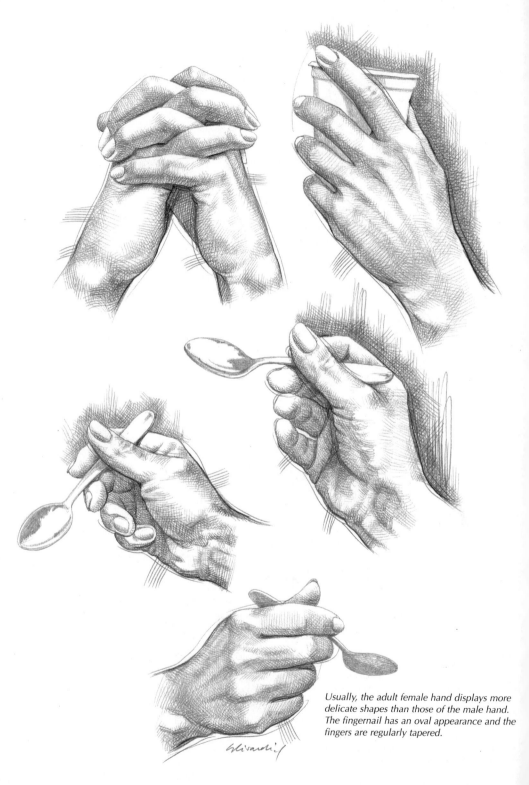

Usually, the adult female hand displays more delicate shapes than those of the male hand. The fingernail has an oval appearance and the fingers are regularly tapered.

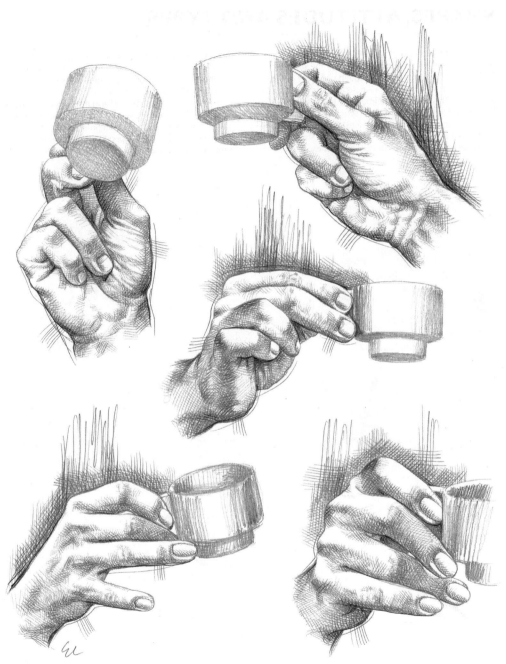

*Different ways of portraying someone holding a
coffee cup are depicted here. The bottom two
drawings show the same gesture made by a
female right hand.*

SHAPES, ATTITUDES AND TYPES

Like most of the previous drawings those shown in this section of the book were produced using the same technique (H, HB and B graphite leads on rough paper, 24 x 33cm (9½ x 13in)), sketching out a single hand or single foot on each page. This was done deliberately because I intended to limit myself to suggesting a short series of various positions (from the innumerable possible ones) interesting from the point of view of anatomical–morphological study, and not examples to copy without discernment. These images,

however, should inspire you to give expression to your own hand or foot, or those of models, in the same or similar positions and study them from different viewpoints or in different lighting conditions as well.

It would be very useful (and also more fun) to make these studies with various drawing techniques (charcoal, watercolour pen and ink, etc.), with different procedures (tonal, linear, mass, etc.), and to assess opportunities to add expressive emphasis or find ways of simplifying them effectively.

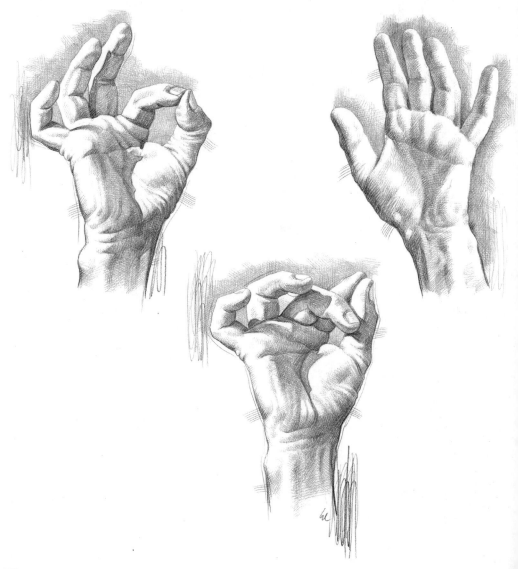

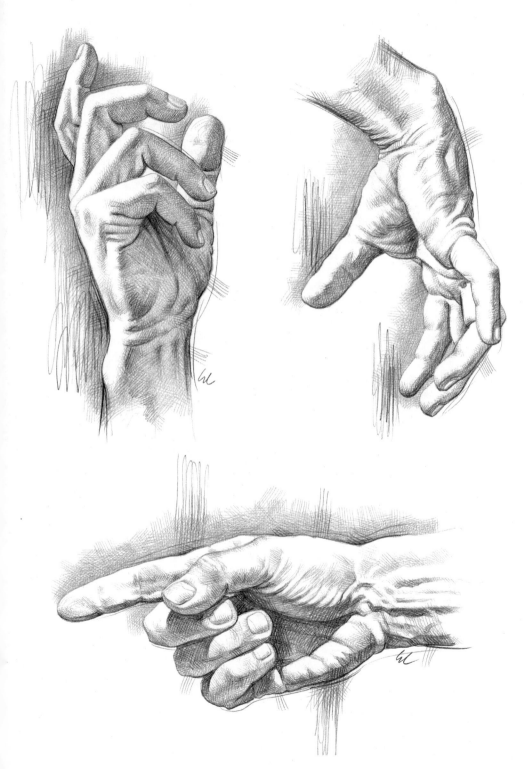

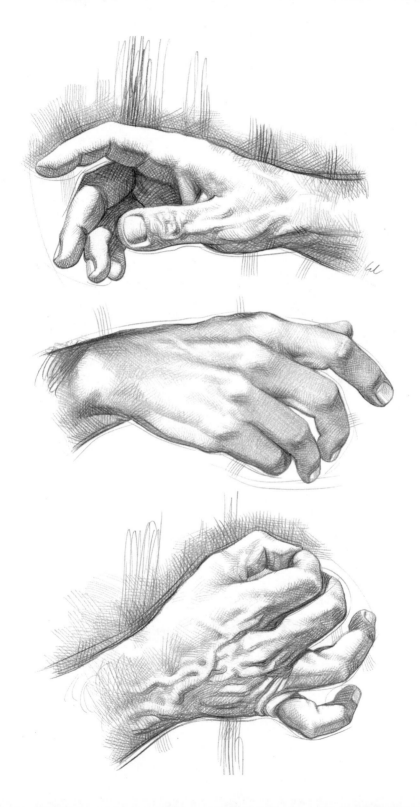

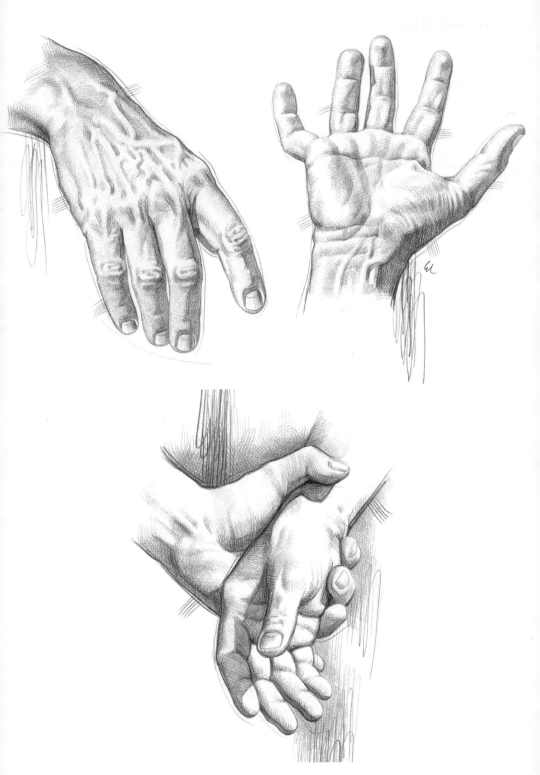

A child's hand and foot

The hand of a newborn baby appears stumpy, with a large, very thick palm (due to the relative development of the muscles at the base of the thumb and the presence of fat pads on the back as well) and short fingers. The details of the nails are precise and reproduce, on a very small scale, those visible on adults. The presence of fat pads determines a furrowed, bracelet-like characteristic around the wrist and the dimples on the back, near the root of the fingers.

A young child's hand still retains these characteristics but to a lesser extent; the fingers appear less short compared with the palm.

A newborn baby's foot is rather flat, because of the relaxation of the ligaments and the abundance of fat tissue filling the plantar cavity.

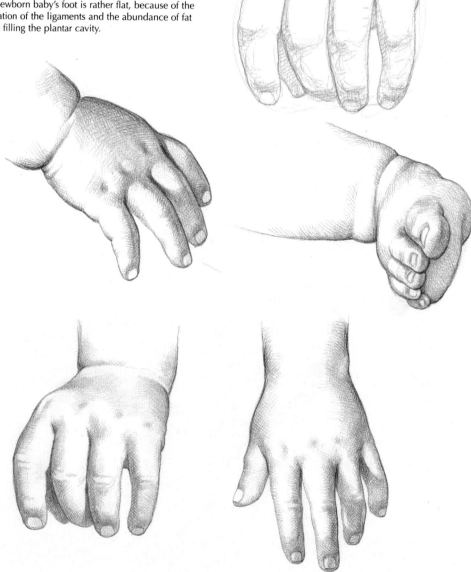

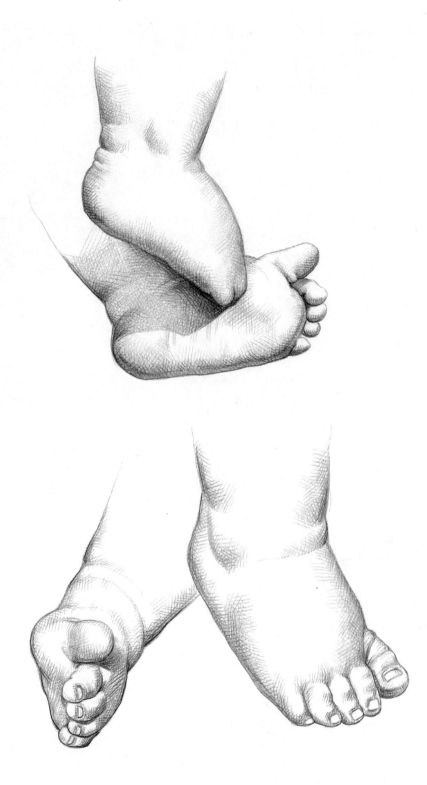

A female adult's hand

As with the head, female hands have smaller bones than male ones, and more delicate muscle development and rounder surfaces. On the whole, they appear longer and more slender.

The fingers are tapered, with joints that are not very obvious and fingernails that are oval in shape. On the back, hairs are scarcely visible, and the superficial veins and tendons are not very prominent.

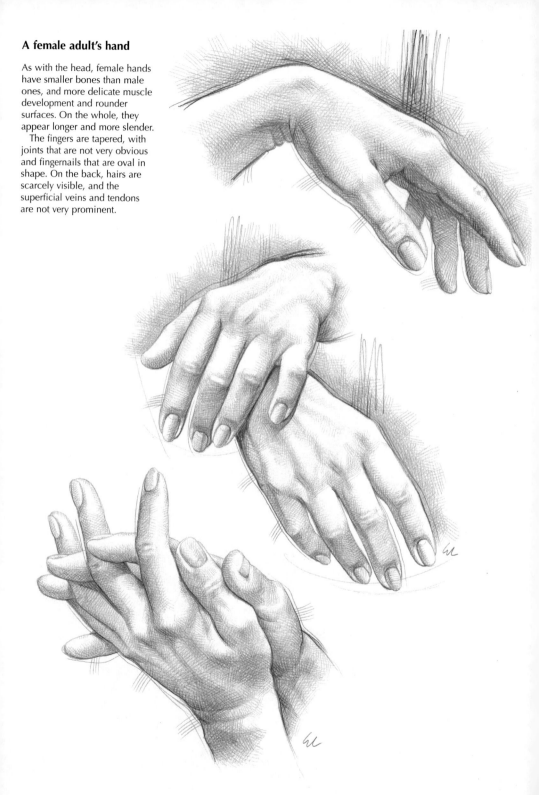

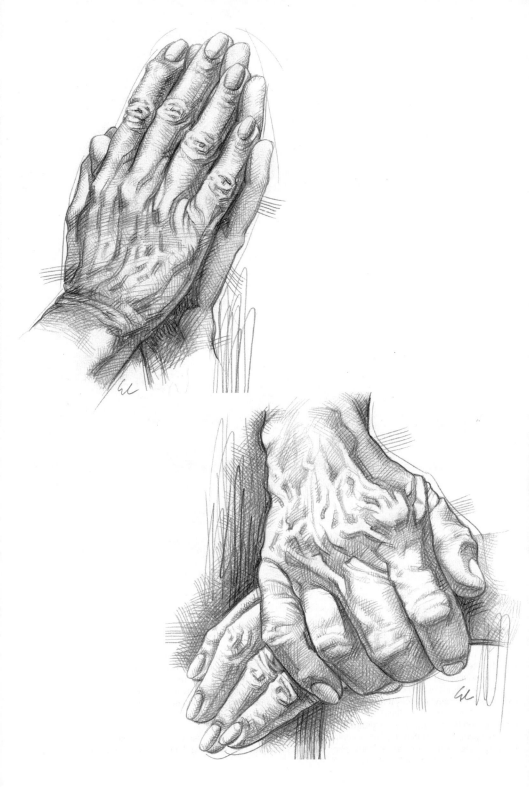

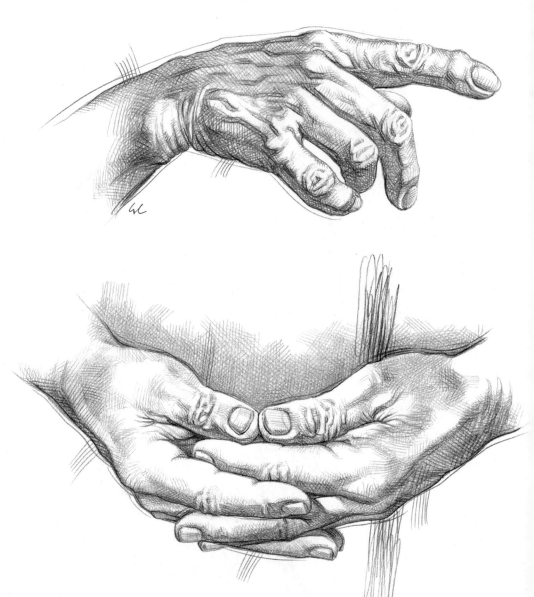

An old person's hand and foot

An old person's hand has a particular appearance either because of atrophy of the subcutaneous fat tissue (which accentuates the prominence of the finger joints and metacarpal bones), or because of atrophy of the intrinsic muscles (especially the first dorsal interosseous muscle). The joints, moreover, can be affected by arthritis, which causes the relative enlargement of the interphalangeal joints and deviation of the fingers. The skin becomes thin, atrophic and inelastic (forming many permanent wrinkles and creases); on the back of the hand there may be numerous brown patches (due to the thickening of melanin) and the superficial veins protrude more.

An old person's foot often displays accentuated callosity around the most mechanically stressed points, the valgus big toe (deviated towards the other toes), and the flattening of the vault (as a result of arthritis of the tarsus and atrophy of the plantar muscles).

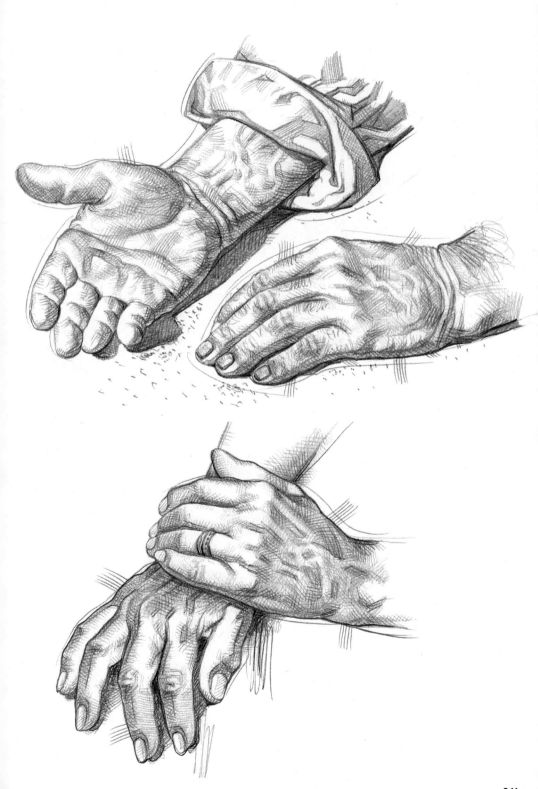

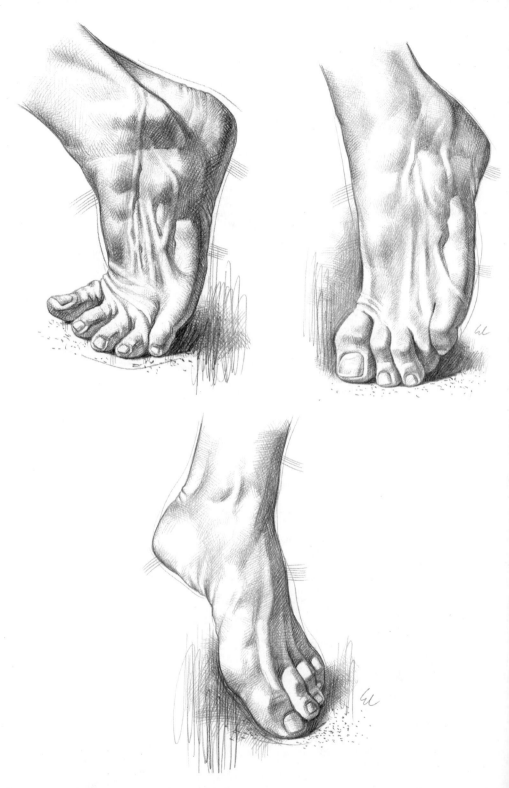

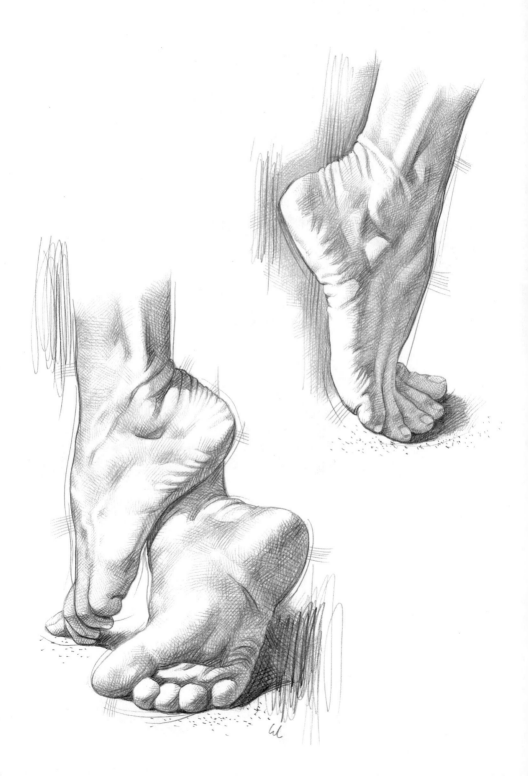

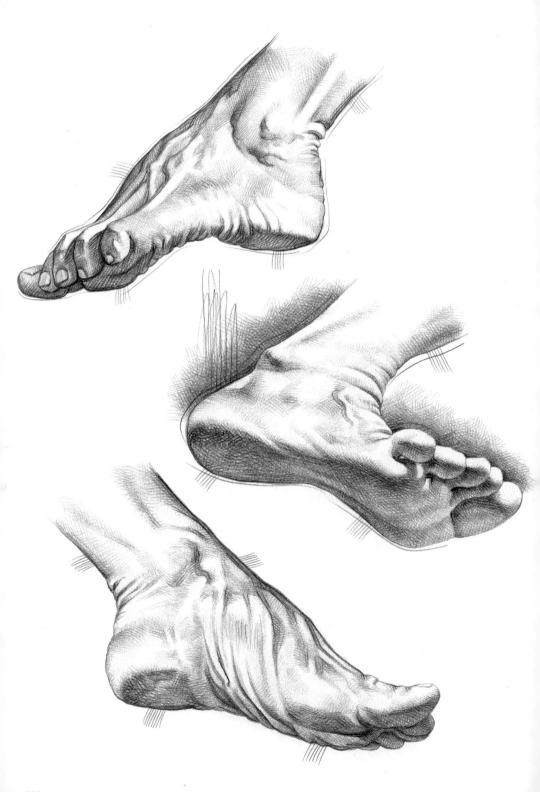

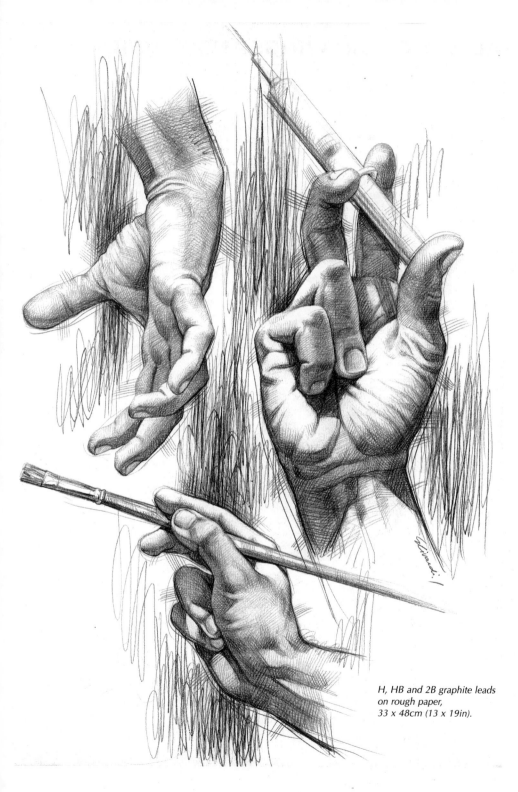

*H, HB and 2B graphite leads
on rough paper,
33 x 48cm (13 x 19in).*

GALLERY OF DRAWINGS AND STUDIES

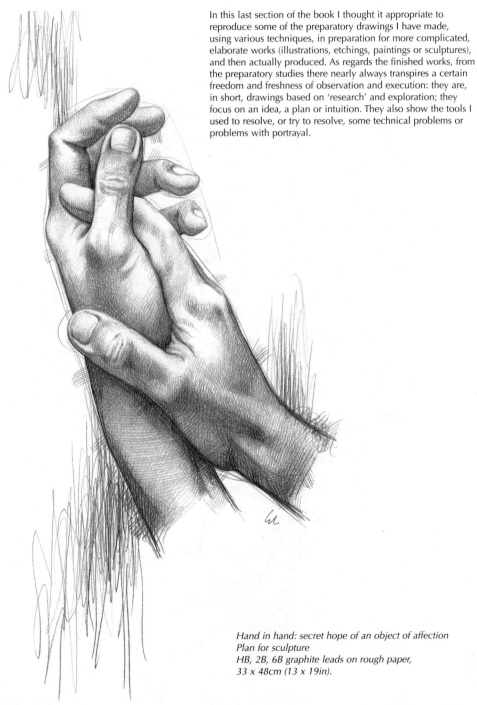

In this last section of the book I thought it appropriate to reproduce some of the preparatory drawings I have made, using various techniques, in preparation for more complicated, elaborate works (illustrations, etchings, paintings or sculptures), and then actually produced. As regards the finished works, from the preparatory studies there nearly always transpires a certain freedom and freshness of observation and execution: they are, in short, drawings based on 'research' and exploration; they focus on an idea, a plan or intuition. They also show the tools I used to resolve, or try to resolve, some technical problems or problems with portrayal.

Hand in hand: secret hope of an object of affection
Plan for sculpture
HB, 2B, 6B graphite leads on rough paper,
33 x 48cm (13 x 19in).

Self-portrait (prayer)
Study for etching
2H graphite lead on
smooth paper,
42 x 56cm (16 1/2 x 22in).

247

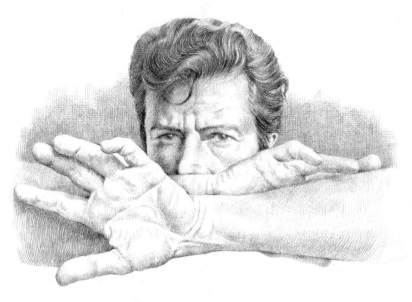

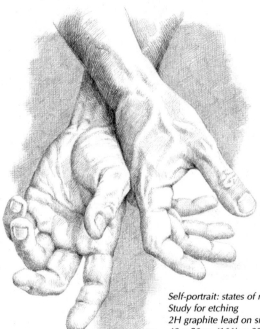

Self-portrait: states of mind. Refusal
Study for etching
2H graphite lead on smooth paper,
42 x 56cm (16 1/2 x 22in).

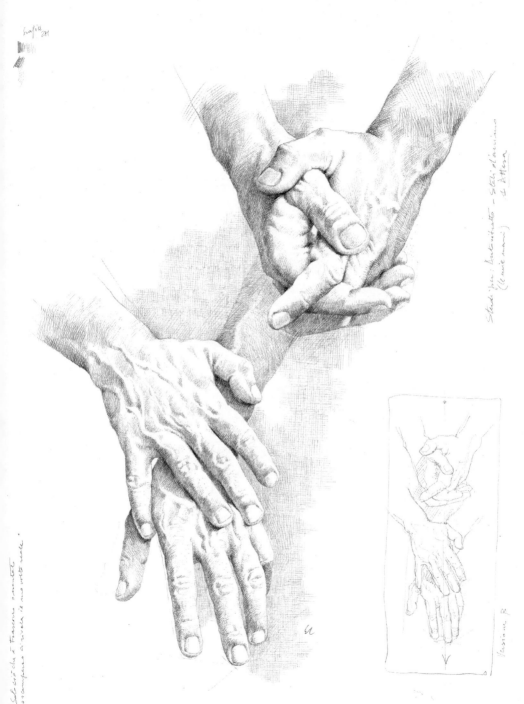

Self-portrait: states of mind. Expectation
Study for etching
2H graphite lead on smooth paper,
42 x 56cm (16 1/2 x 22in).

249

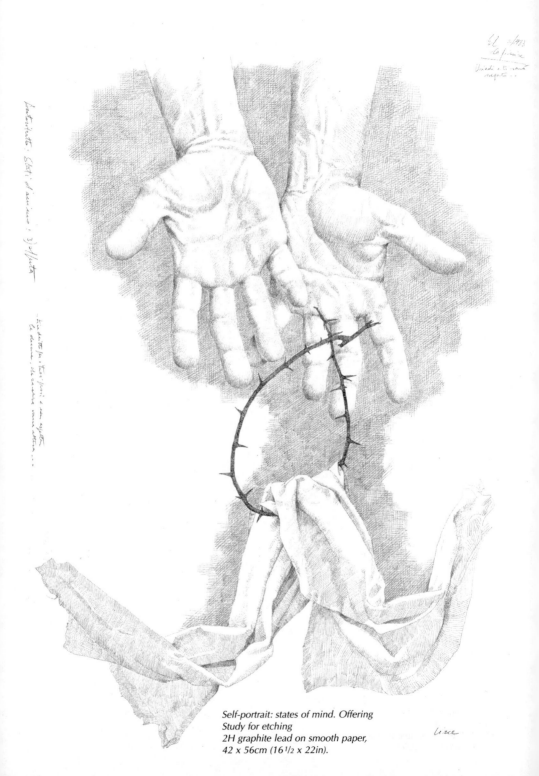

Self-portrait: states of mind. Offering
Study for etching
2H graphite lead on smooth paper,
42 x 56cm (16 1/2 x 22in).

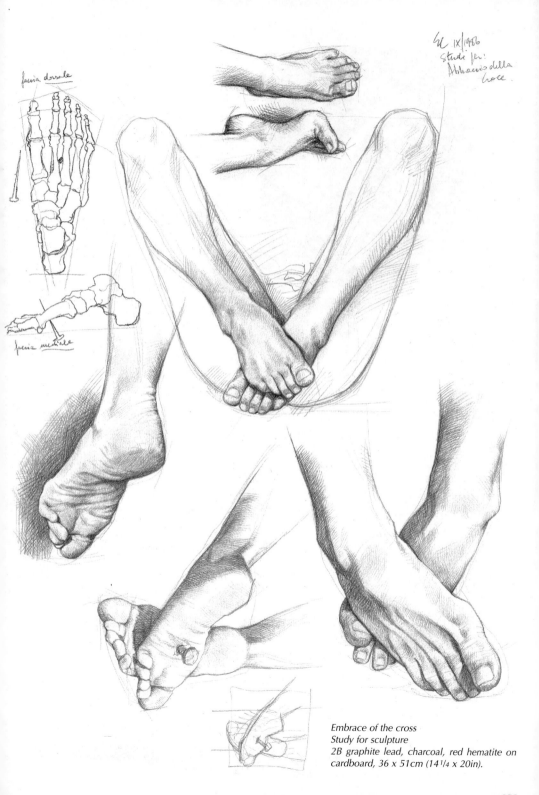

fascia dorsale

fascia mediale

SU IX/1986
Studi per:
Abbraccio della
croce.

Embrace of the cross
Study for sculpture
2B graphite lead, charcoal, red hematite on
cardboard, 36 x 51cm (14 1/4 x 20in).

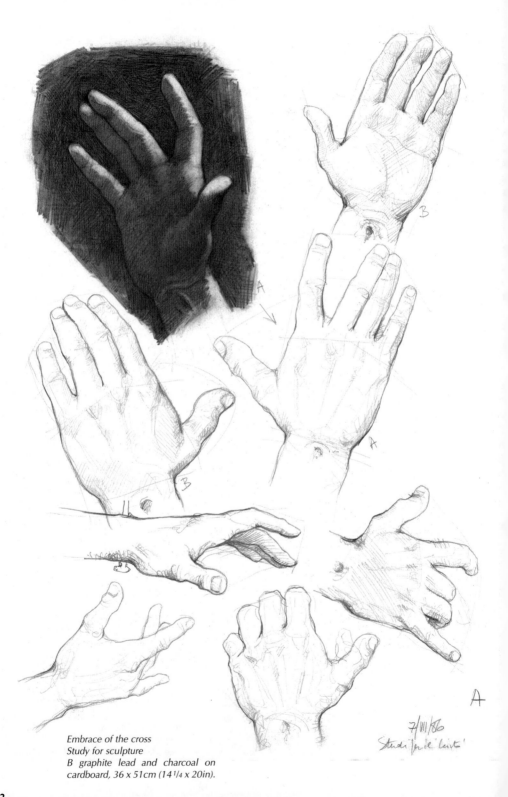

Embrace of the cross
Study for sculpture
B graphite lead and charcoal on
cardboard, 36 x 51cm (14 1/4 x 20in).

7/VIII/86
Studi per le 'leviti'

A

DRAWING SCENERY

By focusing on drawing scenery, this chapter avoids any arguments over the definition of 'landscape'. Scenery is all-encompassing. It includes natural features such as plants, trees, rivers, seas and mountains, as well as the whole environment, both rural and urban, in which man and animals live, and which man has changed through cultivation and construction. In this chapter, scenery includes landscapes, seascapes and buildings, though none is mutually exclusive. You only need look at the history of painting to realise the importance – past and present – of the landscape genre and the sometimes profoundly different ways it has been perceived and interpreted by artists over the centuries.

To paint well, you need to draw well. The artist needs to know at least the basics of perspective and composition. The aim is not to achieve a sterile and academic result for its own sake, but to learn the art of drawing in order to be able to bend it and shape it to your artistic needs, or if necessary to reject it altogether.

This chapter is an attempt to offer a simple and concise overview of the many aspects of drawing scenery, highlighting some of the problems a beginner will be faced with, and giving pointers (based on my teaching experience) on how to approach them to achieve good results. To this end, it is important to note that, besides learning and experimenting with drawing techniques, one needs to learn to 'see' reality – what surrounds us – in order to be able to translate graphically what we perceive. I have included a number of photographs alongside the drawings and diagrams to give a gallery of sample images so that, if you lack the opportunity to study scenes 'from life', you can start practising – in the styles and with the techniques you like – without being influenced by my style of drawing.

TOOLS AND TECHNIQUES

Simple and popular media such as pencils, charcoal, pastels, pen and ink, watercolours, felt-pens, etc., can all be used for drawing scenery. Each medium, however, gives different results, due not only to the specific characteristics of the material and the techniques used, but also to the drawing surface: rough or smooth paper, canvas, white or coloured paper, etc. The drawings shown on these two pages have been done with media which, although commonly used, effectively convey nature's tonal complexity, shades and details.

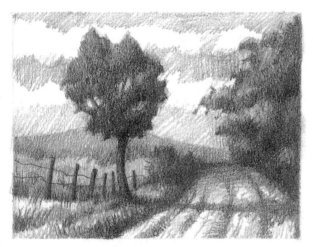

Pencil (H; B; 2B) on rough paper

Pencil is the medium most commonly used for any type of drawing, but it is particularly suited to drawing scenery as it allows spontaneity and is convenient to use. It can be used for complex drawings, or for small studies and rough reference sketches. For the latter very fine graphite (lead) is suitable, while for the former you can use thicker graphites in a softer grade. Graphites in mechanical holders as well as pencils (graphites in a wooden casing), are graded according to their consistency: from 9H (very hard) to 6B (very soft).

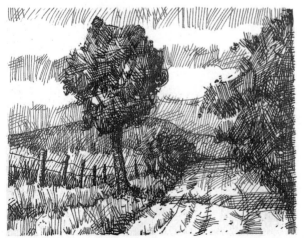

Pen, nib and Indian ink on medium-rough paper

Ink is also often used by artists. It can be applied with a brush, or a nib, but to obtain special effects you can use bamboo reeds, oversized nibs, quills, or a small sponge to make marks. Tones can be made more, or less, intense by varying the density of the cross-hatching and it is therefore advisable to draw on fairly smooth, good quality paper (or board) which will not fray or soak up ink. For drawing out of doors, fountain pens, 'technical' pens, felt-pens and ball-point pens are the most suitable.

Compressed charcoal on Rough paper

Charcoal is perhaps the ideal medium for drawing scenery as it is easy to control when laying out tones, and allows the artist to achieve quite sharp detail. To exploit its versatility and its evocative power, however, it should be used 'broadly', concentrating on the overall rendering of 'shapes'. Compressed, rather than willow charcoal, is also a handy medium when drawing outdoors, although you have to take care not to smudge the paper. Charcoal strokes can be blended and smudged by rubbing with a finger, and tones can be softened by blotting with a soft eraser (a kneadable putty eraser). When completed, the drawing can be protected by spraying it with fixative.

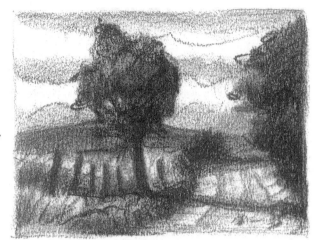

Diluted ink on Not paper

Watercolours, water-soluble inks and water-diluted Indian ink are very suitable for drawing scenery, in spite of being closer to painting than to drawing as they use a brush and require a comprehensive and expressive tonal vision. For quick, outdoor studies you can use water-soluble graphite or coloured pencils (to blend strokes easily, wipe them with a water-soaked brush); it is also preferable to stretch your paper so that the surface does not cockle.

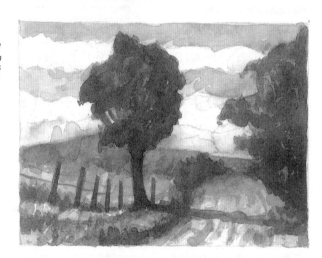

Pen and ink, watercolours, and white tempera on coloured paper

'Mixed' media means using different materials to achieve a drawing with unusual effects. Although still 'graphic' materials, their more complex application requires good control, and a good knowledge of the tools themselves, if we are to avoid muddled results of little aesthetic meaning. Mixed media are very effective on textured and coloured – or dark – surfaces.

PRACTICAL ADVICE

There are opportunities for drawing scenery all around us. Many famous artists drew and painted what they saw from the window of their study or from the hotel they in stayed during their trips. Part of the pleasure of drawing, however, lies in the search, even far away, for a suitable, 'inspiring' subject. You may happen upon interesting vistas from a train, or bus. Some people have even painted scenes from a plane. But much more often, you will explore on foot, by bike or by car – the true 'landscape artist' is one who works outdoors, *en plein air*.

DRAWING OUTDOORS

If you intend to draw outdoors you can expect adverse or irritating situations to occur and you will have to take care of them.

A common problem is a psychological one. You will have to overcome the unease which comes from working while being watched by curious passers-by or boisterous children. Don't worry: you will also meet interesting people!

The weather can also cause problems. Make sure you take the right type of clothing for the season: comfortable shoes, a hat, and a large umbrella in neutral colours for working in the shade or sheltering from the rain. If the weather is bad you can even draw from inside your car, sheltered from rain, wind and cold.

If you travel on roads with little traffic, take care when stopping and looking around.

EQUIPMENT

For essential information on drawing techniques and equipment, I suggest that you read the first chapter in this book, *Drawing Techniques*.

When working outdoors a folding chair, a few soft pencils (or whichever media you have chosen), and a sketchbook made of good quality paper are useful. If you do not have a sketchbook, you can fasten single sheets [quarter sheets, 380 x 280mm (15 x 11in) are ideal] on board with some tape.

Carry a small bag as well to hold (besides the appropriate drawing tools), a bottle of water, a few rags or paper tissues to clean your hands, drink and food for a revitalising snack.

DRAWING TECHNIQUES

As I said above, drawing techniques are covered in the first book of this series, but let us recap a few points for those readers who have just started to learn about drawing.

For good results, make sure that you always keep your pencils sharpened with a knife or a pencil sharpener. To keep graphites in mechanical holders well sharpened, rub and roll them on a piece of sandpaper. Very fine leads and charcoal do not need sharpening.

If you want to draw wide strokes, hold the pencil at an acute angle to the drawing surface. Placing a sheet of tracing paper under your hand while you work will protect your pencil or charcoal drawings from smudging. When you have finished working, spray the whole drawing with an appropriate 'fixative'.

Never use an eraser. If a stroke has not worked, do not erase it. Draw another close to it to correct it and, if necessary, a third one and so on, until you have achieved the result you want. If you erase the imperfect lines, you will be left without terms of reference by which to make your alterations, and it will be like having to draw a new line. Basically, you will not be able to 'use' the imperfection as the basis for making your change. When you are happy, you can trace the correct lines with firmer strokes and erase the wrong ones.

Indian ink becomes viscous if the container is left open for long. You therefore need to add one or two drops of water occasionally. For the same reason, nibs should be cleaned often with a rag. Remember that clean nibs glide more easily on fairly smooth paper.

Do not work on a drawing for too long without taking a break. Every now and then stop, let your mind wander a little and examine what you have done from a distance.

CHOOSING A SCENE

Choosing a scene to draw from life is fairly difficult, because only rarely do you manage to catch it in ideal conditions so that it is more than just generically interesting. If you are studying particular features (for example, trees, clouds or water) or carrying out a simple technical exercise, all you have to do is to observe the individual element carefully. But if your drawing is to be followed by a more complex one in preparation for a painting, or aims for an aesthetic meaning of its own, or is intended to analyse the complexities of perspective and composition, you need to spend more time observing the scene carefully before you start drawing it. Do this even if your work will be limited to rough sketches to capture the basic elements.

PLANNING A SCENE

When you reach a spot that looks promising, do not settle for what you see immediately but, if possible, walk slowly in different directions looking at the scene from different viewpoints (for example, you could sit on the ground or stand on a low wall).

At each location draw quick little sketches that outline the main 'shapes' – light and dark – of the scene (sketch them without worrying about the exact shape of the objects, concentrating instead on their tonal contrast, their relative dimensions, and their proportional relationship); evaluate the 'format' of the drawing (that is, whether it is more effective as a landscape or a portrait). Organise the composition, and insert or eliminate certain elements (see pages 270, 272 and 284), choosing a close-up, detailed view or a panoramic, concise view.

The time you spend planning (observing, moving around, sketching, selecting, etc.) is not wasted. On the contrary, it is extremely useful as it solves perspective and compositional problems, highlights the feelings and emotions a certain landscape inspires in us, and lessens that 'fear of emptiness' we are all likely to feel when we are faced with a blank sheet and we do not know where to start.

LEARNING FROM OTHERS

It can be both enjoyable and informative to get together with fellow artists interested in drawing scenery and to go on outings. On these occasions each artist pursues his or her aims and keeps to his or her style, but the fact that everyone is working on the same subject, in the same conditions, using different media from slightly different viewpoints, allows interesting comparisons and useful exchanges of opinion, as people learn not only from their own experience but also from that of others.

LINEAR PERSPECTIVE

Perspective is a graphic method which represents spatial depth on a flat surface. In this chapter I have summarised the geometrical principles of linear perspective, whereby you achieve the effect of spatial recession through the decreasing size of the objects represented. Following these simple principles the artist can correct, or better understand, the 'intuitive' perspective naturally perceived by the eye.

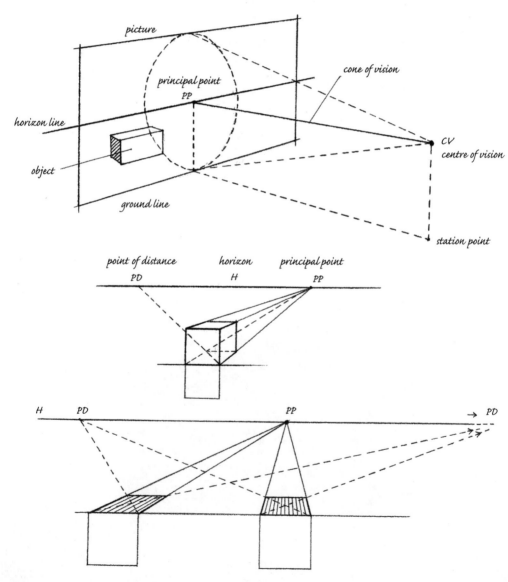

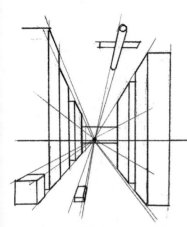

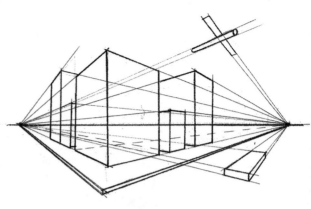

Central (or parallel) linear perspective is based on the principle that the non-vertical parallel lines converge on a single point in the distance. The horizon line always corresponds to the height of the viewer's eye and is determined by the viewpoint, i.e. by the position from which you are looking at an object or a scene.

Angular (or western) linear perspective, on the other hand, considers two vanishing points, positioned towards opposite ends of the horizon line. The objects (which for simplicity's sake are represented as geometric solids) are viewed from the side. Vertical lines remain vertical, but their height appears to diminish towards the horizon and they also appear to decrease in depth. Horizontal lines converge at one of the lateral vanishing points, showing the objects 'foreshortened'.

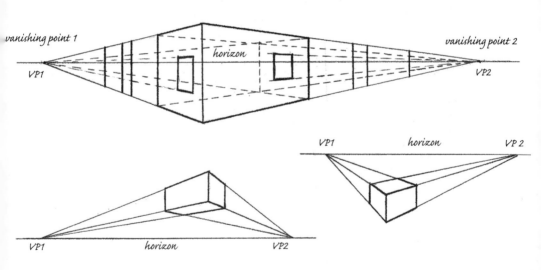

The sketch shown on the right outlines the basic elements that should be considered when drawing scenery. If you hold the drawing surface vertically you will find it easier to draw the horizon line; to compare it with life; and to find the vanishing points. Before sketching a scene – especially if you are going to include buildings and structures – draw a little perspective diagram, so that you can verify, and if necessary amend, what you have perceived intuitively. Remember, however, that perspective is a 'convention'; should not be applied too literally; and should be secondary to aesthetic values.

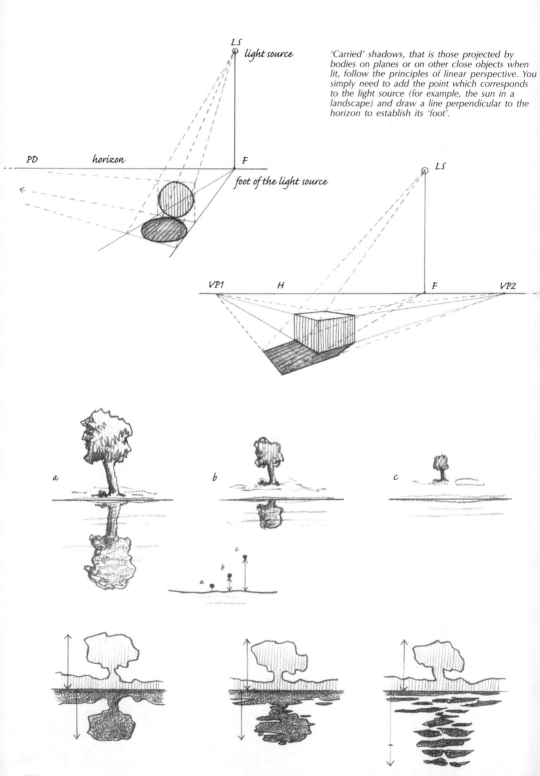

LS
light source

'Carried' shadows, that is those projected by bodies on planes or on other close objects when lit, follow the principles of linear perspective. You simply need to add the point which corresponds to the light source (for example, the sun in a landscape) and draw a line perpendicular to the horizon to establish its 'foot'.

PD horizon F

foot of the light source

LS

VP1 H F VP2

a

b

c

c

b

a

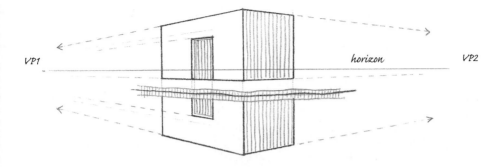

VP1 *horizon* VP2

Water mirrors the objects on its surface, and their outlines can be drawn following the rules of perspective, bearing in mind that the liquid surface is always horizontal. It is, however, extremely useful to observe carefully from life, as reflected images look different depending on the circumstances. They are almost mirror-like if the water is still; they break up if the water is slightly rough, and they almost disappear when the surface is very rough. The sketches at the bottom of page 260 show these effects, as well as the effect of the distance of the object from the water's edge.

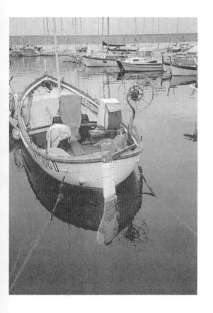

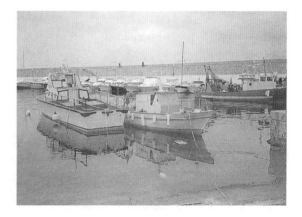

The photographs you see here can be used as a study aid to drawing reflections in some typical situations. My advice is to lay a sheet of tracing paper over the photograph, and draw only the outline of the boats or trees and their reflections on the water. These exercises will help your drawing greatly, especially if you are clever enough to outline just the main waves and breaks and leave out unnecessary fine detail.

It is good practice, especially when you have just started drawing scenery, to use photographs on which to identify and mark the main elements of perspective: the horizon line; the vanishing points and the spot where the visual lines meet them. If possible, take the photographs yourself and then compare their perspective analysis from life, at the exact location from which you took the photograph.

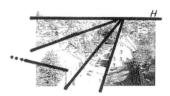

View from above: the horizon is at the top of the drawing.

Horizon in the middle: the lateral vanishing points are outside the edges of the photograph.

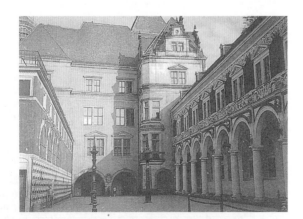

Central perspective.

The camera lens can distort the perspective of objects; careful comparison with reality will enable you to make the necessary corrections.

Central perspective.

View from below: the horizon is at the bottom of the drawing.

AERIAL PERSPECTIVE

Linear perspective does not allow a faithful representation of space within a scene, as objects do not simply seem smaller the further away they are. Their outlines lose sharpness and the air, dust and fumes that come between them and the viewer cause them to lose tonal value, especially where wide vistas are concerned. Tonal, or aerial perspective, takes into consideration these effects and is based on the principle that the elements of a scene, as they recede into the distance, and those close to the horizon, appear gradually lighter, more vague and somehow 'veiled' in relation to the objects in the foreground, near the viewer. The adjacent diagram illustrates this principle. Bear in mind, too, that in a drawing you can create the feeling of depth, of regressing in space, not just by weakening the tones but also by partial superimposition of objects or elements of the scene.

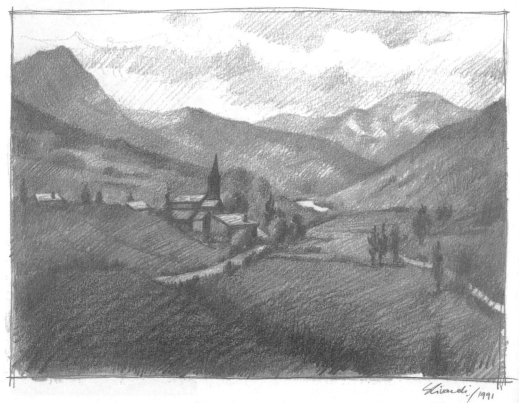

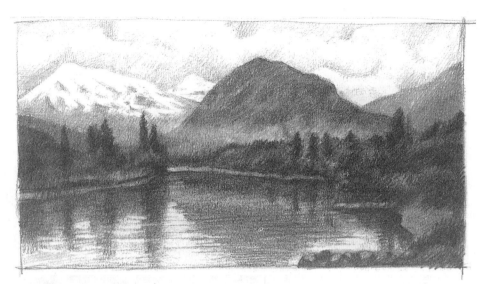

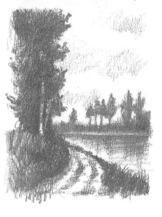

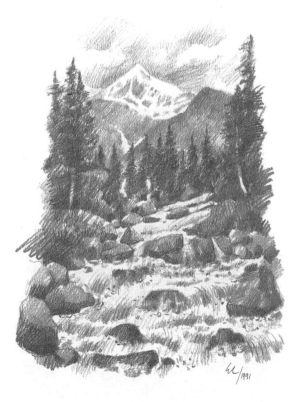

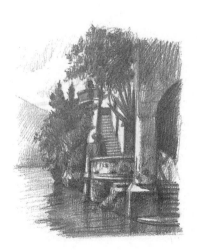

Try to find somewhere you can draw from life, or if this is not possible, take photographs similar to the scenes drawn or photographed in this book. If you cannot do this use one of the black and white photographs in this book or from another source. Study carefully the local tones, i.e. the various shades of grey in different areas, and simplify them. To do this, choose only three or four shades between black and the white of the paper. You can use a very soft pencil and make the mark more or less dark by varying the pressure of your hand. A particularly useful exercise is to put a sheet of tracing paper on top of the photograph, then outline the areas that appear to have the same tonal intensity. You may find it quite difficult at first but observing and practising will improve your perception and make the choice of tones in your subsequent drawings easier and more confident.

COMPOSING A SCENE

Composing a painting or a drawing means choosing and placing the expressive elements that are to be represented, and organising the way they relate to one another on the drawing surface. Composition depends to a great extent on the artist's intuition and 'visual' education, and is not bound by rules. It is possible, however, by observing works of art from the past or by experimental research, to work out a number of principles and tendencies which best suit our need for harmony and our perception of the environment. The sketches shown on this page are made up of non-figurative elements (as used in research), and review some fundamental principles such as unity, contrast, harmony, convergence, dispersion, etc. At the bottom are some linear 'sequences': horizontal, vertical, diagonal, wavy. Practise drawing similar sketches and try to check their emotional effect: some will inspire feelings of calm, and/or harmony, others tension, others still thickening or rarefying, and so on. On the opposite page I have shown solutions which give better aesthetic results to a number of compositional situations. Bear in mind that these are just suggestions, not rules.

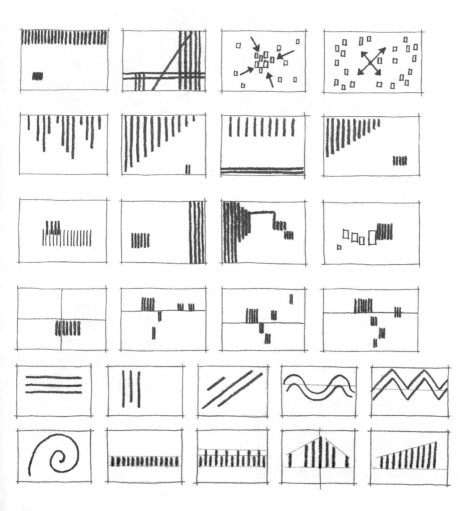

Avoid placing the subject at the centre of the drawing.

Avoid placing the horizon so it cuts the drawing into two equal parts.

Avoid dividing the image into two contrasting (black/white, full/empty, etc.) sections of a similar size.

Leave some 'space' around the subject.

Avoid rigidly symmetrical images.

Break the monotony of horizontal lines by introducing vertical elements.

Avoid lines which converge at the centre of the drawing.

Engineer 'lines of interest' which draw the viewer's eye to the inside of the drawing, rather than outside the edges.

CHOOSING A COMPOSITION

When you start drawing scenery from life you first need to choose a composition, based on the observations in the previous section. Composing a scene means evaluating it from different viewpoints in order to understand it in its various aspects and represent it in the most appropriate and satisfying way. Below are some small preliminary sketches and opposite, the viewpoint I have chosen for a more comprehensive study.

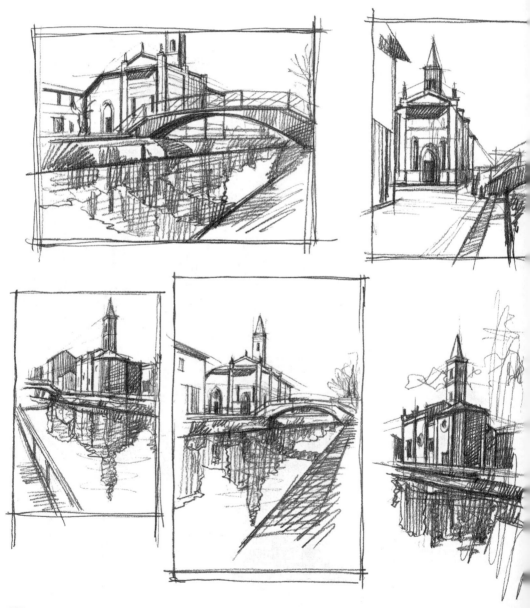

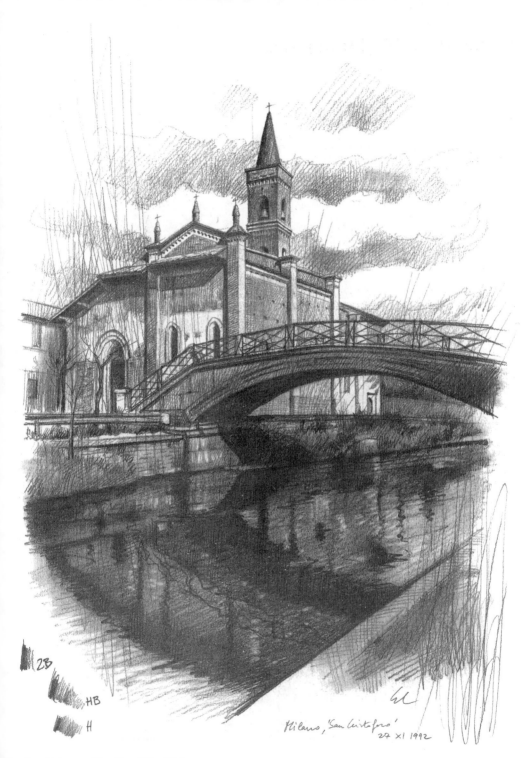

28

HB

H

Milano, 'San Cristoforo'
27 XI 1992

Pencil on Not paper, 33 x 48cm (13 x 19in).

DRAWING TECHNIQUES

FRAMING

Composing a scene is more than just choosing the right viewpoint. It involves deciding which elements should be put in the drawing, which to leave out or which to change in size or position. It also means 'cropping' the picture, that is choosing the size of the drawing; whether it should be portrait or landscape format and so on (see the diagram below as an example). You may find it easier to use a 'viewfinder' (a little rectangular window cut from a piece of card) through which, by moving it closer or further away from your eye, holding it vertically or horizontally, you can 'frame' the actual scene before deciding which view to draw. Many artists find it easier and more convenient to use an empty slide frame.

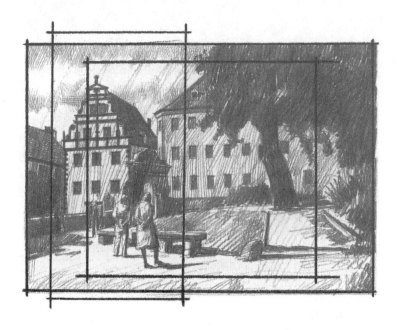

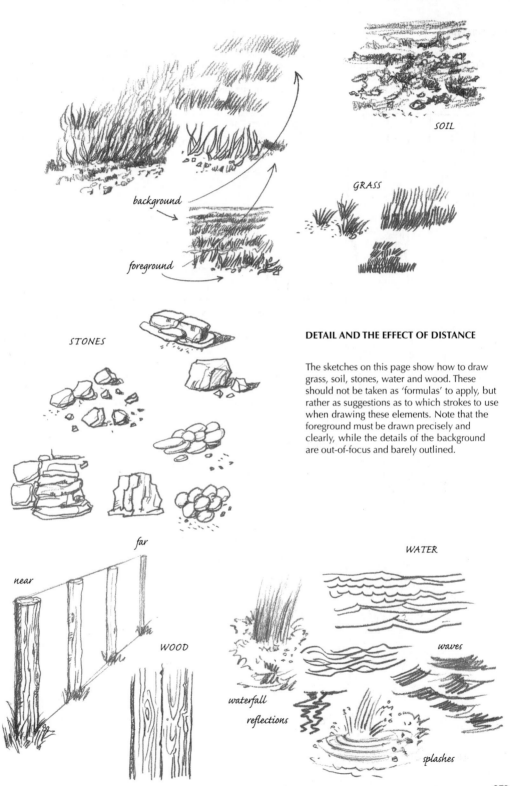

SOIL

background

foreground

GRASS

STONES

DETAIL AND THE EFFECT OF DISTANCE

The sketches on this page show how to draw grass, soil, stones, water and wood. These should not be taken as 'formulas' to apply, but rather as suggestions as to which strokes to use when drawing these elements. Note that the foreground must be drawn precisely and clearly, while the details of the background are out-of-focus and barely outlined.

far

near

WATER

WOOD

waves

waterfall
reflections

splashes

LINE DRAWING

Line drawing can be used to 'build' a scene stage by stage. I start by sketching perspective lines, then outlining the individual elements. I then draw the most important tones and finally add more detailed tones. This is an analytical type of representation, suited to drawing with a pen or hard pencil. On these two pages you can see the four stages of a drawing I sketched from life while on holiday in Germany, when preparing this book. The finished drawing is on pages 276-277.

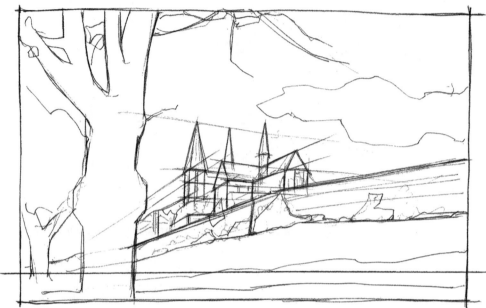

Stage 1 Perspective lines sketched in.

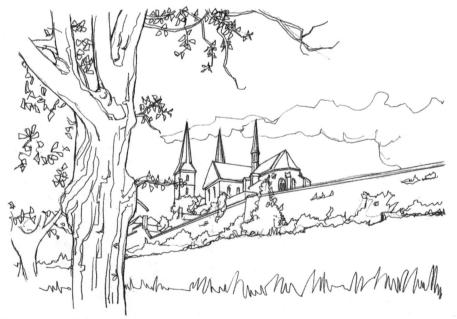

Stage 2 Individual elements of the scene outlined.

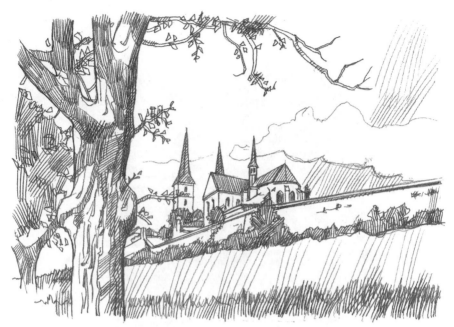

Stage 3 *The most important tones outlined.*

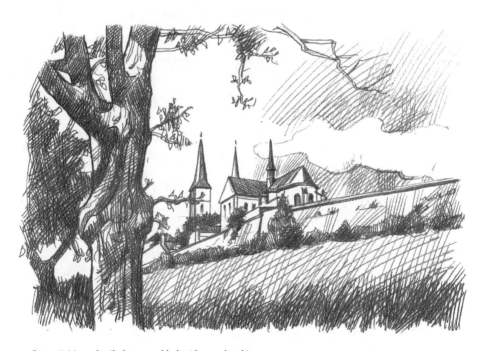

Stage 4 *More detailed tones added with crosshatching.*

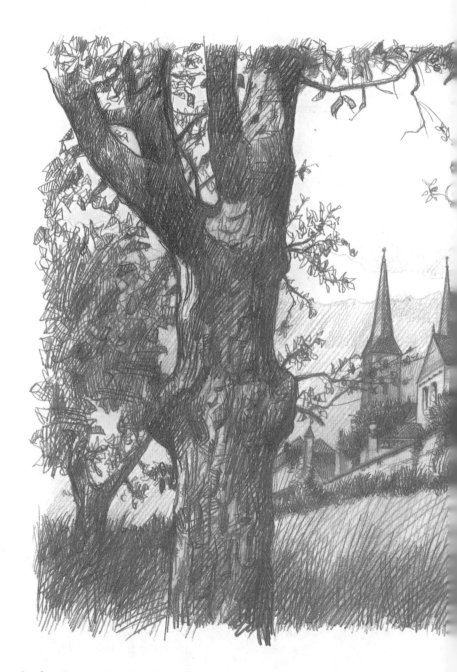

Pencil on Not paper, 33 x 48cm (13 x 19in).

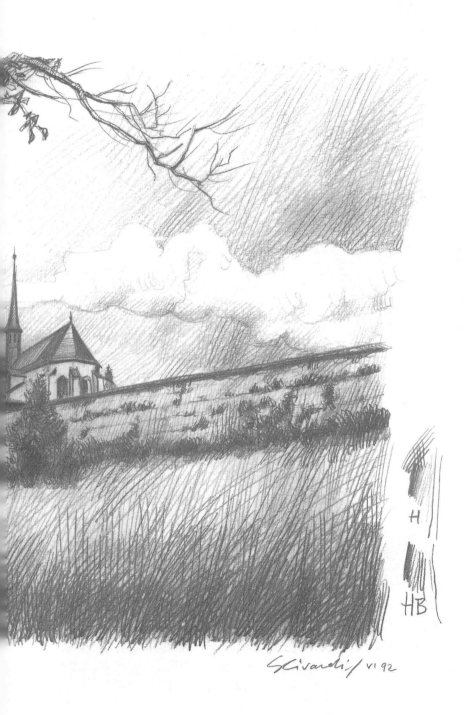

H

HB

SGirardi/ VI 92

TONAL DRAWING

Compared with the more 'graphic' line drawing approach, tonal drawing is definitely pictorial. It concentrates on representing the 'shapes' that make up a scene, with a unitary, structured approach which pays more attention to the interplay of tonal values than to minute detail. It is an approach which works well with soft graphite, charcoal, watercolours or mixed media, all of which are well suited to the tonal shading typical of aerial perspective. To demonstrate this method I have, again, included four successive stages and on pages 280-281 the finished drawing. My advice is to try both the linear and tonal approaches, regardless of which style you prefer, and apply them to the same scene, in order to weigh up their different expressive characteristics.

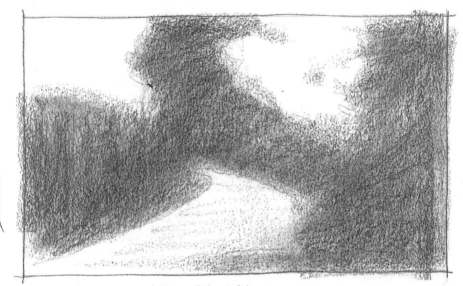

4B

Stage 1 *Rough representation of the overall shape of the scene.*

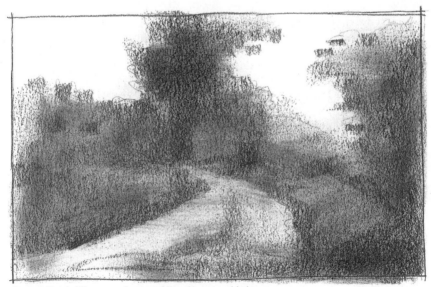

Stage 2 *Tonal differences of some of the elements added.*

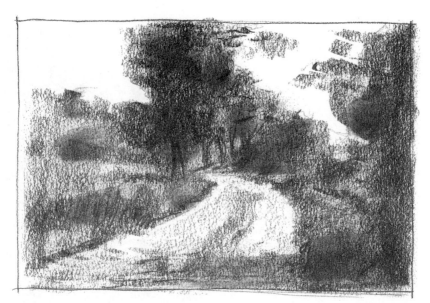

Stage 3 *More tonal 'depth'.*

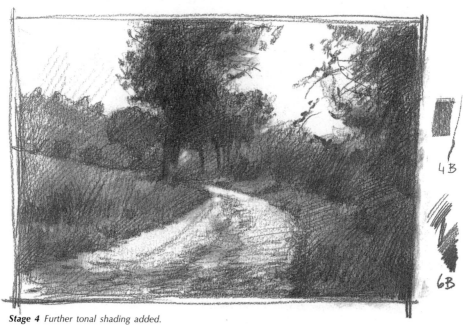

4B

6B

Stage 4 *Further tonal shading added.*

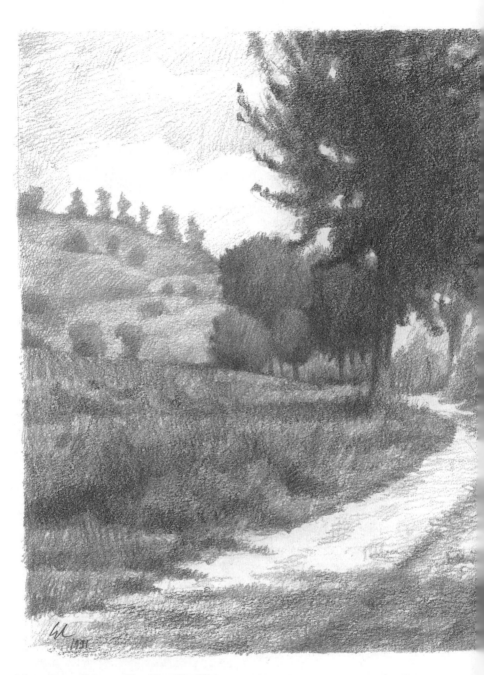

Soft graphite on Not paper, 33 x 48cm (13 x 19in).

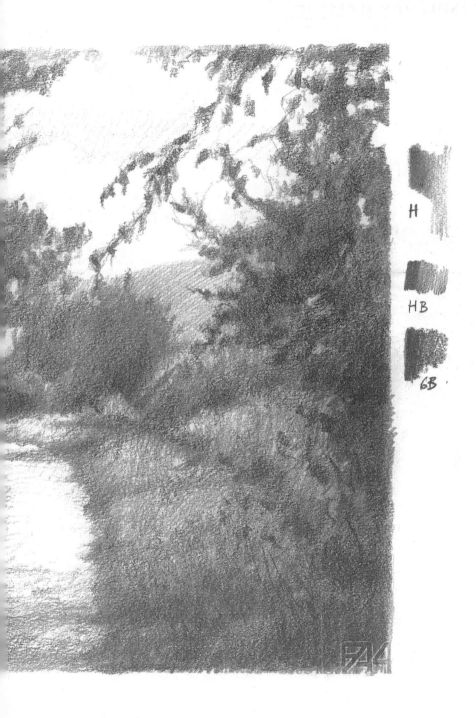

H

HB

6B

PRELIMINARY STUDIES

Drawing can be an autonomous means of expression, with its own intrinsic qualities and values, or it can be a clever tool to study reality, to make visual notes, and to solve compositional problems. It can be, in short, a 'preliminary' study, done as preparation for a more complex work, whether another drawing or a painting.

On this page I have put together some drawings sketched from life on a landscape theme: note how I have 'moved around' the subject, looking for the most suitable viewpoint; how I have tried to replace, eliminate or move certain elements (houses and trees); how I have observed in more detail the architecture of a little cottage, and so on. When going on country walks, always carry a pencil and a pocket sketchbook and draw lots of sketches which will prove useful as visual notes, when you set out to paint or conjure up complex scenes. Many artists also carry a camera which is indispensable for collecting a library of reference scenes and details – but remember that photography is a tool, not a substitute for drawing.

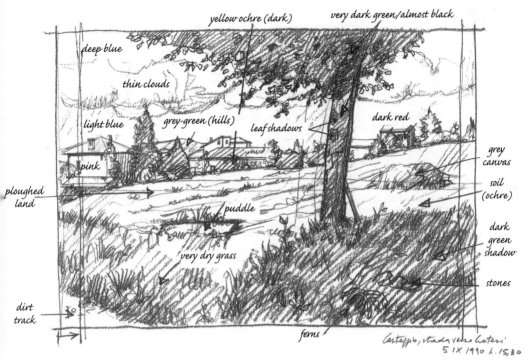

very dark green/almost black

yellow ochre (dark)

deep blue

thin clouds

light blue

grey-green (hills)

leaf shadows

dark red

pink

grey canvas

soil (ochre)

ploughed land

puddle

dark green shadow

very dry grass

stones

dirt track

ferns

Castegpo, study verso Coteri
5 IX 1990 h. 15,30

When you sketch a quick preliminary study in preparation for a painting, take down plenty of information on colours, details of the surroundings, the structure of complex elements, light and weather conditions, etc.

To enlarge a little sketch or photograph to the size wanted, you can use a simple tool called a 'grid of squares', which allows a quick and accurate transfer of the main outlines of an image. It is an intuitive process. Draw light parallel lines to subdivide the original surface into small squares and then transfer the same number of squares on to the canvas, or a bigger sheet, as indicated on the diagram on the right. It is easy to draw on each square the corresponding strokes from the original. The whole drawing will be enlarged in proportion.

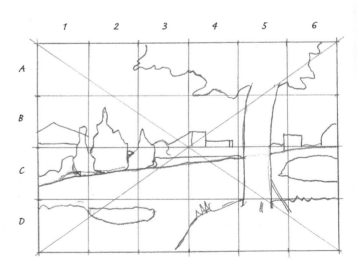

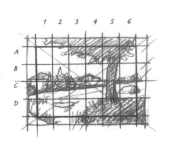

DETAIL

If you have already experimented with drawing scenery, you will have
realised that not everything you see lends itself to drawing. For instance, a
large scene can be enchanting with regard to colour, yet look insignificant
when we try to draw it. Or the opposite can happen, whereby an apparently
unattractive landscape turns out to be unexpectedly interesting when we
start drawing it. The same principles can in part be applied to photography.
This is, in effect, an extremely complex problem to do with visual
perception, psychology and artistic experience. The main difficulty,
however, lies in transferring three-dimensional reality to a two-dimensional
surface without losing the scene's feeling of depth. Sometimes one or two
elements from a large scene can be worked up into an effective drawing of
their own. In the 'panoramic' drawing shown below, the foreground has
limited prominence, is part of the total scene and even the sharpness of the
detail is secondary to its tonal and perspective relationship with the other
elements (rocks, sea, and so on). The same foreground (opposite), taken out
of context, acquires an importance and graphic meaning of its own and
requires a more detailed rendering.

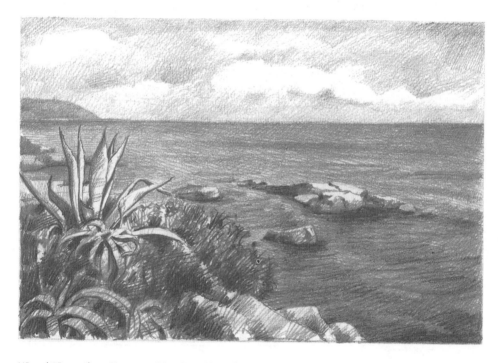

HB and 2B pencils on Not paper, 28 x 19cm (11 x 7° in).

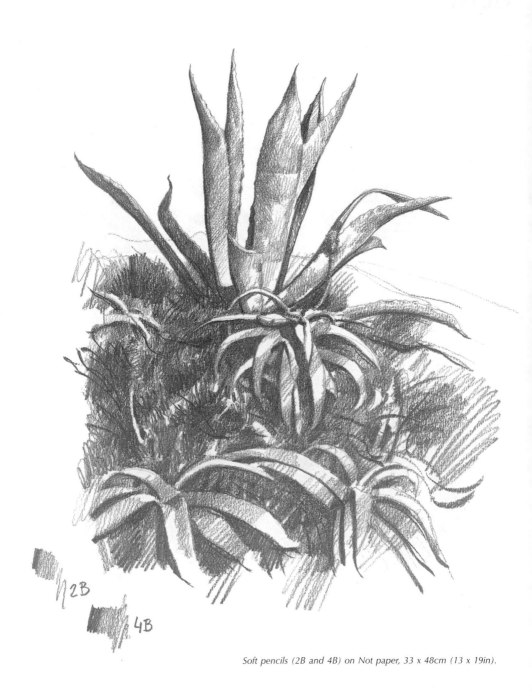

Soft pencils (2B and 4B) on Not paper, 33 x 48cm (13 x 19in).

LIGHT

As light is of prime importance to the artist, you should pay a lot of attention to the sun's effect on a scene. The direction of the shadows varies according to the time of day, as shown in the diagrams below, and in the sketches on the opposite page. If possible, look at the same scene in different weather conditions – broad sunlight; dimmed by clouds; rain; snow; fog and so on.

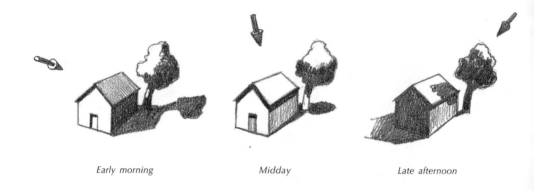

Early morning *Midday* *Late afternoon*

Direct sunlight with cloudless sky.

Indirect sunlight with cloudy sky.

Hill scene sketched in autumn, in the first hours of the morning. At dawn, the sun is low on the horizon and creates long shadows with weak tonal contrasts as the atmosphere is bright and clear.

The same scene drawn at about midday. The sun is almost vertical and creates sharp shadows at the foot of the objects (houses, trees, etc). The tonal contrasts are fairly strong; the whole landscape appears brighter and colours are at their most intense.

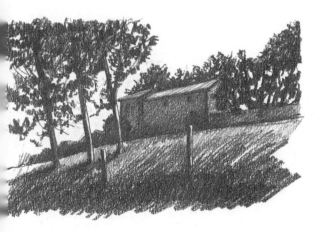

The same scene drawn in the late afternoon. At sunset the sun is again low on the horizon creating strong, long shadows and causing a strong tonal contrast between the sky (very bright) and the other elements of the landscape (dark because of the shade) silhouetted against the light.

WATER

Water can also be an important element of a scene. I have already mentioned the perspective problems of reflections (pages 260 and 261) but here I suggest you simply study water in those situations which are of compositional interest: waves; boats in the harbour; ponds; fountains; streams etc. Waves are caused by wind and reach various heights. When they come close to the shore they look like those shown in the sketch below. The 'crest' juts out in front of the wave and then falls upon it, forming the characteristic breaker which dissolves into foam. When you draw the sea, do not attempt to compete with a photograph in its meticulous representation of detail, but rather suggest the feeling of perpetual movement by drawing short, sketchy strokes in a horizontal direction.

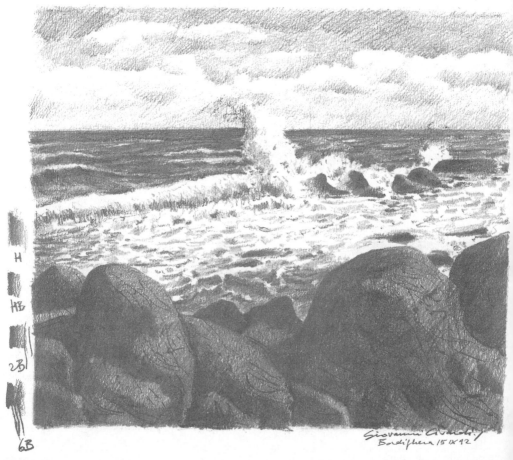

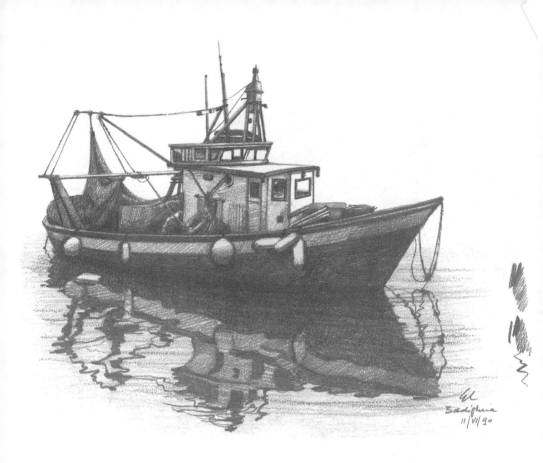

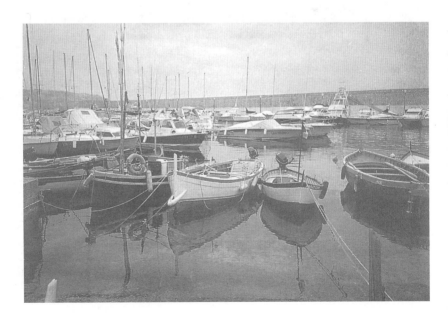

Small ponds and fountains in public parks and gardens are subjects which are both picturesque and easy to find. Practise interpreting these photographs using various media (charcoal, pencil, watercolours, etc.), enlarging them using the 'grid of squares' technique (see page 283), and then look for similar subjects in your own neighbourhood and draw them from life.

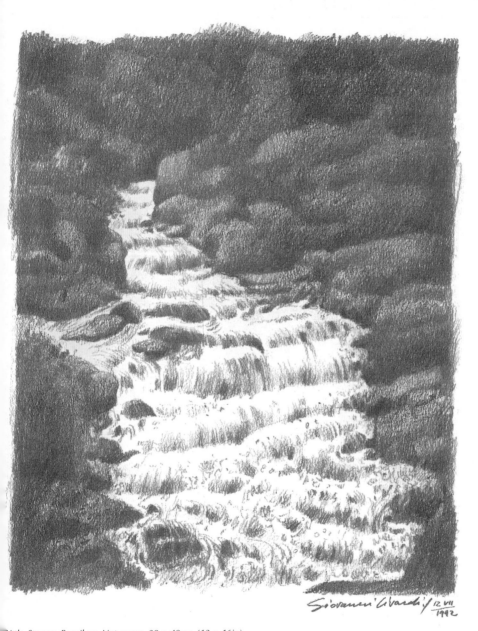

*Little Stream. Pencil on Not paper, 30 x 40cm (12 x 16in).
Short pencil strokes in the direction of the current are
enough to suggest the waterfalls and the water breaking
on the rocks.*

TREES AND VEGETATION

In almost all landscape drawings you will have to represent trees, woods, shrubs and flowers. Vegetation is extremely varied and you need to study it carefully from life to be able to draw it convincingly. Here I limit myself to a few suggestions. When drawing a tree, notice first its general shape, especially its outline (see the sketches on the opposite page); try to understand the direction its trunk and main branches grow and the structure of its bark and leaves. Then I suggest you follow these three stages: firstly, outline the profile; secondly, indicate the most relevant, yet significant, subdivisions of the foliage, and thirdly, sketch some of the foliage detail.

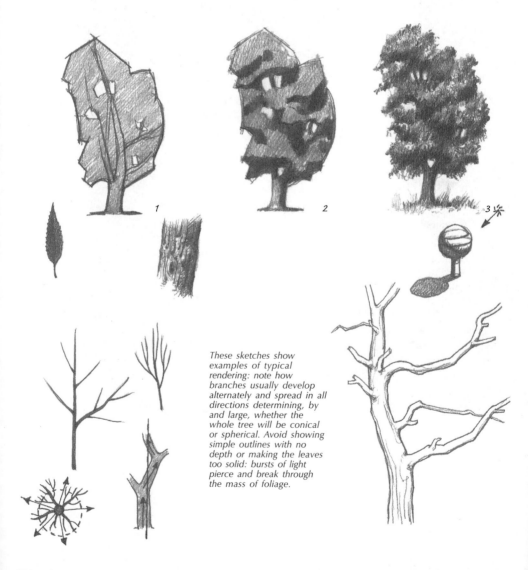

These sketches show examples of typical rendering: note how branches usually develop alternately and spread in all directions determining, by and large, whether the whole tree will be conical or spherical. Avoid showing simple outlines with no depth or making the leaves too solid: bursts of light pierce and break through the mass of foliage.

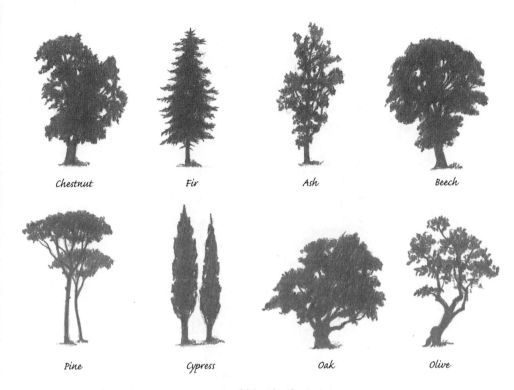

| Chestnut | Fir | Ash | Beech |

| Pine | Cypress | Oak | Olive |

The characteristic outlines of some common trees (useful for identification).

The photographs below show the same tree taken in winter, after shedding its leaves, and during its spring blooming. Carefully compare the two pictures and notice the radical transformation which has taken place.

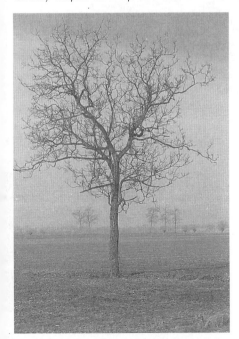

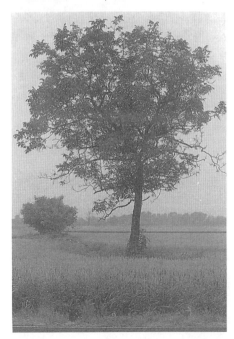

6B pencil on Not paper, 35 x 35cm (14 x 14in).
Trunks are fascinating subjects to draw. Understand their structure and general
direction, then examine the texture of the bark. Use soft grade pencil or charcoal.

Trunks and branches evoke almost abstract shapes.

Grasses and shrubs.

Trees on the edge of a Wood. Pencil on paper, 25 x 30cm (10 x 12in).

Compare the drawing with the photograph below, which shows the subject from a slightly different viewpoint.

BUILDINGS AND STRUCTURES

It is rare to find a scene which doesn't feature something man-made, whether it is a house, bridge, road, or farm machinery. You will have to place these elements in your drawing. When drawing buildings, start with a thorough perspective sketch to highlight architecture, monuments and urban vistas. Buildings in the distance should be sketched in broad shapes, without much detail, while those in the foreground must be drawn precisely. Bear in mind the relative proportions of people to buildings. The adjacent diagrams show the relationship between a man's height and the door, window, and front elevation of a house.

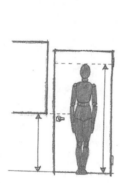

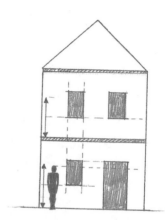

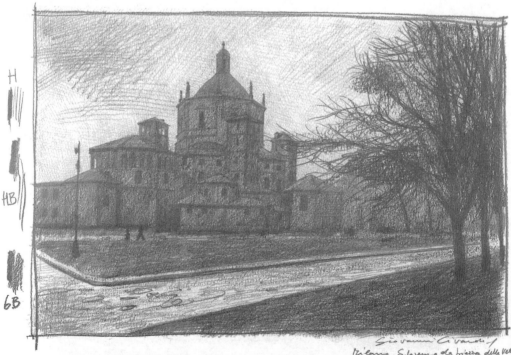

Practise drawing the details of buildings close up. This helps you to understand construction methods and to notice the characteristics of different materials (wood, brick, metal, stone etc.)

Dormer window

Chimney

Door and small window of an old Tuscan house. The position of the window, which looks odd at first, makes sense when it turns out to be the skylight of a staircase. Study these curious characteristics from life – you will often come across them in old country houses.

Brick

Massive rock wall and low stone wall. The materials of each are similar but the dimensions are quite different. In many cases it is necessary to introduce elements of scale (in this case, a man and a flower).

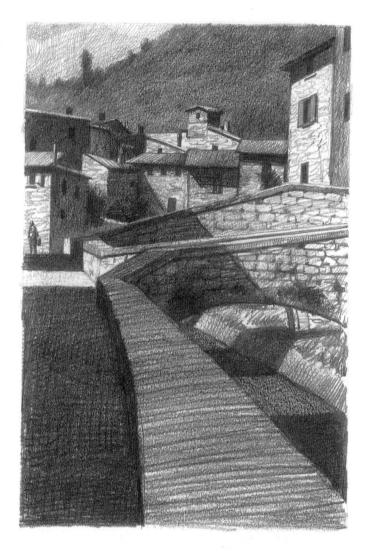

I sketched this little pencil study in a village in Tuscany. What appealed to me was the unusual perspective of the vista. The architectural elements are secondary to the geometric rhythm of the houses, and to the alternating of light and shade. The hilly background is rendered out of focus by finger-smudging the pencil strokes, while the other planes are defined more clearly as they get closer. You can see the texture of the stones in the wall of the little bridge, but I barely hinted at these details when drawing the walls of the houses in the distance. I crosshatched with a soft pencil to achieve increasingly darker tones.

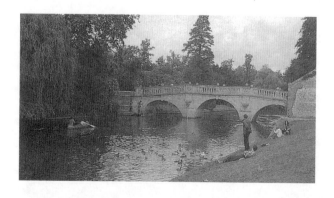

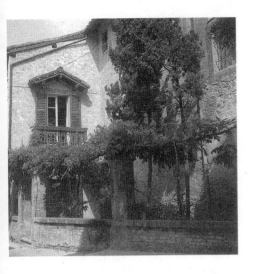

During walks in search of interesting urban scenes, take some photographs but, above all, draw plenty of sketches.

CLOUDS AND SKY

Clouds' shape, consistency and position change so rapidly that only by observing their natural appearance carefully can you work out how to represent them convincingly. The sketches below will help you recognise the various types of clouds, and point out features useful for drawing. Draw close strokes in soft pencil using even pressure and blending well. Smudging is not necessary, except to achieve soft and misty effects, as it is better to keep a certain shape and structure to clouds.

Cirrus *have a stringy or 'necklace-like' appearance. They are found at very high altitudes.*

Cumulus *appear as banks of partly superimposed clouds with a rounded outline. They are found at low altitudes.*

Nimbus *are very dense formations with a jagged outline, very tall and dark. They are found at low altitudes.*

Stratus *appear thin and elongated and are found at medium altitudes.*

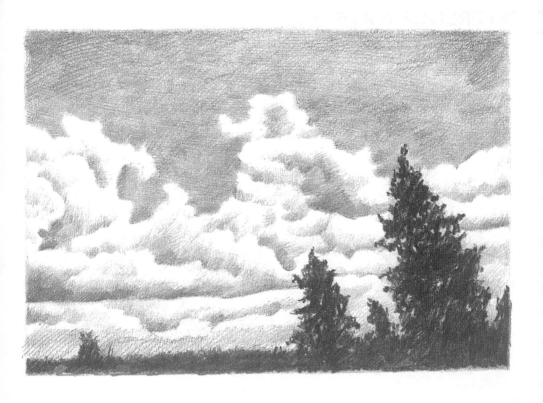

4B pencil on paper, 25 x 35cm (10 x 14in).
This study of a cloudy sky is partly based on photographs but also on many sketches from life. It highlights the tonal contrast between the dark tree-lined foreground and the intensely bright sky.

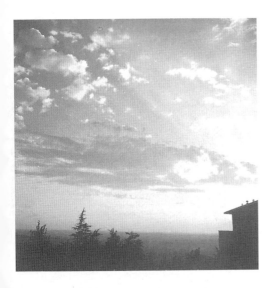

REFERENCE MATERIAL

I mentioned on page 282 how useful it is to sketch lots of little studies from life while you are out and about in search of views to draw. I believe that drawing, even a quick sketch, has invaluable meaning for the artist. However, photographs can be useful for collecting reference material when we have limited time at our disposal or we need to capture fleeting images. Do not neglect, then, to take plenty of photographs. Bear in mind the drawings you will make from them and choose viewpoints and compositions accordingly.

Interno di giardino

Gondola a Venezia

San Gimignano in controluce

The sketches and photographs you
see on these two pages come from
my 'visual notes' file in which, over
the years, I have assembled a large
and varied collection of themes and
subjects related to landscapes,
seascapes and buildings.

FIGURES AND ANIMALS

If you want to draw the surrounding environment and scenes of everyday life you will need to introduce figures and/or animals. These subjects are as fascinating as they are complex to draw. For the moment I would like to reassure you by saying that, in drawing scenes human beings do not usually need more attention than the other elements. You should pay particular attention to scale (note that the total height of a person corresponds to seven and a half times the height of their head); the overall look, and characteristics of the subject.

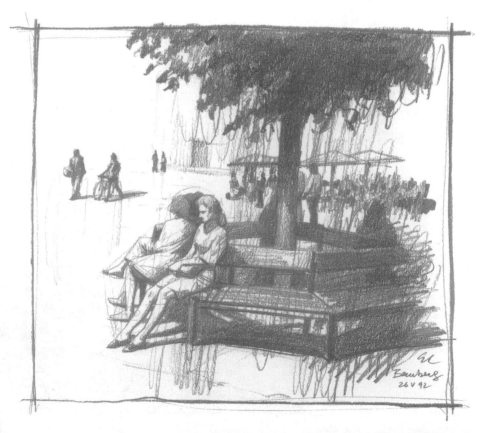

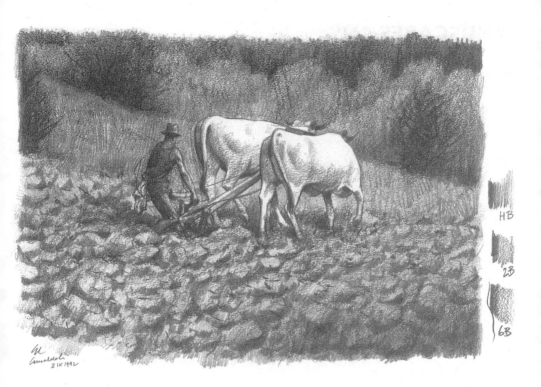

HB

2B

6B

When you need to add figures to a scene you can, at least to begin with and to simplify any problems, refer to good photographs. Start with a detailed sketch, possibly with the help of a 'grid of squares' and use hard pencil on medium size paper. With practice, and once you feel fairly confident, you can move on to doing studies from life. On these two pages I have compared each sketch, drawn fairly quickly, with a photograph of a similar subject which has lots of detail, sometimes secondary or unnecessary.

LANDSCAPES

Landscapes, with their wide open spaces, cultivated fields and gentle slopes, have always evoked in the artist and the viewer alike a feeling of natural peace and human industry. More than other terrains, they epitomise man's work on the land. Try, then, to portray in your sketchbook features that are characteristic of the rural environment: ploughed or planted fields; trees, isolated or in a row; hedgerows; farmhouses; little villages, and clouds in the wide expanses of sky.

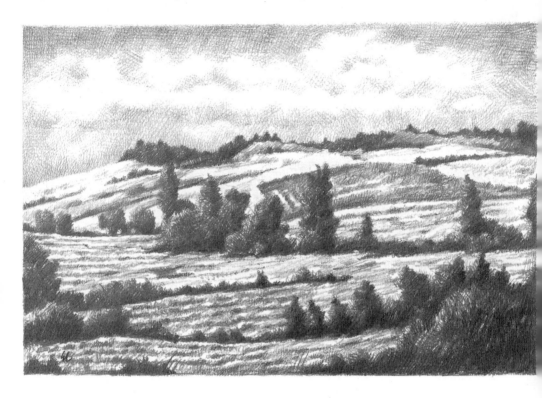

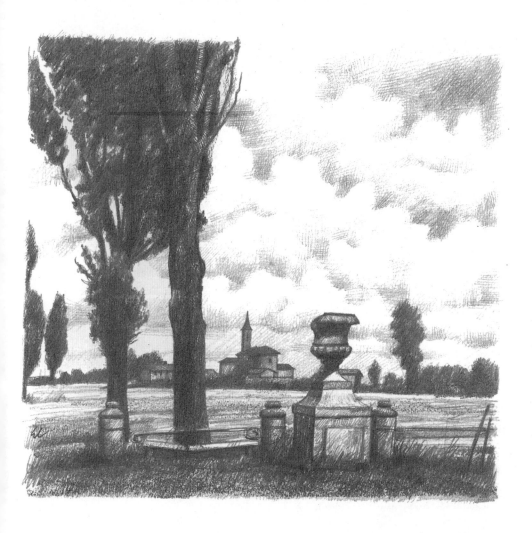

Pencil and charcoal are the ideal media for
drawing landscapes as they allow you to portray
their characteristics concisely, therefore
maintaining the effect of spatial depth. The
drawings on these two pages have been done
with 4B pencil on Not paper. Note the direction
of the pencil strokes which suggest, at intervals,
the terrain's uneven surface and the masses of
vegetation. The photographs show other subjects
you can take inspiration from.

SEASCAPES

The sea is the main subject of a whole genre of painting, the seascape, which also includes boats, ships, reflections, harbours, etc. Before you start drawing the sea, notice the direction and the formation of waves and how they break upon the shore. On a sheet of paper leave just a little room for the sky and concentrate your attention on the watery mass. The distant waves should be sketched concisely, with short, horizontal strokes, not too blended together. The waves in the foreground, however, require a more accurate 'build-up' with short and well-defined strokes suggesting, by their direction, the shape of the wave. Soft pencils and charcoal are both suitable for drawing the sea but watercolours are best at capturing the 'liquidity' of the subject. Keep your drawing simple and concise, avoiding minute, photographic details which weaken the overall structure of the study.

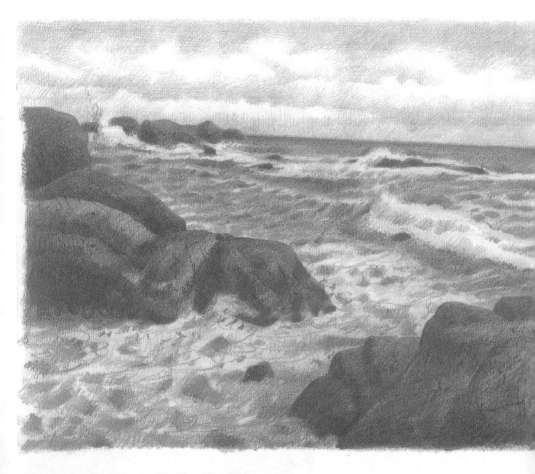

HB and 4B pencil on Not paper, 30 x 33cm (12 x 13in).

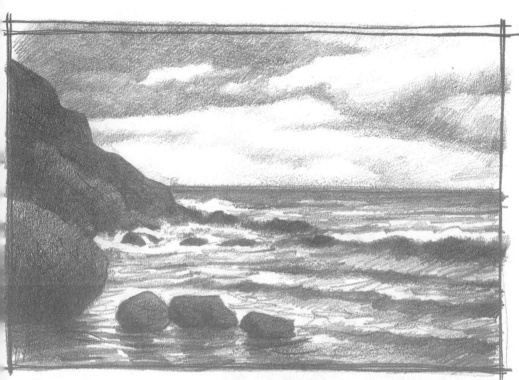

Study in preparation for a painting. 6B pencil on paper, 20 x 32cm (8 x 12°in).

URBAN AND INDUSTRIAL LANDSCAPES

Nearly all of us live in built-up areas – cities, towns or villages. The artist can find many interesting themes in the urban landscape – ancient or very modern buildings, monuments, glimpses of traffic-packed streets, squares, tree-lined avenues, etc. Every city has spots which are 'characteristic'. Do not be afraid that you will end up with banal or 'postcard-style' sketches if you tackle very well-known subjects. Rather, try to convey something of the historic and social atmosphere of a place. Successful artists find unusual features even in well-known tourist spots, which need extra attention if one is to avoid being repetitive.

Go to the outskirts of big cities and you will find
factories, plants, gasometers, railway tracks etc, often
bathed in fumes and mist, the irregular and unusual
shapes of which will present many possibilities. They
may lack the romance of a traditional landscape, but
they have their own beauty, their own expressive
power which justifies a figurative work, especially if
you succeed in conveying the characteristic
'atmosphere' of these places. Try using pen and ink
and practise drawing, taking your inspiration from
photographs or life. After you have done a few little
sketches to sort out any perspective or compositional
problems, do a concise but accurate, light drawing on
a sheet of good quality paper of average size using
pencil. Then working with a pen, using it freely and
fluently, draw the outline of the buildings. Finally,
introduce shadows by crossing or thickening the
hatching or staining with diluted ink.

MOUNTAINS

Only by visiting one of the bigger mountain ranges can you fully appreciate the impressiveness of mountains. The sculptural power of these masses of rock, the contrast between the brilliant white of the snow and the dark shadows of the crevices and the cracks, and the sloping woods and meadows, provide many potential scenes and call for clean drawing, rich in tonal contrasts. Use a soft pencil (charcoal and pen are less effective) and fairly rough paper, pay attention to aerial perspective, and make sure you deal with the various elements differently (rock, grass, trees, snow, ice, etc.). For example, when drawing rocks, especially in the foreground, you need to hint at their rough, irregular texture with hatching or cross-hatching, dotting and the odd mark; short, vertical pencil strokes work well for meadows and trees; lit patches of snow can be suggested by leaving the paper white while strengthening some of the shadows to give thickness and texture to the mantle.

The Dolomites in Summer. Soft pencil on paper, 30 x 40cm (12 x 16in).

DRAWING LIGHT & SHADE

Chiaroscuro generally refers to the graduating tones, from light to dark, in a work of art, and the artist's skill in using this technique to represent volume and mood. Chiaroscuro has been used to suggest form in relation to a light source in the art of many civilisations – although it was unknown to early cultures such as the Ancient Egyptians. It came to the fore in western art, and particularly in Italy, during the 16th century.

Many elements can influence the way in which chiaroscuro is used: the relationship between its own components (light and dark); the relationship with colour; the method of distributing the light and dark elements that characterise the composition and expressive quality of a painting; as well as social and philosophical attitudes. We can see examples of chiaroscuro in many of the works of the great artists: the blazing light and abysmal darkness of Rembrandt's etchings, demonstrating chiaroscuro elements 'of the soul'; a chiaroscuro in which light prevails over dark in the work of Giotto and Michelangelo; a pictorial chiaroscuro in which darkness prevails, but with the dark outlines shaded off, which tends to suggest a lively atmosphere around the volume of the bodies as in Leonardo; a tonal chiaroscuro, in which relations between light and dark are based on the quantity and quality of the light and shade that the colours absorb in themselves in the work of Titian and Giorgione; a luminous chiaroscuro, in which the contrast between the illuminated parts and shadowed parts is violent, intense and unusual as in the work of Caravaggio.

On the pages that follow I have tried to suggest some useful approaches to the complex topic of chiaroscuro by explaining the basic drawing techniques you will need and, especially, by suggesting methods of observation and experimentation. The play of light and shade involves any subject that can be portrayed, not only from a realistic or naturalistic view, but also, and perhaps more importantly today, in representation – in communicating emotions, moods, ideals, dreams, hopes and experiences.

LIGHT AND SHADE

Light is energy emitted from a light source – either natural or artificial: the sun, a flame, a lit lamp, etc. Because of it, we can see objects. Transparent bodies allow light to pass through them in varying degrees; opaque bodies do not allow light rays to pass through them. On opaque bodies, in particular, shadows are produced and they, in turn, can project shadows on to neighbouring surfaces. Very rarely a surface absorbs light completely, more frequently the light is, in varying degrees, reflected and diffused in the surrounding environment.

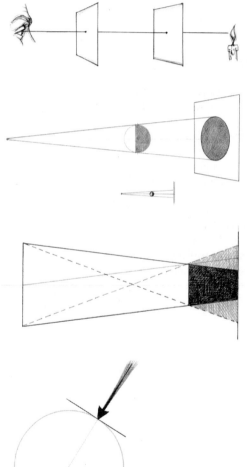

Rectilinear transmission of light and the formation of shadows

Light is transmitted in a straight line. A light ray is a line of light that travels to a given point. Beams of light are all the light rays that cross a given surface.

To demonstrate the linear transmission of light, place a couple of pieces of card, each with a small hole, between your eye and the flame of a candle.

A consequence of the rectilinear transmission of light is the formation of shadows and the way in which they are arranged. A tiny spherical light source produces a cone of light that projects, on a screen in the distance, the shadow of an opaque sphere placed in between.

Point of maximum luminosity on a spherical object

Consider the difference between the sun's rays as they reach Earth at the equator and poles: the intensity is strongest when the light ray is at 90 degrees to the surface on which it falls.

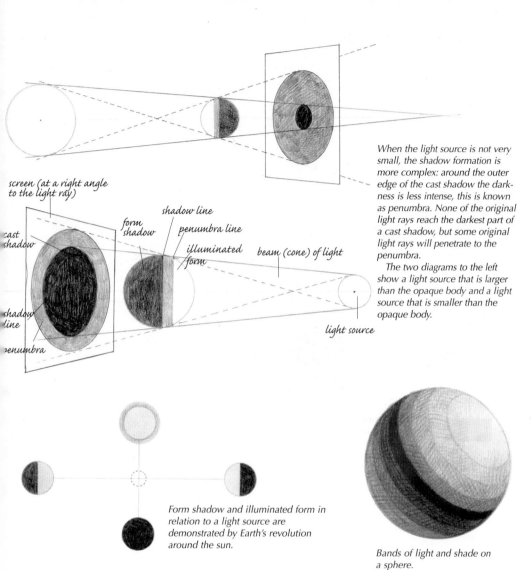

When the light source is not very small, the shadow formation is more complex: around the outer edge of the cast shadow the darkness is less intense, this is known as penumbra. None of the original light rays reach the darkest part of a cast shadow, but some original light rays will penetrate to the penumbra.

The two diagrams to the left show a light source that is larger than the opaque body and a light source that is smaller than the opaque body.

screen (at a right angle to the light ray)

cast shadow

shadow line

penumbra

form shadow

shadow line

penumbra line

illuminated form

beam (cone) of light

light source

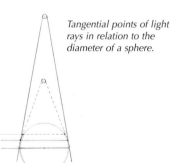

Form shadow and illuminated form in relation to a light source are demonstrated by Earth's revolution around the sun.

Bands of light and shade on a sphere.

Tangential points of light rays in relation to the diameter of a sphere.

Starting lines for form shadow on a sphere.

From the circle (outline) to the sphere (volume).

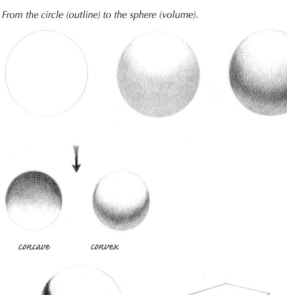

Form shadow and reflected light are, if not essential, at least very useful for suggesting the volume of an object.

concave convex

The three fundamental tones (white, grey, black or light, medium, dark) describe the apparent volume of objects, with both curved surfaces and flat surfaces.

Direction of form shadow and cast shadow of a rod and a sphere in relation to the direction of the light.

1 – frontal light
2 – lateral or side light
3, 4, 5 – light from above (with varying obliqueness)
6 – light from behind

1

2

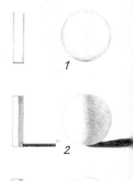

3

4

5

6

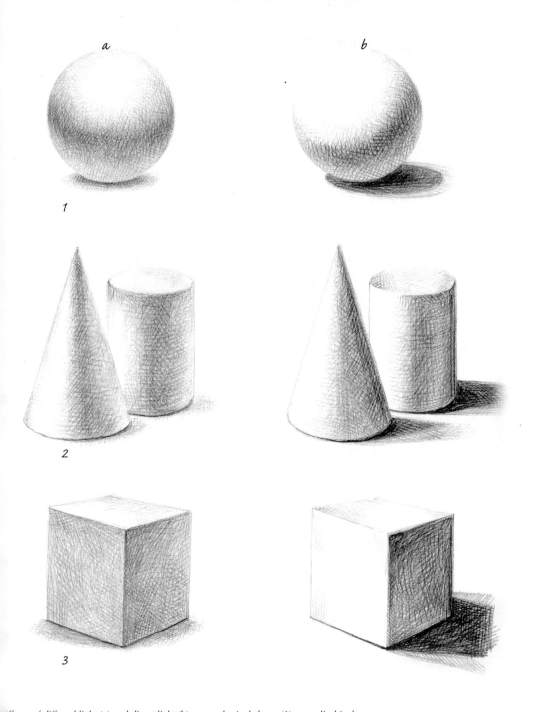

The lettering within the image:

a b

1

2

3

ffects of diffused light (a) and direct light (b) on a spherical shape (1); on cylindrical
nd conical shapes (2) and on objects with flat sides (3). Diffused light on a cloudy day
r example, produces less distinct form shadows and graduated cast shadows. Direct
ght, from an electric spotlight for example, produces both form and cast shadows that
re sharp and intense.

FORM SHADOW AND CAST SHADOW

If light indicates an object's shape, shadows define its volume. Form shadow appears on an object as a result of lighting. Cast shadow is that which the body casts on to other surfaces: neighbouring objects or planes. Cast shadow expresses the relationship between the object and the environment: its development and extension indicate the position of the light source, its nature, its intensity and the way in which the light rays hit the object. Form shadow nearly always contains reflected light, which comes from the environment and is very important for showing the volume of the object. Reflected light never has the same force as direct light, but lightens the form shadow in varying degrees. Consequently, the maximum intensity of this shadow is found along the shadow line, the boundary between the illuminated part of the body and its shadowed part.

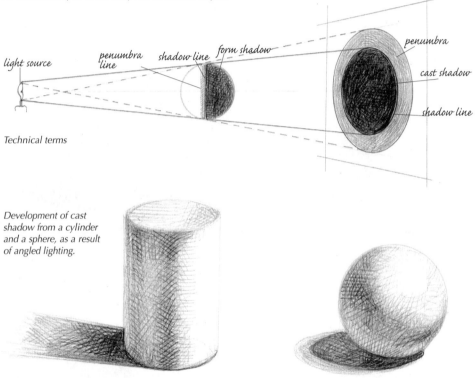

light source · penumbra line · shadow line · form shadow · penumbra · cast shadow · shadow line

Technical terms

Development of cast shadow from a cylinder and a sphere, as a result of angled lighting.

Types of lighting: form shadow produced by different directions of the light.

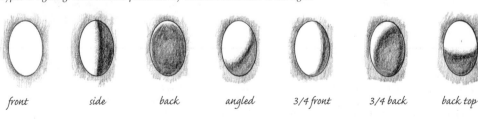

front · side · back · angled · 3/4 front · 3/4 back · back top

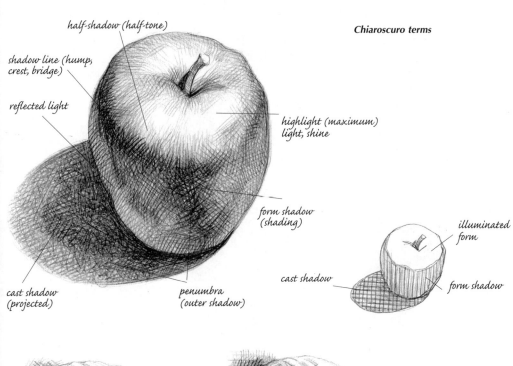

half-shadow (half-tone)

shadow line (hump, crest, bridge)

reflected light

highlight (maximum) light, shine

form shadow (shading)

illuminated form

cast shadow

form shadow

cast shadow (projected)

penumbra (outer shadow)

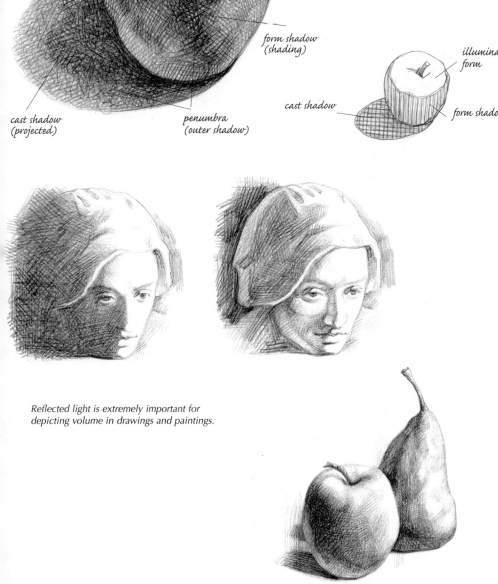

Reflected light is extremely important for depicting volume in drawings and paintings.

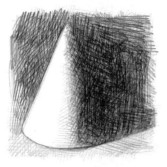

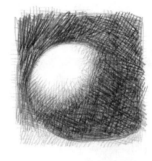

Simple geometric shapes such as a cone, sphere, or cube are ideal for practising the effects of light and shade.

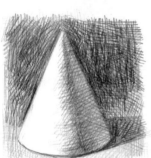

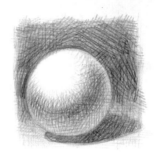

A practical way of estimating the height of a tall object on flat land is to measure its cast shadow and compare it to the length of a shadow cast by a measuring rod.

A cast shadow can profoundly alter the shape of the body that produces it.

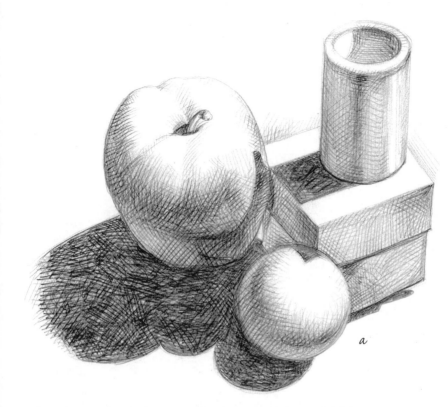

Form and cast shadow on simple objects exposed to direct natural light (a) and slightly diffused light, from a large window (b).

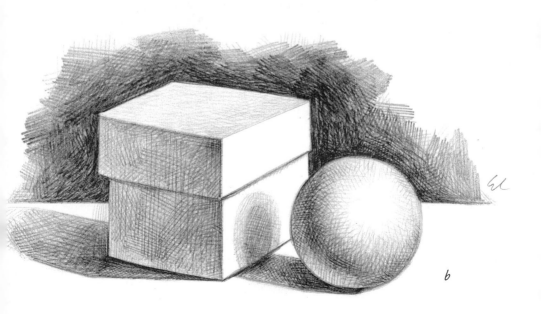

Stones and pebbles are good for studying the development of shadows cast by objects arranged in a complex way and by irregular shapes.

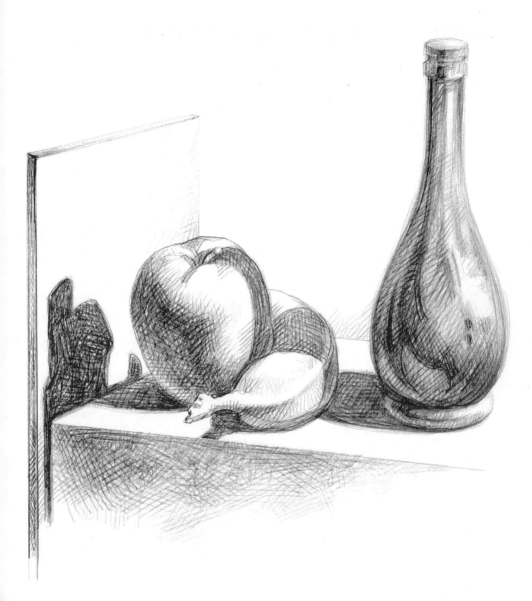

When drawing or painting a still life it is interesting to observe the development of cast shadows, apart from on neighbouring objects, on the surface it is arranged on and the vertical surfaces in the background as well.

PERSPECTIVE AND SHADOW THEORY

'Perspective' is the method of representing objects, landscapes, buildings or figures in order to suggest a sense of volume on a two dimensional surface. In drawings it represents the object just as it appears to the eye of the onlooker. Objects, as a result of lighting, produce shadows on themselves and on adjacent surfaces. The 'shadow theory' considers the objects and shadows in relation to the light source so as to establish, using perspective, the limits of form and particularly cast shadows.

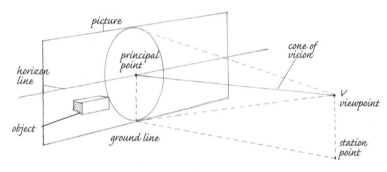

In linear perspective, a sense of depth is created by drawing objects progressively smaller as they go further away from the observer (viewpoint) and making them converge in a point (vanishing point).

Linear perspective is used in two ways: parallel linear perspective, where the object is seen frontally, and angular linear perspective where the object is viewed obliquely.

In parallel perspective the horizontal lines of the sides of a solid cube are arranged in depth lines that converge in a central vanishing point and are organised by distance points positioned on the horizon.

In angular perspective, the horizontal lines of the objects positioned obliquely converge laterally, on the horizon line, in two vanishing points.

In both cases the vertical lines of the objects remain vertical in the drawing.

By varying the level of the viewpoint we obtain different perspectives: from above, from below, etc.

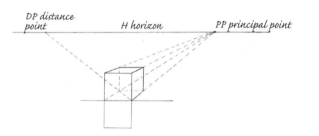

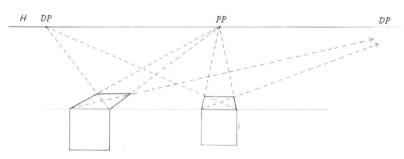

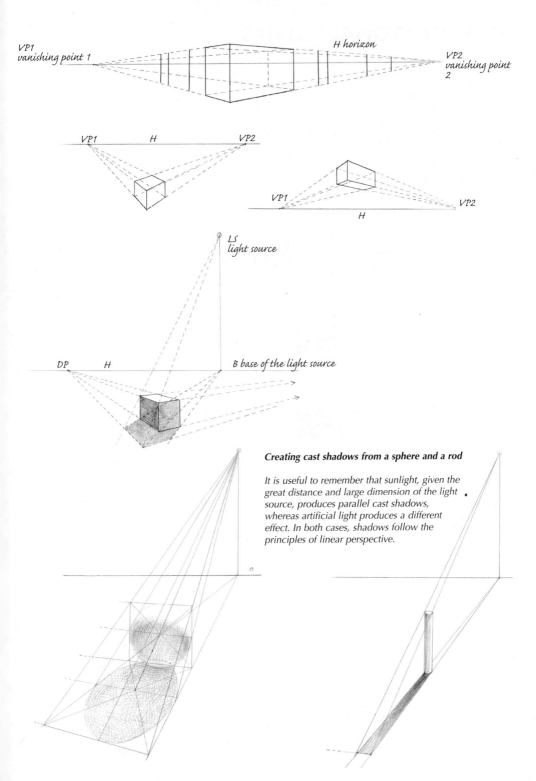

VP1
vanishing point 1

H horizon

VP2
vanishing point 2

VP1 H VP2

VP1 VP2

H

LS
light source

DP H B base of the light source

Creating cast shadows from a sphere and a rod

It is useful to remember that sunlight, given the great distance and large dimension of the light source, produces parallel cast shadows, whereas artificial light produces a different effect. In both cases, shadows follow the principles of linear perspective.

TONE AND TONAL VALUES

The term 'tone' refers to the intensity of an area; how light or how dark it is, irrespective of its colour. 'Tonal value' is the gradation of a tone in relation to other tones using a scale that ranges from white to black, the extremes of an intermediate series of greys. Tone is influenced by factors such as the intensity of the light in relation to the shadow (if the light is very bright, the shadow is very dark and the intermediate gradations are limited); the relationship with adjacent tonal values; the 'quality' of the light (natural, diffused, etc.); the presence of reflected light.

Tone is also the overall effect of light and shade on a surface, you could say the effects produced by the contrasts between light and dark, by the arrangement of light tones and dark tones or their simplification. All these methods will be mentioned later on and are used to establish tonal structure, a fundamental 'constructive' element of a drawing or painting.

white *light grey* *grey* *dark grey* *black*

in separate sections

in adjoining sections

Simplified scale of five tonalities. Our eye also perceives slight differences between similar tones according to whether they are side by side or slightly apart, surrounded by a dark or light surface, etc. These differences in intensity are mainly noticed along the 'contact' line between tonal areas.

gradual shading with continuous progression

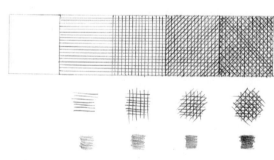

Cross-hatching is a simple technique for showing the various degrees of tonal intensity. Using this method you can progress from the white of the sheet of paper to the most saturated black.

In the sequence of five tones above the white represents maximum light; the light grey, direct light; the grey, diffused or reflected light; the dark grey, shadow; the black, maximum intensity of shadow.

Cross-hatching can 'follow the shape' using strokes that follow the direction of the longest sides or 'contrast the shape' using short strokes that go against the longest sides.

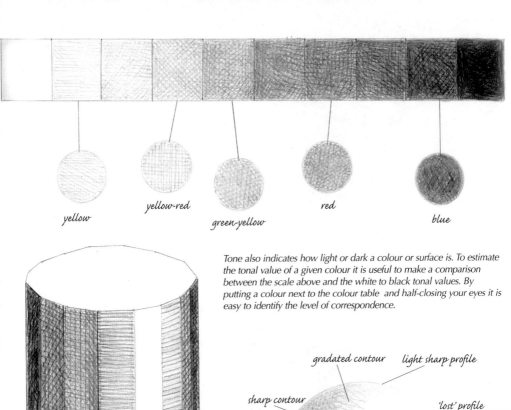

yellow yellow-red green-yellow red blue

Tone also indicates how light or dark a colour or surface is. To estimate the tonal value of a given colour it is useful to make a comparison between the scale above and the white to black tonal values. By putting a colour next to the colour table and half-closing your eyes it is easy to identify the level of correspondence.

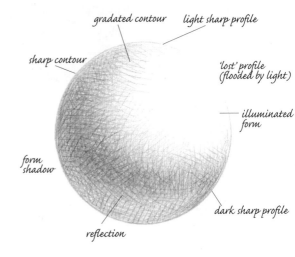

gradated contour light sharp profile

sharp contour

'lost' profile
(flooded by light)

illuminated
form

form
shadow

dark sharp profile

reflection

The sphere is the most suitable solid for highlighting characteristics that light produces on it and for suggesting a way to represent them graphically.

This cylinder and cone have been subdivided into tonal 'planes' (geometrically simplified areas in which a certain tonal value is considered uniform) in relation to the intensity of light and shade.

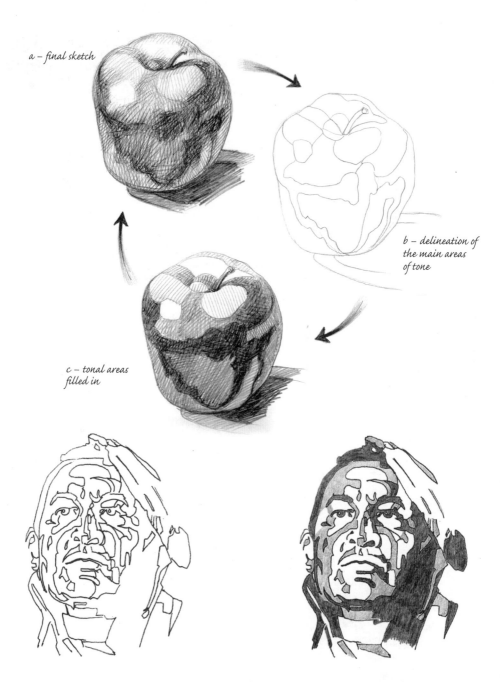

a – final sketch

b – delineation of
the main areas
of tone

c – tonal areas
filled in

Areas of equal tonal intensity. To practise 'seeing' the most appropriate tones
for portraying the volume of an object, it can be useful to single out and
outline the areas in which the tone appears to have uniform intensity.

In the sketch portraying the apple, for example, I have singled out five
important tones (although there are really many more) whilst, in the sketch
portraying the face of the Native American, I preferred to delineate the areas
relating to just three tonal values: white, grey and black.

Assessing the tonal areas of metal objects is particularly complicated because of the shiny, reflective surface. Yet it is a very profitable exercise in observation.

TONAL SIMPLIFICATION

In chiaroscuro, which is based entirely on the modulation of tones of shade, it is advisable to limit the range of tonal gradations to not more than eight or nine or even fewer if it is possible to do so without impoverishing the means of expression. This gives 'consistency' to the portrayed shape, which may be weakened by over-emphasising the shading.

Tonal sketches are a good way to practise recognising and simplifying tonalities (see page 359). This is how you can do it: half-close your eyes, single out the darkest areas, assess the most significant 'local' tones, remember the main intermediate tones from among them.

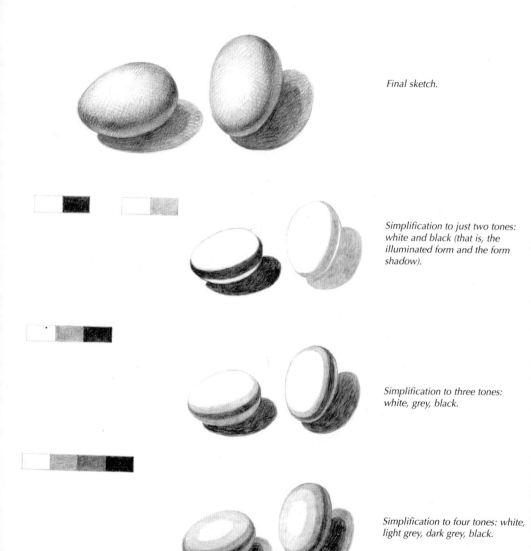

Final sketch.

Simplification to just two tones: white and black (that is, the illuminated form and the form shadow).

Simplification to three tones: white, grey, black.

Simplification to four tones: white, light grey, dark grey, black.

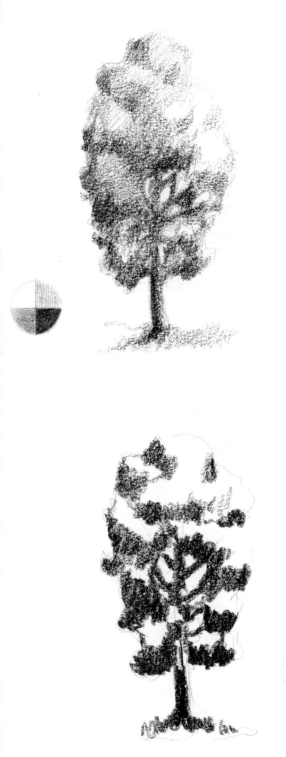

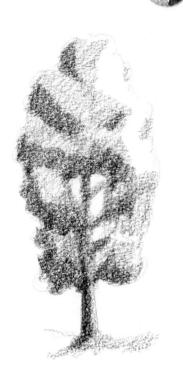

In drawing there are not many strict or binding rules (and it is wise to break them, sometimes, in order to understand their deeper meaning ...), but mainly principles of good technique, of experience, of visual perception. One way of sharpening your powers of observation for shapes and tones is to portray the same subject using a progressively smaller number of tonal areas (from four, to three, to two). Or you can do it the other way round, from extreme tonal simplification to a richer range.

GRADATION OF TONES

Gradating tones are the means by which we produce chiaroscuro. The procedure is sometimes called 'shading' or 'adding value'. It consists in portraying the volume of bodies using tonal variation by observing, recognising and comparing them to the different tonalities we see on the actual object. First establish the range of tones, singling out the area in which the tone appears darkest (for example, black or a certain degree of grey) and that in which it appears lightest (white) and the value of the dominant tone. Then, you can grade the intermediate tones, assessing the changes between the various tonal planes.

It is possible to introduce 'accents' (the lightest and darkest) at appropriate places, in order to best suggest the volume of the portrayed object with maximum efficacy. Delineation of tonal areas is only used as an observation exercise: in the actual drawing, the tonal changes should appear decisive but gradual, without sharp linear contours. The most intuitive technical procedure for shading is hatching, and some examples of the various ways in which it can be produced are shown on this page.

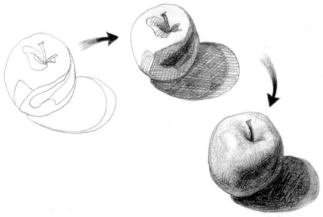

From singling out and filling in the main tonal areas to shading tones in chiaroscuro.

cross-hatching

irregular hatching

parallel hatching

dotting

continuous shading off

casual strokes

circular strokes

Dry leaves offer good opportunities for studying very fragmented chiaroscuro: small illuminated parts alternate with small shadowed parts, sometimes in unexpected ways, suggesting strange and curious shapes, not only in their form but in the shadows cast on the ground.

Shells are also interesting and complex models, suitable for studying complicated protrusions, recesses and grooves as well as areas of light and shade. Their surface is smooth and shiny in places: this helps us observe, on the same object, the various ways in which light is reflected as it falls on both rough and smooth surfaces.

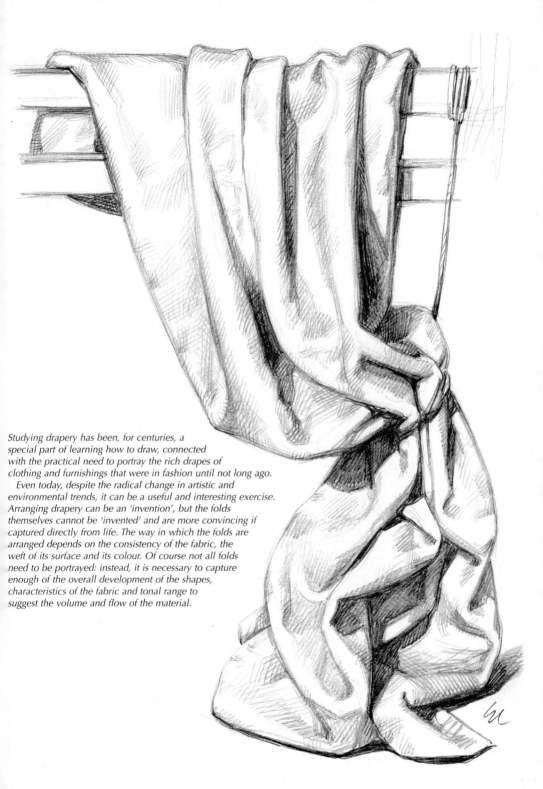

Studying drapery has been, for centuries, a
special part of learning how to draw, connected
with the practical need to portray the rich drapes of
clothing and furnishings that were in fashion until not long ago.
 Even today, despite the radical change in artistic and
environmental trends, it can be a useful and interesting exercise.
Arranging drapery can be an 'invention', but the folds
themselves cannot be 'invented' and are more convincing if
captured directly from life. The way in which the folds are
arranged depends on the consistency of the fabric, the
weft of its surface and its colour. Of course not all folds
need to be portrayed: instead, it is necessary to capture
enough of the overall development of the shapes,
characteristics of the fabric and tonal range to
suggest the volume and flow of the material.

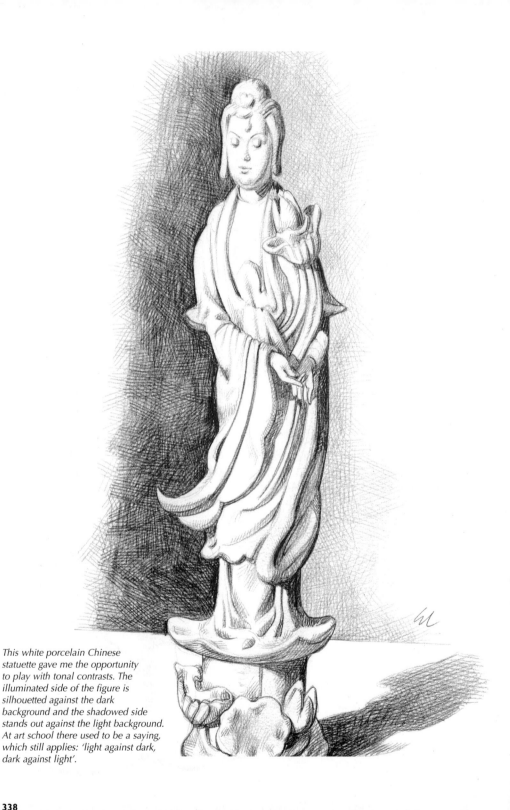

This white porcelain Chinese
statuette gave me the opportunity
to play with tonal contrasts. The
illuminated side of the figure is
silhouetted against the dark
background and the shadowed side
stands out against the light background.
At art school there used to be a saying,
which still applies: 'light against dark,
dark against light'.

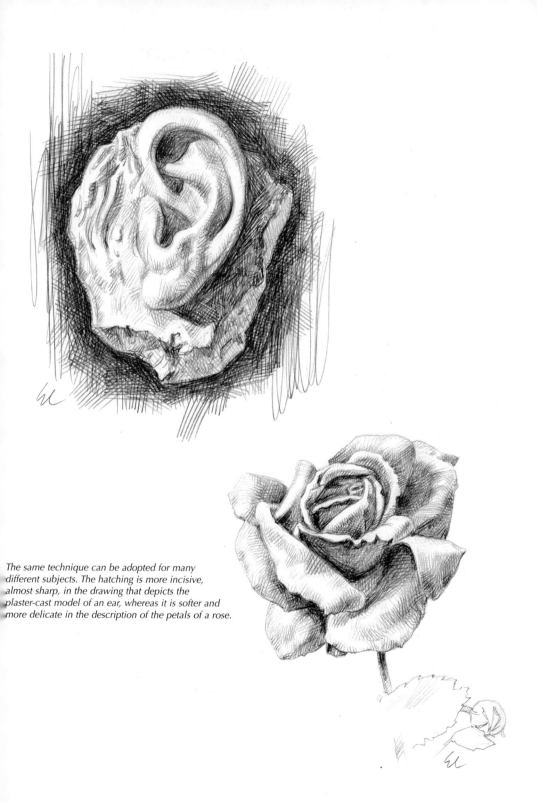

The same technique can be adopted for many different subjects. The hatching is more incisive, almost sharp, in the drawing that depicts the plaster-cast model of an ear, whereas it is softer and more delicate in the description of the petals of a rose.

TONAL KEY AND TONAL CONTRAST

In a drawing or painting the tones are based on a reciprocal relationship, i.e. they appear lighter or darker in relation to other tones, especially if adjacent. A good principle of visual perception explains, for example, that a tone appears with different intensity if placed next to another tone that is lighter or darker: an illuminated (white) area assumes greater force if surrounded by a much darker tone (see page 355). Through tonal contrasts the volume of an object becomes obvious and is more defined. Tonal key refers to the predominant relationship between the tones of a drawing or painting, in other words, to the overall degree of luminosity or darkness. Defining the tonal key and relative contrasts is a decisive factor in producing a successful work of art since it adds solid coherence to the composition and suggests an appropriate mood. For example, a high tonal key is suitable for delicate effects; a middle tonal key inspires an atmosphere of tranquillity and balance; a low tonal key creates drama.

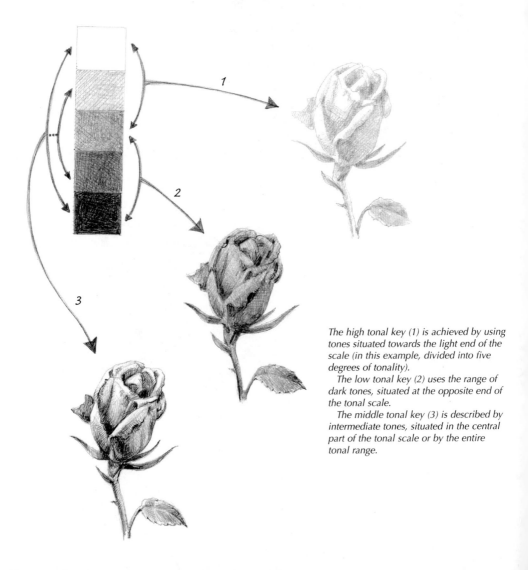

The high tonal key (1) is achieved by using tones situated towards the light end of the scale (in this example, divided into five degrees of tonality).

The low tonal key (2) uses the range of dark tones, situated at the opposite end of the tonal scale.

The middle tonal key (3) is described by intermediate tones, situated in the central part of the tonal scale or by the entire tonal range.

Tonal contrast sometimes corresponds to the tonal key, but not always. For example, a middle contrast can be associated with a middle key but a low contrast can correspond to a high key (depending on how the tones are placed) or, for the same reason, to a low key.

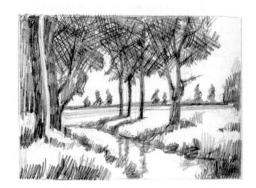

High tonal contrast (tones situated at both ends of the tonal scale).

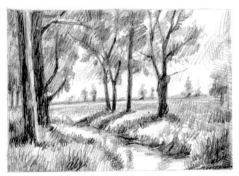

Middle tonal contrast (tones drawn from the whole tonal range or from the mid range).

Low tonal contrast (tones taken from adjacent positions, especially in the dark section of the tonal scale).

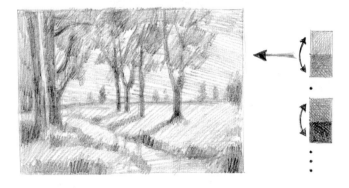

CREATING EFFECTIVE SHADING

There are various ways of producing a good chiaroscuro work, especially in relation to the graphic tools (graphite, charcoal, etc.) or pictorial tools (oil, tempera, etc.) chosen by the artist but, for all these, it is possible to single out a common method, useful for acquiring or sharpening powers of observation and tonal technique.

1 – carefully observe the object, capture the overall proportion, tone and form; 2 – draw, with light strokes that are close together, the main shadows; avoid adding areas of tone that are too uniform or have vague boundaries, identify the darkest and lightest areas only; 3 – add the main tonal gradations observed on the object and in relation to the environment; 4 – the lightest ones are produced, usually, with clean white paper and you can outline them with a slightly darker area, so as to make them stand out more; 5 – evaluate the development and success of the chiaroscuro by observing the object and the drawing with half-closed eyes; 6 – refine the tones and tonal values until you obtain the appropriate intensity and the right relationship between them; evaluate the correctness (on the object, on the drawing and in relation to the environment) of the contrasts and accents.

In a good chiaroscuro work (remembering always that it is about an exercise in observation, and not necessarily about works of art) the shadows must be decisive, quite sharp but not hard, with a certain transparency and able to suggest the development of the planes. Tonal changes should be soft, although firm and well defined, and the points of maximum luminosity situated in the right position, produced with decision and with a coherent, meaningful effect.

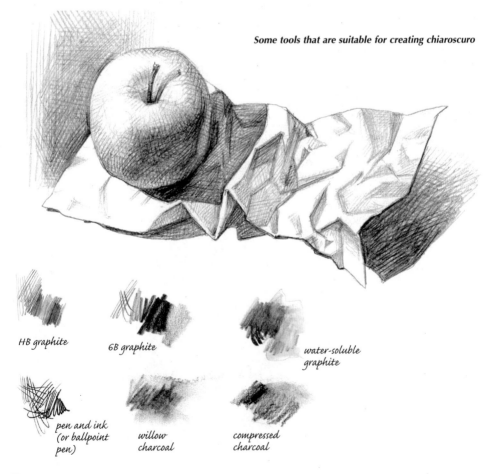

Some tools that are suitable for creating chiaroscuro

HB graphite

6B graphite

water-soluble graphite

pen and ink (or ballpoint pen)

willow charcoal

compressed charcoal

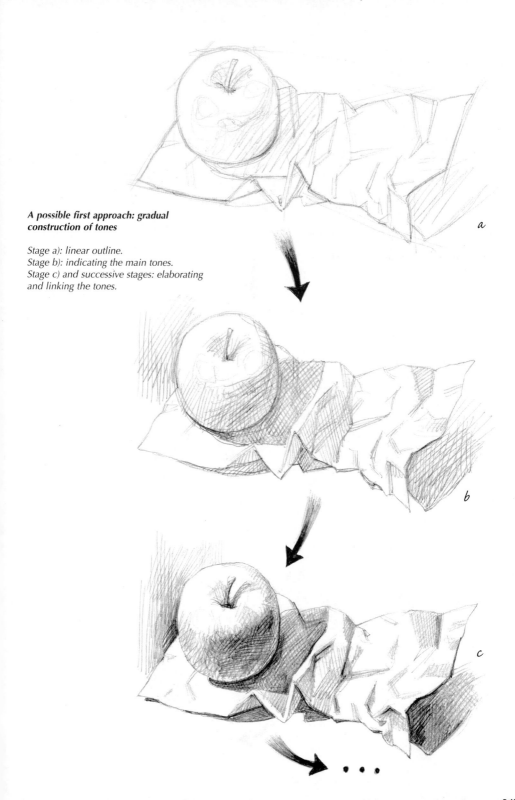

A possible first approach: gradual construction of tones

Stage a): linear outline.
Stage b): indicating the main tones.
Stage c) and successive stages: elaborating and linking the tones.

a

b

c

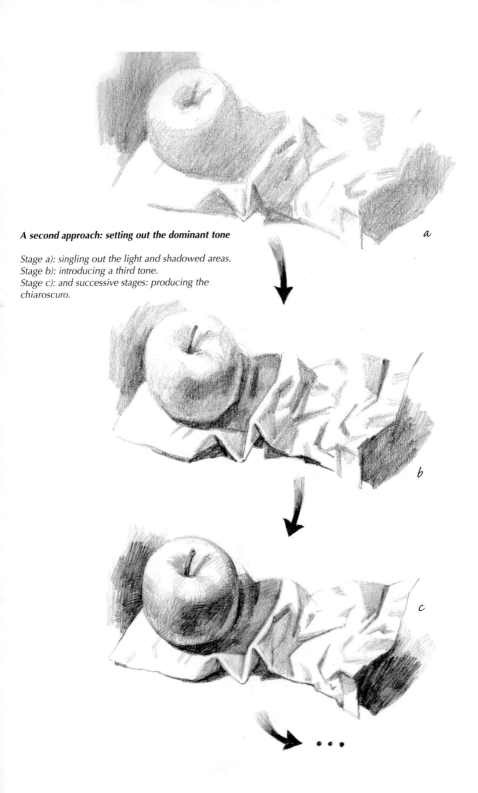

A second approach: setting out the dominant tone

Stage a): singling out the light and shadowed areas.
Stage b): introducing a third tone.
Stage c): and successive stages: producing the
chiaroscuro.

a

b

c

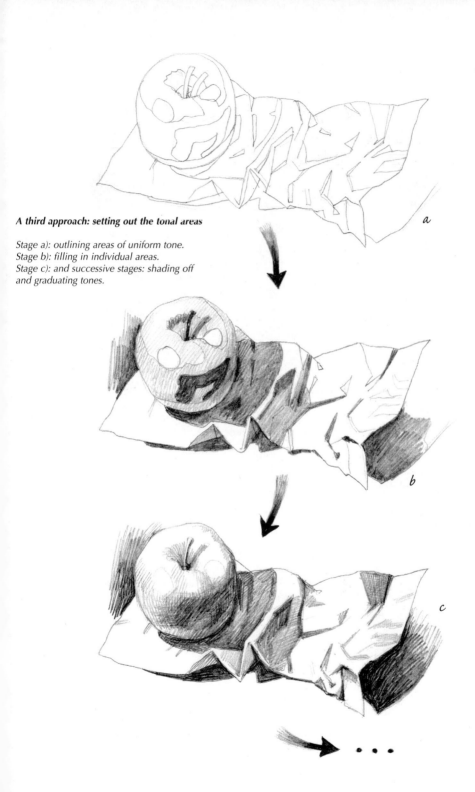

A third approach: setting out the tonal areas

Stage a): outlining areas of uniform tone.
Stage b): filling in individual areas.
Stage c): and successive stages: shading off
and graduating tones.

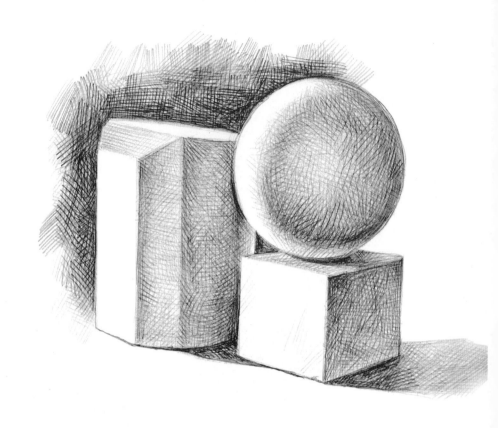

Study of shadows on plaster cast geometric solids

1 – 0.5 HB micro lead
A very fine graphite lead allows you to produce a wide range of tones by simply crossing the strokes more or less densely. Take care to leave some transparency and light in the more intense shadows as well.

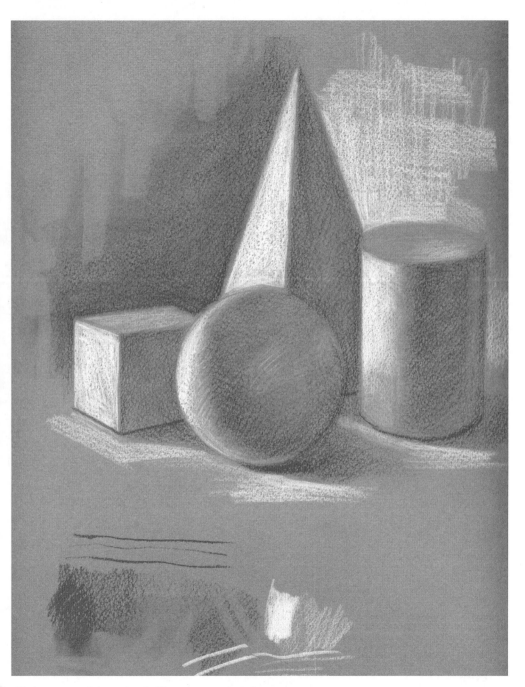

2 – Black compressed charcoal and white gesso, on coloured paper
The use of coloured paper of a moderately dark tonality allows you to depict objects
merely by indicating the darker tones of shade and the lighter areas, illuminated by the
light. The intermediate tone is indicated by the medium itself.

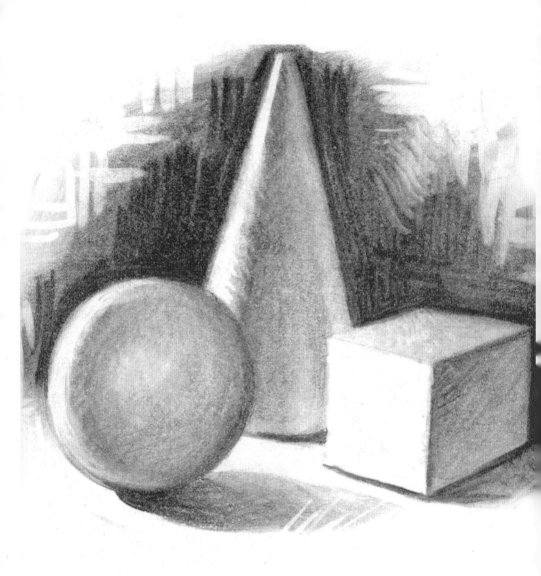

3 – Willow charcoal
The 'willow stick' (obtained by charring small willow twigs) offers a very wide range of greys. Gradation can be achieved by shading off with your finger or a piece of soft cloth. The illuminated areas are emphasised by lightening or removing the charcoal strokes with a kneadable putty rubber.

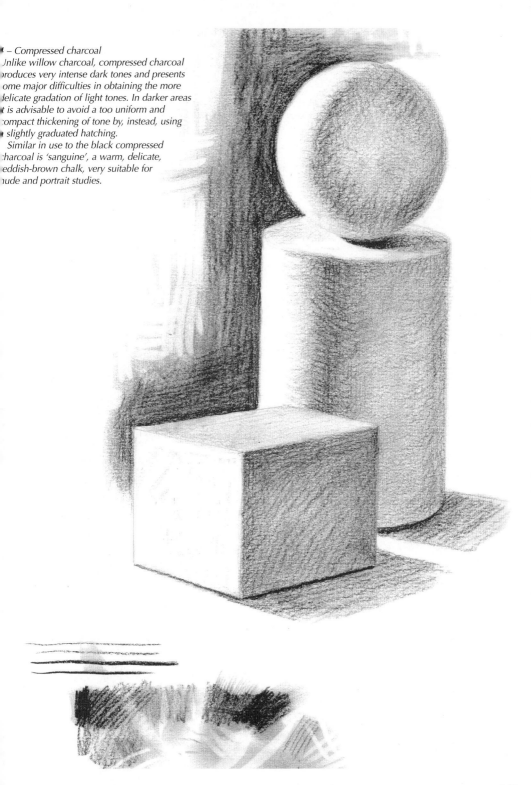

◄ – Compressed charcoal
Unlike willow charcoal, compressed charcoal produces very intense dark tones and presents some major difficulties in obtaining the more delicate gradation of light tones. In darker areas it is advisable to avoid a too uniform and compact thickening of tone by, instead, using a slightly graduated hatching.

Similar in use to the black compressed charcoal is 'sanguine', a warm, delicate, reddish-brown chalk, very suitable for nude and portrait studies.

On the following pages (pages 350–357), you will find some black and white photographs of plaster casts and simple natural elements. They are useful for doing some preliminary exercises in chiaroscuro technique before approaching the study of similar subjects directly from life. The 'copy from plaster cast' method has always been considered a tedious and, nowadays, out-of-date and scholastic practice. And yet, it is fundamental for learning the technique element of drawing, and carefully and calmly analysing the chiaroscuro effects produced by the various objects and different angles of lighting. The white, uniform surface of the plaster cast enables us to single out the more delicate tonal changes and provides the opportunity to observe them very accurately, reproducing them without the complications of colours or movements.

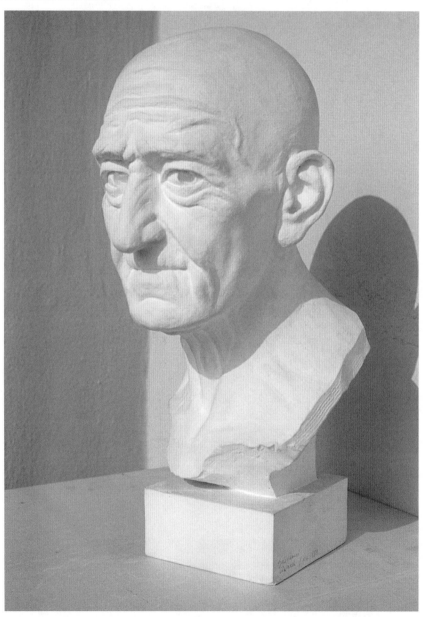

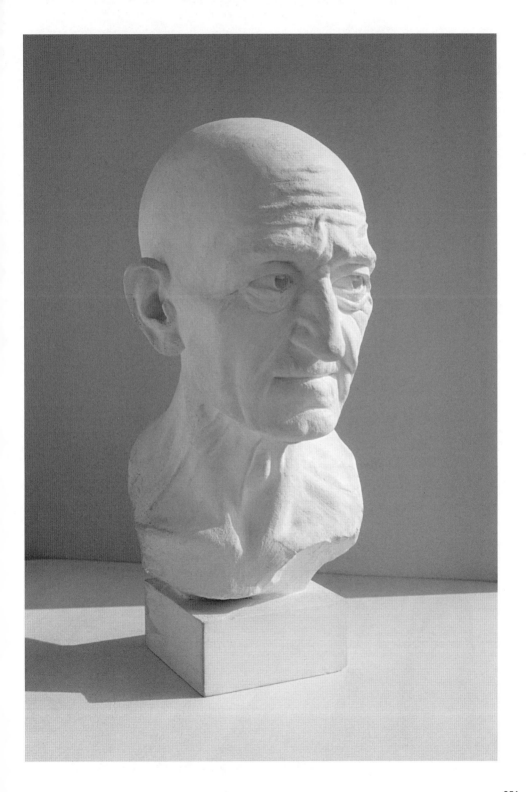

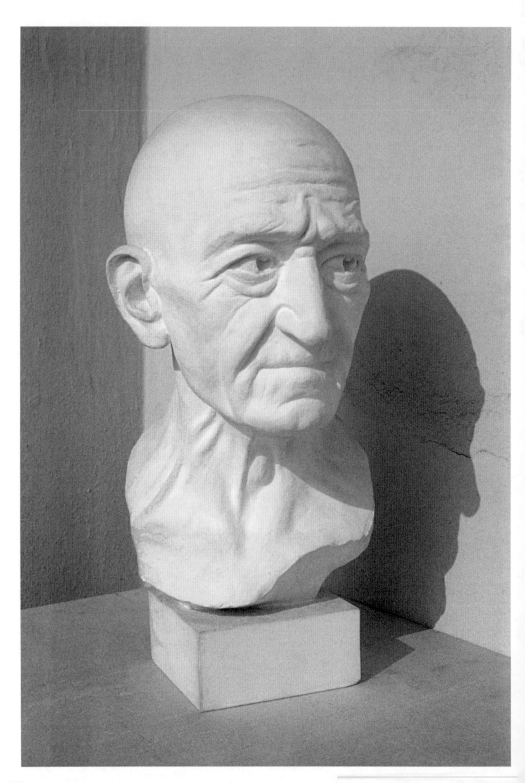

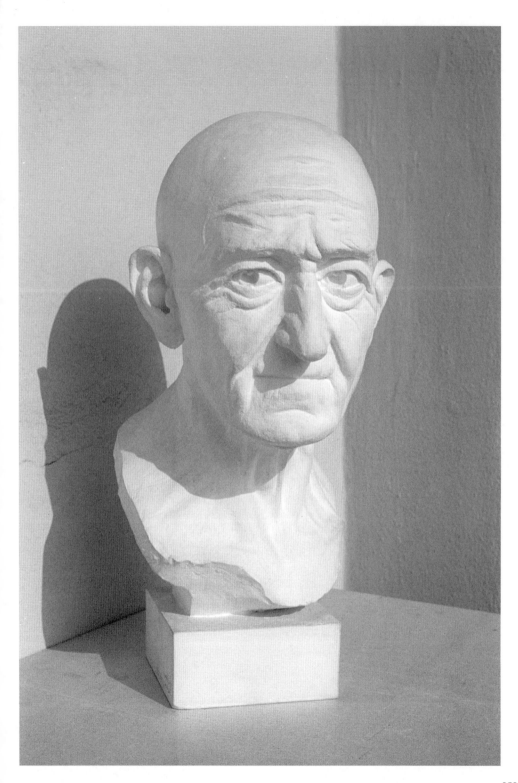

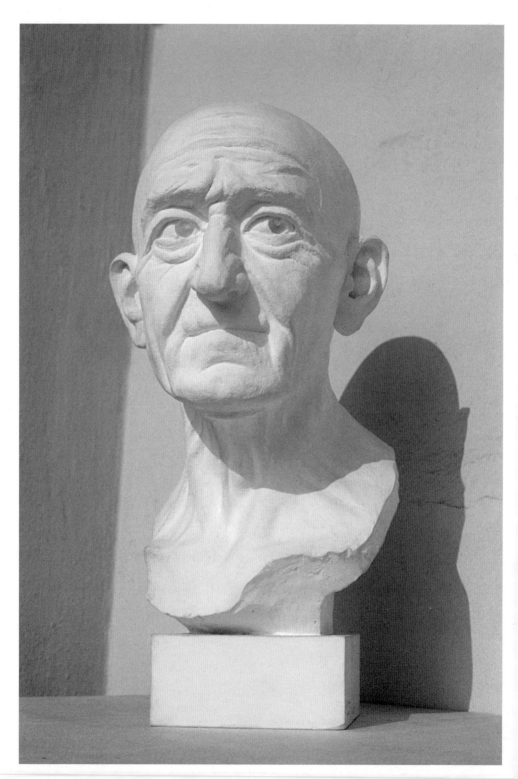

COMPOSITION

Tonal structure – the way in which the light and dark areas are organised and the contrasts that derive from them – constitutes an important aspect of the composition of a painting or drawing. Composition is, in fact, the arrangement of the various elements of a picture to create a coherent and meaningful whole. In composition we try to find the most suitable solution for organising the layout of the forms and tones, according to the principles of balance or unbalance, symmetry or asymmetry, inactivity, or dynamism and tension. These principles are not exact and binding rules but are, rather, generally the result of artistic experience and aesthetic reflection on partly instinctive observation.

 Analysing the works of artists who have made use of chiaroscuro to compose their pictorial works, in various periods and various styles, is particularly useful.

The format of the medium (a–e), which is traditionally rectangular (more rarely square or round), suggests the way in which to arrange the elements of the picture – the composition – in relation to the expressive meaning you wish to give it. This can, depending on how it is organised, arouse different feelings; balance/symmetry (sketches 1, 5, 9, 12); unbalance/asymmetry (1, 3, 4, 6); weight/gravity (7, 8); inactivity (5, 7, 9); dynamism/tension (3, 10, 11).

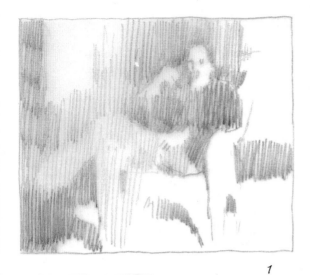

1

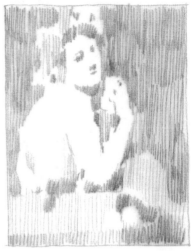

2

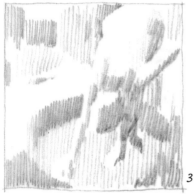

3

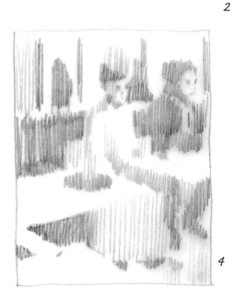

4

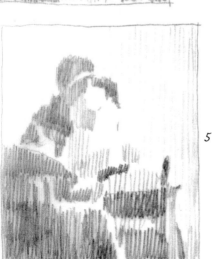

5

*Tonal sketches taken from famous paintings: this is a very
effective exercise for improving your ability to compose
pictures including the use of chiaroscuro.*

1. *John Singer Sargent* Portrait of R.L. Stevenson *(1887)*
2. *Michelangelo Merisi da Caravaggio* Sick Bacchus *(1593)*
3. *Edgar Degas* The Tub *(1885)*
4. *Edgar Degas* The Absinthe Drinker *(1876)*
5. *Johannes Vermeer* The Lacemaker *(1664)*

VOLUME AND RELIEF

The quality (direct or diffused, intense or weak) and type (natural or artificial) of light determine the aesthetic result of the picture. Varying the light can also vary, sometimes in a surprising way, the appearance of the shapes. They may stand out or the finer features of the surface disappear.

The light, in fact, emphasises the relief of whatever it is illuminating and gives the feeling of volume, space and atmosphere. Sculpture and architecture are also affected by light; form being influenced by whether light directly hits or barely touches the surfaces and shapes, creating sharp or soft, intense or weak shadows and creating the subtlest variations of chiaroscuro.

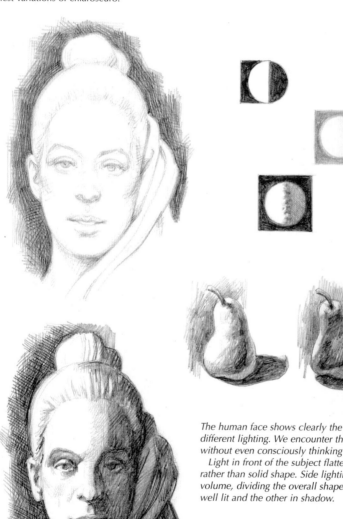

The human face shows clearly the various expressive effects of different lighting. We encounter these images on a daily basis, perhaps without even consciously thinking about them.

Light in front of the subject flattens the relief and suggests a flat, rather than solid shape. Side lighting, on the other hand, highlights the volume, dividing the overall shape into two halves, one of which is well lit and the other in shadow.

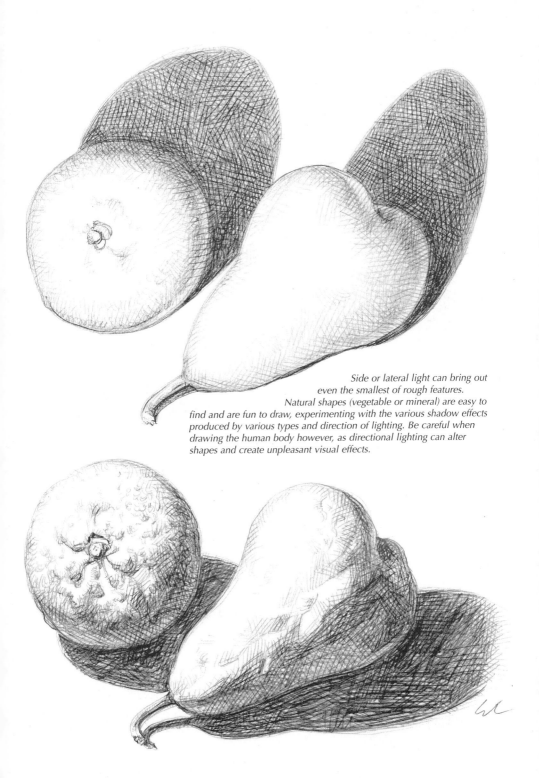

*Side or lateral light can bring out
even the smallest of rough features.
Natural shapes (vegetable or mineral) are easy to
find and are fun to draw, experimenting with the various shadow effects
produced by various types and direction of lighting. Be careful when
drawing the human body however, as directional lighting can alter
shapes and create unpleasant visual effects.*

AERIAL PERSPECTIVE

Aerial perspective considers the effects of tonal gradation produced by distance. When creating landscape pictures, for example, the objects in the foreground (nearest the observer) are very sharp and the tones and colours more intense. In the middle and background, however, these characteristics gradually fade away, are toned down and become hazy. Graduating the tones – from intense in the foreground to soft in the distance – effectively suggests the feeling of depth and the recession of space.

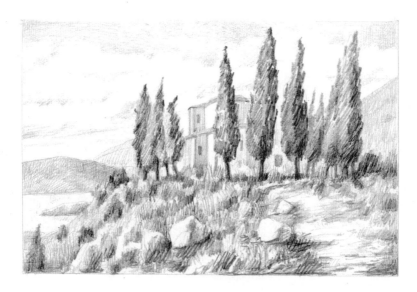

Tonal sketch from The Virgin of the Rocks *(London, National Gallery) by Leonardo da Vinci.*

Pictorial examples of aerial perspective are innumerable and a good way to study (by drawing schematic tonal sketches) the effects obtained by the greatest Western artists, from the Renaissance to the Impressionists.

At short distances (in still life or figure drawing, for example) the effect of aerial perspective is, of course, very modest. You can suggest the feeling of depth by accurately and sharply outlining the elements that are nearest to the viewer and by using softer tones to outline objects or parts that are a bit further away. Another important device is to partially overlap the shapes, so that they form a sort of visual connection as they recede.

EFFECTS OF CHIAROSCURO IN ART

The use of chiaroscuro in art has always existed, to some extent, but it came to the fore during the Italian Renaissance and rapidly spread to the whole of Western art, including contemporary art. Various periods and cultures have made different use of chiaroscuro, attributing it with a variety of characters: for example, highly expressive and dramatic (Caravaggio), or a profound existential experience (Rembrandt), or a glance at intimate, suspended life (Vermeer), or, again, the brightness of the sun in nature and a luminous atmosphere (Monet). Examples of it and its decline in importance are, of course, innumerable. It can be a good exercise to examine some artists' works from various periods and in various styles, making tonal and compositional studies of them (if possible, taken from works directly observed in galleries).

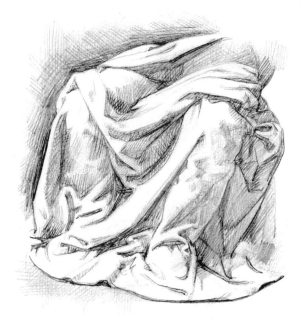

Leonardo da Vinci Study of Drapery *(circa 1478)*

Michelangelo Buonarroti Slave (Atlas) *(1519)*

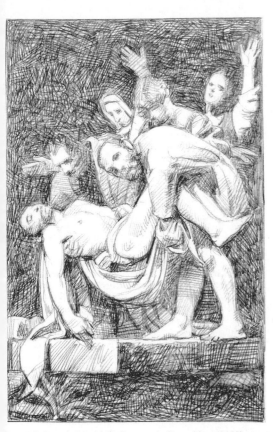

Michelangelo Merisi da Caravaggio Deposition *(1602)*

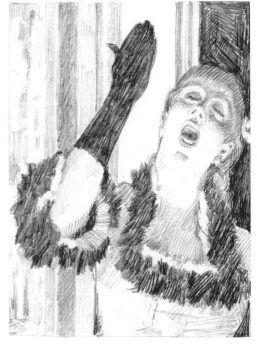

Edgar Degas Café Concert Singer *(1878)*

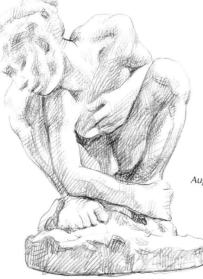

Auguste Rodin Crouching Woman *(1882)*

STUDIES FROM LIFE

It seems appropriate to present here a small collection of my drawings, produced with various techniques at different times during my artistic career. The aim is not to exhibit my own work or propose examples to copy. Anything but. These works should suggest a variety of means and topics with which you can practise observing chiaroscuro and, above all, encourage you to find and follow your own means of expression: find (through careful study of the natural) the most personal and appropriate ways of freely expressing your true personality, emotions and investigative curiosity.

Drawing, with its technical skills learnt well, is the most complete and thorough tool for seeing and knowing the world around us and those who inhabit it, and for expressing the emotions that all this arouses in us.

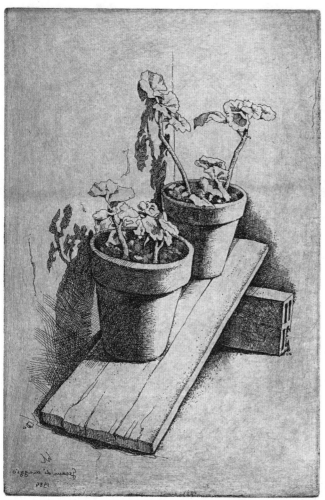

Geraniums
Etching, 15.7 x 21.6cm (6 x 8½in)

I have included several etchings in this section, a copper-engraving technique where the cross-hatching is of fundamental importance for depicting the appropriate chiaroscuro values. Careful observation of etchings can suggest similar results that can be achieved in pencil or pen and ink.

This small study portrays a pair of pots with flowers in my garden, sloping away from each other in a precarious position: perhaps a poor subject, but a pretext for focusing on the almost abstract play of light and shade.

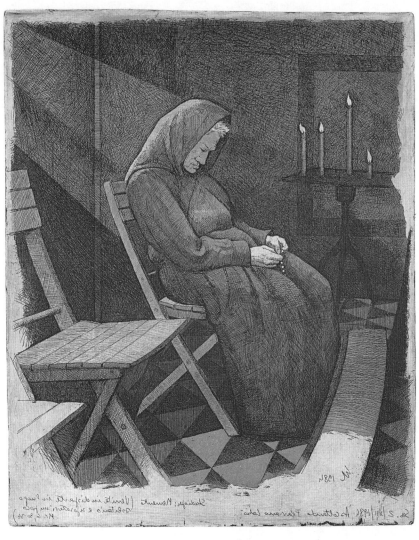

4/6 Giovanni Girardi/.

Rosina in Caravaggio's Sanctuary
Etching and acquatint, 21.4 x 26.4cm (8¹/₂ x 10in)

*Even a very dark environment presents many tonal shifts. In this case, the intense
light coming from a small window 'sculpts' everything it touches and depicts its
volume. It is best not to accentuate the contrasts in tone too much and study,
instead, the subtle modulations; on the praying figure's face and hands and on the
floor, around the candles for example.*

 *In etching, the final print inverts the original image drawn on copper and this
should be born in mind in the composition and in any written notes.*

1/5

Giovanni Civardi

Shells and Kernel: Fragments
Etching, 16 x 10.5cm (6 x 4in)

Birth
Etching, 6.5 x 6.8cm (2$\frac{1}{2}$ x 2$\frac{3}{4}$in)

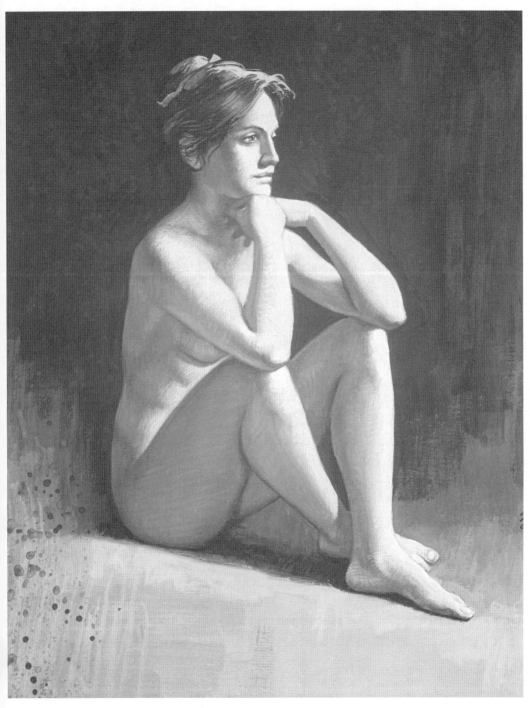

Elsa's Wait
Tempera on canvas board, 30 x 40cm (11³/₄ x 15¹/₂in)

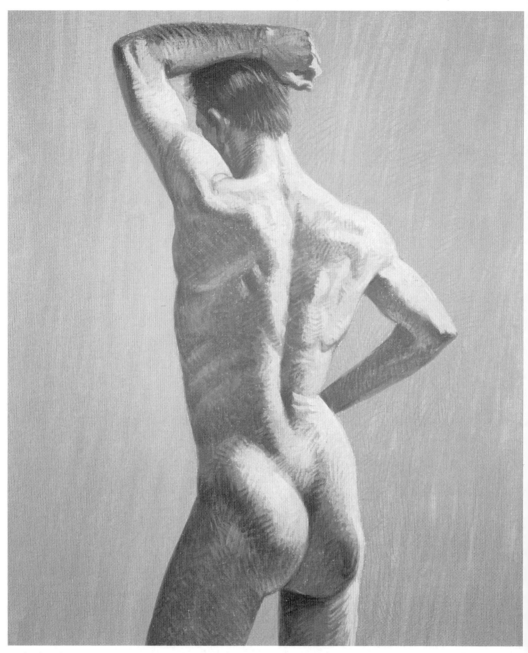

Study of Nude
Tempera on canvas board, 25 x 35cm (10 x 13³/₄in)

Lateral lighting is suitable for emphasising the anatomical details and muscular play of the human figure. However, do not overdo the chiaroscuro or use a skimming light, as the effect can be distorting and even unpleasant. Light reflected by the environment, however, is useful for indicating the body structure accurately and with a sense of volume.

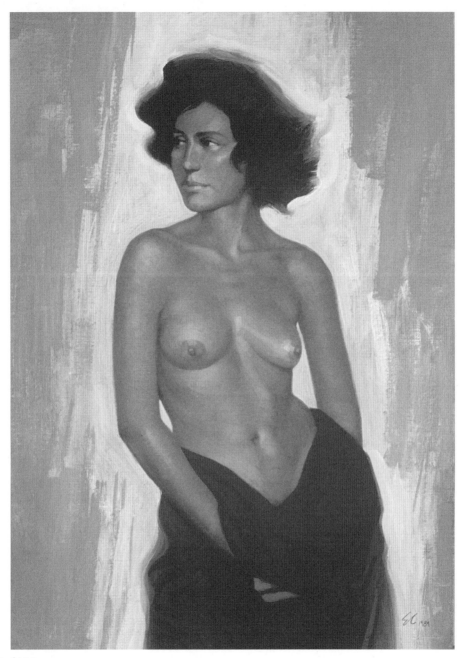

Portrait of Miriam
Oil on canvas board, 35 x 50cm (13³/₄ x 19¹/₂in)

Using oil diluted with plenty of turpentine creates an opaque colour similar to tempera,
and with this you can obtain very delicate tonal changes, suitable for depicting the softness
of the parts of the body on this nude, illuminated by a frontal light that is diffused.

1/8 Giovanni Civardi/.

The Shadow of the Rose on my Table
Etching, 9.5 x 19.5cm (3³/₄ x 7¹/₂in)

*A rose lit from above with a single electric light bulb produces a very definite chiaroscuro
effect with few intermediate tones. The visual weight of the dark background is in the upper
part of the drawing, but is balanced by the vertical arrangement of the two roses and the
shadow that one of them casts on the table.*

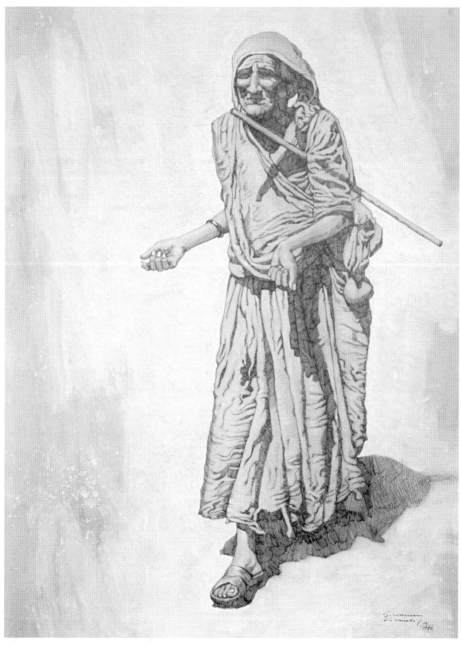

Bikaner: Indian Figure
Pen, China ink, white tempera, yellow ochre acrylic, 50 x 70cm (19¹/₂ x 27in)

This drawing was done on my return from a trip to India, relying on memory and also on photographs and sketches made from life. The play of intense shadows establishes a 'nervous' and lively chiaroscuro, in harmony with the tormented aspect and character of the figure portrayed. The shadows cast by the stick and left arm are useful for giving the feeling of protrusion of these two elements.

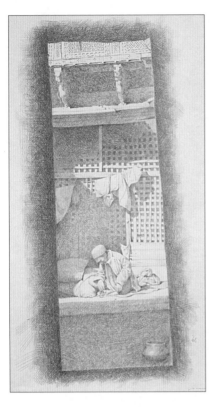

Fragments of Ancient Times
H graphite on cardboard, 36 x 51cm (14 x 20in)

This preparatory study for a book illustration is an excellent example of tonal contrast (see page 340). The play of chiaroscuro between the inlaid work on the building, the overlapping floors and the depth of the setting almost cancels out the crouching figure that is broken down into tonal fragments. In reality the intense sunlight created sharp shadows but the deep darkness of the porch from which the scene is viewed renders them rather pale.

From the
Traveller's Notebook (Visual diary, series 2, no. 2)
0.5 HB graphite, double page 14 x 18cm (51 x 7in)

The true artist is always alert: everything that happens around you or springs to mind can be the object of a work or, at least, a sketch or a simple explorative drawing. I keep a small visual diary – I use pocket-sized notebooks – that I gradually fill with notes of images, thoughts and emotions. This is good practice for all artists. You will realise, then, that chiaroscuro is found everywhere, but drawing it from life can lead to discovering aspects that are unexpected.

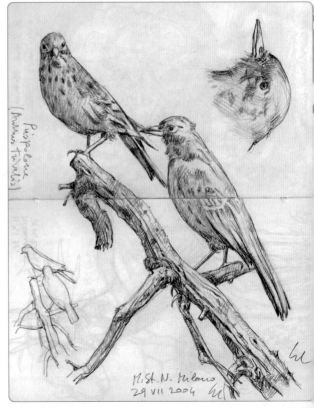

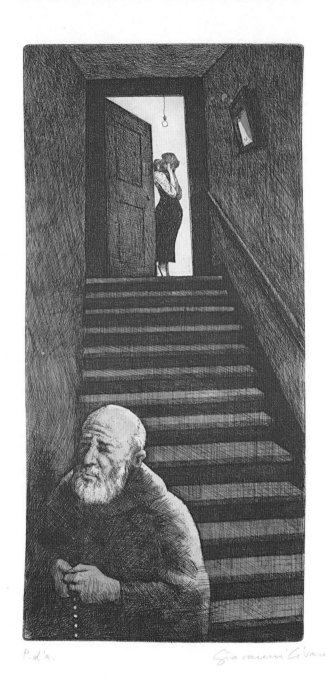

P. d'a. Giovanni Civardi

Mysteries of Life
Etching, 14.8 x 30.3cm (6x 12in)

This is an illustration for a dramatic tale, in which a sad and moving human situation is described. The gloomy tonality of the drawing is lifted by subtle tonal changes on the stairs and walls that enclose it, whilst the passage of light from the half-open door draws your attention to the story's protagonist.

Leaves (Paris, Les Tuileries): Homage to Boldini
H, HB graphite on paper, 42 x 55cm (16$^{1}/_{2}$ x 21$^{1}/_{2}$in)

*Chiaroscuro does not necessarily have to be associated with intense tones of shade.
This drawing shows a fine and delicate central structure that is nevertheless rich in
tonal changes, and chiaroscuro is used to create a misty, autumnal atmosphere.*

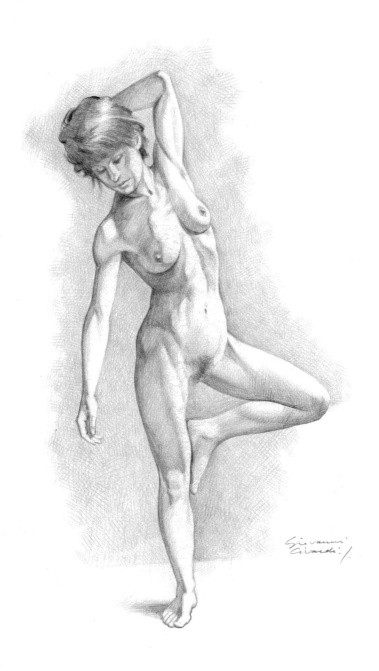

THE NUDE

Drawing the human form involves every part of us: it is about our feelings towards the models as we observe their physical features and sense their moods, comparing them with our own. As with portraits, but to an even greater extent, looking at the bodies of our fellow creatures allows us, in a sense, to catch a glimpse of their life force. Our work represents our attempts to reflect and project this force.

It is therefore neither surprising nor a secret that since the first upsurge of artistic and religious feeling, portraying the human body has been one of the most important themes. The nude figure sums up the essence of humanity, although it has of course been depicted differently in western and eastern civilisations. In the former, for example, a distinctive feature is the stress on analysis, on description, on anatomy, on explaining the organic structure and on reconciling general and individual characteristics. In the latter the focus is on the subject's life force, on any subtle but revealing signs of their internal energies.

Drawing figures, then, is a centuries-old practice for training western artists and is an accepted teaching convention even today. In these times of extremely varied aesthetic trends and artistic means of expression, we still consider drawing from live models a very worthwhile discipline.

There are various teaching methods for drawing nude figures, all of which basically rely on two main approaches. The structural approach follows scientific principles and encourages the artist to concentrate on the constructive (anatomical, technical and geometric) qualities of the model. For example, this involves establishing the length of the segments of the body, the direction of the main axes, the correct proportions, contours and areas of volume. In contrast, the expressive approach tends to concentrate on a more spontaneous view of the figure, on capturing the qualities, emotions and character that lie within rather than on the body's organic structure. The two ends of the spectrum can and must, of course, complement

each other to varying degrees, depending on each artist's artistic temperament and attitude.

I thought it useful, therefore, to set out here some topics to consider when drawing nude figures. These topics will suggest a series of routes that you could take to learn to observe, as if for the first time, with fresh eyes, both male and female human bodies.

When portraying objects in any medium, dividing them according to type or subject matter (still life, animals, landscapes and figures) is somewhat arbitrary. The principle is the same and applies to any object. Observing means 'looking carefully and with wonder'; seeing the relationships between the individual parts and the whole; capturing the 'character' of the object in question; and allowing yourself to feel and to understand. Figure drawing in particular presents many challenges and the ability to perceive and observe varies widely between individuals.

Detailed anatomical knowledge is less important than morphology in understanding and explaining the human form. Human figures are three-dimensional bodies: solid structures with depth, volume and weight. To draw them convincingly you need to learn to create, on a flat piece of paper, the illusion of a solid shape. Having mastered the basic shape, you can then interpret the figure, both subjectively and creatively, through analysis of anatomy, perspective, light and shade. For example, careful observation alone can be sufficient to identify at what points of the body the skeleton appears beneath the surface. A knowledge of anatomy can further confirm the accuracy of the impression, of the visual analysis, but these facts still need to be expressed artistically, plastically and graphically. In short, an entirely 'scientific' rendering can appear unnecessarily academic and laboured, lacking in character. Accuracy need not mean pedantry or slavish imitation. A solid background knowledge can instead reveal itself in simplicity.

SOME PRACTICAL CONSIDERATIONS

*But when something bores you,
leave it alone.*
Eugène Delacroix

FINDING MODELS

Figures are usually drawn from life
during leisure or educational courses
at art schools or colleges, located in
most towns and cities. You can contact
these institutions to find out about
courses and get in touch with both
male and female models. If there are
no art schools near you, you can still
arrange 'nude' sittings, perhaps by
getting together with other artists and
posing for each other. Always ensure
you choose premises with enough
room to accommodate both artists
and models comfortably. Whatever
the circumstances, models must be
treated correctly; remember to check
legal requirements regarding age,
and reach clear agreements about
fees, the place and the length of the
sitting, the purpose of the drawings,
confidentiality, and so on.

WHICH MODELS?

It is not necessary to always look for
professional models, i.e. people who
normally model at art schools or are
sent by employment agencies. Nor
does the model have to be young or
have an 'ideal' body shape which
meets current aesthetic standards.
'Normal' individuals are much more
interesting and full of character: quite
often the most suitable and willing
models can be found at dance,
physical training or acting schools.
However, studying 'nude' figures
does not always require full nudity:
modern-day swimming costumes are
more than enough to safeguard the
subject's modesty and allow extensive
bodily expression. The key qualities
for a model are friendliness, patience
and willingness to participate.
Usually, the spontaneity of the
pose, working together in harmony
and being 'involved' in a project
compensate in full for any lack of
'experience at posing'.

WORKING ENVIRONMENT

The area intended for nude sittings
must have: a separate corner where
the model can undress and get dressed
again; sufficient heating; and a set of
props for assuming the various poses.
It is preferable to have natural light
or daylight (not direct sunlight), if
possible coming from a large window
(old masters used to choose the light
from the north). Artificial light is also
suitable, provided it is not emitted
from multiple sources, which would
cancel out the shadows on the model
or create complicated ones. If this
happens, you should add some
medium-intensity lamps aimed directly
and appropriately at the model, in such
a way that they do not bother him or
her, or produce unpleasant shadowy
effects. A sitting normally lasts upwards
of a couple of hours, with quarter-hour
breaks every hour or so, depending on
the pose. Some soft music can make
the time pass pleasantly for both artists
and models.

1 Overall outline

2 Identifying structural lines

3 Geometrising

DISTANCE FROM THE MODEL

The optimum distance from the model is 2–3 metres (80–120in), so that you can see the whole body without having to move your eyes or head too much. Not all working environments allow every artist to work at the right distance: it is important, therefore, not to alter the perspective too much (unless this is what you are trying to achieve) and to be able to change your viewpoint by going around the model, sitting on the floor or standing on a raised surface.

TECHNIQUES TO USE

Nude studies are seen as exercises in *observing* the model and are therefore usually carried out using 'graphic' techniques, which are simple and immediate (pencil, charcoal, pen and ink, pastels, coloured pencils, etc.). In some cases, however, they can be preparatory drawings for more complex works (paintings or sculptures), which was common practice in the past. It is useful to rest the paper on an easel, so the

paper remains vertical and, therefore, parallel to the model. If you are sitting down, however, it is often easier to hold the paper in place on a medium-sized (30 x 40cm or 40 x 50cm [12 x 16in or 16 x 20in]), for example) lightweight board, which you can rest on your lap.

CULTURAL REFERENCES

Studying nude figures from life can become more rewarding if combined with studying anatomy, history of art, philosophy or psychology. These 'cultural' combinations can help to inform your drawing; their influence can vary in strength and direction according to each individual. They should, however, be subordinate to direct and careful *observation* of the human body; your aesthetic impulses should be primarily your own. The combination of in-depth knowledge and complementary sources of inspiration should be aimed at bringing out and developing each artist's personal expressive style, according

to the following sequence: observing, understanding and interpreting.

WORKING IN A GROUP

Drawing alone is essential for furthering the creative process, but drawing in the company of other artists offers many advantages, especially when the group is small (ten members at most) and is made up of people with varied artistic experiences. Before the sitting, you could make some group decisions, such as deciding on the pose, which position to draw from, the type of lighting and so on. During the sitting you could look over each other's shoulders and find ideas for new technical solutions or new styles of drawing. At the end of the sitting, you could compare and criticise each other's drawings, exchange opinions, suggest projects or alternative ways of studying. The greatest advantage of group work is sharing the cost of the model and the mutual encouragement it brings.

The sketches reproduced here show one of the possible sequences for portraying the human body in drawings and sum up the main successive phases of observing and analysing the figure: from perceiving the overall form and its character, to examining the structural components, to modulating tonal planes and surface peculiarities.

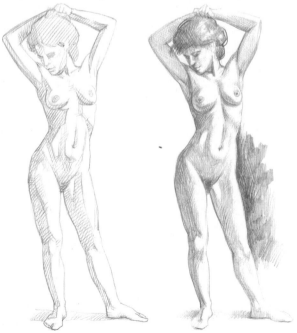

4 Simplifying the organic form *5 Indicating the main areas of volume* *6 Modelling surfaces*

THE MAIN FORM

The most spontaneous and immediate drawings, known as *gestural* drawings, are rapid sketches based mainly on careful observation, which are intended to record as much 'information' as possible in a short time. The need (whether imposed or preferred) to produce a quick 'portrait' of the figure prompts the artist to be alert (almost as if in a 'state of emergency') and encourages him to capture, in an intuitive, but accurate, way, the most important characteristics, including the form and posture, of the body being studied.

This results in a synthetic drawing in which the aesthetic outcome is entirely secondary: its purpose is to show the artist's intention to express in full the structure, posture or action of the subject being portrayed. After all, to draw well, it is essential to learn to see. A gestural drawing is not a goal in itself, but is a way of learning, of practising careful observation and co-ordinating what your eyes perceive with what your hand draws on the paper. In short, it is a way of acquiring experience and a 'freshness' that is inevitably reflected in even the most elaborate and complex final drawings.

Simple and expressive
Giuseppe Verdi

For a gestural drawing to become a useful exercise, some of the following practical issues need to be considered:
• The model should pose for 2–5 minutes.
• Carefully observe the 'character' of the entire figure, in terms of posture and form, and focus on the model rather than the drawing.
• Assess the axes of the trunk and limbs (i.e. the internal structure 'lines' originating especially from the position of the pelvis and spine); the areas of 'tension' between the various body segments; the equilibrium of the body and the direction of the movement or gesture; the contours of the forms.
• Use ordinary sheets of paper of average size (for example: 25 x 35cm or 35 x 50cm (10 x 13¾in or 13¾ x 20in), resting on a solid board, and tools that make it easy to apply repeated strokes, both lightly (or energetically) and densely (for example: soft graphite leads, compressed charcoal and felt-tips).

Rapid drawing exercises can be done initially at a sitting as a warm up exercise, or at the end, after producing more detailed drawings, in order to practise stroke and observation. These options result in graphic effects and psychological aspects of the drawing that are rather different, but interesting and worthy of experimentation.

You can imagine that the point of the tool, as it skims the paper, is exploring the surface of the model's body (almost 'touching it'), capturing its most significant undulations and profiles, and tracing its main structural lines, as well as areas of volume or tone, but in such a way that it suggests the complexity of the body and expressiveness of the posture.

MEASUREMENT

In the human figure, the dimensions of each part relate closely to those of the other parts and are in proportion to the whole body. These relationships are based on the anatomical structure in proportions defined by anthropometry, but also look for inspiration from aesthetic principles of ideal beauty. You will see in the next chapter that physical proportions are more difficult to perceive and evaluate if the figure has assumed a complex pose or is viewed from an unusual perspective. Especially here, therefore, when studying forms that correspond to objective anatomical and morphological features, you may need to take measurements that will enable you to draw a convincing portrait of the subject on paper. One easy and intuitive method is to consider some important stages for assessing relationship between dimensions and suggesting the figure's direction in space:

I learned to measure and see
and to look for the main lines
Vincent Van Gogh

1 – Indicate the points that 'jut out the most' on the sheet – the top and bottom ones (maximum height), those at each side (maximum width) and the middle point, where the perpendicular lines joining up these points cross.

2 – Assess the vertical and horizontal alignments by identifying some reference guidelines (the margins of the sheet, for example, or vertical and horizontal lines present in the surroundings) and measuring the distances between these and the most obvious anatomical or morphological points on the figure.

3 – Assess the oblique lines that, depending on the posture assumed by the model, correspond to the axes of the main body regions. Evaluate the width of the angles formed between these lines, in relation to the vertical and horizontal alignments. Measuring should not, however, become a bugbear for the artist: rather than being a pedantic survey, it should be an exercise in comparing dimensions and distances, aimed at developing a good ability to 'roughly' measure ('knowing how to make a good rough estimate', as Michelangelo used to say), supported by real checks in case of doubt or difficulty.

a – *If your eye is positioned horizontally, level with the centre point of the model (especially if the model is standing up straight), the perceived dimensions appear correct; if the eye is positioned above or below this point the perspective can change.*

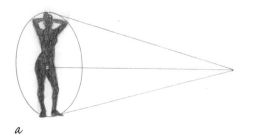

a

b – *Using a very simple, old and intuitive procedure, you can measure 'by sight'. Hold a pencil or measuring rod with your arm outstretched in the model's direction. Close one eye, then make the top of the rod match one end of a body segment, and run your thumbnail down until you reach the other end of the body segment. Compare this measurement with that of other body segments or sections and transfer it to the paper.*

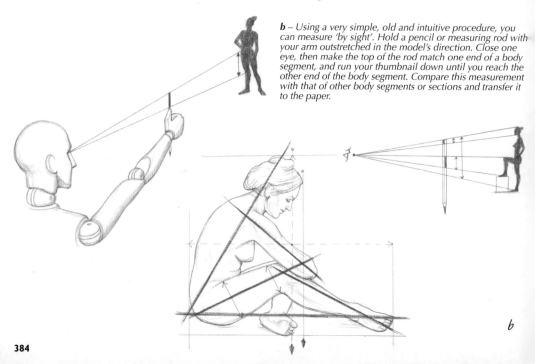

b

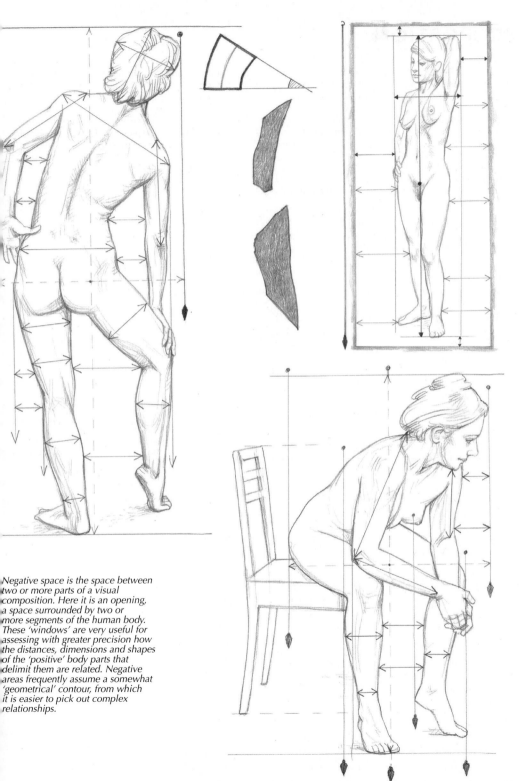

Negative space is the space between two or more parts of a visual composition. Here it is an opening, a space surrounded by two or more segments of the human body. These 'windows' are very useful for assessing with greater precision how the distances, dimensions and shapes of the 'positive' body parts that delimit them are related. Negative areas frequently assume a somewhat 'geometrical' contour, from which it is easier to pick out complex relationships.

PROPORTION

Proportion can be defined as the way in which the dimensions of the individual parts of the body relate to each other and to the figure as a whole. From these relationships it is possible to infer a *standard*, i.e. a set of rules, that make it easier for the artist to portray the human body in accordance with anatomy and anthropometry (the comparative study of sizes and proportions of the human body). These rules can be adapted to allow the artist to portray an aesthetic ideal of beauty.

The schematic drawings here refer to a simple 'scientific' standard (deduced from average statistics for the body's dimensions) for both the male and female adult figure, when standing up straight. The unit of measurement chosen is the head, measured from the tip of the chin to the top of the skull. It is then easy to see that the height of the body corresponds to around seven-and-a-half times the unit of measurement; that the maximum width, at the shoulders, is equal to two units of measurement, etc. The halfway point of the body's height is situated at the lower end of the abdomen. In men it is roughly level with the groin; whereas in women it is situated a little bit higher.

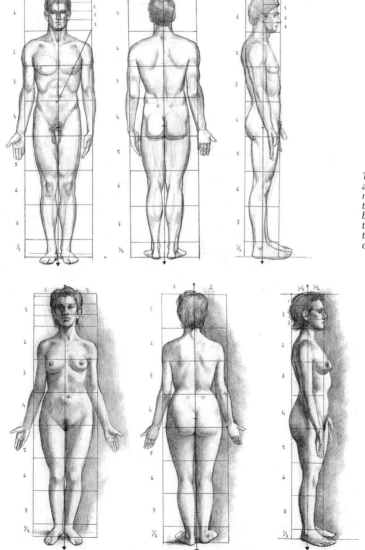

The vertical and horizontal lines form a grid in which it is easy to place the main anatomical references and show the relationships between the various body parts: the middle vertical line (in the front and back projections) divides the body into two halves that can be considered symmetrical.

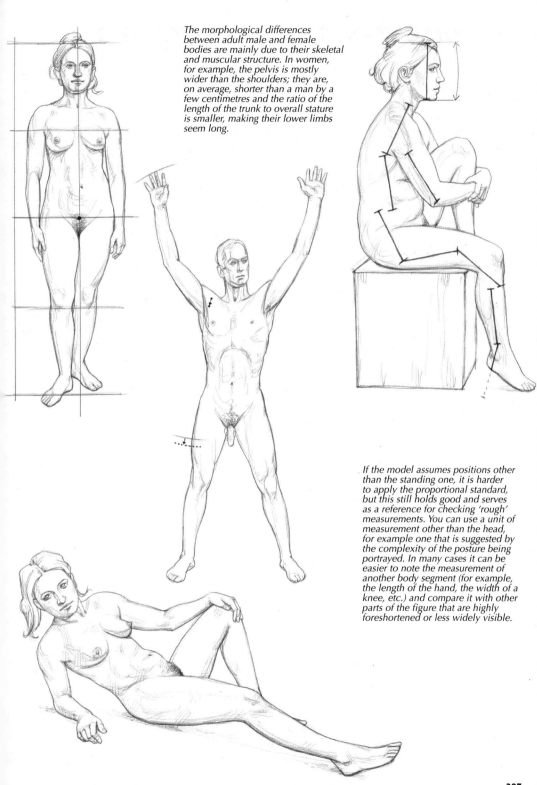

The morphological differences between adult male and female bodies are mainly due to their skeletal and muscular structure. In women, for example, the pelvis is mostly wider than the shoulders; they are, on average, shorter than a man by a few centimetres and the ratio of the length of the trunk to overall stature is smaller, making their lower limbs seem long.

If the model assumes positions other than the standing one, it is harder to apply the proportional standard, but this still holds good and serves as a reference for checking 'rough' measurements. You can use a unit of measurement other than the head, for example one that is suggested by the complexity of the posture being portrayed. In many cases it can be easier to note the measurement of another body segment (for example, the length of the hand, the width of a knee, etc.) and compare it with other parts of the figure that are highly foreshortened or less widely visible.

EXTERNAL STRUCTURE: GEOMETRISING

Geometrising is an abstraction process whereby complex forms (especially those relating to biological organisms) are likened to the shapes of the simplest geometric solids: spheres, cubes, cylinders, pyramids, etc.

You start by choosing the geometric shape that best corresponds to or describes a whole organic shape or one of its segments. At first this is just an approximation but it can help to clarify the form of the individual, their position in space, the ways in which their body segments are divided and their relative proportions. Geometrising forms is particularly useful for correctly conceptualising the figure

when it is seen as foreshortened (cf. page 396): it is easier to put geometric solids – rather than complex and less regular forms – in perspective. In these cases it can be useful if you have access to a well-made and correctly jointed wooden manikin. When drawing nude figures, especially, it is very important to suggest the 'solidity' of the body, defining its areas of volume rather than simple contours. Geometrising is equally useful for correctly perceiving and effectively expressing the effects of light, shade and reflection. These effects, of course, can be easily identified if you first refer to surfaces on geometric solids and then transfer them to similar body shapes accordingly.

a – To represent volume and surface development characteristics effectively, it can be helpful to imagine a series of cross-sections on the solid, according to a succession of 'level lines' that wrap around it. If you imagine the solid to be transparent, you would be able to add where the lines would appear on the parts that are not directly visible as well. On the human body, the section lines at various levels are more complex, but follow the same principles.

b

b – A curved line can also be suggested by a sequence of short straight lines at various angles. This suggests the solidity of the shape and gives it a more genuine sense of volume or depth.

a

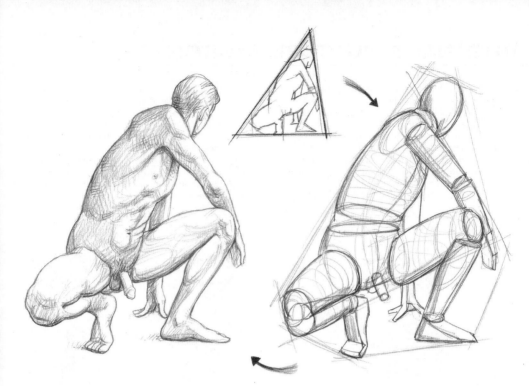

The posture of the whole body almost always suggests an overall shape, the outline of a flat geometric figure such as a circle, triangle, ellipse, square and so on, into which it can be inserted.

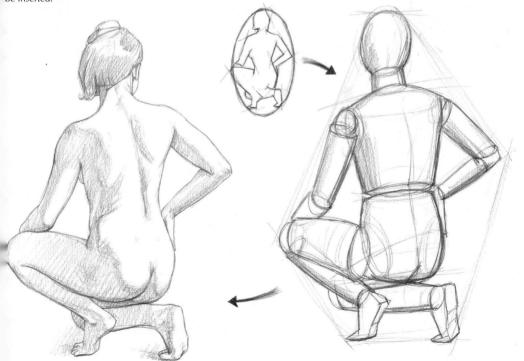

INTERNAL STRUCTURE: ANATOMY

To describe the external forms of the human body in an appropriate and convincing way, it is useful, if not essential, to be familiar with the form, position and function of the elements that make up the internal structure, particularly those concerned with movement: the bones, joints and muscles. Anatomy is a scientific discipline, but it is of great interest to the artist, not only for cultural, historical and philosophical reasons but also because it helps produce a skilful portrayal of the nude figure. Anatomy, in short, should be seen as a tool at your disposal (if you wish to use it) to understand yourself and your body better, and to improve your life drawing. Exact, exhaustive scientific information can be used to 'fully justify' body shapes and explain them better, but this is secondary to a thorough understanding gained through careful observation.

Please note: much has been written about the importance of anatomy to life drawing. I would only like to mention it briefly here and ask that you examine it more closely elsewhere.

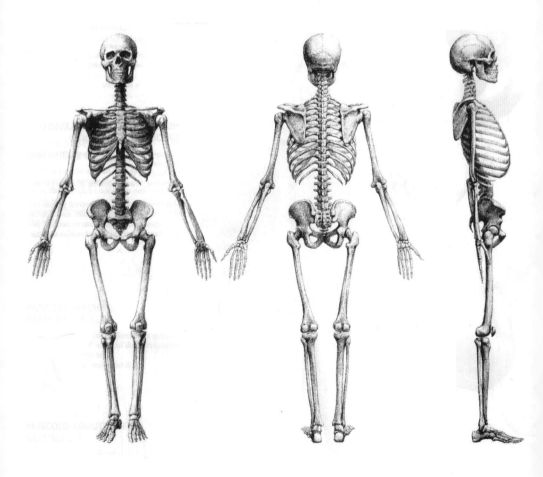

The skeleton is the weight-bearing element of our body, consisting of over 600 bones connected by joints. The skull, the spine, the ribcage and pelvis make up the axial skeleton The bones of the lower limbs and upper limbs, the clavicle and scapulae, make up the appendicular skeleton.

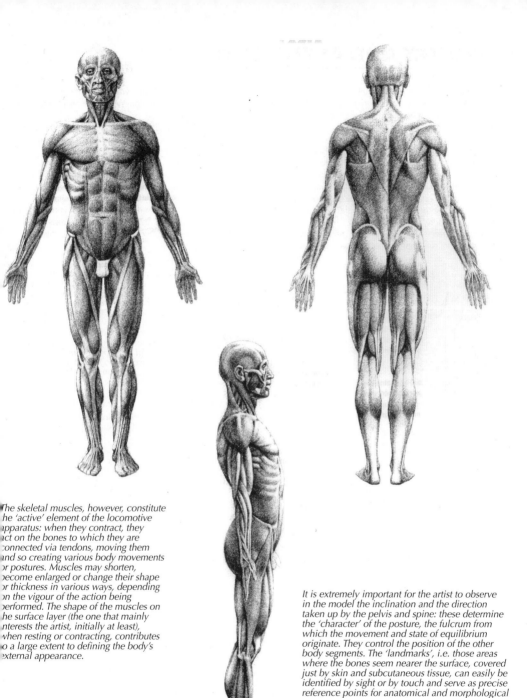

The skeletal muscles, however, constitute the 'active' element of the locomotive apparatus: when they contract, they act on the bones to which they are connected via tendons, moving them and so creating various body movements or postures. Muscles may shorten, become enlarged or change their shape or thickness in various ways, depending on the vigour of the action being performed. The shape of the muscles on the surface layer (the one that mainly interests the artist, initially at least), when resting or contracting, contributes to a large extent to defining the body's external appearance.

It is extremely important for the artist to observe in the model the inclination and the direction taken up by the pelvis and spine: these determine the 'character' of the posture, the fulcrum from which the movement and state of equilibrium originate. They control the position of the other body segments. The 'landmarks', i.e. those areas where the bones seem nearer the surface, covered just by skin and subcutaneous tissue, can easily be identified by sight or by touch and serve as precise reference points for anatomical and morphological measurements or evaluations.

SYMMETRY AND ASYMMETRY

Obliquity expresses action
Rudolf Arnheim

The concept of *symmetry* (a term which, originally, simply meant a 'correct proportion') is closely linked with that of equilibrium, although equilibrium does not necessarily require a symmetrical arrangement for it to exist. Symmetry can be *central* (as in crystals) or *axial*, where the forms on a given plane are distributed as a mirror image either side of a straight line or axis of symmetry. This is the most frequent arrangement for organic forms and, therefore, for the human body as well. If we observe, from the front or back, the body standing up straight (the 'anatomical' position), we easily notice that a hypothetical vertical plane divides the form down the middle, with the right half a twin to the left, although not a perfectly identical match. The side view of the body, however, does not present any symmetry between the front half and back half. Symmetry and equilibrium are not only connected by the physical principles of gravity, but also by 'visual perception' principles, especially those of weight and directionality. Thus *visual weight* depends on the way in which each element (position, distance, colour or tone, mass, etc.) of a composition is arranged in the picture; *directionality*, or the arrangement of the elements according to direction lines, can produce 'dynamic' symmetrical or asymmetrical forms, laden with tension or equilibrium. We associate symmetry with the inability to change, with stability or being static, and for this reason it is only seldom sought in human figure drawing. Relative asymmetry is preferred, suggesting movement or dynamic tension.

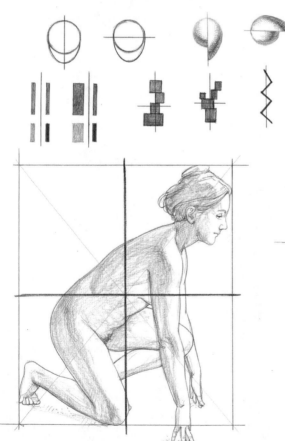

It may be useful, when deciding how to compose the posture of a nude figure, to do a few 'abstract' experiments, comparing and assessing the effects of very simplified areas of volume or tone, arranged both symmetrically and asymmetrically. When drawing and painting, it is useful to analyse symmetry, but it is essential to set out actual body weights when intending to model or sculpt the figure.

A vertical line (or the crossing point of two perpendicular lines) in the centre of a figure composition helps us to judge the degree of symmetrical arrangement, not of the single body elements, but of the main masses containing them. In these two sketches, the area occupied by the body in the right half of the drawing is largely offset by that in the left half. This can also apply to diagonal or horizontal subdivisions.

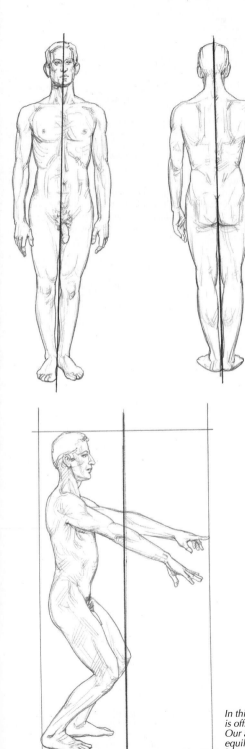

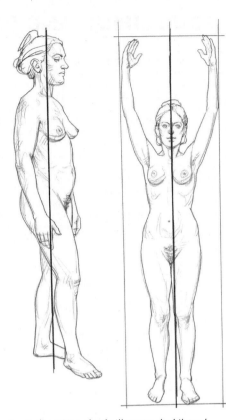

The 'anatomical' position clearly illustrates the bilateral symmetry of the human body seen from the front and back, but negates it in a side view. It is, in short, a suitable position for anatomical or proportional references, but not for artistic portrayal, as it would be too static and inanimate. Since ancient Greek times, the 'opposite' posture has been preferred, especially in sculpture, as the increase in body weight on just one of the lower limbs makes the posture much more expressive and rich, with subtle tensions.

In this drawing, full body symmetry is offset by the gesture of the hands. Our attention is drawn to this, the equilibrium of the rest of the body being less attractive.

EQUILIBRIUM AND BALANCE

Equilibrium, in the physical and mechanical sense, is linked to the position of the centre of gravity, the barycentre, where the body's mass is concentrated. The human figure is continually subjected to mechanical forces (gravity, translation, friction, etc.): if the forces cancel each other out, they 'balance'; there is a state of equilibrium. Without any external assistance or support, the human body maintains its equilibrium with continuous adjustments and, thus, the line of gravity falls within the standing area on the ground. For example, when someone is standing upright, the support area is defined by the outer contour of the feet and includes the area between them. Balance, then, enables us to maintain our posture without falling, both when standing still and moving about. Obviously, when there is wide stability (for example, when someone is sitting or lying down), there is less need for balance. Various body segments

(head, trunk, lower limbs, etc.) each have their own centre of gravity and axis: placed on top of each other, vertically, they describe, as a whole, a line broken into segments angled from front to back, to various degrees. The spine is flexible but strong, anchored to the pelvis: it is the main element for achieving equilibrium and balance, and is also the most interesting structure for describing them effectively in a drawing. In most cases, to confirm that the apparent equilibrium in the drawing matches the model's actual equilibrium, you need only to identify the approximate centre of gravity (it can be projected from a point just below the navel), and draw the line of gravity from this point down to the ground: if it falls inside the support area the body is correctly balanced; if it falls outside the area it means that the body is not balanced or that it is trying to balance by moving other body parts.

a – Balance is the result of an equal distribution of weight: the wider its support area and the lower its barycentre, the more stable an object is.

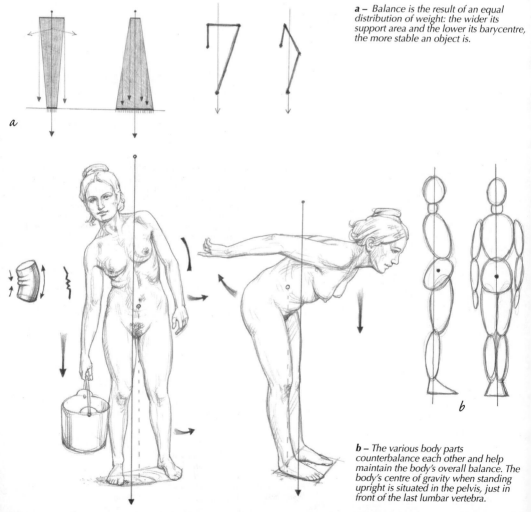

b – The various body parts counterbalance each other and help maintain the body's overall balance. The body's centre of gravity when standing upright is situated in the pelvis, just in front of the last lumbar vertebra.

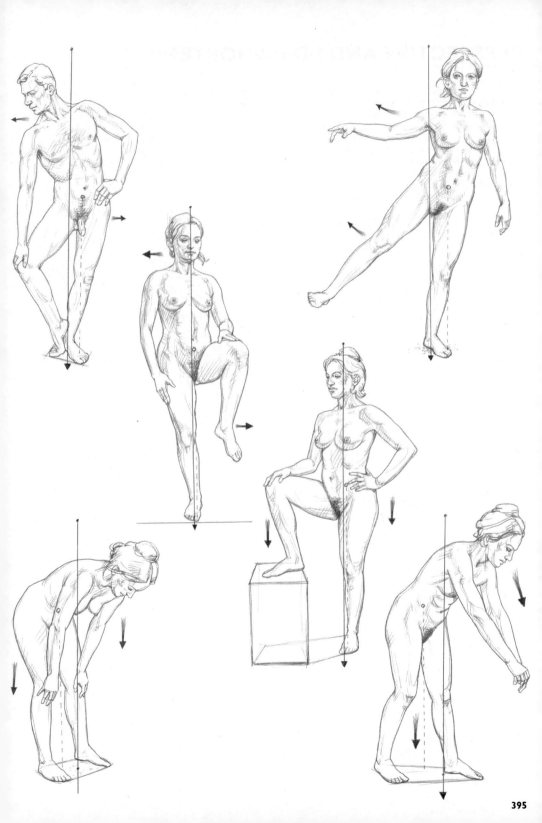

PERSPECTIVE AND FORESHORTENING

Perspective is a graphic means of representing depth in space on a flat surface: the effect of receding into the distance is obtained (in linear perspective) by reducing the size of the objects represented. The human body is mainly put 'in perspective', by using angular (or oblique) perspective, involving two vanishing points towards the ends of the horizon line. We can imagine the body as if it were enclosed in a kind of box, from which it is easy to achieve perspective projection: it is enough as a

first approximation to give just a few ideas on 'intuitive' perspective.

It is worth noting that the human figure is almost always, to some extent, seen and represented in foreshortened conditions. *Foreshortening* is the perspective effect of obliqueness; where all the parts of the body positioned on a horizontal plane, which is not parallel to the projection plane, appear to have their proportions altered to varying degrees or are partly overlapped by other parts.

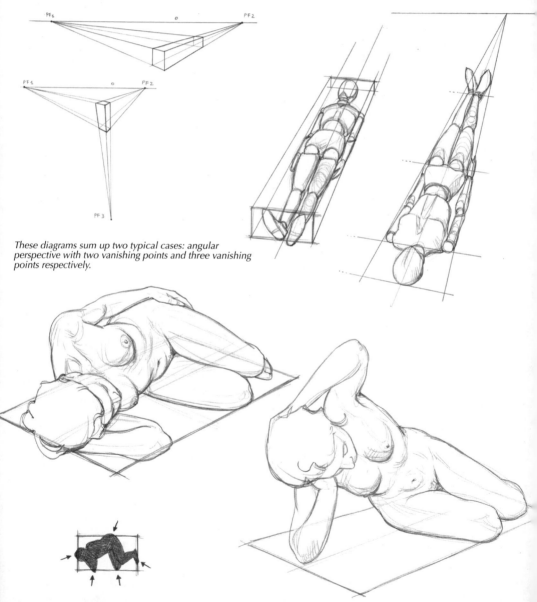

These diagrams sum up two typical cases: angular perspective with two vanishing points and three vanishing points respectively.

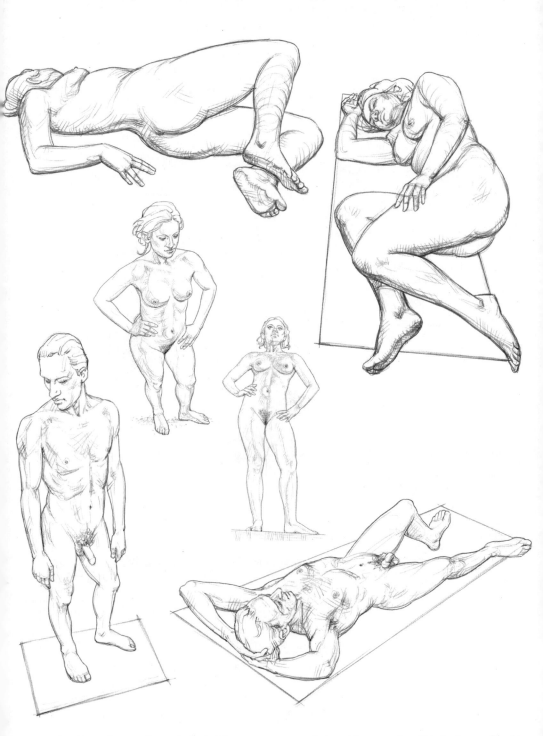

To capture the effects of perspective on the body, it is
sometimes useful to have the model lie down on top of a
simple geometric shape (a square, rectangle, etc.) that can
very easily be put in perspective. Objects often used for this
purpose include rugs, rectangular sheets of newspaper or
wrapping paper, a tabletop or a mat.

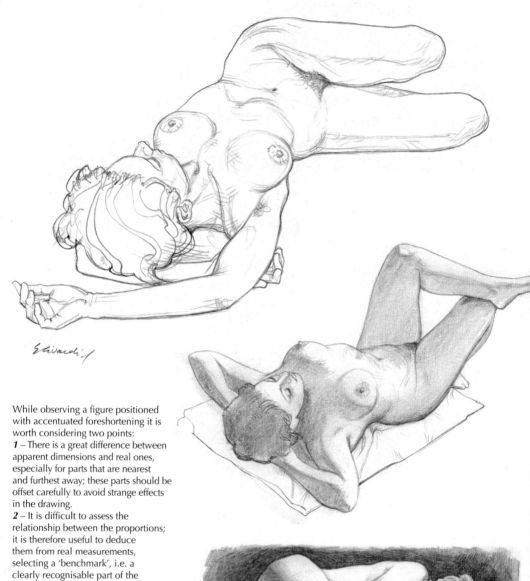

While observing a figure positioned with accentuated foreshortening it is worth considering two points:

1 – There is a great difference between apparent dimensions and real ones, especially for parts that are nearest and furthest away; these parts should be offset carefully to avoid strange effects in the drawing.

2 – It is difficult to assess the relationship between the proportions; it is therefore useful to deduce them from real measurements, selecting a 'benchmark', i.e. a clearly recognisable part of the body, and comparing it with other parts whose shapes and sizes are altered.

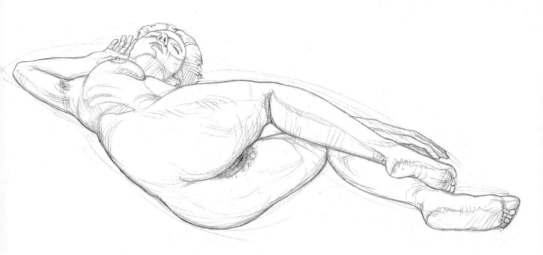

The effect of receding in space can also be obtained by partially overlapping various body sections and drawing those nearest the observer more sharply and with more detail than those further away: a sort of weak 'aerial perspective' between the ends of the body. The volume and roundness of the shapes can be suggested not only through moderate 'geometrising', but also by adding a series of faint 'level lines' to the surface of the body segment being drawn (cf. page 388).

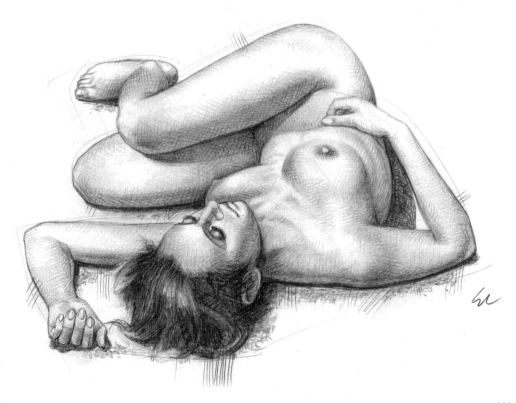

LIGHT AND SHADE

Light moulds the shape of the human body by creating the corresponding *shadows*, just as it does any other object that is illuminated. We know that light can be natural (sun) or artificial and it can hit the surface at various angles and with various degrees of intensity or concentration (direct, diffuse, weak, strong, etc.), and that the shape and direction of the shadows indicate the intensity and position of the light source. In short, light and shade are crucial factors not only for emphasising three-dimensional shapes and putting them into relief, but also for giving the feeling of volume and the idea of space and depth.

The play of light and shade is achieved, in drawings, through *chiaroscuro*, i.e. by means of graduating tones that are shaded off via a sequence of middle values between the lightest and darkest tones. Here are a few ideas to consider when drawing a nude figure:

1 – Illuminate the model with a rather diffused light, from just one moderately strong source.

2 – Assess the middle tone (the 'local' tone), and then identify and show the main areas of maximum light and most intense shadow, thus defining the extreme values of the tonal range.

3 – Pay close attention to the line separating the illuminated areas from the shadowy areas, and to reflected light and cast shadow.

4 – Organise the layout of the light and dark areas, on the body as well as in the surroundings: if they are alternated or contrasted, it can contribute to the composition of the drawing through areas of varying visual weight.

half-shadow (half-tone)

shadow line (hump, crest, bridge)

reflected light

highlight (maximum light), shine

form shadow (shading)

cast shadow (projected)

penumbra (outer shadow)

This sketch is taken from the *Drawing Light & Shade* section of this book, which begins on *page 315*. It sums up chiaroscuro terminology and is easy to understand.

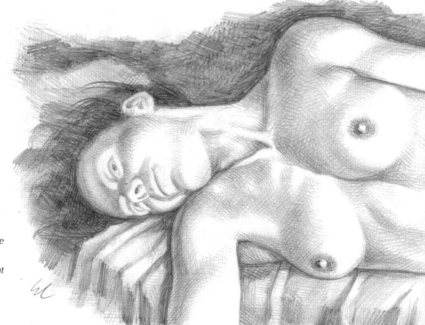

Shadows can produce dramatic and very expressive effects, particularly if the light comes from a rather unusual direction.

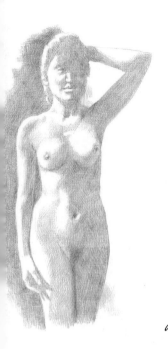
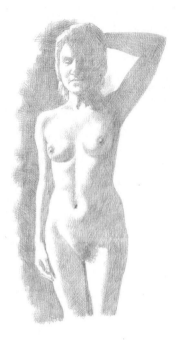
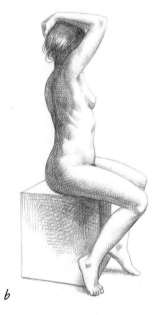

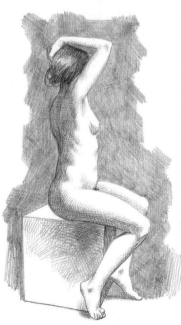

a – Various effects of relief when the figure is facing two different ways, but in the same pose, and with the light coming from the same direction.
b – A different contrast effect on the figure, compared with the background tone.
c – Results produced by weak, diffuse light and strong, direct light.

b

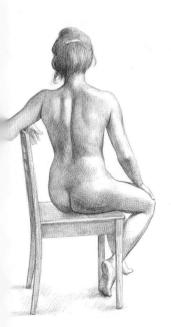
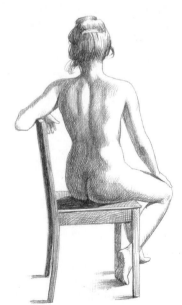

c

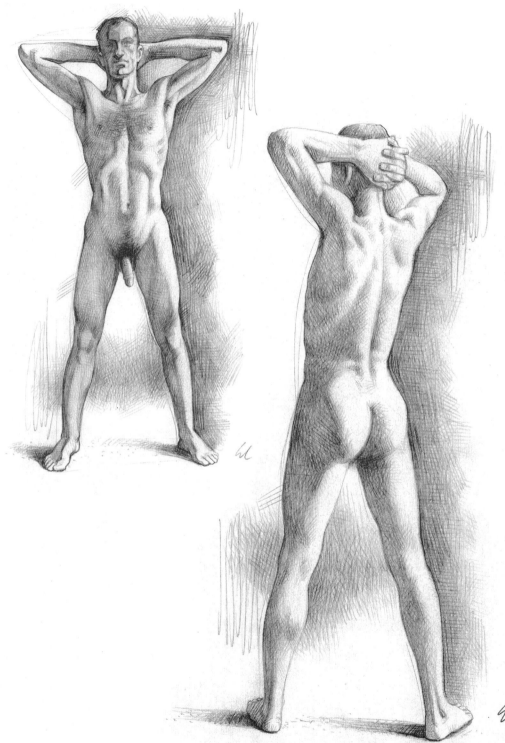

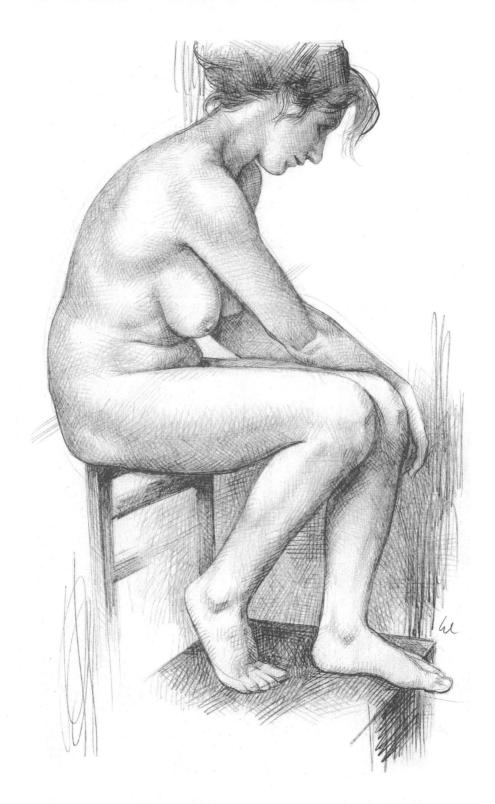

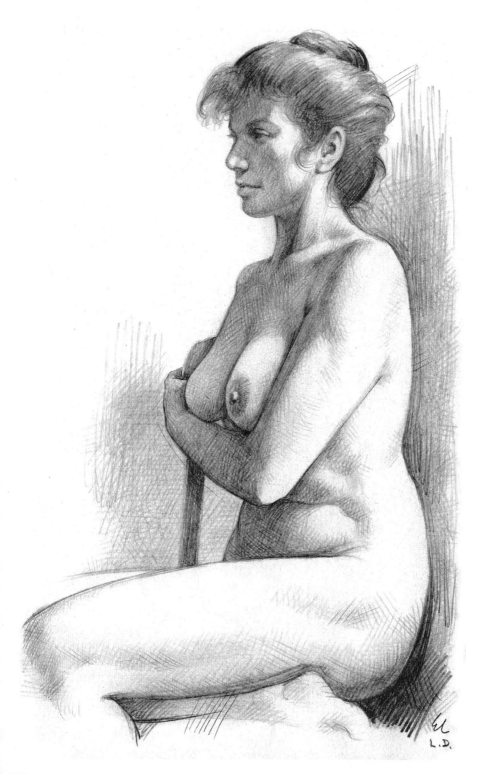

404

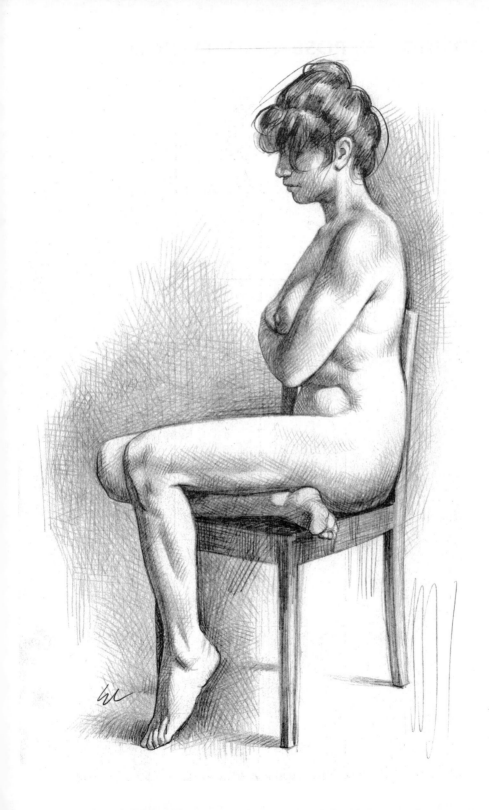

CHOOSING THE POSE AND VIEWPOINT

The choice of *pose* for studying the nude figure depends not only on personal preference but also on the purpose of the drawing and the circumstances in which it is being produced. For example, you may wish to produce a rapid sketch or a very detailed drawing, or you may intend to emphasise the contour lines, the chiaroscuro, the gesture or anatomical features. Sometimes the most expressive choice is suggested by the posture assumed by the models themselves, either intentionally or by chance. Some postures are best described by the male body, others by the female body; in many cases the profile of the body is more suitable for representing

movement, whereas a front (or back) view is more suitable for conveying a state of equilibrium and the tensions involved in maintaining it. Nevertheless, when drawing a nude figure, it can be interesting to do so from different *viewpoints*, turning around the model, so to speak, observing the model from different visual angles, in search of the most favourable, useful or suggestive aspect. An accentuated perspective view can often produce unusual and attractive effects: you can draw the model by placing him or her in a higher or lower position, or you yourself could stand on a raised surface or sit on the floor.

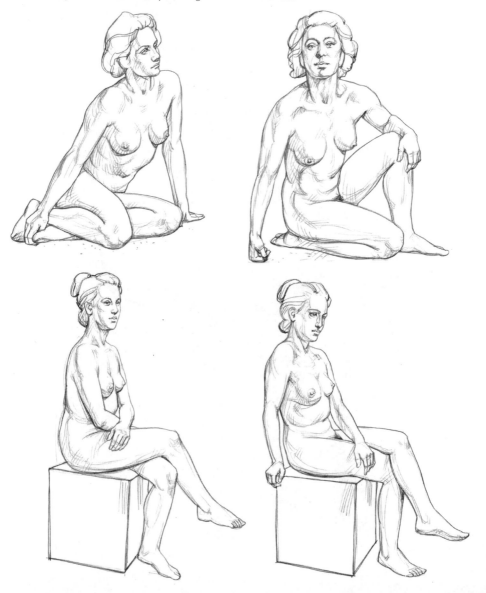

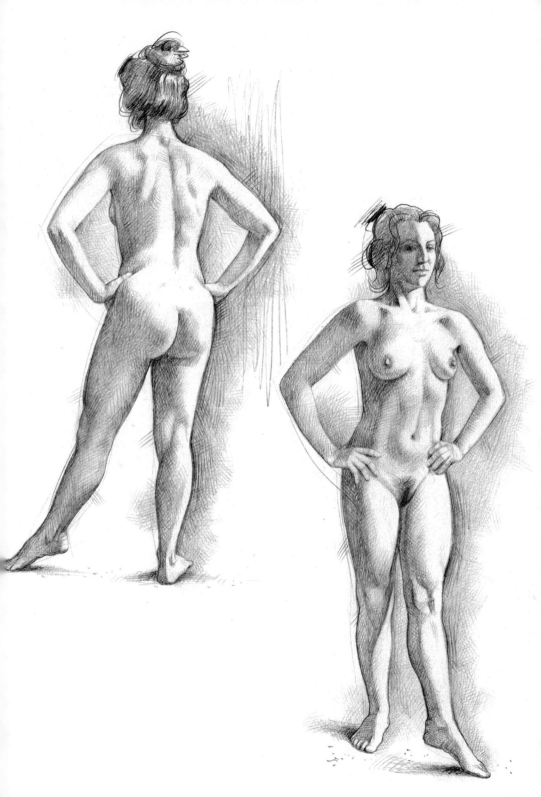

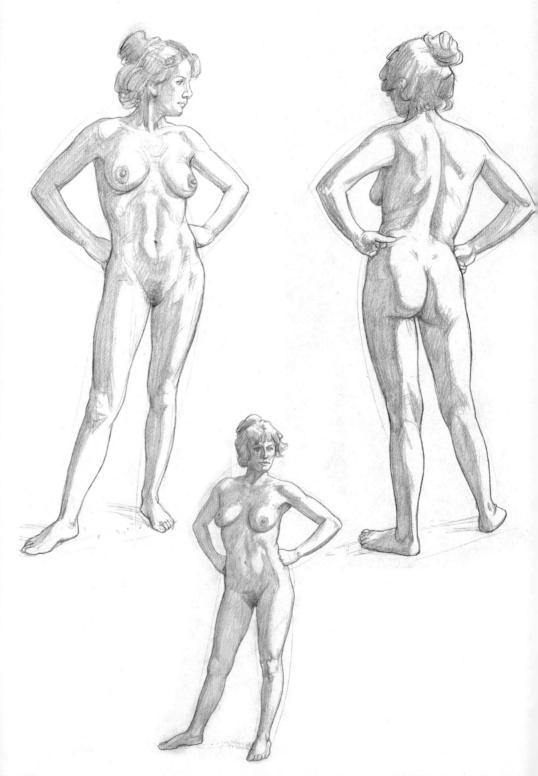

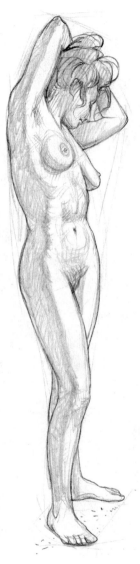

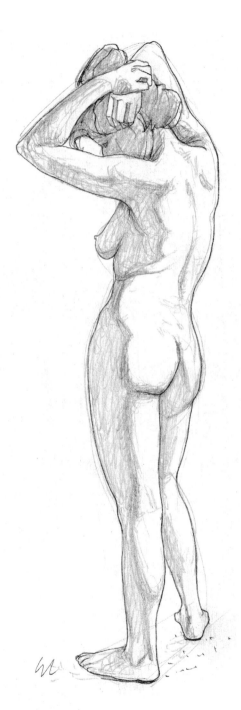

Observing the same pose from different viewpoints is essential for a sculptor, and it is very useful for the artist too, satisfying our curiosity about human forms and translating it into genuinely meaningful drawings. You very often find that some views of the human body prove interesting, for example, from an anatomical point of view, but not so much in terms of the composition or expression, and that all that is required is a slight shift in viewpoint to discover a more stimulating aspect. Our opinions are, of course, subjective, the result of personal taste, refined by life experiences and culture and also by practising, through close examination, drawing nude figures from life.

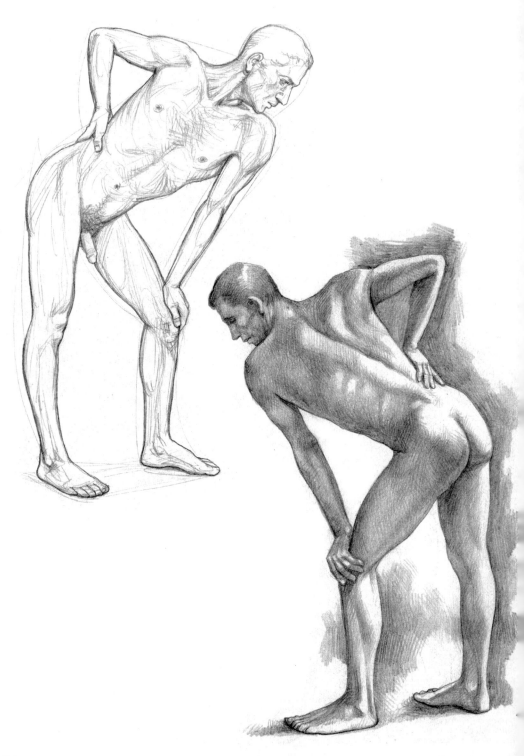

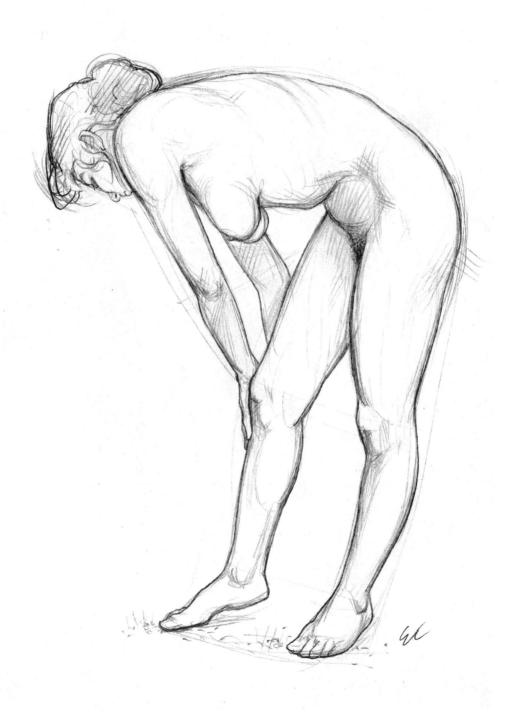

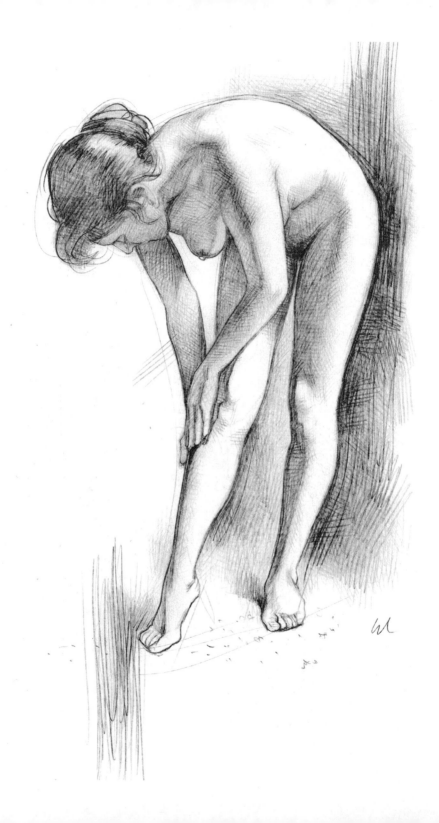

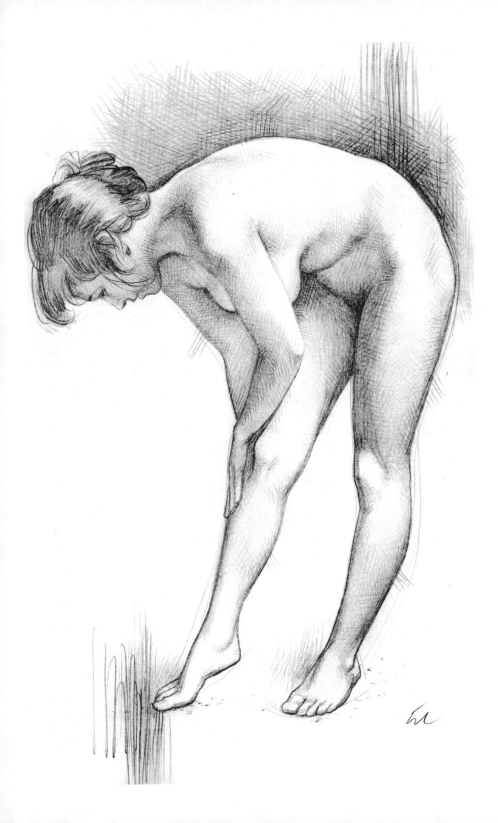

LINE AND TONE

Lines are used to represent the main features of a shape or form (human in our case). Linear drawing is the most synthetic way of depicting objects – it picks out shape and contours, conveying them as linear forms. In fact, lines are an abstract concept, a convention for clearly defining the boundary between a body's surfaces, shadows, masses or structural elements. And yet, depending on how it is drawn (even, broken, continuous, modulated, etc.), a simple line can assume very meaningful and highly expressive aspects. When a human figure's profiles are drawn with just a line, it encourages you to focus on the form's limits and on the most appropriate types of strokes for representing it, intentionally disregarding the less important details that shape the body's surface. But a purely linear drawing is

seldom sufficient to fully define the spatial relationships and volume of the body you wish to portray. To mould the forms effectively, at least according to traditional graphic representation, it is necessary to use *tone* and introduce some chiaroscuro that will indicate the various gradations of shade. For this purpose, it is useful to add, right at the beginning of the drawing, the most important tonal values seen on the model's body and draw them straight away on the whole figure (rather than on individual parts), reducing them to a very limited range, for example: light tone (most intense area of illumination), middle tone and dark tone (most intense area of shadow).

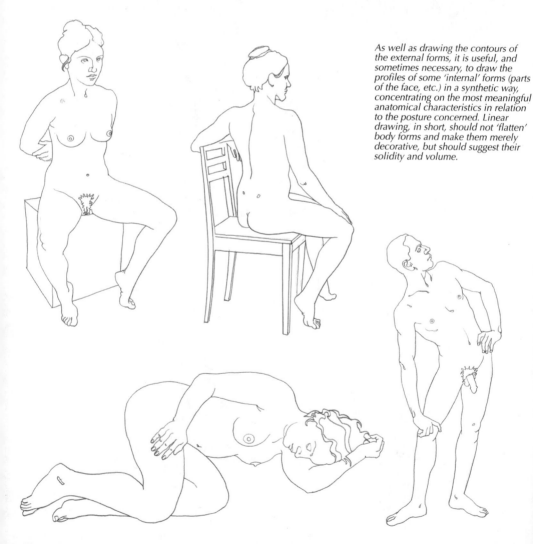

As well as drawing the contours of the external forms, it is useful, and sometimes necessary, to draw the profiles of some 'internal' forms (parts of the face, etc.) in a synthetic way, concentrating on the most meaningful anatomical characteristics in relation to the posture concerned. Linear drawing, in short, should not 'flatten' body forms and make them merely decorative, but should suggest their solidity and volume.

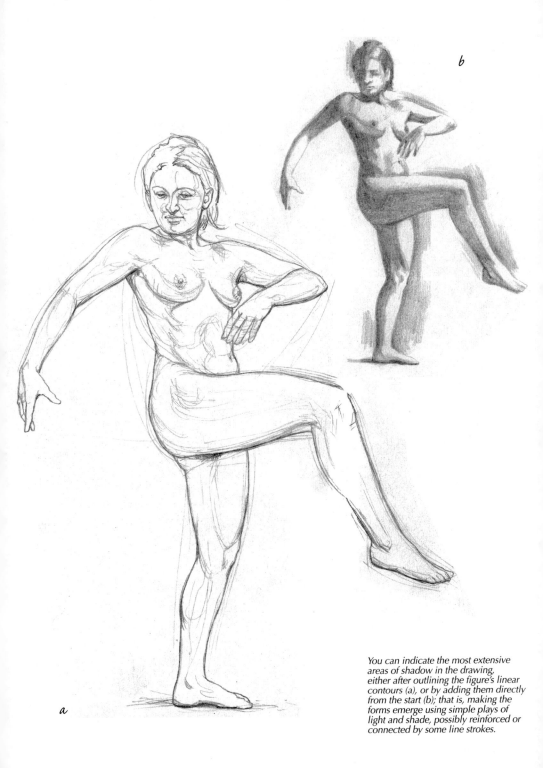

a

b

You can indicate the most extensive
areas of shadow in the drawing,
either after outlining the figure's linear
contours (a), or by adding them directly
from the start (b); that is, making the
forms emerge using simple plays of
light and shade, possibly reinforced or
connected by some line strokes.

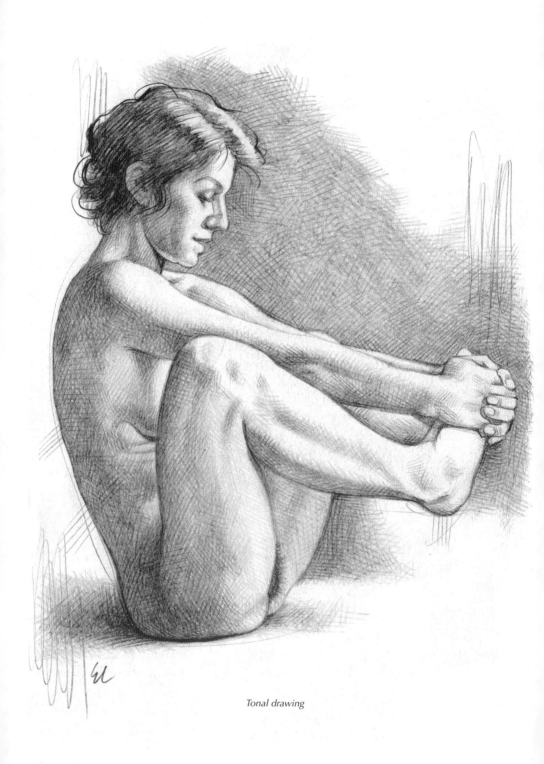

Tonal drawing

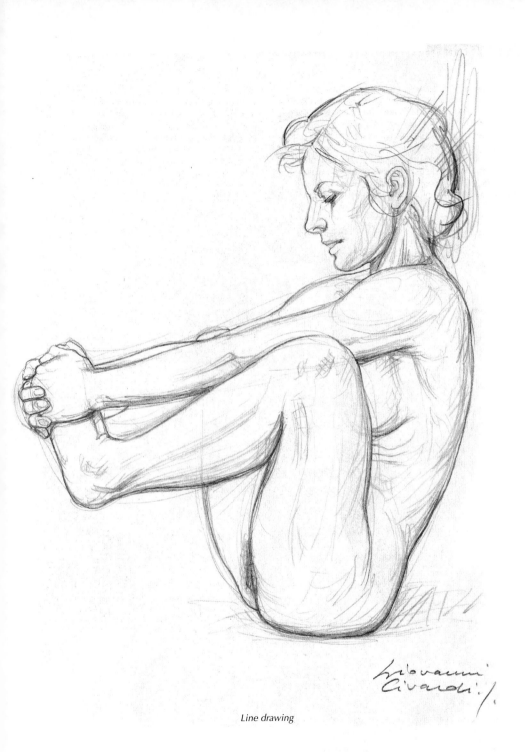

Line drawing

Shading, using its various tones, can heighten the illusion of the body's volume and position in space. You can, of course, combine the two extreme methods (pure linear drawing and pure tonal drawing) to varying degrees.

RHYTHM

A line's progress can vary or be interrupted at regular intervals and acquire a rhythmic value. *Rhythm* is something that repeats itself at cyclic and definite intervals: it is very common in nature and you can see it in the forms of the human body. For example, a small curve alternates with a larger one, a convex profile with a concave one, and so on. It is interesting and useful to identify the relationships between alternating lines in any body position, which give the figure rhythmic scansion, organic unity or a flow of lines and forms. Varying forms and alternating directions

eliminate the monotony of visual uniformity; even the structural axes of the various segments, if they have a dominating sense of direction, can configure and express the potential 'forces' that suggest equilibrium, tension or dynamic effect. However, rhythm is not only found in lines, but also in other components that help structure the composition of a drawing, painting or sculpture: for example, in tone, colour, volume or the layout of elements with 'visual weight', etc.

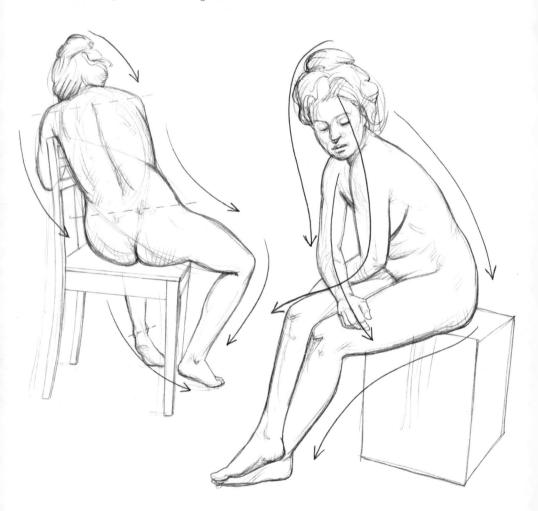

The rhythm of the pose is marked by an 'internal' line that runs along the entire length of the body, and follows the posture adopted by the figure or the movement it is making. In the human body, moreover, the shapes of the limbs are connected with the shape of the trunk: rhythm is seen in the way in which each part is joined to the next one and how all the parts come together in the whole body.

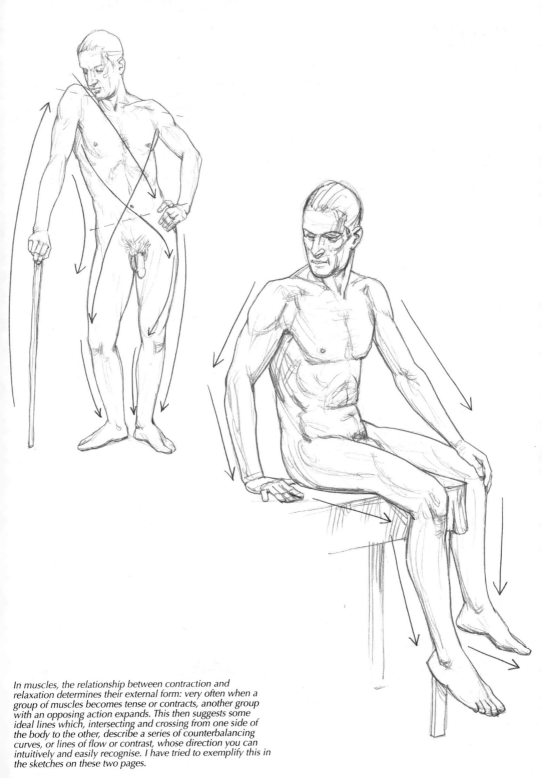

In muscles, the relationship between contraction and
relaxation determines their external form: very often when a
group of muscles becomes tense or contracts, another group
with an opposing action expands. This then suggests some
ideal lines which, intersecting and crossing from one side of
the body to the other, describe a series of counterbalancing
curves, or lines of flow or contrast, whose direction you can
intuitively and easily recognise. I have tried to exemplify this in
the sketches on these two pages.

GRAVITY

The force of gravity attracts objects downwards and can be said to act through the centre of gravity (or barycentre) of an object. The position of the centre of gravity above the base of the body affects that body's equilibrium. We also need to consider other aspects of gravity. The body's external shape is determined by a rather rigid support structure, the skeleton, and by tissues of various thicknesses, the so-called 'soft tissues', such as the skin, muscles, fat, etc. The force of gravity does not alter the appearance of the bones, acting on them only to make the individual skeletal components adjust their balance as a result of the body's position at a particular time. However, as is clear from general observation, the shape of soft parts does change. In women, the changes are perhaps more obvious and easily noticed: hair, breasts or stomach, for example, compress, expand, lengthen or sink into the trunk depending on whether the model is lying face down, is on her back, is standing upright or lying on one side or, even standing on her head. The soft tissues, moreover, adapt to the shape of the support or to another part of the body with which they are in contact. The extent of the adaptation correlates to the solidity of the support and the level of compression of the organic tissue.

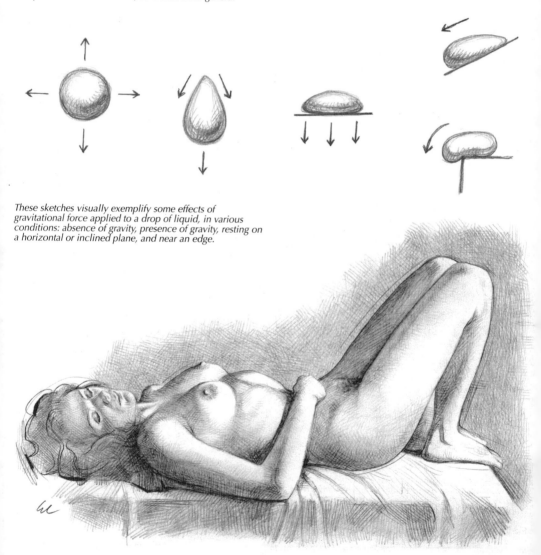

These sketches visually exemplify some effects of gravitational force applied to a drop of liquid, in various conditions: absence of gravity, presence of gravity, resting on a horizontal or inclined plane, and near an edge.

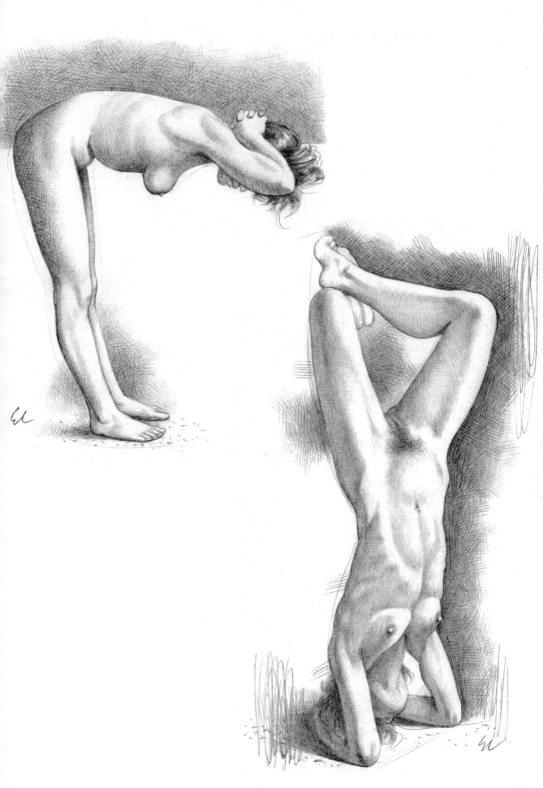

SKETCH AND STUDY

When we know too well,
we know too little

Your observation of a subject changes depending on how you want to draw it. When drawing nude figures you can explore different aspects, for example, composition, anatomy, expression, structure or chiaroscuro. You could employ different types of drawing along the way towards your final drawing, which may be an end in itself or a preparatory study for a complex work. In practising drawing the human figure, we can identify two principal means for learning and improving: sketches and studies, which are different in their conception, purpose and end result.
A *sketch* is the first rapid, synthetic note, which fixes the preliminary idea for a planned composition or interesting physical pose. In its most fundamental form, a sketch can coincide with a 'gestural' drawing (cf. page 380) and encourage the artist to identify the main lines of the form

immediately and synthetically, without worrying about the drawing's apparent incompleteness. It consists, in short, of taking the first notes inspired by the model's spontaneous, casual pose or a precise posture that you wish to investigate, aspects that seem worthy of closer examination in more elaborate studies from life.

A *study*, however, is the task of observing, of carefully recording and analysing some aspects of the figure: anatomic structure, proportions, the 'character' of the pose or effects of light and shade. A thorough investigation of the study is also reflected in a more meticulous technical rendering, produced with the most appropriate graphic tools for conveying the form's particular features, and assessing the effectiveness of different aesthetic solutions.

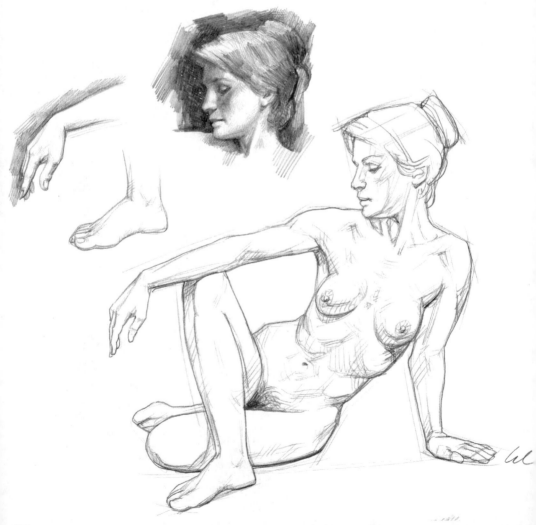

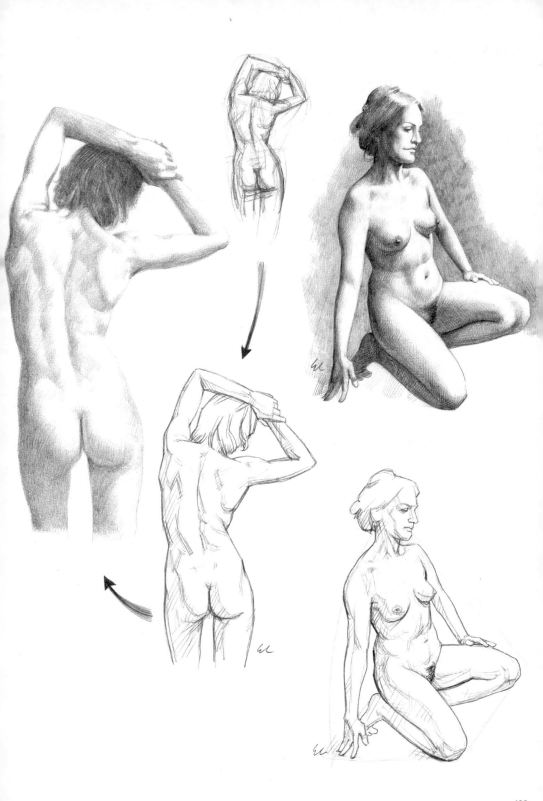

DRAPERY

Drapery provides excellent opportunities for studying aspects of volume on the human figure. It is an ideal tool for accentuating the shape of some parts of the body. In a paradoxical way, drapery actually enhances nudity. At the same time, it can minimise other body shapes and can also become a composition tool. The direction of the folds, the shadows that these produce, the way in which the fabric is supported by the skin in some places, causing it to billow out and yet adapt to the figure, and the way it falls to the ground under the influence of gravity, are all factors that influence the artist when arranging the composition of the whole figure. In making a study of the draped figure, it can be advantageous to consider the following points. First, the weight, thickness and density of the fabric determine the quantity, size and direction of the folds. Choose quite

a light fabric so that it does not hide the anatomical forms (which should be allowed to 'show through' to some extent). Second, when starting to draw the fabric, it is a good idea to draw the most meaningful and important folds, following their direction clearly and surely, so as to suggest the presence of the body shape they cover. Third, a figure that is only partially covered by drapery offers a further advantage over one that is fully covered or dressed in everyday clothing: it enables us to recognise more easily the anatomical regions that support the fabric and give rise to the folds, or the diarthrodial joints from which the creases fan out.

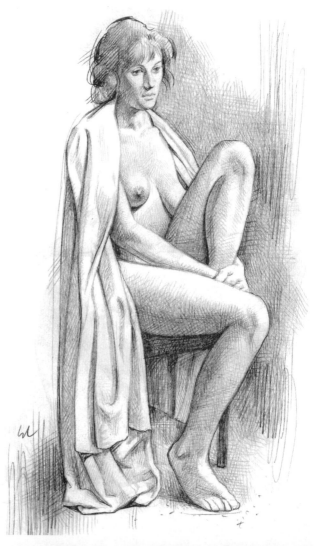

This sketch shows the difference in folds from some supporting or bending regions of the body. Ancient Greek sculptures provide numerous examples of drapery, which are both the result of invention and careful observation from life. I recommend that you do some research into the various artistic styles used for depicting drapery in different civilisations.

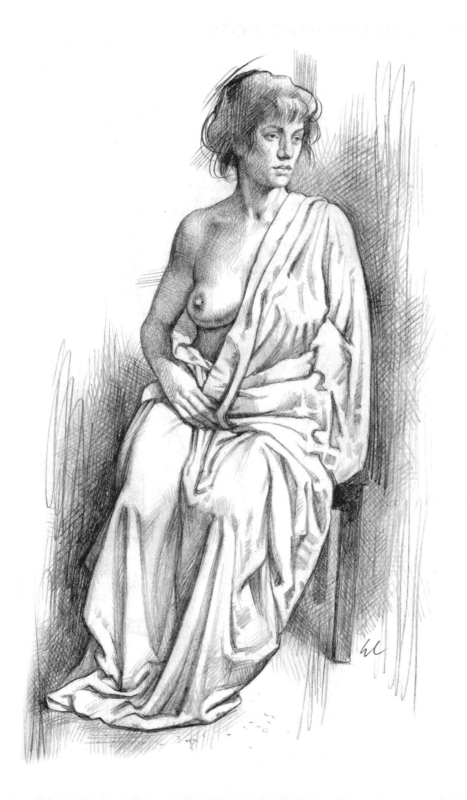

STATIC AND DYNAMIC POSES

In this section of the book, I have selected a small series of drawings taken from my notebooks of studies from life*, a short selection of poses that you could ask your models to assume during nude sittings; you could use these poses as a basis from which to make changes, for example, to the lighting, viewpoint or state of motion. The variety of positions and postures of the human body that attract the artist's attention is, of course, unlimited, although these positions and postures can be placed in some wide, general categories: standing upright, sitting, reclining, etc. Each category has abundant subcategories. The term 'dynamic' usually implies activity, movement of the body, and we know all too well how difficult it is to perceive and draw a moving object correctly. You need to observe the actual development of the movement very carefully, and it is better if it is repeated several times, to aid the capture of the most meaningful and effective 'changes' and to express the direction and coherence of the movement. Alternatively, you could refer to photographic and film footage, even though,

with these tools, perspectives seem highly distorted and the movement is 'frozen' in a sequence. This is useful for understanding the anatomical mechanism of the action, but not very well suited to an overall and coherent perception of the completed gesture. Therefore, I prefer to indicate with 'dynamism' a sort of *tension* in the forms or axes, forces of expansion, contraction or torsion, which animate the body and allow signs of vitality, energy and vigour to show through it. These feelings are, however, rarely suggested by positions that I call 'static', of which calm, equilibrium and relaxation are the main characteristics. The drawing of a posed body assumes either a mainly static or mainly dynamic characteristic with the help, in short, not only of the model's postural and anatomical appearance, but also by variations in the symmetry or asymmetry, equilibrium, chiaroscuro, composition or rhythm, as discussed on previous pages.

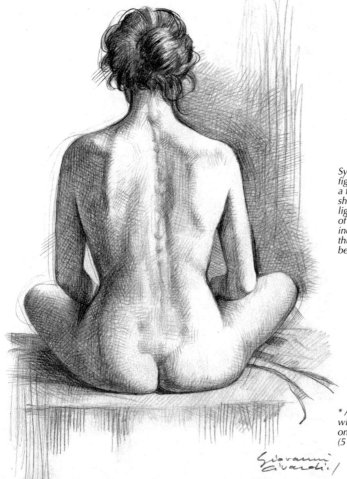

Symmetry and equilibrium render the figure perfectly stable and also allow a feeling of meditative tranquility to show through in the drawing. A lateral light, however, can shape the surfaces of the back, emphasising any slight indentations and protuberances, and thus prevent planes and tonalities being monotonous.

*Almost all the sketches were drawn with a 0.5mm HB micro lead pencil, on paper measuring 13 x 20.7cm (5 x 8in) (Moleskine notebooks).

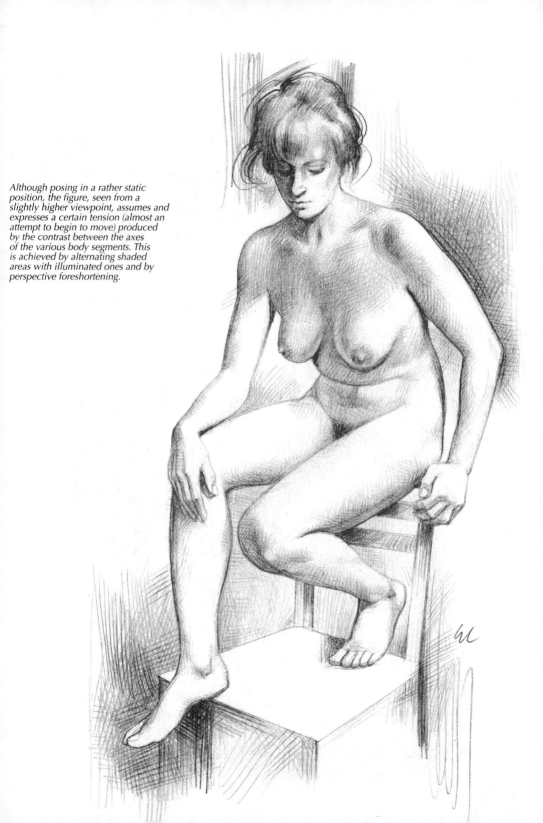

Although posing in a rather static position, the figure, seen from a slightly higher viewpoint, assumes and expresses a certain tension (almost an attempt to begin to move) produced by the contrast between the axes of the various body segments. This is achieved by alternating shaded areas with illuminated ones and by perspective foreshortening.

When you have the opportunity to work with models who
have had gymnastic training, it is very easy to capture, in
their spontaneous postures, a dynamic characteristic, a
tension between opposing forces. See, for example, this
pose, where the contraction of the muscles in the back,
abdomen and thighs tends to oppose the gravitational pull
exerted on the trunk and head bent forwards.

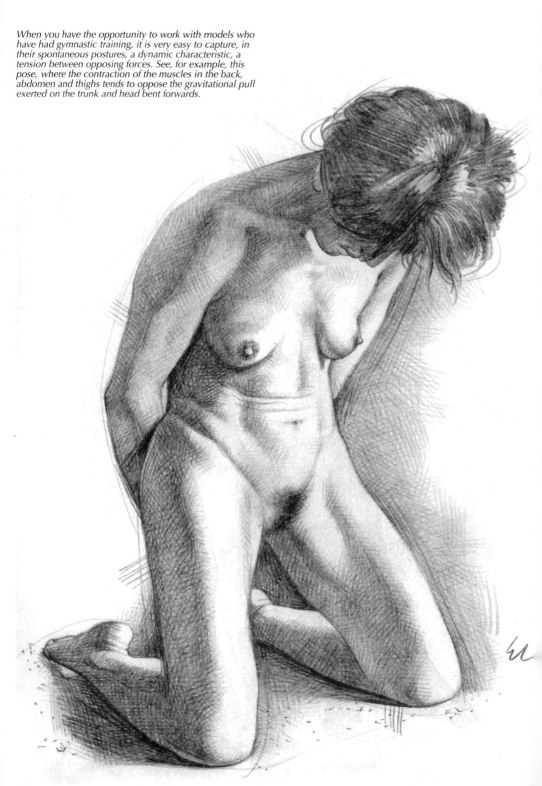

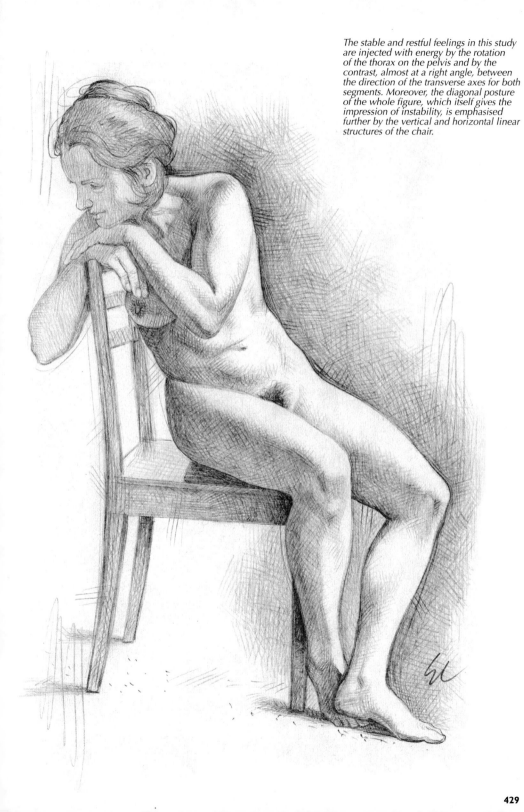

The stable and restful feelings in this study are injected with energy by the rotation of the thorax on the pelvis and by the contrast, almost at a right angle, between the direction of the transverse axes for both segments. Moreover, the diagonal posture of the whole figure, which itself gives the impression of instability, is emphasised further by the vertical and horizontal linear structures of the chair.

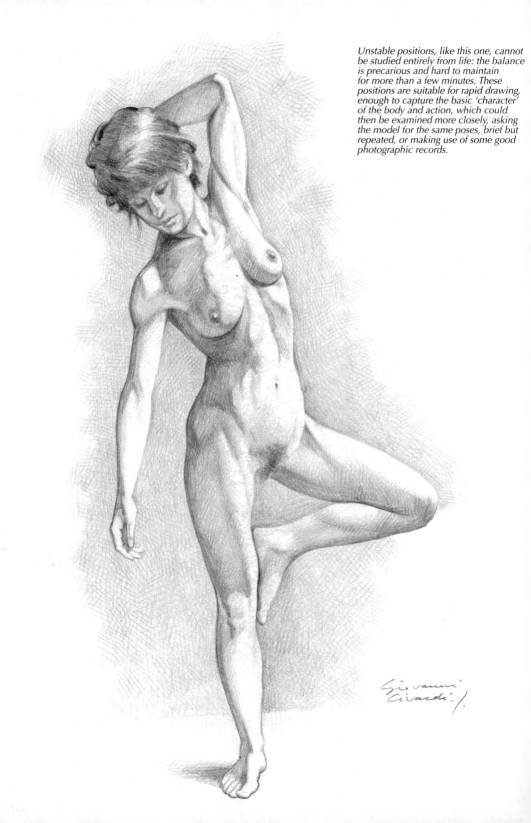

Unstable positions, like this one, cannot be studied entirely from life: the balance is precarious and hard to maintain for more than a few minutes. These positions are suitable for rapid drawing, enough to capture the basic 'character' of the body and action, which could then be examined more closely, asking the model for the same poses, brief but repeated, or making use of some good photographic records.

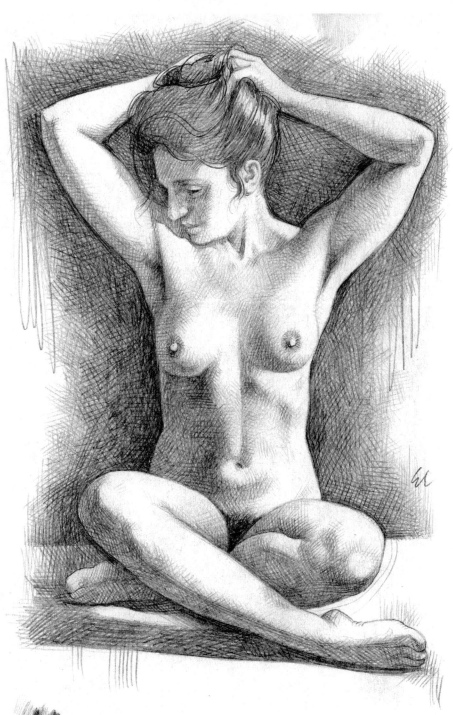

The model is different, but the pose is similar to the one shown on page 426. The symmetry is made even more obvious by the mirror-image position of the raised arms, and yet this contrasts with the rotation of the head, so much so that we see almost a profile of the face. A further contrast is the very slight difference in position and shape of the breasts, which, it is useful to remember, are twin body parts that are rarely perfectly symmetrical.

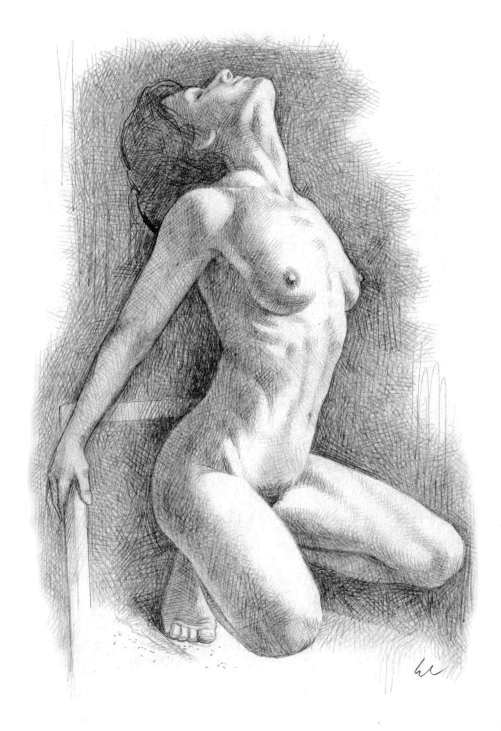

Despite appearances, this position is still rather static. The tensions mainly lie in the composition and chiaroscuro. In fact, the drawing was produced entirely from life, with the model posing for the whole time, about half an hour. According to the model, she did not even get very tired.

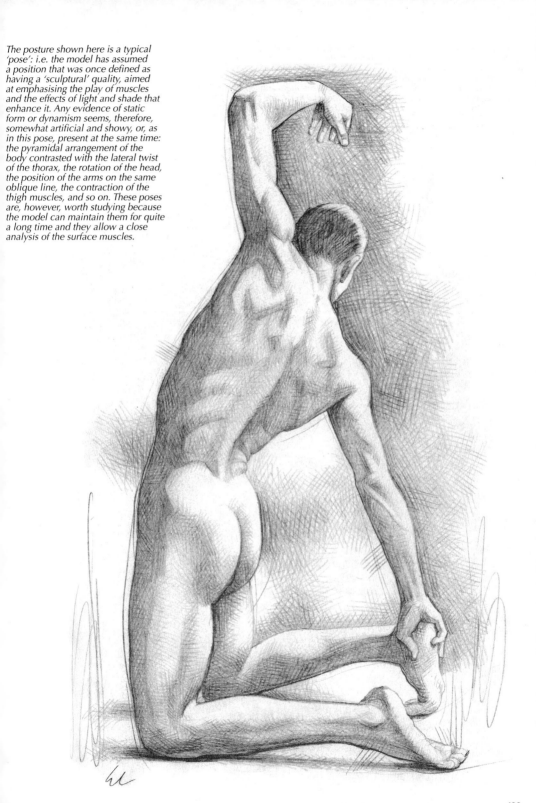

The posture shown here is a typical 'pose': i.e. the model has assumed a position that was once defined as having a 'sculptural' quality, aimed at emphasising the play of muscles and the effects of light and shade that enhance it. Any evidence of static form or dynamism seems, therefore, somewhat artificial and showy, or, as in this pose, present at the same time: the pyramidal arrangement of the body contrasted with the lateral twist of the thorax, the rotation of the head, the position of the arms on the same oblique line, the contraction of the thigh muscles, and so on. These poses are, however, worth studying because the model can maintain them for quite a long time and they allow a close analysis of the surface muscles.

Sometimes, the positions assumed by the body can be placed into one of two categories: 'open' or 'closed'. Open forms are those associated with the appearance and feeling of expansion, divergence or spreading out of the body segments towards the surrounding space, as if they were driven by centrifugal forces. Closed forms, on the other hand, seem to express a sense of concentration, condensing, as if the body's segments were being drawn in by a centripetal force. The position drawn here is a very closed one, which is conveyed by the joining of the hands and interlacing of the fingers. But it also suggests 'explosive' tension, caused by the twisting of the thorax and emergence of the left knee, whose relationship with the other body parts is not easy to judge, at least at first glance.

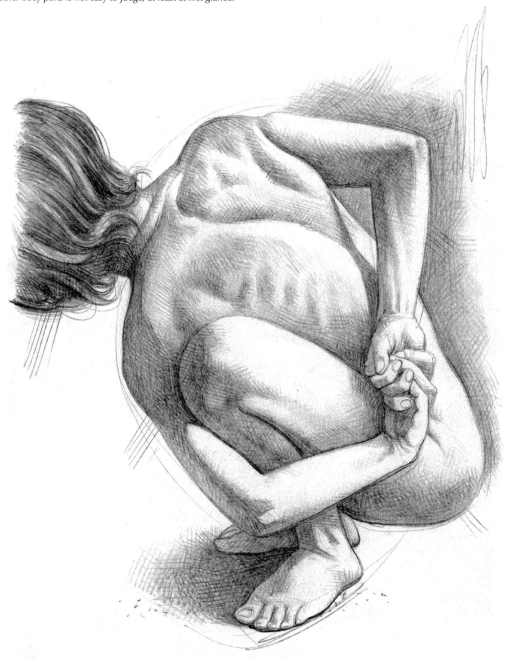

When a closed action is in progress, it results in a decidedly dynamic drawing, in the widest sense of the term. If you do not wish to use photographs or poses repeated over and over, it is quite difficult to make an accurate study of these positions. Even if the action is simply slowed down, it breaks up and alters the sequence of the gesture and reduces its natural, spontaneous flow. The artist and the model, therefore, are forced to use their imagination and creativity for the drawing, finding an acceptable compromise and the best way of 'stopping' the movement: after a quick drawing that fully captures the character of the gesture and the anatomical forms that define it, and after a few photographs for reference, they have to devise some means of support so that the model can maintain the pose (although with a partial loss of tension and spontaneity), for at least a few minutes. The model portrayed in this drawing, for example, was 'sitting' on the arm of an easy chair and was resting her fingers on a cardboard box.

Both male and female dancers, particularly those who practise contemporary dance, are very disposed to assuming postures derived from their line of work. It is good, then, to let them move freely and capture a position that seems interesting and expressive, not only from an aesthetic point of view but particularly for the possibilities it could offer as an anatomical/morphological study.

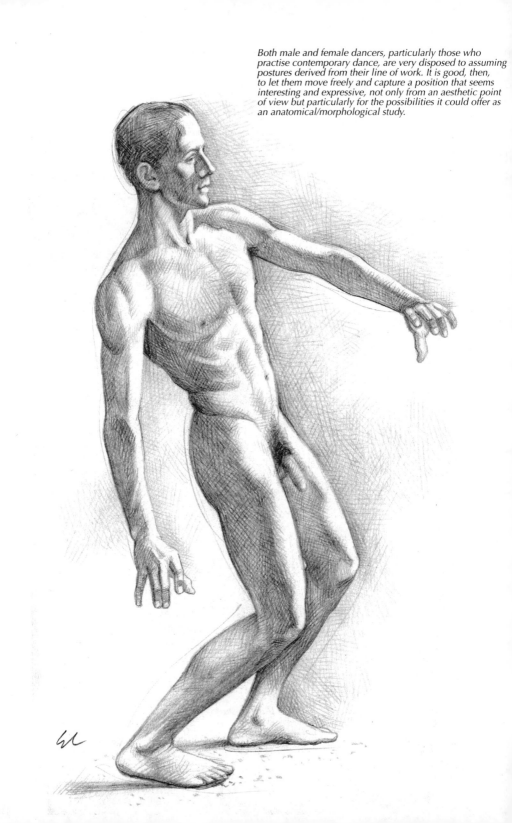

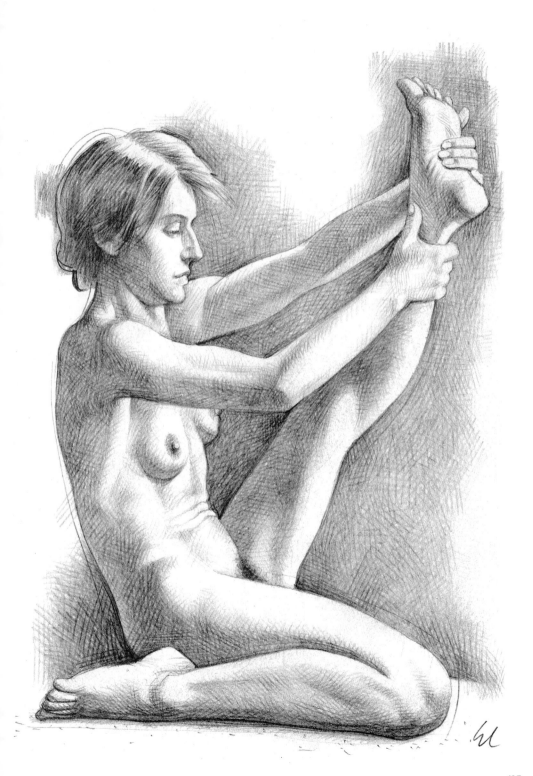

This is another 'closed' form, posed by the same model who appeared in some earlier drawings and who is particularly skilled at assuming athletic positions. In these cases, however, it is preferable not to accentuate any muscle bulges or the denseness of the shadows they cast. It is better, instead, to depict the muscles correctly according to the intensity of the action being carried out.

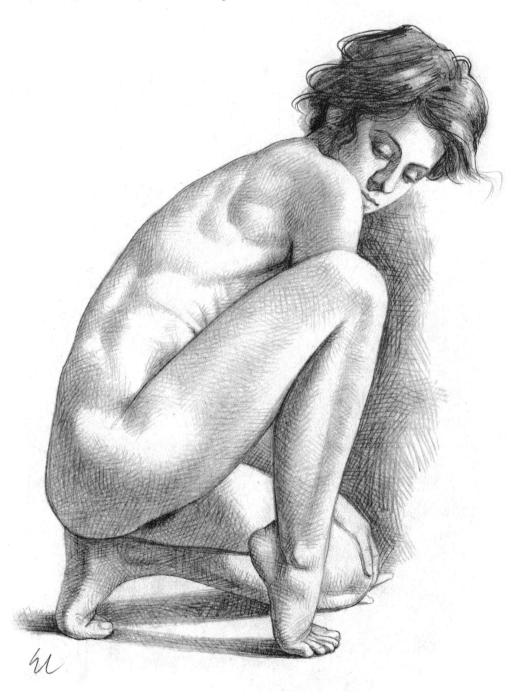